# ART
# AND
# EMPIRE
## TREASURES FROM
## ASSYRIA IN THE
## BRITISH MUSEUM

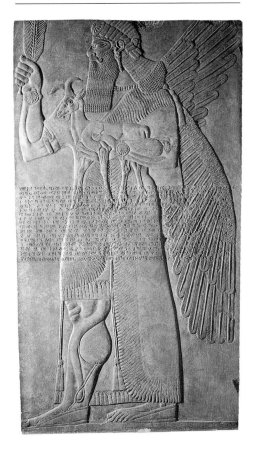

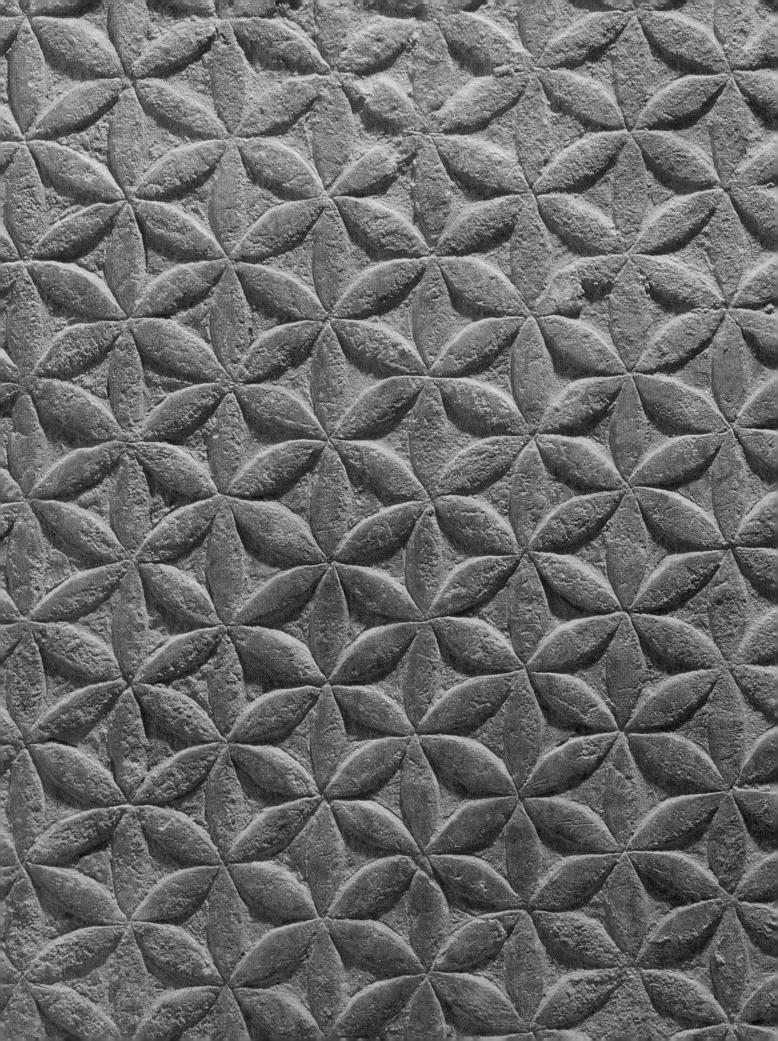

# ART
# AND
# EMPIRE
## TREASURES FROM
## ASSYRIA IN THE
## BRITISH MUSEUM

### EDITED BY
### J.E.CURTIS AND J.E.READE

**WITH CONTRIBUTIONS BY**
D.COLLON, J.E.CURTIS, I.L.FINKEL,
A.R.GREEN, H.MACDONALD
J.E.READE, C.B.F.WALKER

**FOREWORD BY**
**R.G.W.ANDERSON**

**THE METROPOLITAN MUSEUM OF ART**
**NEW YORK**

**DISTRIBUTED BY**
**HARRY N.ABRAMS, INC., NEW YORK**

This book has been published in conjunction with the exhibition 'Art and Empire: Treasures from Assyria in the British Museum', held at The Metropolitan Museum of Art, New York, from May 2 through August 13, 1995, and at The Kimbell Art Museum, Fort Worth, Texas, from October 1995 through February 1996.

The exhibition is made possible in part by The Dillon Fund.

It was organized by The Metropolitan Museum of Art and The British Museum. An indemnity has been granted by the Federal Council on the Arts and the Humanities. Additional assistance has been provided by N.H. Horiuchi Inc. Tokyo.

ILLUSTRATION ACKNOWLEDGEMENTS
The photographs on pp. 16–17, 18, 19, 23, 24–5, 27, 28–9, 37, 133 and 152 are by J. E. Curtis. Those on pp. 15 and 112 and the drawing on p. 93 are reproduced courtesy of the British School of Archaeology in Iraq. The map on p. 9, the photographs on pp. 14 and 92 and the drawings on pp. 125, 138, 140, 141 and 172 are by Ann Searight.

HALF-TITLE PAGE Protective spirit. Relief from the palace of Ashurnasirpal II at Nimrud, about 875–860 BC (no. 8).

TITLE PAGE Detail of a stone carpet from the throne-room of Ashurbanipal at Kuyunjik, about 645–640 BC (no. 45).

Library of Congress Cataloging-in-Publication Data
Art and Empire: treasures from Assyria in the British Museum/edited by J.E. Curtis and J.E. Reade: with contributions by D. Collon . . . [et al.]: foreword by R.G.W. Anderson.
    p.   cm.
   Catalog of an exhibition held at the Metropolitan Museum of Art. May 2, 1995.
   Includes bibliographical references.
   ISBN 0-87099-738-6 (pbk.). — ISBN 0-8109-6491-0 (Abrams)
   1. Art. Assyro-Babylonian—Exhibitions.   2. Art—England—London—Exhibitions.   3. British Museum—Exhibitions.
I. Curtis, John.   II. Reade, J.E.   III. Collon, Dominique.
IV. Metropolitan Museum of Art (New York, N.Y.)
N5370.A78  1995
730'.0935—dc20
                         94-47101
                         CIP

Designed by Harry Green

Printed and bound in Italy

# CONTENTS

Foreword    *page 6*

The Discovery of Assyria    *page 9*

The History of Assyria    *page 17*

Assyrian Civilisation    *page 32*

Chronology    *page 38*

1    Reliefs and Sculptures    *page 39*

2    Palaces and Temples    *page 92*

3    Magic and Religion    *page 109*

4    Furniture and Fittings    *page 121*

5    Vases and Vessels    *page 133*

6    Horse Trappings and Harness    *page 161*

7    Dress and Equipment    *page 171*

8    Seals and Sealings    *page 179*

9    Administration and Society    *page 190*

10    Literature and Science    *page 198*

11    Assyria Revealed    *page 210*

Bibliography    *page 222*

# FOREWORD

As early as 1860 a British Parliamentary Committee was involved in discussions over how the Assyrian collection, largely acquired by Austen Henry Layard, might best be displayed in the British Museum. As a result of Layard's activities, the Museum had formed the basis of what has now become the finest collection of Assyrian antiquities outside Iraq. Though this collection is of world-wide interest, most pieces have never been seen outside their London home.

One of the greatest responsibilities, and pleasures, of museum work is to make objects available to as wide a public as possible. This can be achieved to some extent through permanent galleries and publications, but an international touring exhibition reaches a new audience and we are delighted that it has been possible, with this exhibition, to provide greater access than ever before to the British Museum's Assyrian collection. Assyria was one of the greatest civilisations in the ancient world, but it remains much less well known than those of Egypt, Greece and Rome. It is hoped that the exhibition will stimulate interest in the sophisticated culture of Assyria and go a little way towards redressing the balance. Certainly the objects provide us with invaluable evidence of this civilisation. Although artistic achievements are reflected in other media such as bronze and ivory, it is the stone bas-reliefs which surely make the greatest impact, with their narrative scenes of Assyrian life. The cuneiform tablets indicate the important contribution which Assyria made to science and literature.

Preparing the exhibition has taken considerable efforts on the part of curators, conservators, stonemasons and photographers. Many of the reliefs are normally displayed on walls into which they have been cemented. Removing them has had to be done with the greatest care, though, interestingly, the very thorough examination which has been necessary throughout the process has itself revealed new information about the objects. The effort has been rewarded by the number of museums around the world that asked to borrow the exhibition, which was initially intended as a display for the Museo Nacional de Antropología in Mexico City. The Director of The Metropolitan Museum of Art, Philippe de Montebello, expressed the wish for the exhibition to come to New York, and interest by other museums followed rapidly; 'Art and Empire' will now circumnavigate the globe.

The exhibition has been organised by the Department of Western Asiatic Antiquities, of which the Keeper, John Curtis, together with Julian Reade and Tim Healing, should be especially mentioned, though many others, including Stefan Flis and the team of museum assistants,

have made significant contributions. Ken Uprichard and his staff of stone conservators have borne the heavy burden of preparing the bas-reliefs for travel, though other conservation disciplines have also been involved. The stonemasons' team has been led by Ted Wood, and photography has been co-ordinated by Alan Hills. This catalogue has been prepared for publication by Teresa Francis of British Museum Press with her customary skill and enthusiasm. Our warm thanks are due to these and others not mentioned who have made this major venture possible.

R.G.W. ANDERSON
*Director, The British Museum*
*August 1994*

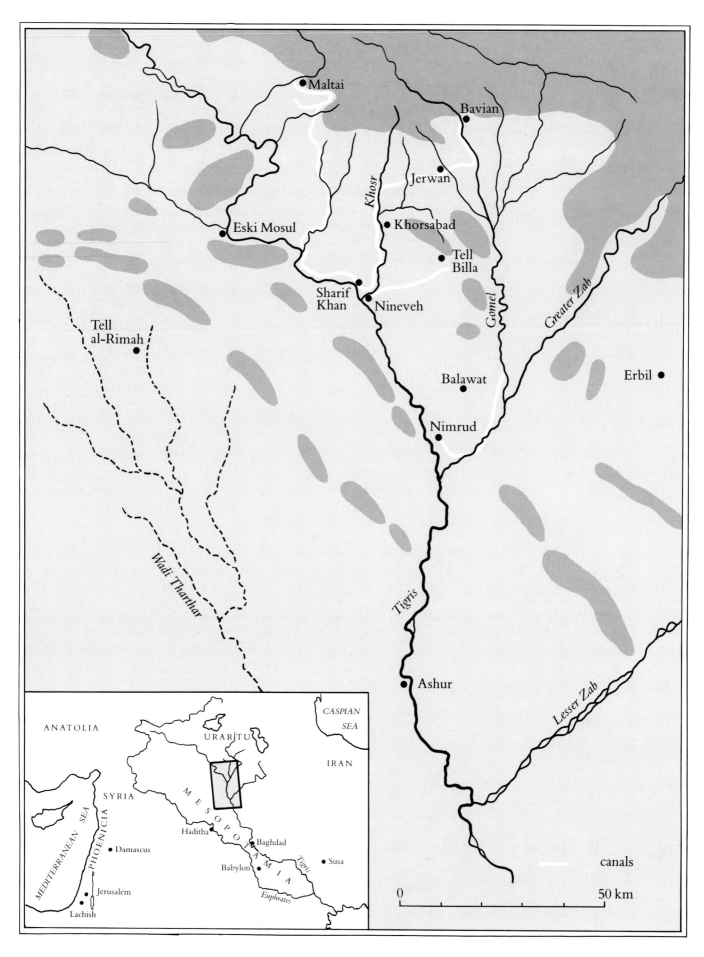

# THE DISCOVERY OF ASSYRIA

Until the middle of the last century, European knowledge of Assyria was largely derived from accounts in a few classical authors, notably Herodotus, and from references in the Bible. It was the description in the Book of Kings of Sennacherib's abortive invasion of Israel that prompted the famous lines by Lord Byron:

> The Assyrian came down like the wolf on the fold,
> And his cohorts were gleaming in purple and gold;
> And the sheen of their spears was like stars on the sea,
> When the blue wave rolls nightly on deep Galilee.
>
> Like the leaves of the forest when summer is green,
> That host with their banners at sunset were seen.
> Like the leaves of the forest when Autumn hath blown,
> That host on the morrow lay wither'd and strewn.
>
> *The Destruction of Sennacherib*

FIGURE I Map of Assyria.

Although more detailed information was contained in the works of the early Arab geographers, relying partly on local tradition, this was not widely known, if at all, in the west. The location and history of Assyria were only very vaguely understood. We now know that Assyria was centred in northern Mesopotamia (modern Iraq) and that between the ninth and seventh centuries BC this state dominated the whole of the Ancient Near East. The main cities were Nineveh, Nimrud and Ashur, all on the banks of the River Tigris, and Khorsabad. It is easy to take this knowledge for granted, and assume that it was always common, but this is certainly not the case. The first European traveller to note the location of ancient Nineveh was the Jewish rabbi Benjamin of Tudela in the twelfth century, and in the following centuries a number of others commented on the ruins across the River Tigris from Mosul. These included the Danish scholar Carsten Niebuhr, who visited the site in 1766. The first scientific examination of Nineveh was undertaken by the brilliant Orientalist Claudius James Rich, the East India Company's Resident at Baghdad, who in 1820–21 completed a survey of the ruins.

There now enters our story the man who more than any other was responsible for the way in which Assyria caught the public imagination. This was Austen Henry Layard, who in 1840 passed through Mosul on his way to India. Sailing down the Tigris on his way to Baghdad he saw Nimrud, which made an enormous impression on him: 'My curiosity had been greatly excited, and from that time I formed the design of thoroughly examining, whenever it might be in my power, these

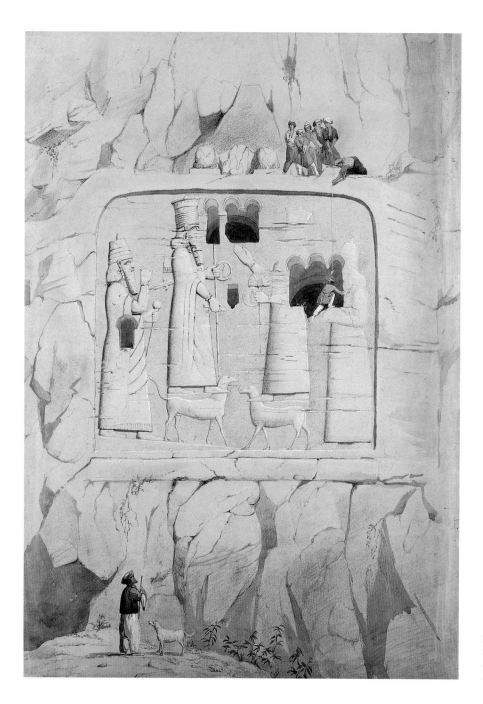

FIGURE 2 Layard, on the end of a rope, investigating rock sculptures of Sennacherib at Bavian, north of Mosul. Watercolour by F. C. Cooper, 1850.

singular ruins' (Layard 1849: 9). He visited Mosul again in 1842, when he made the acquaintance of Paul Emile Botta who had been appointed French Consul there. Botta was also interested in excavation, and in December 1842 started digging on Kuyunjik, the larger of the two mounds within the walls of ancient Nineveh. But he did not find much, and in spring 1843 he transferred his attention to the site of Khorsabad about 20 kilometres north of Mosul. The results from two campaigns in 1843 and 1844 were impressive. He cleared a good deal of the northern part of the palace of Sargon (721–705 BC) and also made soundings in

Palace F. During these operations he uncovered a great many bas-reliefs, many of which were drawn by the artist Eugène Flandin who was sent out to Mosul in 1844. The results of this work were published in five magnificent folio volumes, sponsored by the French Government and called *Monument de Ninive*. These appeared in 1849–50.

Meanwhile, Layard started work at Nimrud, 40 kilometres south of Mosul. He was able to realise his earlier dream of working there through the generosity of Sir Stratford Canning, British Ambassador to the Sublime Porte, who himself financed the excavations before this responsibility was shouldered by the Trustees of the British Museum. Layard worked at Nimrud in the years 1845–7 and 1849–51. The results were spectacular. In the North-West Palace of Ashurnasirpal II (883–859 BC) he excavated mainly in the state apartments to the south of the main entrance, but was unable through lack of funds completely to empty many of the rooms, having to content himself with trenching round the walls. Nevertheless, he uncovered very many stone relief slabs and a

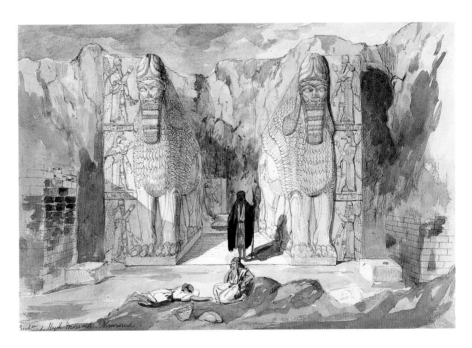

FIGURE 3 Entrance to the shrine of Ninurta, Nimrud, built by Ashurnasirpal II, *c.* 865 BC. Watercolour by F. C. Cooper, 1850.

number of colossal stone gateway figures, some of which are now in the British Museum. Elsewhere on the site, Layard excavated in various temples and three more palaces. In front of the so-called 'Central Building' he found the Black Obelisk of Shalmaneser III, which shows the Biblical king Jehu submitting to the Assyrian king and tribute being brought from various parts of the Near East. He even worked briefly around the ziggurat and Fort Shalmaneser. It is difficult to overestimate the size of Layard's contribution, not only to our knowledge of Nimrud but also to Mesopotamian archaeology in general. These discoveries

created a buzz of excitement in nineteenth-century Europe, and inevitably there was some influence on contemporary decorative arts. In London, for instance, we find porcelain figures of Assyrian kings and queens being produced by W. T. Copeland and Sons Ltd. There are even suggestions that the full beards favoured by Victorian worthies may have had their origins in the Assyrian sculptures.

During these years Layard also worked at Nineveh, which led to some friction with the French. With Botta he had struck up a cordial relationship, even though he disapproved of his habit of smoking opium. But Botta had been temporarily replaced as consul by a Monsieur Rouet, who was less accommodating and felt that the French had a prior claim on Nineveh. Nevertheless, Layard did some trial excavations in 1846 and again in 1847, on the latter occasion discovering the palace of Sennacherib (704–681 BC) in the south-west corner of the Kuyunjik mound. He went on to uncover much of this palace. In his own words:

> In this magnificent edifice I had opened no less than seventy-one halls,
> chambers, and passages, whose walls, almost without an exception, had been
> panelled with slabs of sculptured alabaster recording the wars, the triumphs,
> and the great deeds of the Assyrian king. By a rough calculation, about 9,880
> feet, or nearly two miles, of bas-reliefs, with twenty-seven portals, formed
> by colossal winged bulls and lion-sphinxes, were uncovered in that part
> alone of the building explored during my researches. (Layard 1853: 589).

Amongst the many important sculptures discovered in this palace was the series illustrating the siege and capture of Lachish in Palestine.

In May 1851 Layard left Mosul, never to return. He was only 34. He entered politics – a sad waste of his talents, as he did not shine in this arena – and from 1861 to 1866 was Under-Secretary for Foreign Affairs. He eventually retired to Venice. Layard's work at Nineveh was continued by his protégé Hormuzd Rassam, who came from a local Christian family in Mosul and was a brother of Christian Rassam, the British Vice-Consul. He had originally been taken on by Layard as an assistant in February 1846, and his knowledge of local conditions and customs proved to be invaluable. Rassam was sent back to Mosul in 1852, and was soon hard at work, making various discoveries including the White Obelisk of Ashurnasirpal I (1049–1031 BC) in the south part of the Kuyunjik mound. But his eye was drawn to the north part of the mound, where he suspected there might be another palace. Under a rather loose agreement this part of the mound was a French preserve, so Rassam resorted to the expedient of digging at night. He immediately came across stone slabs belonging to the North Palace of Ashurbanipal. There was little the French could do except gracefully concede that they had been outmanoeuvred. Before April 1853, when his funds were exhausted, Rassam hurriedly excavated the magnificent series of reliefs in

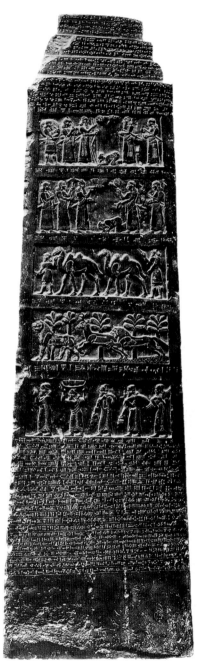

FIGURE 4 The Black Obelisk of Shalmaneser III, c. 825 BC, found at Nimrud by Layard in 1846.

Room C showing the royal lion hunt, and came across a collection of cuneiform tablets which were part of the 'royal library' of Ashurbanipal.

After Rassam's departure, overall charge of the British Museum excavations in Assyria was entrusted to Colonel H. C. Rawlinson, the British Resident in Baghdad. Rawlinson was a distinguished scholar who is remembered for his part in the decipherment of cuneiform. His copies of the cuneiform inscriptions carved on a cliff-face at Bisitun near Kermanshah in Iran, made in 1836–7, proved invaluable to the pioneers of cuneiform studies. Rawlinson was anxious that British excavations should continue and now enlisted the help of the Assyrian Excavation Fund. This body, supported by private subscriptions, had been established in the late summer of 1853 with the object of excavating at sites in Mesopotamia. It had appointed as its excavator William Kennet Loftus, who had left for Mesopotamia in October 1853, accompanied by the artist William Boutcher. In the first part of 1854, Loftus and Boutcher worked at Warka in southern Iraq; at Rawlinson's request they then went up to Mosul. In the meantime, the Assyrian Excavation Fund had not raised as much money as hoped, and found itself in financial difficulties. It was therefore proposed that Loftus and Boutcher should work on behalf of the British Museum and that the costs should be shared between the Museum and the Fund. Under these arrangements they excavated at Nineveh from October 1854 until March 1855, clearing out more of Ashurbanipal's palace and finding much of interest, including further series of lion hunts. During these years Loftus and Boutcher also worked at Nimrud. Their most interesting results were obtained in the Burnt Palace, where an important collection of ivories was found.

Meanwhile, excavations at Khorsabad were resumed by Victor Place, who had been appointed French Consul in 1851. In four campaigns between 1851 and 1855 he excavated in its entirety Sargon's palace as well as the complex of temples abutting it on the south side, examined all the city gates and made a cursory examination of Palace F. In front of the temples were glazed brick panels and wooden columns covered with metal, and in some of the rooms of Sargon's palace were large collections of metalwork. Unfortunately, most of this material and much else from Khorsabad was lost when rafts carrying it downstream capsized near Qurnah on the lower Tigris. It has never been recovered. Place's discoveries were, like those of Botta, published in sumptuous folio volumes which are now very rare (Place 1867–70).

The years 1845–55 represent the great decade of Assyrian discovery. Thereafter, the pace of exploration slackened, but there was a revival of interest in 1873–4 when the brilliant cuneiform scholar George Smith worked at both Nimrud and Nineveh. He had found amongst the many tablets from Kuyunjik in the British Museum the so-called Chaldaean

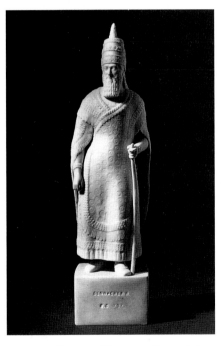

FIGURE 5 Figurine of Sennacherib, made in Parian porcelain by W. T. Copeland & Sons Ltd, c. 1868.

account of the Flood and was originally sent out by the *Daily Telegraph* to find the missing portion of the story. In this quest he was successful, but otherwise his excavations were not very productive. In 1876 he died of dysentery in Aleppo at the tragically early age of 36. Spurred on, perhaps, by the favourable public reaction to Smith's expeditions, the Trustees of the British Museum again engaged Hormuzd Rassam to work in Mesopotamia on their behalf during the years 1878–82. Rassam's greatest discovery in Assyria during this period was the two sets of bronze gates from the small Assyrian city of Balawat, 15 kilometres north-east of Nimrud (see nos 42–3). He had been drawn to the site by reports that fragments of embossed bronze bands offered for sale in Mosul had been found at Balawat during the digging of a grave. Sure enough, he found further bronze bands which had been fixed to wooden gates set up both by Ashurnasirpal II and his son Shalmaneser III (858–824 BC). They had embossed and chased decoration showing, like the stone reliefs, scenes of warfare and hunting. At Nineveh, Rassam excavated both on Kuyunjik and on Nebi Yunus, while at Nimrud his discoveries included the Kidmuri Temple to the north-east of the North-West Palace.

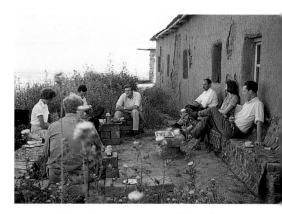

FIGURE 6 Part of the 1962 team at Nimrud relaxing outside the dig-house where Agatha Christie, wife of Sir Max Mallowan, wrote some of her novels.

Only six years were to pass before the British Museum decided to renew work at Kuyunjik, and this time they sent as their field director E.A.W. Budge, who is mainly remembered nowadays for his popular books on Egyptology. Budge worked at Nineveh for two seasons, 1888–9 and 1890–91, but his efforts were mainly directed towards finding tablets. The aims of his successor, L.W. King, who reopened the excavations in 1903, were more ambitious. In 1904–5 he was joined by R. Campbell Thompson, who then took sole charge of the work. The main discovery during this period was that of the Nabu Temple. Over twenty years later Campbell Thompson returned to Nineveh, again on behalf of the Trustees of the British Museum. Between 1927 and 1932 attention was focused on a Temple of Ishtar as well as the Nabu Temple, and there was some excavation on the plain below Kuyunjik. The most significant enterprise, however, was a gigantic sounding down through the prehistoric levels to virgin soil, taking the history of Nineveh back to the sixth millennium BC. In recent years (1987–90) a team from the University of California at Berkeley, led by David Stronach, has examined an artisans' quarter in the outer town and has found in the Halzi Gate evidence of the terrible destruction that overtook Nineveh in 612 BC.

We must now retrace our steps to the years before the First World War. As yet we have made no mention of Kalah Sherqat, the site of Ashur, the earliest Assyrian capital, more than 100 kilometres south of Mosul. Layard, Place and Rassam all visited the site and made excavations there, but, perhaps deterred by the absence of stone reliefs, they

did not persist in their efforts and it was left to a German team to make a thorough investigation of the mound. The German excavations at Ashur were opened by Robert Koldewey in 1903 and continued until 1914, mainly under the direction of Walter Andrae. Many buildings were examined, including the great ziggurat restored by Shalmaneser III, temples dedicated to various gods, several palaces and a large number of private houses. Excavation of the city fortifications included the Tabira Gate, and amongst the many graves and tombs discovered were those of some of the Assyrian kings. Unfortunately, the latter had all been emptied in antiquity, but many of the other graves were still intact.

In the years between the wars, excavations at Khorsabad were resumed by the Oriental Institute of the University of Chicago, who worked there from 1928 to 1935 under the direction of Gordon Loud. All the buildings on the citadel were excavated or re-excavated, as well as Palace F in the outer town. This substantial work was fully published in two volumes, making a significant contribution to Assyrian studies (Loud 1936; Loud and Altman 1938).

After the Second World War, there was further activity at Nimrud when Sir Max Mallowan resumed work on behalf of the British School of Archaeology in Iraq. This expedition worked at Nimrud from 1949 until 1963, from 1958 onwards under the direction of David Oates and in 1963 under Jeffrey Orchard. In the North-West Palace the British School team cleared out the wells in Rooms AB and NN: from sludge at the bottom of the latter were recovered at great risk the two ivory heads known as the 'Mona Lisa' and the 'Ugly Sister' respectively. Elsewhere on the acropolis the British School expedition examined most of the major buildings and made a valuable contribution to the understanding of the history and topography of the city. From 1958 onwards the building in the south-east corner of the city known as Fort Shalmaneser was the main focus of attention. This combined the functions of royal palace and military arsenal, and as well as reception rooms there were storerooms and barracks. The ground-plan of this vast building was established by Oates, and many of the chambers were cleared out, producing extensive and varied collections of carved ivories. These rooms seem to have served as repositories for the booty brought back from successful military campaigns. After finishing at Nimrud, Oates went on to excavate Tell al-Rimah, a site which was occupied from the third millennium BC into Late Assyrian times. The work at Nimrud was continued in 1974–6 by a Polish team led by Janusz Meuszynski, which excavated on the central part of the Nimrud acropolis, and more recently an Italian mission and a team from the British Museum have been working in Fort Shalmaneser.

In the last thirty years, however, the most important work at all the

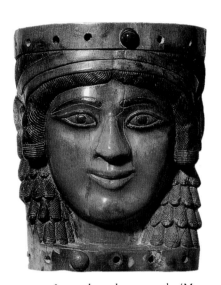

FIGURE 7 Ivory plaque known as the 'Mona Lisa', found in a well at Nimrud and now in the Iraq Museum, Baghdad.

main Assyrian sites has, quite rightly, been undertaken by the Iraqis themselves. The Department of Antiquities, especially under Dr Mu'ayyad Sa'id Damerji, has been active everywhere, clearing out and restoring previously excavated buildings to make them interesting and presentable to tourists, and sometimes making new excavations. Discoveries have included a Temple of Sibitti at Khorsabad, and a hoard of silver jewellery, mainly earrings and finger-rings, found beneath the floor of a room in the New Palace at Ashur. At Nineveh, a columned building was found by Manhal Jabr in the outer town, and on Nebi Yunus winged bulls, different from other examples in that they are made up of small blocks of limestone, have been uncovered in the shadow of the mosque itself. An important initiative by the Iraqis has been the setting up of a series of rescue projects in which foreign expeditions have been encouraged to take part. These are the Hamrin Basin Rescue Project, the Haditha Dam Salvage Project and the Eski Mosul Dam Salvage Project. Ths work, particularly in the two latter projects, has resulted in the discovery of a number of small Assyrian sites, adding to our knowledge of Assyrian life outside the major urban centres.

Pride of place in recent discoveries, however, goes to those at Nimrud. In 1975 the clearance of a well in Room AJ of the North-West Palace produced a spectacular collection of ivories. Recently, even more remarkable discoveries have been made in a series of four tombs excavated between spring 1988 and November 1990 by Muzahim Mahmud in the southern part of the same palace. These tombs contained vessels in precious metal and an astonishing array of gold jewellery, and seem to have been the graves of the consorts of a number of Assyrian kings.

This account of Assyrian discovery closes, then, with finds that in their own way are almost as remarkable as those which in the mid-nineteenth century so effectively caught the public imagination. The difference is that this time there is no Layard to publicise the discoveries, and nowadays the public imagination is less easily fired by the uncovering of ancient civilisations.

JEC

FIGURE 8 Fort Shalmaneser at Nimrud after the conclusion of excavations by the British School of Archaeology in Iraq.

# THE HISTORY OF ASSYRIA

Assyria lies at the heart of the so-called Fertile Crescent, the region of the Middle East stretching from Iraq to the Mediterranean where some of the world's earliest civilisations, based on agriculture, developed and flourished. Today the ruins of the great cities of Assyria are located in northern Iraq, but the name survives in the modern state of Syria which once formed part of the empire.

What we know of ancient Assyria is derived from many sources. There are references in the Bible and in the early Greek historians, and these ensured that the existence of some such empire was already recognised when the first archaeologists went there. What they found, however, far exceeded all expectations. Digging uncovered extraordinary monuments, architecture and everyday objects, as well as written documents of kinds which can bring some portions of ancient society back to life. They include official royal inscriptions naming kings and telling of their achievements; administrative archives and letters giving the details of diplomacy, politics and taxation; texts about religion, magic, astrology, medicine and mathematics; records concerning property, commerce, marriage, loans, slaves. They are far from complete – we sometimes know a lot about one short period but little about what happened immediately before or afterwards – but they are particularly informative about Assyrian history during its most important period, the ninth to seventh centuries BC, when this small state came to dominate the Middle East, from Iran to Egypt.

Another source of information, providing not the specific details of ancient history but the background within which Assyria evolved, is the modern landscape. It is a region of gently rolling plains and rough hills, dotted with market towns and small villages. There are flocks of sheep and goat, fields of wheat and barley, occasional irrigated orchards. The traditional building material is simple plastered mud-brick, with some rough stone. These and other elements of the basic lifestyle have hardly changed over thousands of years. The land is crossed by large perennial rivers, most notably the Tigris, but farmers rely on the spring rains for most of their crops. To north and east lie mountain ranges, once heavily wooded, that mark the boundaries of Turkey and Iran; to the south-west an increasingly dry steppe stretches towards the deserts of Arabia.

Assyria was just one state among many within the Fertile Crescent. Much of its urban civilisation was derived from Babylonia (originally Sumer), in southern Iraq, where writing itself evolved before 3000 BC. To the west, in Syria and along the Mediterranean coast, at one time or another, numerous cities, states and empires have flourished and

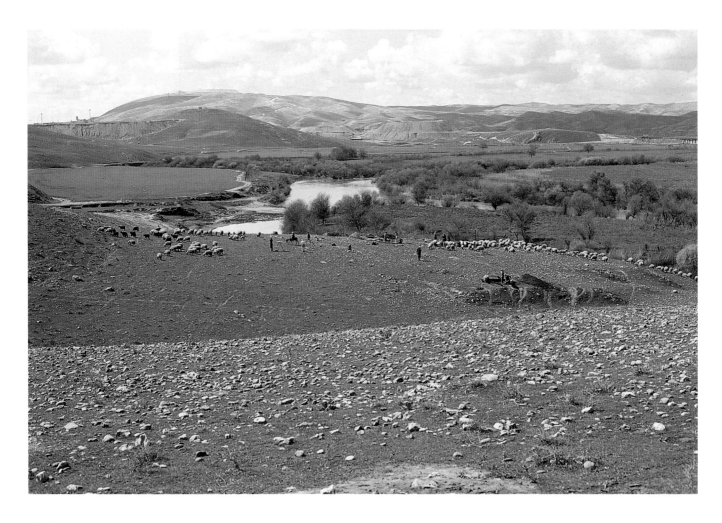

declined. Egypt had a civilisation almost as old as Sumer; Turkey and Iran had populous centres too. Trade among these regions was developing well before 5000 BC. Turkey, for instance, was the prime source of obsidian, the volcanic glass from which knives were made before the introduction of metal, and elaborate networks came to exist for the exchange of raw materials. The location of Assyria encouraged participation in these exchanges, and Assyrians developed far-flung interests. It was a trade in tin and textiles which led, about 2000 BC, to the establishment of Assyrian trading colonies in central Turkey. This was the so-called Old Assyrian period, documented in extensive detail by the chance of archaeological discovery.

The Old Assyrian business documents are written in Akkadian, a Semitic language related to Hebrew and Arabic. Semitic languages have been spoken throughout history in most of the lands of the Fertile Crescent, but other languages prevail in the mountains to the north. For many centuries, perhaps millennia, the most important of these was Hurrian, and this was spoken in the empire of Mitanni which had come to dominate Assyria by 1500 BC. At this time the links between states

FIGURE 9 The River Tigris winding through the Assyrian countryside near the village of Babneet, north-west of Mosul.

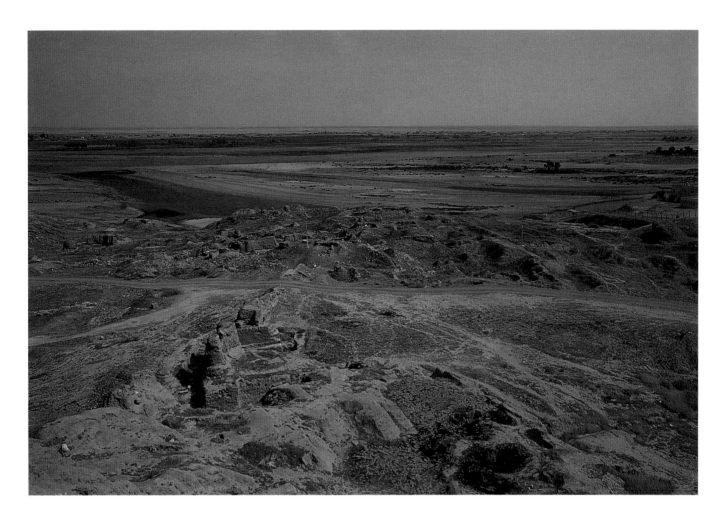

FIGURE 10 The site of Ashur (Qala'at Sherqat) as it appears today, with the River Tigris in the background.

had grown broader and stronger, and the Middle East was essentially divided among five Great Powers: the empires of Egypt, of Mitanni, and of the Hittites in Turkey, met and clashed in what is now modern Syria, while the Kassite and Elamite empires competed in southern Iraq and Iran. It was an international age, with cultural cross-fertilisation accompanying war, diplomacy and trade. Akkadian became the lingua franca of long-distance communication. There was created then, despite huge local diversities, a common Middle Eastern heritage which Assyria shared.

The name of Assyria is actually derived from the city of Ashur, home of the god of the same name. The city lies beside the Tigris river, on a hill overlooking a fertile plain, and its walls came to enclose some 55 hectares. With its good communications, the settlement may have begun as a tribal and cult centre. One of the principal figures in the government of Ashur was the high-priest of the god, and the offices of high-priest and king were not separate; the king's powers, originally circumscribed in many ways, were eventually to become absolute. Since kings were in the habit of leaving their names on documents buried in the founda-

tions of palaces and temples they had commissioned, and there have been extensive excavations at Ashur and elsewhere, we can sense something of the status of any particular king by the number of his recorded buildings. After 1400 BC, when the empire of Mitanni was falling apart, the kings of Ashur gradually extended their political power and influence into neighbouring territories. Two kings communicated directly with Egypt, causing bitter complaints because Assyria was not yet recognised as a Great Power, and Ashur-uballit I (1363–1328 BC) even intervened in Kassite Babylonia. The expansion is especially associated with Ashur-uballit, whose name, 'Ashur-has-preserved-life', was the same as that optimistically taken centuries later by the very last king of the disintegrating Assyrian empire.

The kingdom of Assyria first comprised the Tigris valley in north Iraq, roughly a quadrangle with its corners at Ashur, Nineveh, Erbil and Kirkuk. It continued to grow until it reached the Euphrates river in the west, effectively displacing Mitanni altogether. This was the so-called Middle Assyrian empire, which reached its peak under Adad-nirari I (1305–1274 BC), Shalmaneser I (1273–1244 BC) and Tukulti-Ninurta I (1243–1207 BC). The last of these kings founded a new capital city over 70 hectares in size which was named after himself and contained its own Ashur Temple, decisions which must have been deeply offensive to many people in Ashur itself and were perhaps responsible for his murder.

The growth of the Assyrian empire, as of its commercial interests, had much to do with its geographical location. The hinterland of the city had no clear natural boundaries, and the fertile lands on which it depended were open to recurrent attack from two directions. The inhabitants of the steppe lands to the south-west were tribal herdsmen who, like many others of more recent history, were inclined to raid or otherwise exploit their settled agricultural neighbours; the mountain tribes to the north-east behaved in the same way. This meant that the rulers of Ashur needed to be ready to defend themselves, and all the local notables must have had some responsibility for defence. There was probably a tradition of small-scale annual campaigns to assert Assyrian authority and deter trivial raids. Kings indeed undertook at their accession ceremony to extend the land of the god Ashur. The step from defence to aggression being a small one, sometimes imperceptible, Assyria became periodically locked into the role of aggressor, and ambitious kings saw no limit to their dominion. Moreover, once land had been brought under the nominal sovereignty of Ashur, by conquest or voluntary submission, it was regarded as inalienable, so that any future king had a virtual obligation to recover whatever his predecessors might temporarily have lost.

Towards the end of the thirteenth century, however, there were serious territorial losses. They were part of a pattern of difficulties which affected all the great Middle Eastern powers at this time, and which largely transformed the political map. One principal cause was a straightforward deterioration in the natural environment. In these lands even a minor climatic change, specifically in this case a reduction in the average rainfall over a number of years, can have a significant effect on people's ability to provide food for themselves and their animals, and to defend themselves successfully. Other people, themselves perhaps the victims of comparable circumstances, may come looking for land or loot. Civilised and centralised states are often inflexible and vulnerable to unexpected problems of this kind, which were to affect Assyria, with varying degrees of severity, over almost 300 years. Some kings, notably Tiglath-pileser I (1114–1076 BC), who was the first ruler to carry Assyrian arms to the shores of the Mediterranean, maintained the prestige of the state, but by the mid-tenth century Assyrian territory again comprised little more than the Tigris valley in north Iraq, with some surviving interests elsewhere. The countryside had been largely infiltrated or overrun by tribesmen of pastoral origin who came from the marginal lands to the south and west; they spoke Aramaic, another Semitic language.

The process of recovery was a long one, assisted by another minor climatic change, this time for the better. From 934 BC until an outbreak of civil war in 826 BC, we have a series of records, incomplete and self-interested but often hugely informative, describing the relentless annual campaigns of five successive kings. First they secured the Assyrian heartland; then they recovered the territories of their Middle Assyrian predecessors; then they extended their influence far beyond, in every direction. Sometimes there was straightforward conquest, followed by incorporation of the conquered territory into a province of what the Assyrians always called the 'land of the god Ashur'. Sometimes a local ruler accepted Assyrian sovereignty and became a vassal king or governor. Sometimes, in more remote regions, there was what the Assyrians saw as acceptance of Assyrian hegemony, though the local rulers were mainly concerned to maintain or establish discreet good relations.

All this imperial expansion naturally depended on the exercise of force, or on implicit or explicit threats. It is plain from the results that the Assyrian army was effective (the sculptures show it in action), but it was not originally a standing army. We can envisage with some confidence an annual levy, after the spring harvest, with dignitaries across the kingdom assembling the able-bodied men and marching out with the king, joined on the way by other forces which owed allegiance to Assyria. Opponents had the option of submission, in which case they were well treated, or of

resistance; while there was all the brutality common in warfare, defeated enemies could still submit. Only rebels, rulers who had sworn allegiance and then broken their oaths, were ruthlessly suppressed and killed with the maximum deterrent publicity. The population of defeated states could be left in place, but the Assyrians also practised, on a massive scale, a procedure which was eventually to have a deep influence on Assyria itself. This was deportation and resettlement. Not merely skilled craftsmen, who were always in demand, but tens of thousands of ordinary farmers were shifted with their families from one part of the empire to another, to occupy lands awaiting cultivation or those left vacant by other deportees. In this way people were unable to maintain local loyalties and contacts perilous to Assyrian interests; they became instead associated with the central authority itself, tied farmers dependent on the state and subjects of the empire. What the Assyrians could not do was make them speak the official language, Akkadian. The resettlement policy actually encouraged the adoption and spread of a new lingua franca, Aramaic, which many of the deported peoples already had in common.

Subject lands paid tax or tribute, which accumulated in palace and temple stores. Little is known of trading practices at this time, and there was no currency as such, apart from silver measured by weight; official establishments fed and housed people attached to them, while small-scale barter is likely to have been commonplace. There were many raw materials and finished goods which Assyria needed but did not produce. For instance, any grand new building required timber from mountainous regions, while many campaigns seem to have had as their prime purpose the acquisition of horses for the army. While Assyria had its own skilled craftsmen, such as iron- and coppersmiths, fine workmanship in luxury items was especially associated with the lands between Assyria and the Mediterranean. The demand for exotic products kept pace with the growth of the empire, and the accounts of some campaigns read like collecting trips, as the Assyrian army displayed its strength and received treasures in return. Successful kings commemorated their achievements by renovating or rebuilding ancient shrines, founding palaces, fortifying cities, and digging canals for irrigation; prisoners of war provided convenient labour. Grand public constructions, besides immortalising kings always conscious of their place in history, enhanced Assyrian prestige, and were intended not only to satisfy Assyrian aspirations but to impress and overawe potential opponents.

When Ashur-dan II (934–912 BC) came to the throne, Ashur was still officially the principal city of the kingdom. It was crowded with ancient temples and palaces, and there was a weight of tradition about the place, inhibiting any king who valued his powers as secular ruler more

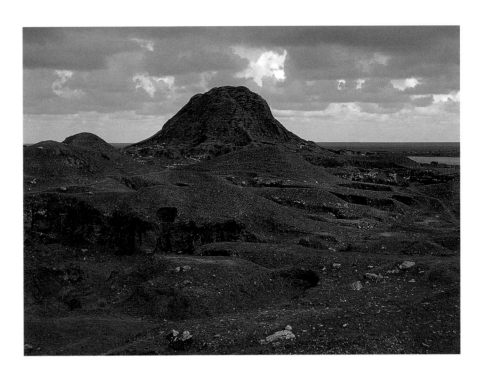

FIGURE 11 The site of Ashur, with the ziggurat in the background.

highly than his religious status. Ashur was always to remain the formal cult centre of the state, though a goddess of fertility, under many names, was more universally worshipped. Ashur was, however, inconveniently situated on the southern edge of what was now the Assyrian heartland, and was not the best centre for communications, military organisation and administration of the economy. Various references suggest that the city of Nineveh, further north, was no less important. It may even be that Tukulti-Ninurta II (890–884 BC) took Nineveh as his capital, naming it after himself as Tukulti-Ninurta I had done with his own new foundation. Once again, any such move must have been bitterly resented at Ashur, but resistance to change seldom lasts indefinitely.

It was the next king, Ashurnasirpal II (883–859 BC), who took definitive action and by so doing established his reputation for all time. He opted for an existing town, located between Ashur and Nineveh, and vastly extended it with no change of name. This was Kalhu (Biblical Calah), whose modern name of Nimrud still recalls that of its principal god, the war god Ninurta. Here, on a raised citadel mound, Ashurnasirpal built a palace that far outshone anything existing in Assyria beforehand; its brilliantly coloured walls were lined with stone panels, every one of which was inscribed with the king's name and a summary of his achievements. Nearby was a temple area, large but occupying much less ground than the temples of Ashur, and there were palaces for other officials too: such palaces had a range of functions, as ministries, offices, residences, reception suites, stores and so on. The whole town was 360

hectares in area; one record states that the original population numbered 16,000, while 47,000 more were brought to work on the project. It was completed by Shalmaneser III (858–824 BC), who added the temple-tower that affirmed Nimrud's status as a cult-centre comparable with the most celebrated cities of Assyria and Babylonia. Shalmaneser's most remarkable building, however, was more directly practical in function: sometimes known as Fort Shalmaneser, it was a combined palace, camp, factory, storehouse and arsenal, thoughtfully located a safe distance from the citadel, where the army could be mustered for the annual campaign and supplies could be stockpiled. The construction of this complex acknowledged the growing responsibilities generated by imperial expansion.

In this period there was concurrently a change in the status of the king. Behind him there now stood not only an ancient aristocracy but a new corps of administrators, men who were appointed as state officials or as governors of newly acquired provinces. The governors, especially, were liable to retain their posts for many years, with commensurate influence. Many of them were eunuchs, with a primary loyalty to the system which supported them. There was a contradiction here, between the old Assyria and the new. The ruler himself, with his court and supporters, was increasingly an embodiment of empire rather than ancient kingship, a prototype of the inaccessible despot. So long as the empire continued to expand, success was its own justification, but it did not necessarily win unanimous approval. There was a difference between defending the state, expanding its borders within known terrain, and marching away for months on end to the Mediterranean; there was a difference between loyalty to a traditional local dignitary and to a royal eunuch. At the same time the empire was not monolithic: it was rather a network of royal cities and provincial capitals with variable degrees of influence over each other and the surrounding countryside. Problems of this nature are seldom described in the Assyrian documentary sources, which usually present only the official view of affairs, but they are implicit in the political situation.

Broadly, by 860 BC, the Assyrian empire had recovered all the territories lost around 1200 BC, and expanded a little beyond them. A new king, Shalmaneser III (858–824 BC), attempted to maintain the process of expansion. His long reign is a catalogue of expeditions into Babylonia, Syria/Palestine, Turkey and Iran, but at the end there was little to show for it. In Babylon he had supported one ruler against another, but in this ancient kingdom, which was acknowledged as the source of Assyrian civilisation itself, he did not assert formal Assyrian sovereignty: the kings of Assyria and Babylon even appear on one monument shaking hands, a pleasing contrast with the standard submission scene. In Syria/Palestine

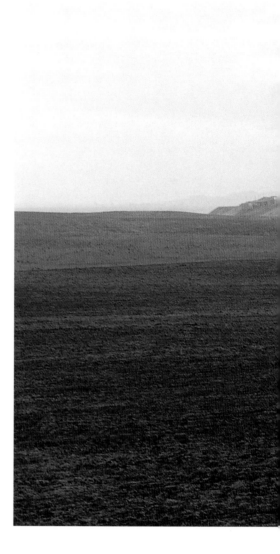

FIGURE 12 The citadel of Nimrud, with the ziggurat on the right, seen from Fort Shalmaneser.

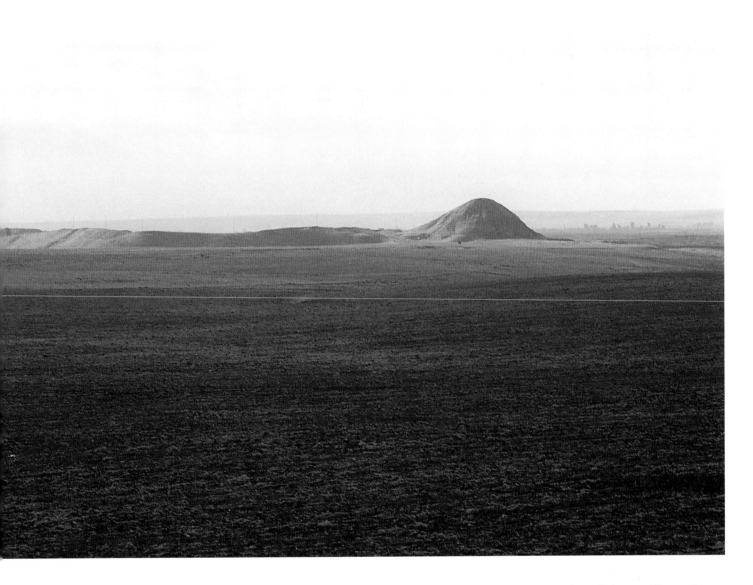

and southern Turkey Shalmaneser encountered coalitions of lesser kings who joined forces to oppose him; they were eventually defeated in battle, but the local dynasties survived. In eastern Turkey and western Iran the state of Urartu (Biblical Ararat) presented growing opposition since it too was an expanding empire: Assyrian armies had to march further east into Iran in their perpetual search for horses. Shalmaneser rebuilt the walls of Ashur, but he failed to win its support, and in his last years the problems of the empire expressed themselves in open warfare between two of his sons: it was the first identifiable instance, in this period, of the fraternal rivalries, aggravated by a lack of clear rules on the royal succession, which were ultimately to play a part in the destruction of the empire.

When this civil war ended, the new king, Shamshi-Adad V (823–811 BC), found himself again the ruler of a state of Middle Assyrian dimensions, with independently minded governors in many of its prov-

inces and with powerful neighbours in Urartu and Babylonia. He took the imperialist stance, and set about the process of conquest all over again, campaigning perhaps as far as the Caspian Sea, but died within a few years. He was succeeded by a child, Adad-nirari III (810–783 BC). The early years of Adad-nirari's reign were dominated by his mother acting as regent, the first of two Assyrian queens to succeed in imposing their personalities on history; this one was Sammuramat, whose reputation as Semiramis survived into Greek legend. From this point, for about sixty years, Assyrian foreign policy followed a somewhat different line. There were still the annual campaigns, but they seem – unless this is purely the result of military failure – to have been pragmatic rather than systematically aggressive. Occasional marches into Babylonia and Syria maintained Assyrian prestige without imposing Assyrian rule; expeditions to Iran collected horses; there were wars with Urartu. Meanwhile, away from the capital, local governors had their own agenda, building up power through prosperity, encouraging agricultural settlements and production. Babylonia had suffered severely at the hands of Shamshi-Adad V, and remained in turmoil, but its culture was deeply respected by the Assyrians, and there is evidence for growing Babylonian influences on Assyrian intellectual life. Probably there were many Babylonians, prisoners or refugees, in Assyria itself. The most notable buildings of Adad-nirari III's reign are indeed temples to Nabu, originally the Babylonian god of writing – 'Trust in no other god', as one inscription says – and though it is difficult to correlate this kind of development directly with other trends, we may detect some shift away from the official Assyrian devotion to a cult centred on the aggressive qualities of Ashur or Ninurta. There almost certainly existed, concurrent with belief in magic and evil spirits, an acknowledgement that different gods could be alternative facets of a single divine authority variously and inconsistently manifested. There were political advantages in associating the state with one supranational divinity, and Nabu seems to have been acquiring this status.

By the mid-eighth century, Assyria's position was that of a power with great resources whose status was being challenged. The northern kingdom of Urartu had grown much as Assyria had done, through conquests and alliances, and was expanding into Assyrian spheres of influence in both Syria and Iran, threatening Assyrian territory itself. An effective response came at last with Tiglath-pileser III (744–727 BC), who seized the throne after a revolution. For the next forty years he, his son Shalmaneser V (726–722 BC), and a third king, Sargon (721–705 BC), who deposed Shalmaneser, were vigorous and successful exponents of the old aggressive policy. By 705 BC Urartu was confined to its mountains in the north, and Assyrian rule extended from the Gulf

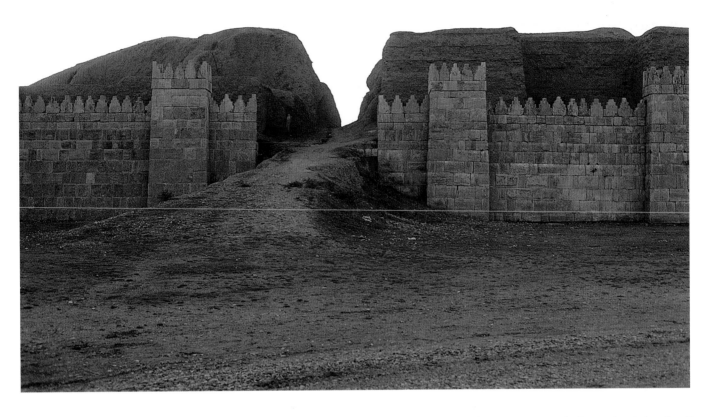

FIGURE 13 The restored Shamash Gate at Nineveh.

to the Mediterranean, with vassal kingdoms, including the island of Cyprus, around the edges of the empire.

While local rulers survived if they had submitted in time, with Assyrian advisers to ensure compliance, most of the region consisted of provinces paying regular tax under Assyrian governors. The governors were under stronger control than previously, and the royal forces had grown into a permanent army. A network of roads with posting stations ensured rapid communications across the empire. Representatives of the government were everywhere; some were secret agents, concerned with state security. Everyone was answerable to the king as absolute authority, but the king himself lived in a court surrounded by individuals, men, women and eunuchs, with ideas and ambitions of their own. Rival queens, for instance, promoted the interests of their own progeny. The preferences and personality of the king were critical. This was the system that provided the model for many subsequent empires, dependent for its survival on force rather than loyalty.

One way to stabilise the imperial structure and integrate its population was by propaganda, and one of the forms this took, after the example of Ashurnasirpal's Nimrud, was magnificent public works. Tiglath-

pileser III, the first king of the revived empire, did indeed build himself a new palace at Nimrud, but this may have been a practical expedient since the existing one, over a century old, was probably decrepit as well as old-fashioned. It was Sargon who took the more drastic step of founding an entirely new capital city, named after himself and now known as Khorsabad. It was not far from Nineveh, and was basically an imitation of Nimrud. It included a citadel complex and a separate arsenal or camp. Just as at Nimrud, the citadel incorporated a royal palace, its associated temple quarter and temple-tower, several other palaces for high officials and a large Nabu Temple. While Khorsabad was overall slightly smaller than Nimrud, only 320 hectares within its walls, the palaces were bigger. Sargon inaugurated the new capital shortly before he was killed on campaign. This disaster, a consequence of the convention that Assyrian kings usually led the army in person, was the worst kind of propaganda, and was ascribed by some to divine displeasure. Khorsabad suffered the fate of other artificial foundations, and was abandonded. Sargon's son, Sennacherib (704–681 BC), facing a crisis which might have led to the collapse of the entire empire, resolved it with courage and imagination.

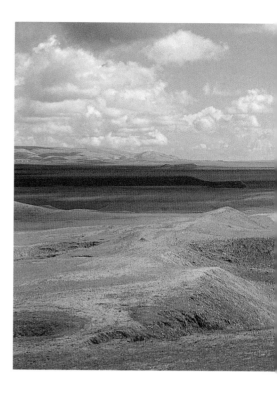

Within Assyria, Nineveh was probably by now the major centre of population; Ashur could no longer compete. It was accordingly Nineveh which Sennacherib chose as his capital, and during his reign he converted it into a city bigger and better than anything his predecessors had known. When he had finished, its walls enclosed 720 hectares, and an elaborate network of canals brought water from the mountains to irrigate its parks and orchards. Sennacherib was particularly proud of his technological innovations. The royal palace containing government offices on the citadel was built to a new design, and it is probable that the entire civil administration was centralised in this building, instead of being split as previously among several palaces. An odd feature of one series of wall-panels showing public works is that many eunuchs appear as labourers, and it is possible that the king deliberately attempted to reduce the court influence of this important body of people; if so, however, there is no clear documentary support, and this is just one example of the way our evidence is always defective – here full of detailed information, there demanding that we read between the lines, elsewhere perhaps leaving us wholly ignorant of some major development.

Sennacherib decided that there should be no more foreign expansion, and the annual campaigns came to an end. Sargon may have been working towards this conclusion, but with Sennacherib it is clear-cut. Assyrian prestige was maintained by aggressive retaliation when imperial interests were threatened. Assyria now had five powerful neighbours: Egypt, ruled by a Nubian dynasty, which occasionally entered into

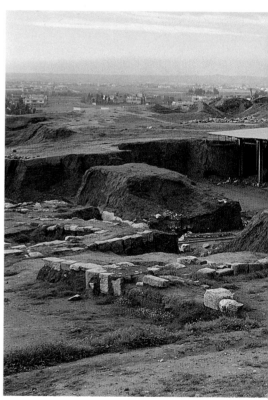

FIGURE 14 *(top)* The ruins of Khorsabad, as seen in 1970.

intrigues with rulers in Syria/Palestine; Phrygia in modern Turkey, home of the legendary Midas; Urartu to the north; various small states and tribal groups in central Iran, which were soon to be united under the Medes; and Elam in southern Iran. Also significant, as an unpredictable threat on the northern frontier, were hordes of mounted tribesmen such as Cimmerians and Scythians, coming from the steppes of eastern Europe. Tributary neighbours included the Biblical kingdom of Judah with its capital at Jerusalem, the Phoenician cities with their commercial links across the Mediterranean, and a range of Arab tribes with links towards Yemen and Oman. The maintenance of satisfactory relations with these various states and interests was never easy, but the most complicated area of all was Babylonia.

Assyrian attempts to dominate the rich and independent city of Babylon had taken various forms, including alliance, the imposition of nominee kings, and the appointment of the Assyrian king himself as king in Babylon. None had really worked, since the Babylonians themselves were proud, and there were so many rival tribes in Babylonia – and indeed rival cities – that there was always someone anxious to profit by disruption. Moreover any Babylonian leader could look east for support, to the kingdom of Elam, which had its own interests in the region and no wish to see Assyria strong. The Assyrians themselves were concerned with Babylonia not only because of ancient history, but also because of its strategic position: it adjoined the main route to central Iran, and would be dangerous in enemy hands. Other motives are possible, such as a wish to profit from Babylonian wealth and commerce, and it is likely that many individuals at the Assyrian court had their own links with Babylonian affairs.

Sennacherib dealt with the problem at its heart. After two disastrous experiments with other methods, he destroyed the city and incorporated the worship of Marduk, who was regarded in Babylon as supreme god, into the cult of Ashur. This seems comparable with the promotion of Nabu by Adad-nirari or Sammuramat. Sennacherib was creating what was effectively a new imperial cult, one to which Babylonians too would perhaps subscribe. With Ashur as supreme god and Nineveh as cosmopolitan metropolis, with the provinces consolidated and peaceful, the Assyrian empire could be viewed as the natural and proper World Order, something with which all subject peoples could identify.

In destroying Babylon, Sennacherib was probably influenced by emotion, for the Babylonians had betrayed his own eldest son to his death, and it seems that emotion was also responsible for a decision that undermined his otherwise far-sighted policies. He appointed Esarhaddon (680–669 BC) as his official heir, and Esarhaddon was such a bad king, besides being sickly and superstitious, that it is difficult to believe Senna-

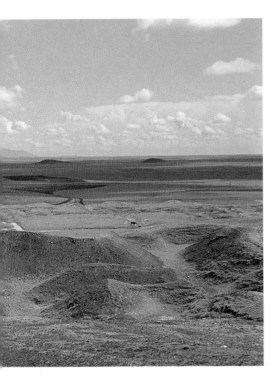

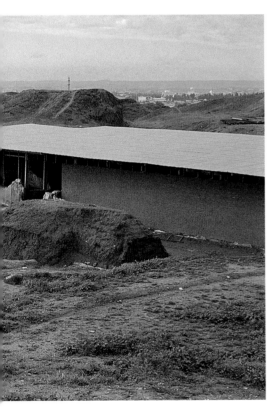

FIGURE 15 Sennacherib's palace at Nineveh as it appears today.

cherib could have chosen him had it not been for the influence of Naqia, the young man's mother. Naqia went on to influence the choice of Esarhaddon's successors too, and stands beside Sammuramat as exemplar of an Assyrian queen controlling the course of events. Sennacherib himself was murdered by another son, in a failed attempt on the throne. During Esarhaddon's reign, problems on the western frontier escalated to an Assyrian invasion of Egypt, an enormous undertaking without long-term success; the Medes grew to dominate central Iran. Meanwhile Esarhaddon was rebuilding Babylon; he arranged that on his death one of his sons should be king of Babylon while a second ruled the Assyrian empire as a whole – an invitation to civil war. In 670 BC Esarhaddon is recorded as executing many senior Assyrians, presumably for fear of treason. At the end of his reign he was busy with an abortive attempt to remove the Assyrian capital from Nineveh back to Nimrud.

The reign of Ashurbanipal (668–c.631 BC) is sometimes seen as Assyria's golden age. Sculptures from the palace which he built at Nineveh represent the finest and most imaginative surviving examples of Assyrian art. He was himself a cultivated man, patron of temples and collector of ancient writings, a devotee of Nabu and literate in an age when the skills of literacy were mainly restricted to a special class of intellectuals. He was an admirer of his grandfather Sennacherib, whose empire had survived the ineptitude of Esarhaddon with its administrative structure intact, and ambassadors came to Nineveh from as far west as Lydia, on the Aegean Sea, and from Fars (Persia) in central Iran. Nonetheless Ashurbanipal was unable to cope with events as they unfolded. There was a war with Elam, and eventually Elam helped Babylon to rebel. The capture of Babylon was followed by Assyrian invasions of Elam, in the course of which the ancient capital city of Susa was destroyed, and a succession of rival claimants to the Elamite throne found themselves prisoners at Ashurbanipal's court. This was a disaster that the Elamites had brought on themselves through dynastic squabbling, but the collapse of Elam left the eastern frontiers of the Assyrian empire even more exposed to Median expansion. Meanwhile Phrygia and Urartu were overrun by nomadic hordes, which threatened the empire from the north and west. Egypt, recovering its independence, was soon to resume its old interest in Syria/Palestine.

The final collapse of the Assyrian empire took some twenty years, from Ashurbanipal's death or abdication to the last recorded mention of an Assyrian army in 609 BC. What happened is obscure, as the foundation records and other texts, which are so informative about earlier reigns, grow increasingly rare; the historical framework begins to depend on Babylonian rather than Assyrian records. There were at least four kings in this period, two of them brothers and one possibly a

eunuch; the successions may have been disputed. There is a Greek story of a Median attack on Nineveh, perhaps about 626 BC. What did happen in that year, however, was the seizure of the city of Babylon by a southern official. This man was Nabopolassar, founder of the Neo-Babylonian dynasty and father of Nebuchadnezzar. By 620 BC Assyrian garrisons had been driven out of Babylonia. Nabopolassar continued striking north-west, and the chaos of these years is reflected in accounts of Egyptian and Iranian troops operating on the Euphrates. The Assyrian cities hastily repaired their walls. In 614 BC a Median force ransacked the countryside and destroyed Ashur. In 612 BC it was probably Babylonian engineers who helped direct the waters of Sennacherib's canal system against the walls of Nineveh itself. Assaulted by a combined force of Babylonians and Medes, the city was captured, and the king, Sinsharrishkun (*c.* 626–612 BC), was killed. A last Assyrian king, Ashur-uballit II (*c.* 611–609 BC), briefly retained control of some western provinces, looking to Egypt for help, but the empire was gone.

Biblical prophets, writing soon afterwards, rejoiced over the fall of Nineveh. They gave the Assyrians a reputation for callous barbarism which was to receive ample confirmation when the royal palaces, with their endless scenes of warfare, were rediscovered in the nineteenth century. Now that we can read the original records of the time, we recognise that the Assyrians were no worse than other men in this respect. What is more significant is the legacy of the empire. By their policies of centralisation and deportation, the Assyrians united much of the Middle East, and this cultural and linguistic unity survived through centuries. The Persian empire, reaching from India to Greece, was a grander version of what the Assyrians had put together, and owed much to their example. Assyrian art, science, literature and technology, integrated from many sources and revealed by excavation, represent a synthesis of ancient Middle Eastern civilisation as a whole, to which much of the European tradition owes its origin. JER

# ASSYRIAN CIVILISATION

Of all the surviving artefacts which make Assyrian civilisation so distinctive, the best known are certainly the colossal stone gateway figures and the carved stone slabs which lined the mud-brick walls of the palaces of various kings between Ashurnasirpal II (883–859 BC) and Ashurbanipal (668–c. 631 BC), and which provide a vivid picture of war and peace in Assyria. The British Museum has the largest collection of these reliefs outside Iraq, and those illustrated in the present catalogue have been carefully chosen to represent the principal types. They include scenes depicting ceremonies at the Assyrian court, the Assyrian army on campaign and the king hunting lions. We see how the reliefs developed between the ninth and seventh centuries BC, with the stiff, rather wooden art of the ninth century giving way to a more flexible and more naturalistic treatment in the time of Ashurbanipal. The appearance of the human figures, however, remains characteristic throughout: the men wear large beards, squared-off at the bottom, and the arm and leg muscles are exaggeratedly pronounced. When the reliefs were discovered in the mid-nineteenth century it may well have been the solid, respectable appearance of these figures that appealed to the Victorian public. Here were people with whom they were able to identify, the representatives of an ancient people who were not only proud and successful but were also mentioned in the Bible. Just as distinctive as the human figures on the reliefs are the gateway figures, gigantic stone bulls or lions with bearded human heads wearing horned caps, a sign of divinity.

The barbarous and callous character of the Assyrians has often been stressed, and was even noted by Layard himself. It is true that the reliefs show their enemies being treated in a brutal fashion. We see people impaled on stakes, being flayed alive and having their heads cut off, and similar acts of cruelty are described in Assyrian written sources. But it would be quite wrong to condemn the Assyrians on these grounds. There is no reason to suppose they were any more or less cruel than their contemporaries, and evidence for similar barbarous acts can be found in many ancient cultures, both eastern and western. Indeed, such brutality is by no means restricted to the ancient world. But why did the Assyrians apparently revel in it and depict it in such graphic detail in their art? For an answer to this, we have to consider the purpose of the reliefs. They were set up in rooms of state and were meant to be seen by visitors to the Assyrian court. Their purpose was crudely propagandistic. They extolled the virtues of the Assyrian king, they celebrated his conquests and they demonstrated his prowess at hunting lions. They

FIGURE 16 Assyrian workmen carrying spades, pick-axes and saws for cutting stone, from a relief of Sennacherib, *c.* 700–695 BC (WA 124823).

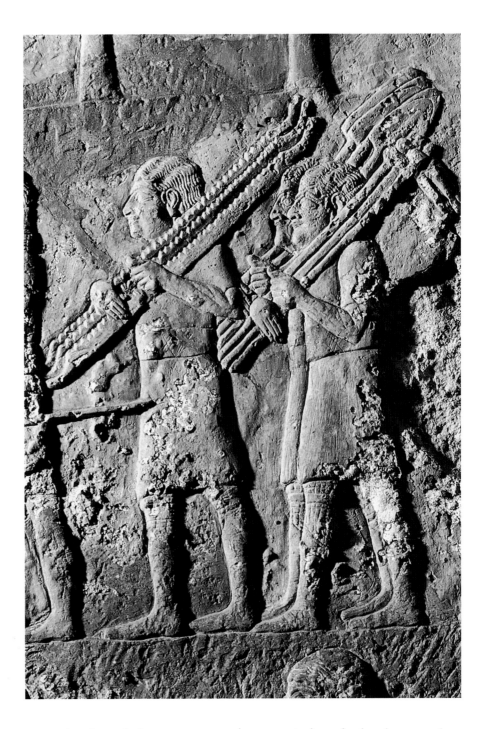

were also intended to serve as a sharp reminder of what happened to those who did not submit to Assyrian domination or who attempted to throw off the Assyrian yoke.

Assyrian narrative art was by no means restricted to the stone bas-reliefs. For example, similar scenes appear on strips of bronze nailed to wooden doors. The most famous of these are from Balawat (nos 42–3), but examples have also been found at most of the other main centres. Clearly this sort of art – both the reliefs and the bronze gate-bands – is

monumental, that is, it is found only in important public and religious buildings in the principal Assyrian cities of Nimrud, Nineveh, Khorsabad, Ashur and Balawat. Not surprisingly, archaeological excavations in Assyria in the last 150 years have tended to concentrate on these centres and on large, important buildings therein, as these represent the best chance of finding important and significant material. This has to some extent distorted our view of Assyrian culture, as industrial quarters in cities and small settlements or villages dependent on agriculture have been largely overlooked. It is almost certain that skilled craftsmen and artisans would have worked in the major Assyrian centres, and even if we do not have archaeological evidence for their presence there we know of it from other sources. For example, one of the gates at Ashur was known as the Tabira Gate, or Gate of the Foundry-Workers (Dalley 1988: 97–8). Probably specialist craftsmen were grouped together by trade in particular parts of the city, as they are nowadays in places such as Baghdad and Mosul. We know a little about how these craftsmen were organised and their working practices, but we are much more familiar with their products, a selection of which are illustrated in this book. Full descriptions are given in the catalogue, but here it will be useful briefly to consider the main categories of material.

Stone-carving finds its finest expression in the bas-reliefs, but many smaller items were also made of stone. We know that colossal figures, and perhaps also reliefs, were carved, or at least roughed out, at the quarry, but smaller artefacts must have been produced in urban centres. Whether the stonemasons who fashioned reliefs also undertook other work is unknown, but it is likely that they did. This would not have included seal-engraving, however, which was a specialist craft in its own right. Assyrian seal-engravers produced a large number of cylinder and stamp seals in various kinds of stone and occasionally in other materials as well. As described in section 8 of the catalogue, many of these seals are in styles that can confidently be recognised as Assyrian.

Metalworking flourished in Assyria. Large quantities of bronze and ironwork have been found, testifying to the productivity of Assyrian smiths. Some very elaborate projects were embarked upon. Excavations have uncovered monuments such as the Balawat Gates, but from written sources we know of even more ambitious ventures. For example, Sennacherib claims to have set up in his palace at Nineveh colossal bronze lions each weighing an extraordinary 11,400 talents or approximately 42 tons (Curtis 1988: 92). The range of existing bronzework is large, embracing most areas of Assyrian life. Many of the objects are utilitarian, not much different from those in use in other parts of the Ancient Near East, but some are characteristically Assyrian in style or iconography. Such objects are easy to recognise, and are sometimes found far beyond

the borders of Assyria. Thus, some of the bronze objects found in the Temple of Hera on the island of Samos off the west coast of Turkey are clearly Assyrian (Jantzen 1972). They include statuettes of male figures and horse cheekpieces.

Iron was also plentiful in Assyria, perhaps even more so than bronze. In one single room of Sargon's palace at Khorsabad, Place found a huge hoard of ironwork weighing in total about 160,000 kilograms, or about 157 tons. Iron was used mainly for tools and weapons, and there is some evidence that Assyrian blacksmiths employed techniques such as carburising and quenching to improve the quality of their material and make it slightly harder and more durable than ordinary wrought iron (Pleiner and Bjorkman 1974; Curtis *et al.* 1979). The quantities of bronze and iron that were in circulation are of course an indication of the great wealth of the Assyrian empire, but this is demonstrated even more clearly by the recent discovery of the tombs of some Assyrian queens at Nimrud containing very large and hitherto unsuspected amounts of goldwork. The contents of these tombs also testify to the high level of technical competence reached by Assyrian goldsmiths.

The ubiquitous material in Mesopotamia is clay, and not surprisingly we find many objects made from this material. The clay was either sun-dried, as in the case of the apotropaic dogs buried beneath thresholds (nos 73–7), or it was fired in a kiln (terracotta), like the corbels, the so-called 'hands of Ishtar', that were used as architectural decoration (nos 53–5). In common with other contemporary cultures the Assyrians made large amounts of pottery, much of it in a style that is distinctively Assyrian (see nos 123–52). Sometimes it was made at small village centres, as we know from the discovery of a pottery kiln at Khirbet Qasrij in the Eski Mosul area (Curtis and Collon 1989). The wide range of Assyrian pottery types includes some distinctive glazed wares (nos 141–2). Here the technology overlaps with that of glassmaking, and we are in the fortunate position of having cuneiform texts, mostly from Nineveh, which describe the manufacture of glass in Mesopotamia (Oppenheim *et al.* 1970). However, it is difficult to recognise Assyrian products with certainty, and there has even been speculation that the most famous glass vessel found in Assyria, the so-called Sargon vase (no. 115), may be a Phoenician product.

Two other industries, ivory-carving and woodworking, were probably closely related, but unfortunately we have practically no surviving specimens of carved wood. Ivory, on the other hand, is well represented in the archaeological record. Ivories in Assyrian style, as opposed to those that are clearly Syrian or Phoenician, which were obviously imported in bulk, were presumably carved by native Assyrian craftsmen using imported ivory. Their products, although neither so numerous

nor so splendid as the Phoenician ivories in particular, are nevertheless outstanding works of art in their own right.

The artefacts described above have been found mainly at the sites of Assyrian capital cities. Life outside these main centres is less well documented, but with the excavation of smaller village sites in the recent Haditha and Eski Mosul dam projects the balance is beginning to be redressed. We know that the people in these rural areas lived in mud-brick houses with mud roofs, constructed in the same way but without the expensive decoration of the splendid palaces and temples in the towns. They used artefacts of exactly the same type, particularly pottery and tools, as their urban counterparts. Naturally, however, luxury goods were much scarcer.

In many fields of material culture Assyria shared a common legacy with its southern neighbour, Babylonia. Their inhabitants spoke the same language, Akkadian, written in the same cuneiform script, although naturally there were some slight differences of dialect and script between the two areas. We are extremely fortunate in that many clay tablets survive from Assyria. Large groups have been found at Nimrud and especially at Nineveh. Many of the latter come from a royal library or libraries established by Ashurbanipal (see page 198). Various texts were collected together, and some were specially copied for inclusion in the library. Altogether, these tablets provide an unparalleled insight into the life and workings of an ancient society, and their importance cannot be overestimated. They include letters, usually dealing with affairs of state: others are concerned with various kinds of business transaction or with medicine, mathematics and other technical matters. There are also copies of Babylonian literary works such as the Myth of Creation and the Epic of Gilgamesh (no. 214). Particularly important from an historical viewpoint are the royal inscriptions, which include annals written on cylinders and prisms. These describe the main events of a king's reign and are an invaluable historical record.

From cuneiform texts we learn a great deal about Assyrian religion and beliefs, although much still remains obscure. There are tablets describing rituals and incantations, and large numbers of omen texts showing that the Assyrians attached significance to natural phenomena of all kinds. They believed in a pantheon of gods, each of which had a different function. Foremost amongst these were Ashur, the Assyrian national god, and his consort Mullissu; Shamash, the sun god; Sin, the moon god; Nabu, the god of writing and scribes; Adad, the god of storms; and Ishtar, the goddess of love and war. As well as being mentioned in texts they are represented in art; for example, on a series of rock reliefs at Maltai in Iraqi Kurdistan they are shown in procession standing on the backs of real or mythical animals.

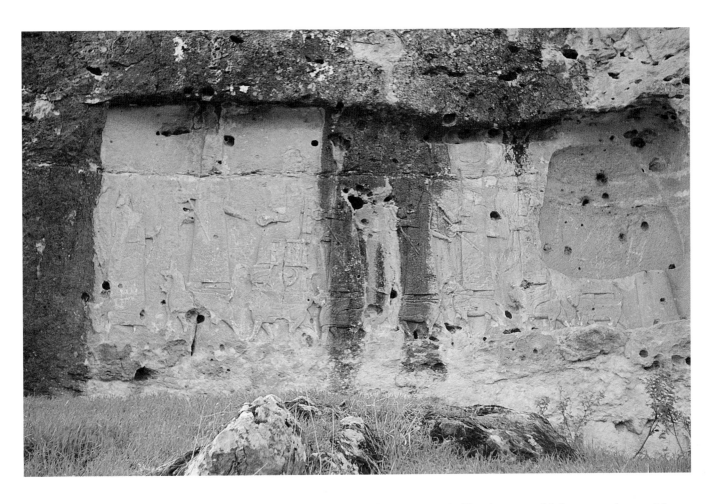

FIGURE 17 A rock carving of Sennacherib at Maltai, showing a procession of gods.

No discussion of Assyrian civilisation would be complete without some reference to the pre-eminent position that Assyria enjoyed in the contemporary Near East. This resulted in luxury goods of all kinds flowing into the kingdom, whether as booty, tribute or through normal trade channels. For example, on his eighth campaign, in 714 BC, Sargon claims to have removed vast quantities of material from the temple of Musasir in Urartu (Thureau-Dangin 1912). Large numbers of foreign artefacts have been found at the Assyrian cities, particularly Nimrud. We may single out ivories as the best example of this phenomenon, and beautifully made Syrian and Phoenician panels and plaques belonging to various types of furniture as well as other items have been found in abundance. But equally large amounts of gold, bronze, glass and so on presumably reached Assyria, and, once there, were put to active use rather than being locked away in storerooms. In this sense, then, the imported goods became an integral part of the material culture of Assyria, and reflect Assyrian civilisation just as vividly as indigenous Assyrian products.

JEC

# CHRONOLOGY

BC

| | |
|---|---|
| 10,000–3500 | Evolution of agricultural communities throughout the Near East |
| 3500–3000 | Evolution of writing in Babylonia<br>Contacts with Assyria |
| 3000–2500 | Ninevite 5 period: long-distance trade passing through Assyria |
| 2500–2000 | Growth of Assyrian cities |
| 2000–1750 | Old Assyrian period: Ashur a major trading centre with merchant colonies in Turkey |
| 1500 | Assyria within empire of Mitanni |
| 1400–1200 | Growth and decline of Middle Assyrian empire |
| 1200–900 | Spread of Aramaic tribes |
| 930–830 | Growth of Late Assyrian empire<br>Ashurnasirpal II refounds Nimrud |
| 830–745 | Consolidation of empire<br>Attacks from north (Urartu) |
| 745–700 | Further expansion of empire to Mediterranean and into Babylonia, Iran and Turkey<br>Sargon II founds Khorsabad |
| 700–640 | Consolidation of expanded empire<br>Periodical frontier wars and internal problems, especially in Babylonia<br>Sennacherib refounds Nineveh<br>Invasions of Egypt and Elam<br>Palace of Ashurbanipal built at Nineveh |
| 640–610 | Internal power struggles<br>External threats<br>Provincial rebellions<br>Disintegration of empire<br>Attacks by alliance of Babylonians and Iranian Medes. Fall of Ashur (614). Fall of Nineveh (612) |
| 609 | Last reference to an Assyrian army |

# KINGS OF ASSYRIA

| | |
|---|---|
| 1132–1115 | Ashur-resh-ishi I |
| 1114–1076 | Tiglath-pileser I |
| 1075–1074 | Asharid-apil-Ekur |
| 1073–1056 | Ashur-bel-kala |
| 1055–1054 | Eriba-Adad II |
| 1053–1050 | Shamshi-Adad IV |
| 1049–1031 | Ashurnasirpal I |
| 1030–1019 | Shalmaneser II |
| 1018–1013 | Ashur-nirari IV |
| 1012–972 | Ashur-rabi II |
| 971–967 | Ashur-resh-ishi II |
| 966–935 | Tiglath-pileser II |
| 934–912 | Ashur-dan II |
| 911–891 | Adad-nirari II |
| 890–884 | Tukulti-Ninurta II |
| 883–859 | Ashurnasirpal II |
| 858–824 | Shalmaneser III |
| 823–811 | Shamshi-Adad V |
| 810–783 | Adad-nirari III |
| 782–773 | Shalmaneser IV |
| 772–755 | Ashur-dan III |
| 754–745 | Ashur-nirari V |
| 744–727 | Tiglath-pileser III |
| 726–722 | Shalmaneser V |
| 721–705 | Sargon II |
| 704–681 | Sennacherib |
| 680–669 | Esarhaddon |
| 668–631 | Ashurbanipal |
| 630–627 | Ashur-etel-ilani |
| 626–612 | Sinsharrishkun |
| 611–609 | Ashur-uballit II |

*Note:* A few dates, particularly those of the later kings, are uncertain.

# 1 RELIEFS AND SCULPTURES

The Assyrian sculptures consist mostly of stone panels which originally lined the walls of huge royal palaces. They were carved between about 870 and 620 BC and constitute one of the most impressive and eloquent witnesses of ancient Mesopotamian civilisation, giving us an extraordinary glimpse into the minds and material culture of people whose empire at its greatest extent stretched from the Mediterranean to the Gulf, from the mountains of Iran and Turkey to the deserts of Egypt and Arabia (Reade 1983).

Although most of the sculptures now appear as individual panels, separated from those which once stood beside them, they were once part of elaborate decorative schemes. The palaces were built principally of sun-dried mud-brick (adobe). Bricks glazed with brilliant colours were used at particularly prominent points on the exterior. The interiors of rooms were frequently painted, and there will have been rich textiles on the floors. The carved panels, generally some 2 metres high and themselves painted in part, were set against the bases of the walls, both on exterior façades and in the principal apartments, with painted plaster continuing upwards to the ceiling, which was also painted (see nos 243, 245, 249).

There were also Assyrian sculptures of other kinds, such as free-standing statues, stelae, and commemorative obelisks placed in or outside temples; some sculptures were carved in the living rock to record royal achievements. These other monuments are liable to be made in a range of stones, but the material most favoured for the palace sculptures was a form of gypsum, sometimes known as alabaster or Mosul marble. This fine-grained stone is abundant in the Assyrian heartland; a brilliant grey-white in colour, it can be obtained from quarries or opencast mines, and it is fairly soft and easy to work, though it tends to harden and darken after exposure. It is eminently suitable for the use to which it was put, and its availability was a major reason for the development of stone sculpture in Assyria. The Assyrians used iron picks to reach stone of good quality, and large two-handled iron saws to cut it into rough blocks which were then chiselled into shape (see Fig. 16). The actual carving of the wall-panels could be done with points and chisels after the panels had been mounted on the palace walls; lastly they were polished, fine details were added, and they were at least partly painted.

King Ashurnasirpal (883–859 BC) or one of his advisers seems to have been the first person to observe the special qualities of gypsum and to suggest it should be used on a substantial scale in this way. At the time Ashurnasirpal was creating a new palace, in what was indeed a new

capital city, Nimrud (ancient Kalhu or Calah). He was following an ancient precedent, proclaiming by a new foundation his status as a major monarch, one who expected his fame to last for centuries; several later Assyrian kings were to act in the same way, immensely proud of the cities and palaces which they created. While these Assyrian palaces stand in a long tradition of royal architecture, and wall-paintings were already well known, Ashurnasirpal's extensive use of stone decoration was an innovation in Mesopotamia. The king may have heard stories of the ancient stone monuments of Egypt, but was probably influenced directly by acquaintance with the Hittite buildings of southern Turkey and northern Syria, which frequently incorporated panels of basalt or limestone. A previous Assyrian king, Tiglath-pileser I (1114–1076 BC), who also visited Syria, had already erected a few basalt figures in a palace of his own, and Ashurnasirpal was following this example. Assyrian rulers were always ready to experiment with new ideas, especially those associated with opulence and a grand life-style. The palace sculptures were far more than decoration. The architectural tradition in which they belonged, and of which they are the finest surviving relics, was designed to impress, astonish, intimidate, to present an image of the Assyrian capital city as capital of the civilised world, of the royal palace as centre of the universe, and of the Assyrian king as the most powerful man alive, deputy of Ashur, the most powerful god. The sculptures projected these messages both to the people who saw them – Assyrians and others – and to the supernatural world, whose inhabitants included malevolent spirits eager to spread misfortune and disaster. Each palace had its specific characteristics, as each king with his team of designers expressed the spirit of his reign and competed with his predecessors to create a monument of incomparable splendour. For us, the sculptures provide a vivid picture of ancient landscape and architecture, equipment and technology, civil and military organisation, daily life and religious practices; they are historical records in themselves; and they repeatedly offer remarkable insights into Assyrian attitudes and official ideology.

Unquestionably the most imposing of all Assyrian sculptures are the gateway figures in the shape of human-headed winged lions and bulls, standing up to 5 metres tall. Usually they were monoliths, weighing up to 30 tons. Moving them at all was such an achievement that Sennacherib (704–681 BC) devoted an entire series of sculptured panels to showing how it was done, with hundreds of men dragging them on sledges. These giant figures, however, were only the most prominent of a host of guardian spirits which the Assyrians called into service to protect their palaces. Smaller figures were very common in the palace of Ashurnasirpal, and some rooms were panelled with little else, but both here and in later palaces they were regularly positioned at doorways. Many

of them resemble winged men, like angels, but other varieties come to the fore in the seventh century, probably as a result of closer contact with the magical traditions of Assyria's southern neighbour, Babylon. There are documents describing rituals which involved the burial of magical figurines under floors, and as the descriptions of the figurines

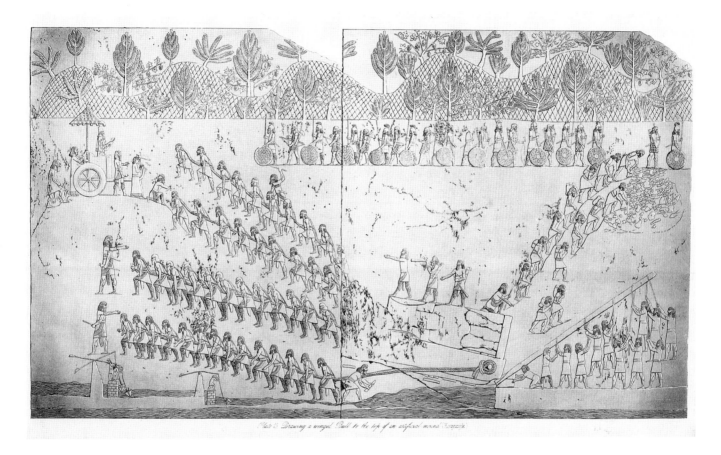

Relief of Sennacherib showing labourers hauling a colossal sculpture for the king's palace. Engraving after a drawing by F. C. Cooper (Layard 1853a: pl. 15).

correspond broadly with the figures carved on the walls, we can often identify them by name. One of the most striking, for example, is a winged human figure with an eagle's head; this is a variety of *apkallu* (see nos 67–72), once mistakenly identified with the god Nisroch, mentioned in the Bible.

Narrative reliefs show the achievements of the various kings in war, in the hunt and in public works. These had been standard themes of Mesopotamian art since about 3500–3000 BC, glorifying royal power and responsibility, since it was a king's duty to honour the gods, to protect the state from enemies of every kind, and to promote national prosperity and prestige. The sculptures were executed by workmen of variable standard, some more closely controlled and supervised than others, with the finest work in the most important rooms. The location of particular kinds of subject-matter reflected the architectural context;

for example, sporting scenes showing the king's personal achievements tended to be in the more private areas. Exterior façades sometimes displayed large-scale processions of people bringing tribute to the king, surrounded by his courtiers. Formal scenes showing the king as high-priest were prominent, both in sculpture and in glazed brick.

The stylistic evolution of Assyrian sculpture tends to reflect contemporary developments in the writing of history. Earlier narrative scenes had tended to summarise or symbolise royal achievements, so that a long story was compressed into a single brief composition. There were many examples of this convention in small works of art and probably in textiles, and so there are in the earliest Assyrian sculptures. Each wall-panel is liable to be treated as a self-sufficient unit, with few figures overrunning from one panel to the next. By the end of the seventh century, however, physical divisions between wall-panels were virtually ignored, and compositions sometimes occupied entire rooms. This gave limitless opportunities to fill out the broad background against which the principal events were happening, to include minor incidents and occasionally to utilise the dramatic potential of empty space. Because the purpose of the narrative sculptures was to tell stories, the artistic conventions are correspondingly straightforward. The scale of a person or a place depends on its importance in the story. Successive scenes produce a cinematic effect: the spectator could begin at one point, looking at the advance of the Assyrian army, for instance, and follow its progress through battle and siege to ultimate victory, with the defeated population marched off into captivity under the eyes of the Assyrian king. There are many variations on this basic theme. Trouble was often taken to represent dress, architecture and landscape accurately, and the carvings were manifestly derived from drawings made in the field. The one subject not represented was Assyrian defeat: there are no Assyrian dead. One is reminded of the formula with which the king would close his official report to the god Ashur: after describing some long and bloody campaign, he would admit that there had been just six Assyrian casualties – one charioteer, two horsemen and three foot-soldiers. JER

## REIGN OF ASHURNASIRPAL II

Ashurnasirpal II (883–859 BC), or people working for him, created Assyrian sculpture as we know it. At his new capital of Nimrud they combined existing artistic traditions, variously expressed, in what was essentially a new medium, the sculptured palace. Most of the wall-panels in Ashurnasirpal's palace had magical subjects, which repeated themselves along the walls in much the same way as the design of a Mesopotamian cylinder seal, rolled across clay, could be repeated almost indefinitely. Other walls had narrative subjects, representing in stone the achievements that Assyrian kings had long been accustomed to record in written annals. Working as they were in a new medium, Ashurnasirpal's artists were influenced by tradition and sometimes treated the physical divisions between panels as frames beyond which a narrative composition, or one element in a composition, could not be extended. They were also aware, however, of the way in which long stretches of wall could be exploited to construct long and complex compositions. Wall-paintings probably provided a precedent for this, and it is exemplified in the overall scheme of Ashurnasirpal's throne-room.

In the narrative sculptures effective description takes precedence over visual reality, and there is little concern with relative scales and perspective. The style of the sculptures is largely linear, in low relief embellished with incised detail, but considerable care is taken with the contours of flesh and musculature. JER

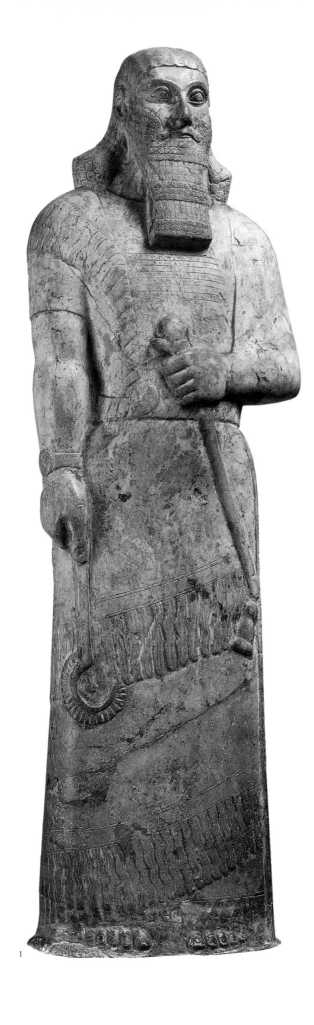

1

## 1 Statue of the king

This statue was placed in the Temple of Ishtar, where it was found, to remind the goddess of the king's devotion. It is made of magnesite, and the original pedestal on which it stands is of reddish stone. Both are unusual materials, probably brought back from a campaign abroad, though the actual workmanship of the statue is clearly Assyrian. Kings often boasted of the exotic things they acquired from abroad, not only raw materials and finished goods but also plants and animals.

The king stands bare-headed, without the royal crown. His hair is long, which was the fashion at the Assyrian court of this time, but his long and magnificent curled beard is more imposing than that which a courtier would have worn. It has been suggested that the Assyrians used false hair and beards, as the Egyptians sometimes did, but there is no evidence for this. The king's dress consists of a short-sleeved tunic on top of which a long fringed shawl has been fastened, covering most of his body below the waist; the shawl is drawn over the left arm, round the back, and then forwards over the right shoulder, to be secured to the belt in front. In his right hand he carries a ceremonial sickle of a kind which gods sometimes use in fighting monsters; the mace in his left hand symbolises the authority vested in him as vice-regent of the supreme god. The inscription carved on his chest proclaims his titles and genealogy, and mentions his expedition westward to the Mediterranean Sea.                    JER

About 875–860 BC
From Nimrud, Temple of Ishtar Sharrat-niphi
WA 118871
Statue: H 113 cm, W 32 cm, D 15 cm. Base:
    H 78 cm, W 35 cm, D 55 cm
Layard 1853: 361; 1853a: pl. 52. Grayson 1976:
    196. Strommenger 1970: 13–14, pl. 1

## 2 The king on campaign

Ashurnasirpal is travelling in a chariot through a hilly landscape with attendants. This is probably a campaign in the mountains of Kurdistan, which adjoined Assyria to the north and east. A river at the bottom is represented schematically by lines and spirals, and the rough ground by a pattern of scales.

The king can be identified by his flat hat with a pointed top, and his is the grandest beard. The two arrows held upright in his right hand, with the bow lowered in his left, symbolise victory. He wears a sword on his wide belt, and the end of the sheath is decorated with a pair of lions back to back. He has two wristlets; both incorporate rosettes, worn in the position of a modern wrist-watch. A spare bow and arrows, an axe and a spear are carried in quivers on the side of the cab; decoration including a prancing bull is incised on the quivers, which would probably have been made of embossed bronze. The back of the chariot, from which a spear-shaft projects diagonally backwards, is closed by a studded shield with a central boss in the shape of a lion's head.

An attendant holds a sunshade over the king's head; in battle this man would draw his own sword, from its simpler sheath, while using a shield to protect the king from arrows.

The charioteer holds three or four reins in each hand, together with a whip. This is a typical light chariot of its period, holding a maximum of three people, with six-spoked wheels. A thick yoke pole is visible, rising from the base of the cab, and a patterned cloth hangs between the top of the cab and the elaborate yoke itself, which is visible above the horses' shoulders. The horses themselves, led by a groom in front, are richly caparisoned, with crests and tassels in addition to their harness. Three horses are shown, as in many chariot teams of this date, and there has been much debate over the various chariot fittings and methods of harnessing that may have been employed for teams of two, three and four horses.

An armed groom in front is helping to lead the horses. His raised arm wears a wristlet similar to the king's; this is an anomaly of a kind not uncommon in Assyrian art. It seems, from the great majority of sculptures, that there were strict rules governing what individuals of a particular status could be seen to wear: probably rosette wristlets were only meant to be worn by royalty and gods, but the men doing the carving were not particularly familiar with such rules and applied them inconsistently.

This is one of two pieces that originally formed the lower section of a single right-angled panel in the corner of a room; they were sawn apart for ease of transport in the nineteenth century. At the top of the panel can be seen a few signs of the so-called 'standard inscription', summarising the achievements of the king, which was written across the middle of virtually every panel in the North-West Palace. Another version of this text was written on the reverse side of the panels, invisible against the mud-brick wall.          JER

About 875–860 BC
From Nimrud, North-West Palace, West Wing
WA 124557
H 101 cm, W 86 cm, extant TH 20 cm
Paley and Sobolewski 1987: 77, pl. 5. Reade 1985: 210, pl. XLIa

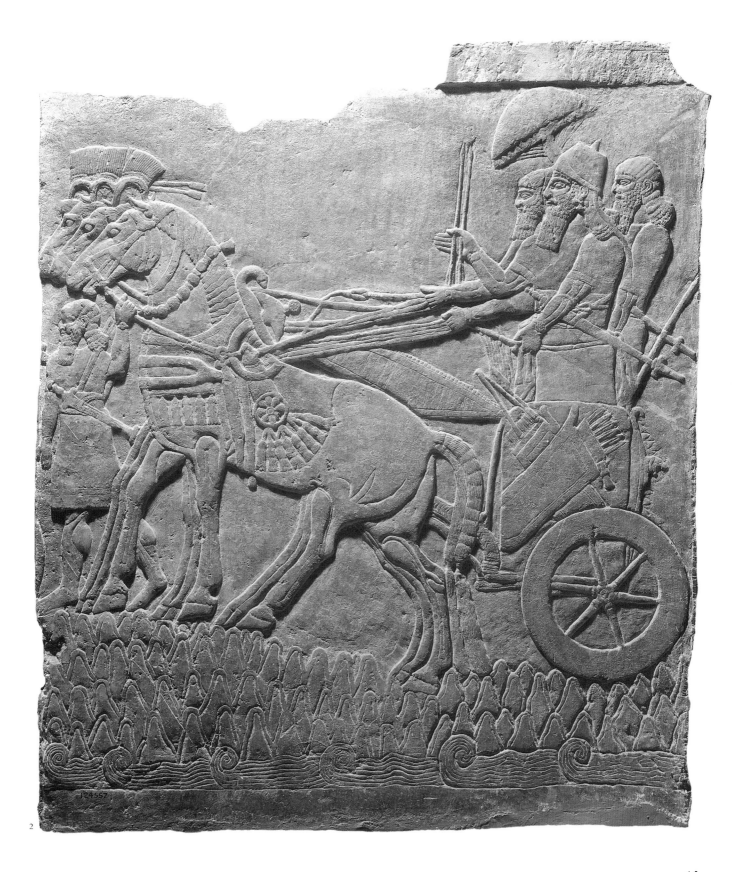

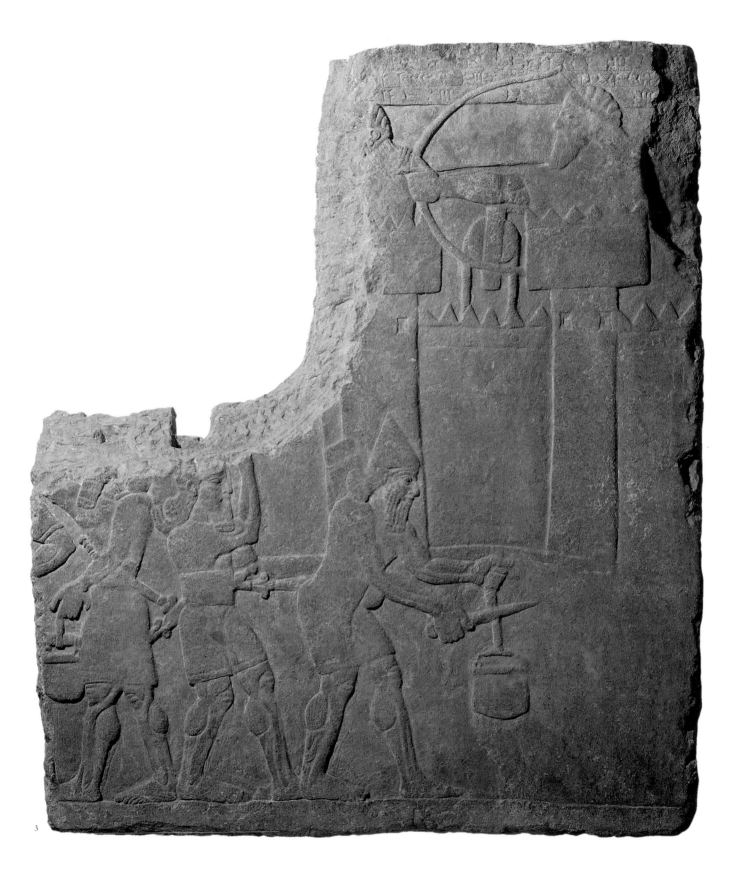

3

## 3 Episode from a siege

This piece is from a series of wall-panels which showed the Assyrian army attacking an enemy fortress, and illustrates an incident of technological interest. The fortress stands on a rise, perhaps an ancient mound. Inside the walls is a pulley with two ropes hanging from it. Though there is no visible link between the pulley and the bucket below, it is clear that the Assyrian soldier in the foreground has cut the rope with which someone inside the fortress has been trying to collect water from a source outside the walls. This soldier must be the same as the one on the left of the panel, who holds the bucket in his left hand and lifts his right arm in a gesture of triumphant greeting towards someone, presumably an officer or the king himself, who appeared with the main Assyrian force on panels further to the left. The central figure, with both arms raised, is holding a shield over his head as a protection against enemy shots. Meanwhile an enemy soldier on a tower is shooting an arrow at the Assyrians to the left; he is wearing a headband, but this item of dress is not sufficient to identify the location of the scene; it may have been somewhere in Syria. The architecture of the fortress, with lines of rosettes below the crenellations and pairs of windows in the towers, suggests a place of some distinction; in Assyria such rosettes would have been made of glazed bricks.

The scale of the defender, unnaturally large in relation to the tower on which he is stationed, is typical of ninth-century art. So is the general composition to which this panel must have belonged, with the attacking Assyrians on one side and the people attacked on the other. Within a single composition, however, it is unusual at this date to show a single person more than once in consecutive moments, as in a strip-cartoon.

There are traces of the standard inscription at the top of the panel.  JER

About 875–860 BC
From Nimrud, South-West Palace, but probably originating in the North-West Palace
WA 118906
H 104 cm, W 93 cm, extant TH 19 cm
Layard 1849: II, 31–2. Barnett and Falkner 1962: 25, pls CXXII–CXXIII

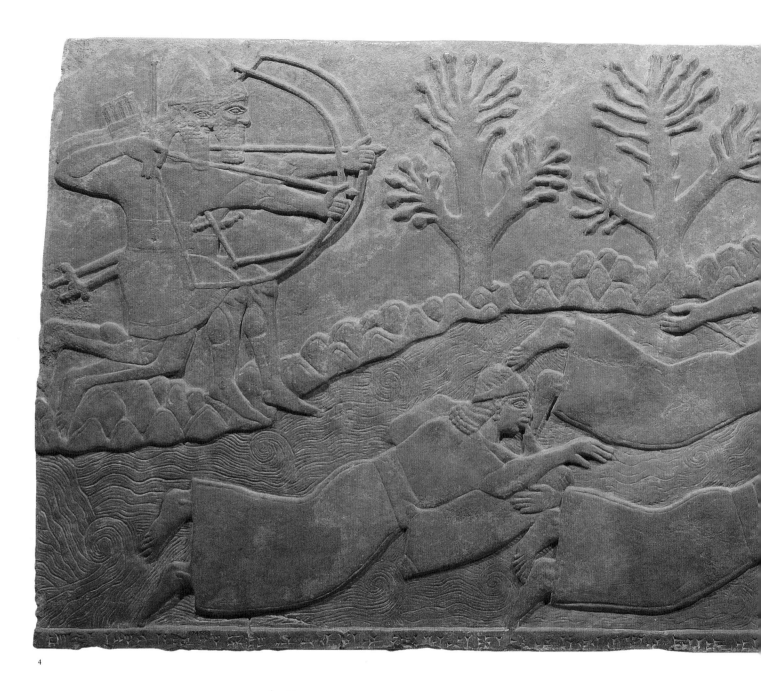

4

## 4 Escape across a river

This panel, which is a complete composition, probably shows an incident described in Ashurnasirpal's annals. In 878 BC the king was campaigning down the Euphrates river, and reached the enemy capital a little south-east of the modern town of Ana. Then, 'in the face of my mighty weapons, Kudurru with seventy of his soldiers fell back into the Euphrates to save his life' (Grayson 1976: 138).

Two Assyrian archers are shooting at the enemy; they are dressed and armed as typical Assyrian soldiers, with pointed helmets, short kilts, swords and bows, and with quivers on their backs. Two of the trees growing on the bank are crudely drawn and hardly identifiable, but the third is unmistakably a date-palm. There are three enemies in the water: their long robes indicate that they are all people of high status rather than ordinary soldiers. One is swimming, and has been hit by

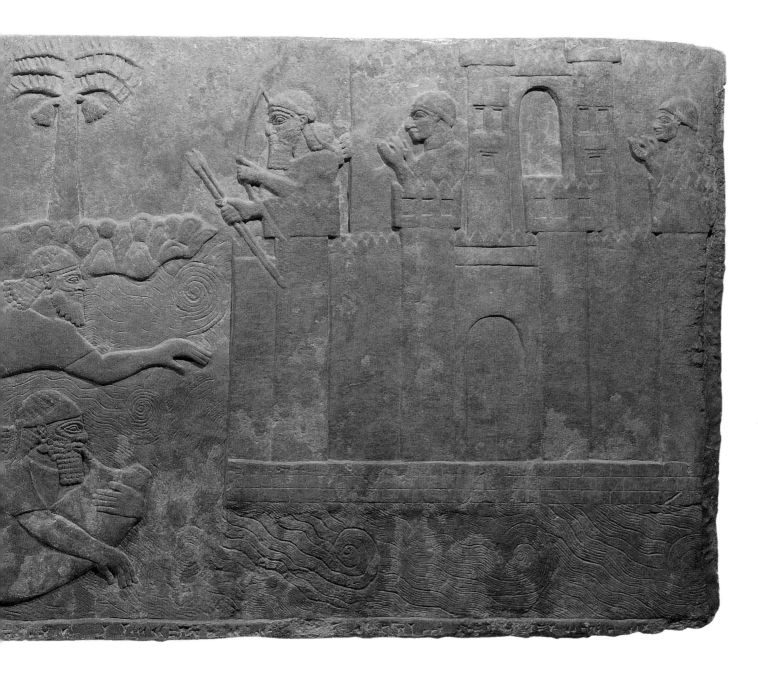

arrows. The other two are using inflated animal-skins to help support themselves in the water, blowing into them as they struggle towards the fort on the right. The one without a beard is probably a eunuch: eunuchs were employed extensively at the courts of the ancient Orient – not only to guard women – and many of them reached positions of high responsibility.

The foundations of the fort, which may be on an island, appear to be of stone, whereas the walls themselves would prob-ably have been mud-brick. The arched shape of the doors is typical of the period.

There are traces of the standard inscrip-tion at the bottom of the panel.      JER

About 875–860 BC
From Nimrud, North-West Palace, Room B,
   panel 17 (top)
WA 124538
H 88 cm, W 225 cm, extant TH 9.5 cm
Layard 1849: I, 128–9; 1849a: pl. 33. Meuszynski
   1981: 23

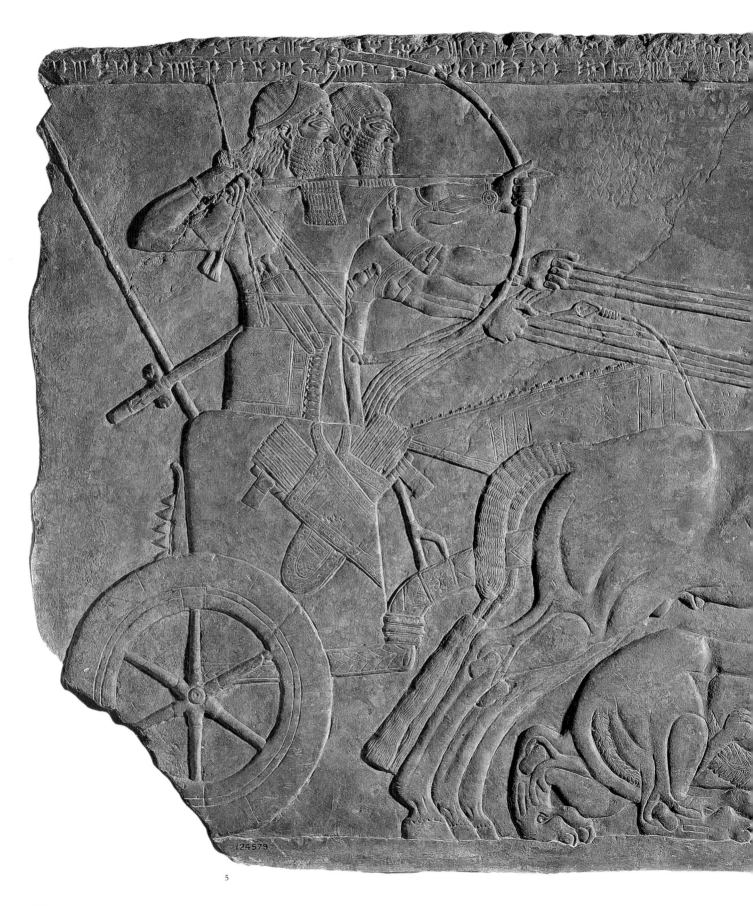

124579

5

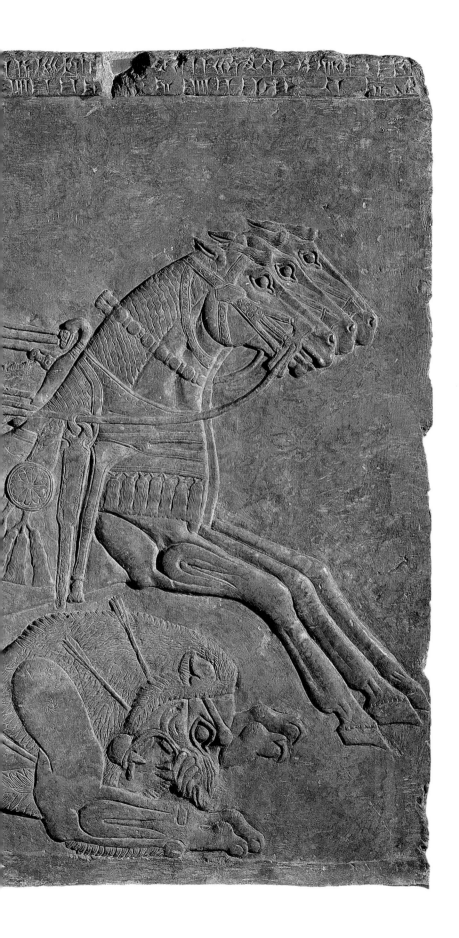

## 5 Royal lion hunt

The lion hunt has special significance in ancient Mesopotamia. Even before 3000 BC 'royal' figures are shown killing lions, and the Assyrian royal seal itself (see no. 194) represented this theme, with the king on foot confronting a lion face to face. The Mesopotamian lion, now extinct, was somewhat smaller than the more familiar African lion (one was compared in the nineteenth century to a 'large St Bernard dog'), but it was still a formidable opponent. Lions represented the wild forces of nature which it was a king's duty to control, and it seems that at some stage there developed a rule that the killing of lions was reserved for royalty alone.

The archer shooting a bow wears a diadem with two bands hanging down behind. This kind of diadem encircled the royal hat, but the later king Ashurbanipal is sometimes shown wearing it on its own; otherwise it was worn by the crown prince, so this figure may be either Ashurnasirpal himself or his son and heir, Shalmaneser. A double sheath in the archer's belt holds a dagger and whetstone. There is a spare arrow in his hand, and axes in addition to arrows in the quivers on the side of the chariot. His bow-string is not fully represented: it would have run inelegantly across his face. The chariot itself is broadly similar to that in no. 2, but there are no crests on the horses' heads.

It was a familar convention in Assyrian art to show a fallen enemy or victim beneath the horses drawing the victor's chariot. Here a lion has been hit by three arrows. The composition is incomplete, and we may envisage another lion further to the right.

There are traces of the standard inscription at the top of the panel.       JER

About 875–860 BC
From Nimrud, North-West Palace, West Wing
WA 124579
H 98 cm, W 139.5 cm, TH 23 cm
Budge 1914: pl. XLII
Paley and Sobolewski 1987: 76, pl. 5. Reade 1985: 211, pl. XLIVb

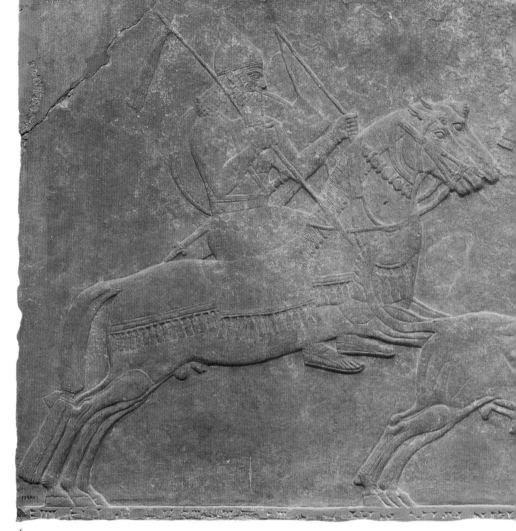

6

## 6 Royal bull hunt

Wild cattle still lived in the Assyrian steppe at this time, though they were probably rare. The basic composition of this scene is similar to that of no. 5, with the royal chariot rushing to the right across a fallen bull. The warrior in the chariot is King Ashurnasirpal himself, wearing the distinctive royal hat. Here, instead of shooting forwards, he has turned to deal with another bull that has charged the chariot from behind. The king grasps it by the horn, while driving his sword into its neck.

Behind the king rides an armed horseman, leading a mount for the king. At this stage the Assyrians had not mastered the art of fighting individually from horseback. Instead they treated horses as platforms much like chariots, and rode in pairs, with one man fighting with bow or spear while the other controlled both horses. This horseman has a round shield on his back, and one of his duties would have been to use it to protect the king. The royal horse has a saddlecloth woven with a kind of geometric pattern which is still widely seen in the Middle East today. Traces of such incised details, sometimes much more elaborate, can often be seen on clothes and other textiles in the Assyrian sculptures.

This slab is the upper part of a panel that stood on the wall close to the royal throne, and perhaps represented an exploit of which the king was particularly proud. No. 7 was the lower part of the same panel. There are traces of the standard inscription at the bottom of the slab. See nos 246–7 for Layard's original drawing of this panel and an early engraving of it. JER

About 875–860 BC
From Nimrud, North-West Palace, Room B, panel 20 (top)
WA 124532
H 93 cm, W 225 cm, extant TH 9 cm
Layard 1849: I, 129; 1849a: pl. II. Meuszynski 1981: 23

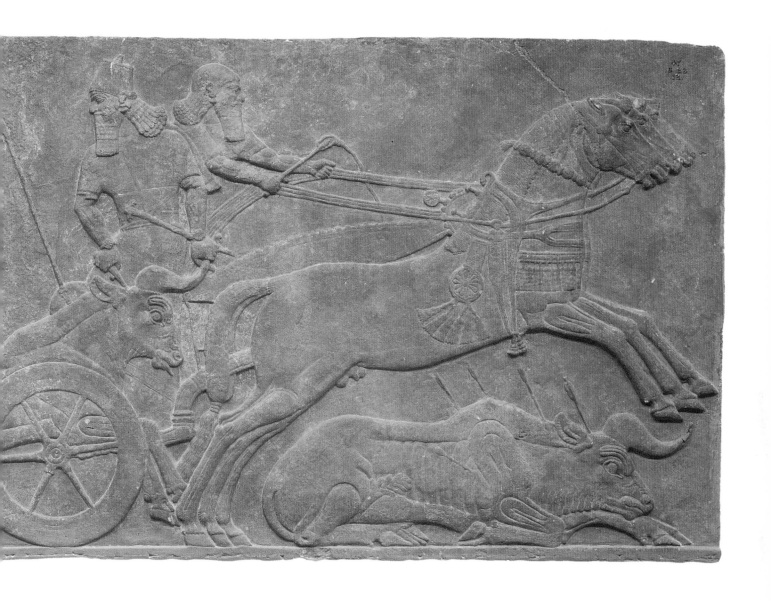

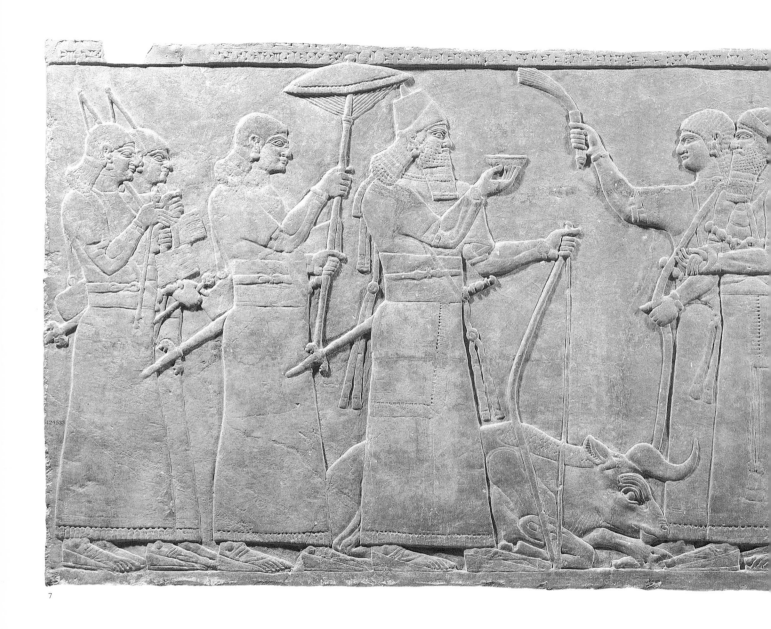

7

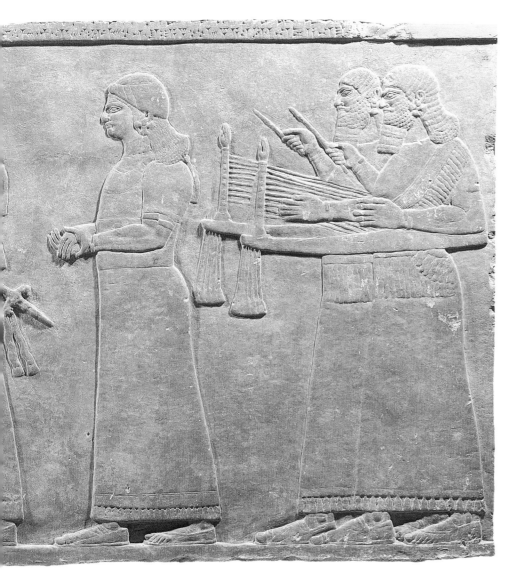

fied as eunuchs. Documents refer to Assyrian courtiers as being either bearded men or eunuchs: some beardless figures in the Assyrian sculptures are of course women, but they are not frequent; others are children, or priests whose hair was completely shaved off on consecration, but these can usually be recognised without difficulty.

The king, like his attendants, wears what is basically a simple short-sleeved tasselled robe, with traces of incised embroidery. An apron hanging down his back from his wide belt was to help prevent chafing against the edge of the chariot cab. He wears the standard royal crown with diadem; on his arms are rosette wristlets and plain armlets like those of his attendants, though royal armlets more usually ended in animal-heads; his bead necklace is balanced by a tassel at the back of the neck. His sword-sheath is attached to a strap over his right shoulder; the purpose of the double tassels which hang down in front of him and behind remains unclear. He is pouring his libation from a gadrooned bowl of a kind which continued in fashion even after the Assyrian period.

The officer facing the king is the crown prince, presumably the next king, Shalmaneser. He is dressed much as the king, but with only the diadem on his head. The man behind him may be the chief eunuch, with a specific headband to mark his office. Both have their hands crossed in a distinctive gesture used by courtiers in the royal presence. To the right a pair of musicians are playing on nine-stringed horizontal harps.          JER

About 875–860 BC
From Nimrud, North-West Palace, Room B, panel 20 (bottom)
WA 124533
H 90 cm, W 225 cm, extant TH 10 cm
Layard 1849: I, 129; 1849a: pl. 12. Meuszynski 1981: 23

## 7  Celebration after a bull hunt

This is the aftermath of the hunt shown in no. 6. The bull lies on the ground, and the king rests his bow while pouring a triumphant libation of wine, a scene comparable with no. 29, which shows a similar libation over two centuries later.

On the left are two royal bodyguards, both carrying maces as symbols of authority in addition to their arms. The figure carrying a sunshade, who also has a quiver, would be the bearer of the king's bow. Another figure is waving a fan or fly-whisk in front of the king; he has a towel over his left shoulder. All these four are beardless, and may therefore be identi-

## 8 Protective spirit

This figure, a man with wings like an angel, is a protective spirit, probably an *apkallu*, one of a pair which guarded an entrance into the private quarters of the king. He carries a goat and a giant ear of corn, possibly symbolic of fertility though their precise significance is uncertain. He wears a kilt with long tassels hanging from it, indicating his semidivine status, and a fringed and embroidered robe which is drawn round the body and thrown over his shoulder, leaving the right leg exposed. There are sandals on his feet. A bead necklace round his neck is held in position by a tassel at the back. His armlets have animal-head terminals, and there are rosettes on his wristlets and on his diadem. He has the magnificent curled moustache and long curled beard and hair typical of ninth-century figures. The musculature of his leg is exaggeratedly drawn, with a prominent vein encircling his ankle.

Across his body runs the standard inscription. This was incised after the carving of the figure was complete, and cuts through some of the fine details of decoration on the dress. JER

About 875–860 BC
From Nimrud, North-West Palace, Room Z,
   door a, panel I
WA 124561
H 224 cm, W 127 cm, extant TH 12 cm
Layard 1849: II, 8. Paley and Sobolewski 1987:
   60, pl. 4

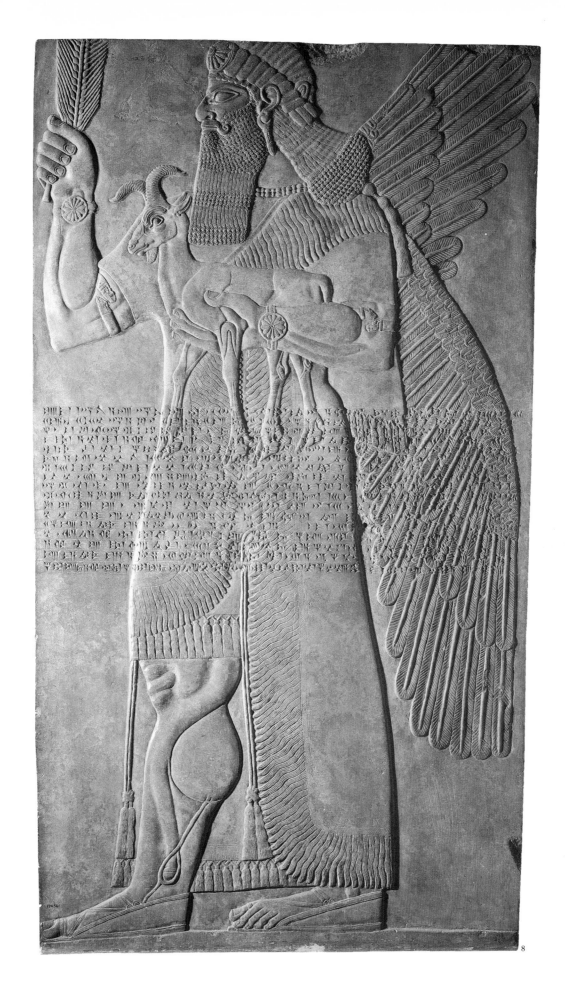

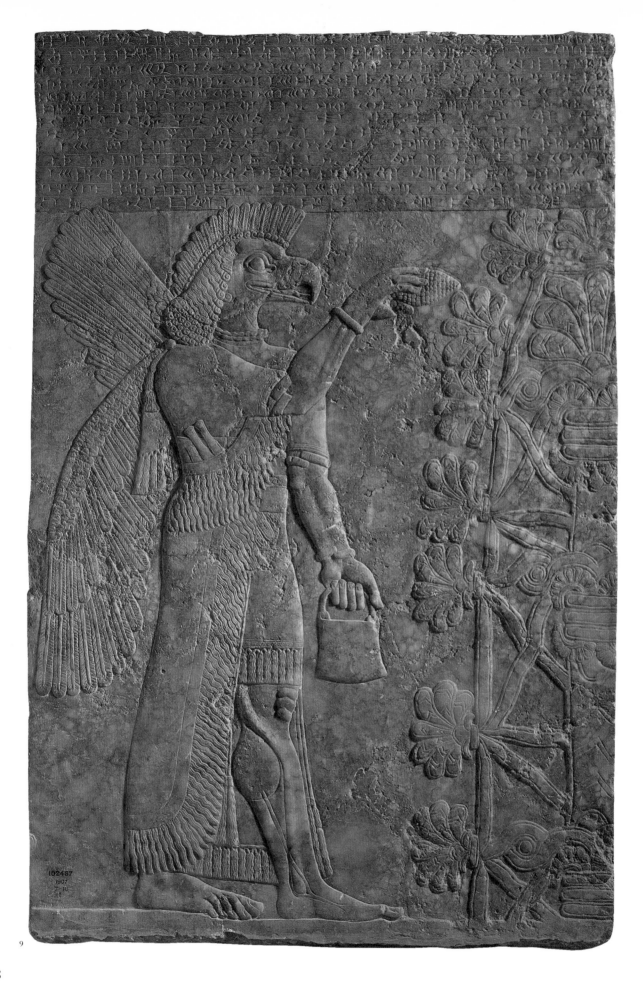

9

## 9 Protective spirit and Sacred Tree

This winged eagle-headed figure is a classic Assyrian type of protective magical spirit, and great numbers of such figures decorated the palace. He wears much the same clothes as no. 8, more simply drawn because of the smaller scale, and has two daggers and a whetstone in his belt. The cone in his right hand is described in Assyrian texts as a purifier, and was presumably envisaged as being covered in liquid from the bucket in his left hand. The cone may derive its shape from the male date-spathe, used to fertilise female date-palms.

On the right is half a Sacred Tree, again a symbol of great importance in Assyria. The trunk has a large palmette at its top, and a network of palmettes surrounding it, only half of which are preserved on this piece. Around the trunk are three sets of horizontal binding, each supporting horn-like growths and volutes, and a chevron pattern runs up it. The Sacred Tree was extremely common in magical sculptures of Ashurnasirpal's reign, and probably represented the fertility of the land which the magical figure was protecting. Parpola (1993) has maintained that it acquired great esoteric significance in Mesopotamian religious thought.

Part of the standard inscription is preserved above the scene.     JER

About 875–860 BC
From Nimrud, North-West Palace, Room I,
   panel 17(?). Presented by W. Howard Esq.
WA 102487
H 141 cm, W 95 cm, extant TH 4 cm
Layard 1849: I, 387. Paley and Sobolewski 1987:
   17, pl. I

## REIGN OF ADAD-NIRARI III

Adad-nirari III (810–783 BC) came to the throne as a child, and for some years his mother Sammuramat, the original Semiramis, was the power behind throne. The buildings of Ashurnasirpal and Shalmaneser III at Nimrud were still in good repair. Those constructed under Adad-nirari seem to have been lesser palaces, occupied by government officials and others, and decorated with schematic paintings but without the carved stone panels that seem to have been reserved for buildings where kings resided. Adad-nirari's principal monument at Nimrud was the Temple of Nabu, which included free-standing figures of attendant gods.     JER

## 10 Stela of Adad-nirari III

This fragmentary basalt stela shows the king in an attitude of worship in front of divine symbols. Monuments of this kind were erected inside and outside temples, and rock carvings often showed the same scene. Their presence was an assertion of Assyrian hegemony.

The king has his right hand raised, as if he had just snapped his fingers; this is a standard gesture of worship. In his left hand he holds the mace symbolic of authority. The symbols are, from top to bottom, a crude version of the winged disc of Shamash, the sun; a rosette or star symbol representing Ishtar or the planet Venus, goddess of the human passions expressed in love and war; and the thunderbolt of the weather god Adad.

The rough style of carving and the type of stone point to the provincial origin of this piece. It was probably erected by Nergal-eresh, who was for many years governor of the region where it was found. The inscription describes a campaign westward across the Euphrates in 805 BC.     JER

About 805–800 BC
From Sheikh Hamad (ancient Dur-Katlimmu),
   eastern Syria
WA 131124
H 82 cm, W 50 cm, TH 14.5 cm
Millard and Tadmor 1973

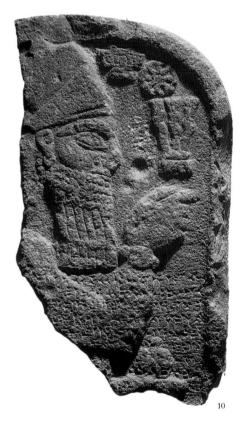

10

## REIGN OF
## TIGLATH-PILESER III

Tiglath-pileser III (744–727 BC) revived the fortunes of Assyria at a critical moment in its history. Towards the end of his reign he was building himself a new palace at Nimrud, which was left unfinished; it was largely robbed of its sculptures by Esarhaddon, a later king who required wall-slabs for a projected palace of his own.

Tiglath-pileser's sculptors had the work of Ashurnasirpal, over a hundred years earlier, as their obvious model, but they appear to have had fewer technical resources. For instance, the only colossal human-headed bull recorded from the palace was carved in low relief like a conventional wall-panel; many of the carvings are relatively flat, recalling the simple linearity of most ivories cut in the Assyrian style, and they tend to be poorly finished. The compositions, however, are varied, imaginative and well organised, and indicate that the designers had thought seriously about ways of expressing a sequence of historical events in stone. They created decorative schemes which were not merely impressive, like those of Ashurnasirpal, but a visual equivalent of the written annals. They were unquestionably indebted to the kind of systematic narration embodied in small-scale monuments such as the bands of the Balawat Gates (nos 42–3). This tradition may have had wider currency in paintings, textiles and small objects, which have seldom survived.      JER

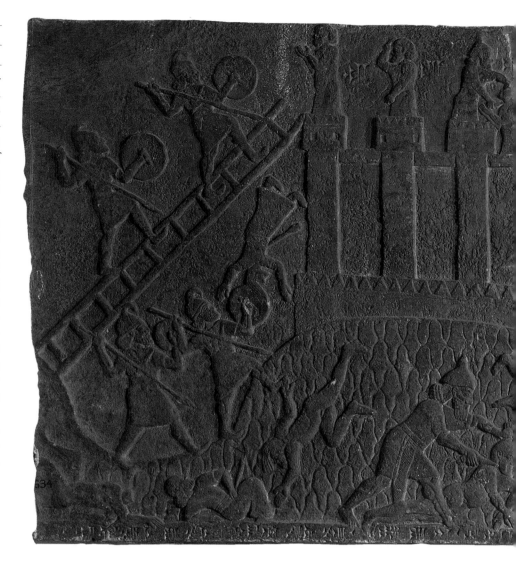

## 11  Attack on an enemy town

This is the upper half of a panel once divided into two registers by a central band of inscription. The latter stretched all round the room and was a record of the king's entire reign; this extract is not directly related to the carvings, but a separate caption at the top gave the name of the town attacked as U[pa?], possibly in Turkey.

The Assyrians are attacking from both sides. On the right archers shoot at the town, guarded by swordsmen with high shields. The foremost archer is a senior official, wearing a long court robe under what was probably an armoured jacket. The sculptor has struggled to provide an adequate representation of face, beard, arms, dress, sheath and bow, and reached a visually impossible but effective solution. Both archer and guard have helmets of an unusual design. The high shield of the foremost archer is cut short by the representation of a wheeled siege-engine. It has giant spears projecting from its front, which have been used to lever away at the fortifications of the town. Machines like these, which are known from several Assyrian sculptures, also provided platforms from which archers could shoot at close range. The surface was probably leather, and inside there was a store of water for use if the enemy tried to set the machine on fire with flaming torches. The machines were presumably moved by men, as an animal might panic, and sometimes steep ramps had to be built in order to bring them close enough to the enemy wall. Infantry could advance behind a

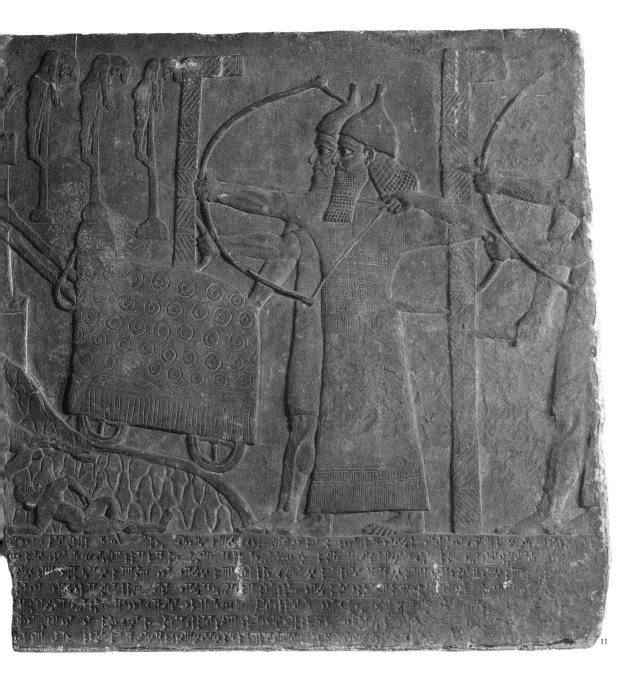

11

siege-engine, under its cover. Its function was comparable with that of the modern tank.

On the left a second group of Assyrian spearmen are attacking across a ditch, and scaling a ladder. Their uniform is distinctive; they wear crested helmets, carry round shields, and have straps across their chests. Appearing first in Tiglath-pileser's reign, they are probably soldiers drawn from the western half of the empire or from its mountainous fringes. In front a soldier in more traditional Assyrian dress,

with a pointed helmet, is cutting off an enemy head. The literal head-count was the standard means of estimating the numbers of enemy dead.

The events of the attack, from beginning to end, are here compressed into a single composition, since the enemy themselves are shown in successive stages of defeat. Three have been impaled on stakes, to intimidate the remainder. Two are tumbling from the walls, one with his hair falling loose. Some of the bodies have been stripped. Those on the battlements

raise their arms in surrender or submission; one is being killed by an Assyrian.                                    JER

About 730–727 BC
From Nimrud, Central Palace
WA 115634 + 118903
H 109 cm, W 211 cm, extant TH 13 cm
Layard 1849: 369; 1849a: pl. 63. Barnett and
    Falkner 1962: 14–16, pls XXXVII–XL

61

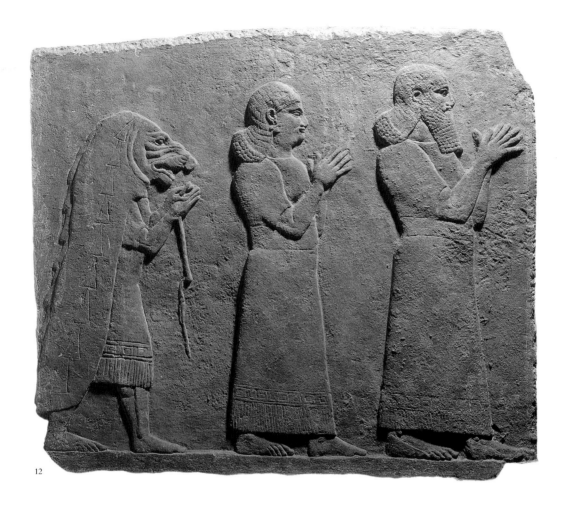

12

## 12   Victory celebration

This fragment is part of a victory celebration scene, in which the king would have been shown in triumph. The two right-hand figures, clapping their hands, are Assyrian courtiers. The figure on the left, whose garment is visible under his cloak and who carries a whip, is probably a soldier. The cloak is a lion skin, probably with bells attached. A figure of this kind is known from other Assyrian victory scenes, from the reigns of Ashurnasirpal and Esarhaddon, though it is less common than might have been expected; the lion-skin mummery was perhaps a traditional act, immediately after battle, that did not fit comfortably into formal Assyrian art. It honoured Ishtar, the goddess of fertility and of human passion as expressed both in love and in war. Her animal was the lion, and various documents refer to people wearing lion skins or lion masks

at Ishtar festivals in different parts of the ancient Middle East.                                JER

About 730–727 BC
From Nimrud, Central Palace
WA 136773
H 82 cm, W 93 cm, extant TH 8 cm
Barnett and Falkner 1962: 9–10, pls I–II

## 13   The capture of Astartu
(ABOVE)
## The king in procession
(BELOW)

This panel, once the left end of a composition, was found reused in a later palace. It belonged to a series in which a central band of inscription, listing the events of the reign in chronological order, divided two independent compositions in separate registers. The text on this panel happens to describe a campaign in the north, but the upper composition represented a campaign in the west, and the name of the

town represented, Astartu, is given in a caption at the top.

Astartu was situated in modern Jordan. It is shown as a typical Middle Eastern fortress town, built on top of a mound which probably covered the remains of much older settlements. There are towers at intervals along the walls, and a high town gate; inside, at the top on the left, is a building with an arched entrance, perhaps the citadel. The town has just been captured and its inhabitants are being marched away. An Assyrian soldier waving a mace escorts four prisoners, who carry their possessions in sacks over their shoulders. Their clothes and their turbans, rising to a slight point which flops backwards, are typical of the area; people from the Biblical kingdom of Israel, shown on other sculptures, wear the same dress. Above them a second Assyrian soldier is driving two fat-tailed sheep. Further to

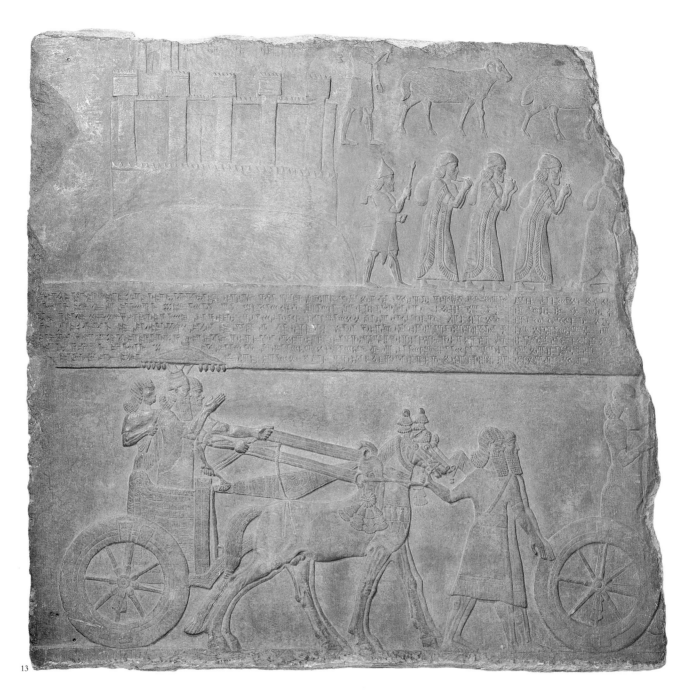

13

the right they would have met the Assyrian king, reviewing his troops and their booty.

In the lower register, the king himself appears in a chariot under his tasselled state parasol, which is held by a eunuch. He wears the royal hat, somewhat higher than the ninth-century type, and a fringed robe. His right hand is raised, while his left holds a flower. His chariot is larger than the ninth-century type, with a quiver

at the front, and the wheels have eight spokes rather than six. The patterns on the cloth hanging between the front of the chariot and the yoke include a winged disc, a solar symbol of great significance throughout the Ancient Near East. The charioteer holds three reins, but two horses are actually shown drawing the chariot, gaily caparisoned and led by a pair of grooms wearing quivers. The one man visible in the poorly preserved chariot to

the right once held a pole with a circular ornament on top; this was one of the sacred standards which accompanied the Assyrians into battle. JER

About 730–727 BC
From Nimrud, South-West Palace, but probably
    originating in the Central Palace
WA 118908
H 190 cm, W 195 cm, extant TH 16 cm
Barnett and Falkner 1962: 30, pls LXVIII–LXXI

63

## REIGN OF
## SARGON II

Sargon (721–705 BC), who had seized the Assyrian throne by force, founded a new capital city named after himself at Khorsabad, ancient Dur-Sharrukin. It included a magnificent palace decorated with carved stone panels; since this was a French discovery, the British Museum has relatively few examples of his sculptures. Many of them were removed from the palace in antiquity, when it was abandoned on his death. Some of those that survived show war, sport and feasting, as well as the punishment of rebels, but the majority projected a somewhat optimistic image of a peaceful world, an ordered universe in which tribute-bearers from east and west brought their gifts willingly to Sargon's magnificent court.

The panels are cut in exceptionally high relief. Although their design, general style and subject-matter are unmistakably Assyrian, Sargon mentions that he deported skilled workmen from conquered states to Assyria, and it is possible that the quality of the carving in his palace reflects the experience of men from Syrian cities like Carchemish, where an independent school of sculptors was accustomed to producing sophisticated wall-panels in harder stone.  JER

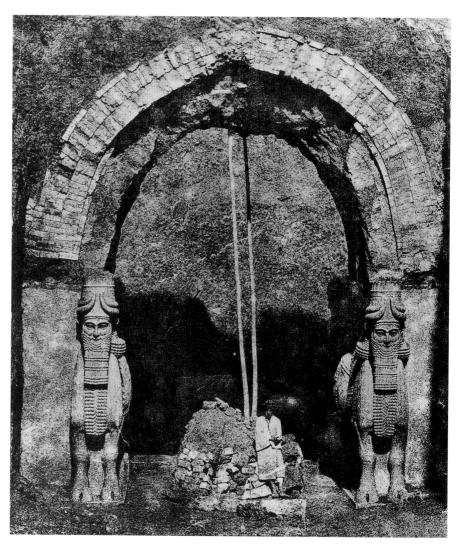

Human-headed winged bulls supporting an arch, as found by Victor Place in Sargon's palace at Khorsabad. Photograph taken in the early 1850s by M. Tranchand.

14

## 14  Head of a eunuch

This head, which is over lifesize, belonged
to a figure of a eunuch, one of the attend-
ants of the Assyrian king. He wears an
earring of a classic Assyrian type, and his
curled hair-style is intermediate between
that of previous reigns and the shorter
squared cut which became fashionable in
the seventh century. A pattern of rosettes
is embroidered on the neck of his robe.

About 710–705 BC                          JER
From Khorsabad, Royal Palace,
    façade n, panel 16(?)
WA 118816
H 64 cm, W 53 cm, extant TH 12 cm
Botta and Flandin 1849–50: I, pl. 29. Albenda
    1986: 167

15

## 15  Head of a bearded man

This bearded head of a man, over lifesize,
comes from a figure in a procession of
tribute-bearers. The turban on his head
and the style of his hair and beard identify
him as someone from the west of the
empire, probably the Syrian coast or
Turkey. Processions of tribute-bearers
were shown in the main court of the
palace and in some domestic rooms. The
top of the panel was cut to a rounded
shape during the nineteenth century. JER

About 710–705 BC
From Khorsabad, Royal Palace, façade n, panel
    22
WA 118830
H 62 cm, W 53 cm, extant TH 12.5 cm
Botta and Flandin 1849–50: I, pl. 29. Albenda
    1986: 169

## REIGN OF
## SENNACHERIB

The palace of Sennacherib (704–681 BC) was constructed to a novel design for the new capital, Nineveh, incorporating both the traditional suites of rooms and others which probably functioned as government offices. Virtually all the excavated rooms in the public part of the palace were decorated with stone wall-panels, mostly showing scenes of warfare. Some walls showed formal processions or public works, and there were magical figures at the doors. The sculptures were severely damaged by fire when Nineveh was sacked in 612 BC. Layard estimated that he had excavated over 3,000 metres of sculpture, with twenty-seven doors flanked by colossal winged bulls or lion-sphinxes. The carving must have necessitated new techniques of mass-production. The narrative reliefs are cut less deeply into the stone than at Khorsabad, and the quality of carving is very variable. A notable feature is that the narrative scenes are no longer divided into two registers with a wide band of inscription between them, as had been normal previously, but fill the entire height of the panels. This change, one with which Sargon's sculptors had experimented, meant that many more figures, on different scales, could be incorporated within single compositions, and there is consequently much more circumstantial detail. Often a composition occupied an entire room, with the most important scene, such as the attack on an enemy fortress, prominently situated opposite the doorway. The king himself takes a less dominant place within the narrative, and never appears fighting in person, but the compositions always direct the eye towards him, as he stands or sits receiving prisoners and booty.

JER

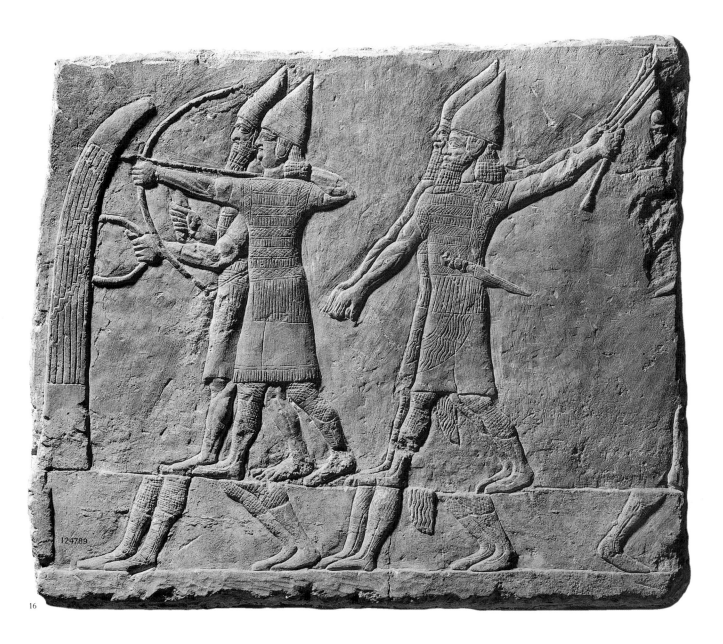

16

## 16 Episode from a siege (recarved fragment)

All the figures are Assyrian soldiers, with their distinctive pointed helmets and scale-armour on the upper part of the body. On the left a eunuch officer is shooting his bow, probably towards an enemy town. He is guarded by a man resting a large shield on the ground in front. Behind him are two slingers, whirling stones in the same direction; modern slingers in the Middle East are said to have a range of about 100 metres. On the right there are traces of another figure, probably a slinger bending down to pick up fresh ammunition.

These figures were originally cut at a lower level on the panel, and part of the first version remains. It was replaced by another at a higher level. A possible explanation is that the floor level had to be changed; another is that the carvings on this stretch of wall were simply done at the wrong height through haste or inadequate supervision.       JER

About 700–695 BC
From Nineveh, South-West Palace, Room I,
   panel 16
WA 124789
H 62 cm, W 74 cm, extant TH 11 cm
S. Smith 1938: pl. XLI

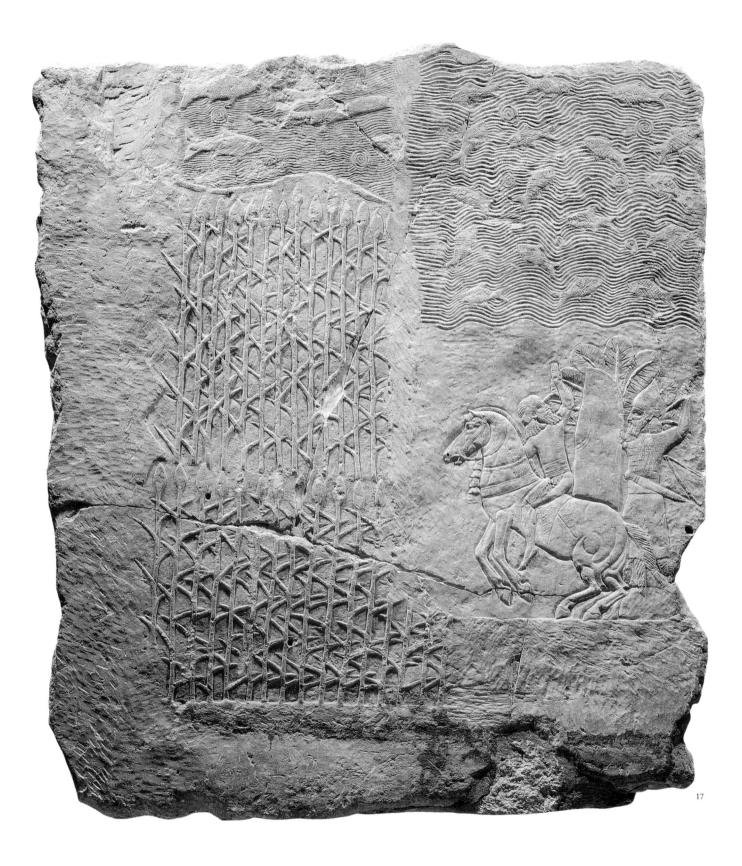

17

## 17  Episode from a battle (recarved fragment)

This panel is a striking example of the practical, matter-of-fact way in which the Assyrians solved problems. Sculptured panels from the palaces of Ashurnasirpal, Tiglath-pileser and Sargon were all reused by later kings, but on this occasion a panel has been left in position on its wall but scraped down, and the original carving has been partly replaced with an updated version of a similar subject.

The reeds and water on the left are original, from a scene that showed one of Sennacherib's campaigns in the marshes of Babylonia (southern Iraq). Running vertically down the panel, and drifting right towards the base, is a line of chiselling which deleted whatever was once carved on the right-hand side. What we see there now was carved over half a century later, by Ashurbanipal or one of his sons, perhaps Sinsharrishkun who also campaigned in Babylonia. The distinction between the two periods is clearest at the top, with different treatment of the water and fishes. On the right an Assyrian soldier, in uniform typical of the later period, is pursuing a member of the Babylonian cavalry whose horse rears as it reaches the reeds, integrating the original landscape into the later scene.

The whole appears as a satisfactory unit, with a dramatic effect that has been compared with Chinese art. In fact the battle represents the left-hand end of what must have been a much longer composition, with two registers of fighting separated by a central river in much the same way as narrative scenes had been separated, in panels of the ninth and eighth centuries, by horizontal bands of inscription. The plain left-hand edge of the panel would not have been carved, but masked by the end wall or colossal figure against which it once abutted. The bottom of the panel is also plain, and the original floor would have been roughly level with the line of black bitumen along its face. JER

About 700–695 and 640–620 BC
From Nineveh, South-West Palace
WA 124773
H 144 cm, W 132 cm, extant TH 12 cm
Reade 1967: 42–5, pl. XII

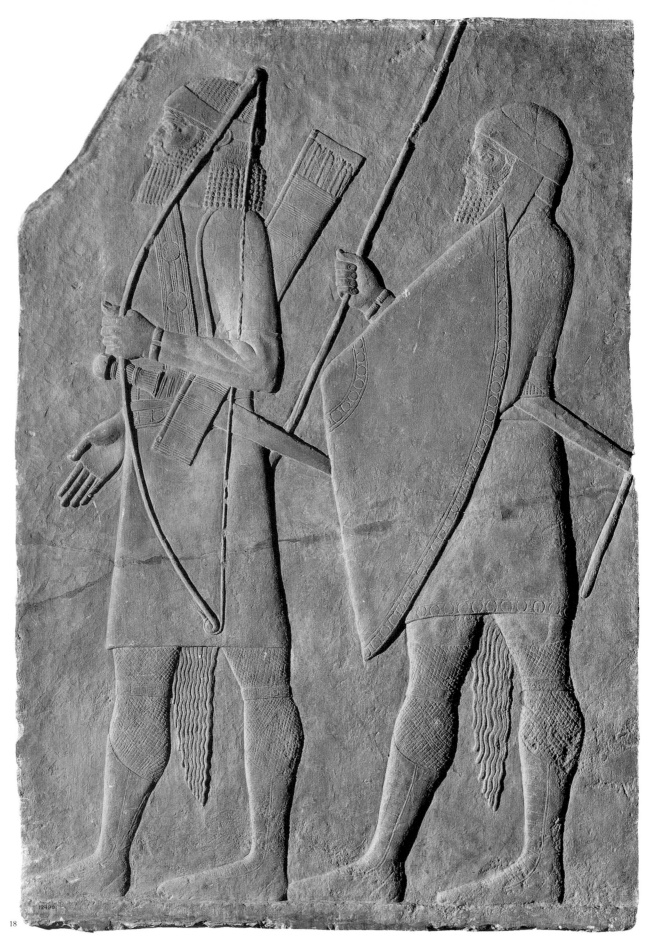

## 18 Soldiers of the royal guard

This panel was one of a group found, out of position, somewhere between the palace of Sennacherib and the Temple of Ishtar, principal goddess of Nineveh. They may have lined a bridge or corridor used by the king when visiting the temple, and they represented him and his entourage in formal court dress. The two figures on this panel formed part of his bodyguard, with uniforms that are basically austere but have much fine detail.

The archer on the left is one of the lightly armed soldiers who were probably drawn originally from the recently settled Aramaic-speaking communities in and around the Assyrian heartland. The spearman on the right exemplifies the manner in which the Assyrians incorporated contingents from all parts of the empire into their forces. While his shield is similar to those held by Assyrian soldiers, his turban, fastened by a headband with long ear-flaps, and his short kilt curving upwards above his knees, identify him as coming either from Palestine or from somewhere else nearby. Almost identical uniform is worn by the men of Lachish, in the kingdom of Judah, as represented in panels showing Sennacherib's campaign there in 701 BC.            JER

About 700–695 BC
From Nineveh, South-West Palace/Temple of
   Ishtar
WA 124901
H 160 cm, W 111 cm, extant TH 9 cm
Barnett 1958: 164, pl. 32B

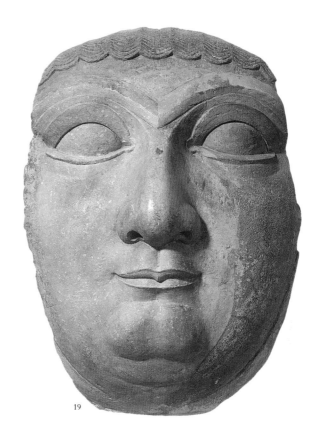

19

## 19 Face of a sphinx

This probably belonged to the head of a colossal sphinx put together from different materials such as wood and bronze. Sennacherib records that several of the colossal figures in his palace were made in this way, partly overlaid with gold leaf. The practice of making composite statues was long established in the ancient Middle East, but none of any size survives intact. The tradition was carried on to Greece, where some of the finest divine images were described as chryselephantine (ivory and gold). The figure to which this head belonged may have been the base of a giant column, of the type represented by no. 44.

Unlike the human-headed winged lions and bulls, the clean-shaven sphinx is not typically Assyrian, though like them it was regarded as having protective magical powers. It was adopted from the west, where it was at home in Syrian art, and constitutes another example of Assyrian willingness to accept foreign ideas.    JER

About 700–695 BC
From Nineveh, South-West Palace
WA 118909
H 60 cm, W 40 cm, D 23 cm
Layard 1853: 610. Strommenger 1970: 30, pl. 21

## REIGN OF
## ASHURBANIPAL

On the accession of Ashurbanipal (668–c. 631 BC), the South-West Palace of Sennacherib was still the grandest building at Nineveh, and it continued to be used as government offices. In the first half of his reign Ashurbanipal had new sculptures carved on existing wall-panels in this palace, but subsequently built a new palace as his personal royal residence. Further sculptures in the South-West Palace were carved later in his reign, and possibly also in the reigns of one of his sons.

While some of Ashurbanipal's sculptures were mass-produced to fairly stereotyped designs, generally arranged in two or three registers, the quality of the carving is superior to that done under Sennacherib, and they include exceptional pieces which rank among the greatest Assyrian achievements. The Battle of Til-Tuba (nos 20–22) is a composition in which every spare corner is crammed with detail; the traditional Assyrian dislike of empty space is utilised positively to express the chaos of war, with unstoppable movement from one panel to the next. In contrast, in the later sporting scenes, especially those shown on superbly finished panels which probably derive from the king's private apartments (nos 28–9), empty space is employed to create suspense, an air of dramatic anticipation. JER

## 20–22 The Battle of Til-Tuba

The Battle of Til-Tuba (or the River Ulai), showing the Assyrians defeating the Elamites of southern Iran, is arguably the finest large-scale composition in Assyrian art. Though the beginning of the battle is lost, the rout of the Elamite army on three adjoining panels forms essentially a complete unit on its own. This was one of a series of about ten compositions, recounting the story of an entire campaign, which lined the walls of a room in Sennacherib's palace but were actually carved for Ashurbanipal. The carvings are described in several clay tablets (see no. 40), which enable us to restore the entire decorative scheme in principle. Some of the incidents in the battle are also described in captions cut on the sculptures themselves, but the tablets give additional details which help to explain what is happening. The battle scene occupies the lower half of these three panels; the upper half, less well preserved, shows a review of prisoners deported after the campaign.

The Assyrians are attacking from the left, where the Elamites have been stationed on a mound. The two armies are clearly distinguished by their equipment.

The defeated Elamites are driven into the river. Detail of no. 22.

An Elamite tries to pull a wounded friend to safety. Detail of no. 20.

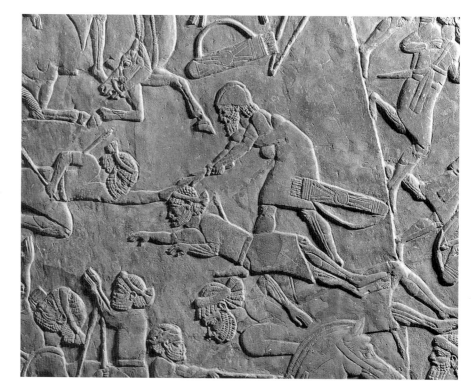

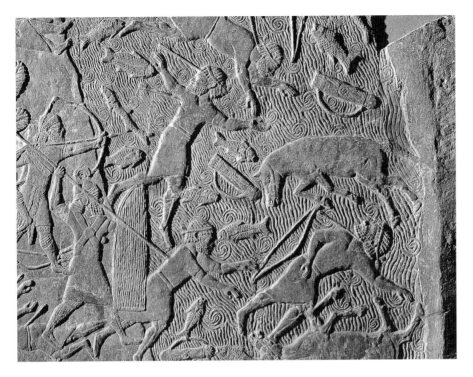

The Assyrian cavalry and some of the infantry have pointed helmets and wear scale-armour above the belt; most of them carry spears and shields, as do other infantrymen in crested helmets, and there are lightly armed archers with headbands. They tend to operate in pairs, with an archer protected by a spearman. The Elamites are nearly all lightly armed archers, with headbands tied at the back; their quivers are decorated with palmettes. Some of them are riding carts drawn by donkeys or mules. It is clear that, once the heavily armed Assyrians have forced their way through the Elamite lines, the Elamites cannot operate effectively at close quarters. They stumble back down the side of the mound, and their retreat turns into a rout, which ends as they are driven into the River Ulai. The growing chaos is graphically reflected in the overall arrangement, with the largely horizontal lines of figures losing coherence as they move right, and the river stopping them dead as it cuts across the scene from top to bottom.

Within the battle, critical incidents are picked out, forming an internal sequence of events like a strip-cartoon operating independently of the general progress of the battle. This sequence starts near the centre of the composition, with the crash of the chariot carrying the Elamite king, Teptihubaninsushnak, known to the Assyrians as Teumman, together with his son Tammaritu. Teumman is distinguished by his royal hat and fringed robe; Tammaritu is dressed like the other Elamites. The two are thrown out of the chariot, and Teumman's hat falls off, revealing his receding hairline. Leaving the wreckage with its struggling horses,

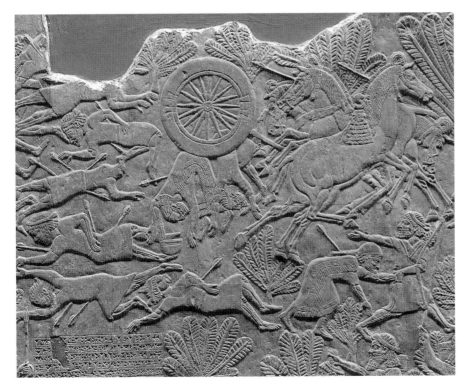

The Elamite king hurries away wounded, after his chariot has crashed. Detail of no. 21.

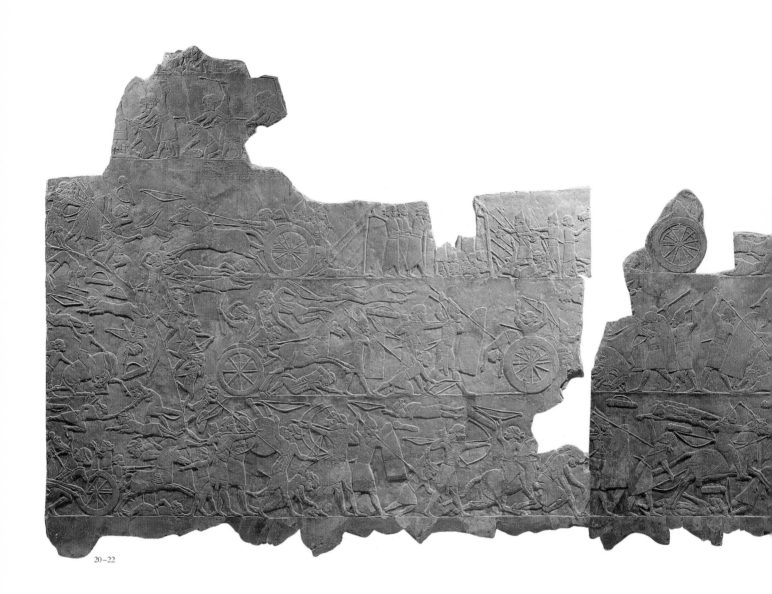

20–22

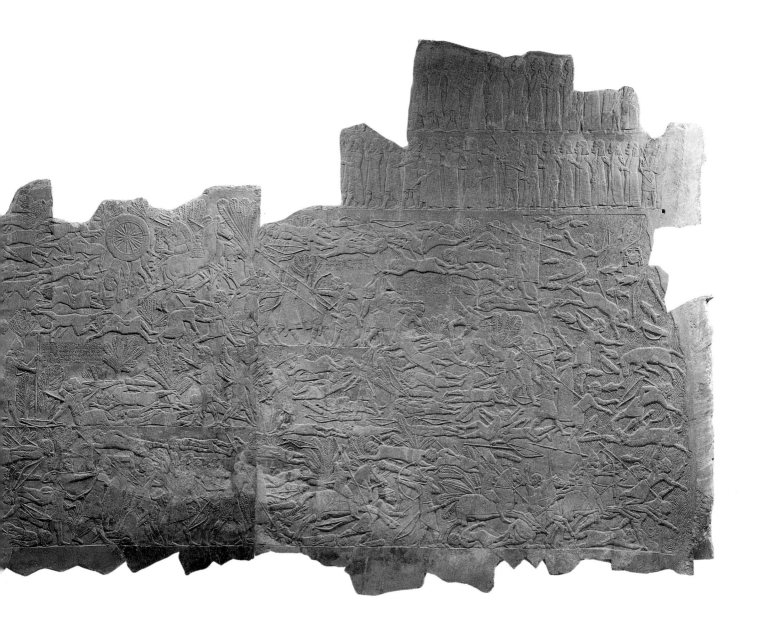

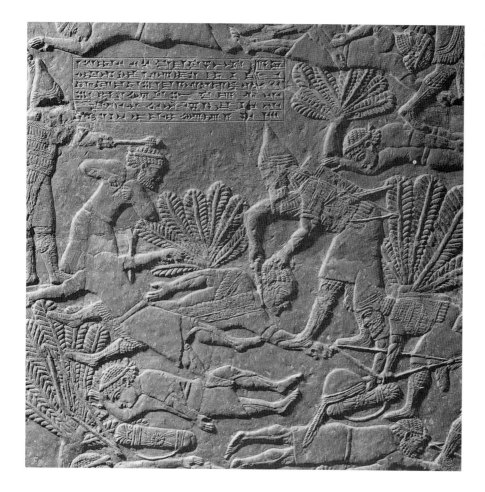

One Assyrian soldier cuts off the head of the Elamite king, while another picks up the royal hat. Detail of no. 22.

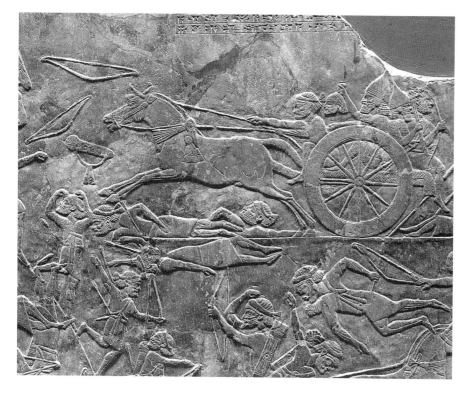

An Assyrian soldier, sitting in an Elamite chariot pulled by a donkey or mule, waves the head of the enemy king. Detail of no. 20.

the two hurry off right, but Teumman is hit by an arrow. His son shoots back, but the two are surrounded and killed. The Assyrians killing them do not use ordinary weapons of war but axes and maces; there is symbolism here, as maces represented authority and were employed for executions. Then the Elamites' heads are cut off. An Assyrian soldier recovers Teumman's hat from the ground, and another hurries back left, waving Teumman's head in the air. The head next appears further left, held by an Assyrian in front of a tent where Elamites, some of whom were on the Assyrian side, are being employed to identify the dead. Finally an Elamite cart drives off left, with an Assyrian soldier in it waving the head triumphantly. The head was taken to Assyria, where Ashurbanipal had sensibly remained, and was subjected to various indignities.

Two other specific incidents are shown, in the central row below Teumman's chariot. On the right an Elamite noble is cutting his bow in token of surrender, while an Assyrian threatens to kill him, and on the left a wounded Elamite calls to an Assyrian to cut off his head. Both incidents are described in the clay tablets, from which we also learn that the prisoners in the upper register, men, women and children, belong to the Gambulu tribe of Babylonia which had broken its oath to Assyria and supported the Elamites. In one detail at the left, men are forced to kneel in front of querns; they are members of the ruling family, and are being forced to grind up the bones of their ancestors. Two small fragments, mounted to the right of the tent, show similar scenes of punishment.

The date of Ashurbanipal's war with Teumman is uncertain, with suggestions ranging from 663 to 653 BC. It was the first of a series of wars which culminated in the destruction of the ancient Elamite capital city of Susa. When Nineveh was destroyed in 612 BC, there were men who still recognised the scenes depicted in this composition. The heads of the Assyrian soldiers cutting off those of Teumman and his son have both been defaced, presum-

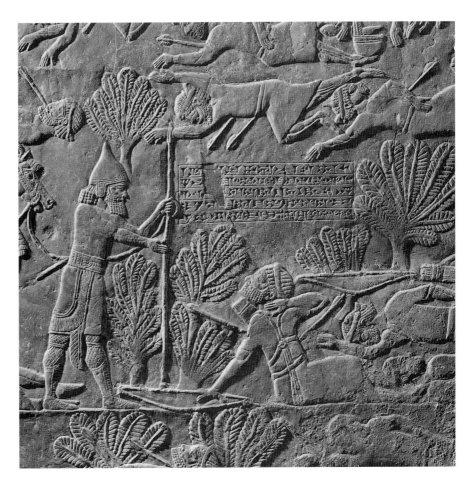

ably by Elamite soldiers or ex-prisoners rampaging through the palace.

The panels are carved in a fossiliferous limestone, not the standard gypsum. The stone was brought by Sennacherib down the Tigris from the Judi Dagh, near Cizre in modern Turkey, where he had observed it on campaign. Several Assyrian kings note with pride their imports of unusual materials such as this.    JER

About 660–650 BC
From Nineveh, South-West Palace, Room
    XXXIII, panels 1–3
20  WA 124801a
H 182 cm, W 199 cm, TH 15 cm
21  WA 124801b
H 173 cm, W 172 cm, TH 15.5 cm
22  WA 124801c
H 204 cm, W 175 cm, TH 17.3 cm
Layard 1853a: pls 45–6. Reade 1976: 99–100, pl.
    21, 2; 1979: 96–101, 107

A wounded Elamite invites an Assyrian to kill him. Detail of no. 21.

## 23 A city, perhaps Nineveh
(ABOVE)
## Soldiers of an Iranian army
(BELOW)

This panel probably shows part of two independent compositions, in upper and lower registers. The division between the scenes has been treated flexibly, however, and the river between them could be regarded as belonging to both.

Above is a city which is unmistakably Assyrian and may be Nineveh itself. It has massive triple walls with one small postern gate visible; the two outer walls may represent a two-tiered main city wall, while the inner wall surrounded a citadel. At the top, inside the citadel, there is a building decorated with colossal human-headed winged bulls and with columns supported by bases in the shape of lions. It corresponds tolerably well to Sennacherib's description of the South-West Palace at Nineveh, which he had built about fifty years previously (see no. 37), and may represent this very building. The lion column-bases would have been made of bronze (compare no. 39), supporting a portico in front of one of the main façades; columned porticoes of this nature were introduced to Assyria from the west. Sennacherib was particularly proud of the technological skill displayed in casting the bases. The winged bulls are on the façade of the building proper. They are striding, with four visible legs, whereas those made by Sennacherib were slightly different, with only three legs visible from the side. Winged bulls with four legs visible from the side were represented in Sargon's palace at Khorsabad, and since he too commissioned bronze lion-bases there is a possibility that it is really his palace shown on this panel. On the other hand, Khorsabad had been largely abandoned many years previously, and it is usually unwise, in interpreting Assyrian art, to place too much reliance on details which may simply reflect artistic licence.

The three rows below show soldiers from Iran, probably from Elam, on foot, on horses and in carts. They are charging to the right, and give the impression of people in good heart, perhaps setting out on campaign. Although the Elamites more usually appear as enemies of the Assyrians, as in nos 20–22, there were warring parties within Elam itself, and whichever of them was losing seems to have been inclined to look to Assyria for support. Elamite documents have been found at Nineveh, and the Assyrians welcomed political refugees who might be useful at a later date. Other Iranian soldiers served in the Assyrian army. This, then, is probably an expedition on which the Assyrians posed as liberators, and had a substantial Iranian force helping them.

About 645–640 BC                                JER
From Nineveh, North Palace, Room H,
    panel 7(?)
WA 124938
H 192 cm, W 118 cm, extant TH 10 cm
Barnett 1976: 49, pl. XL

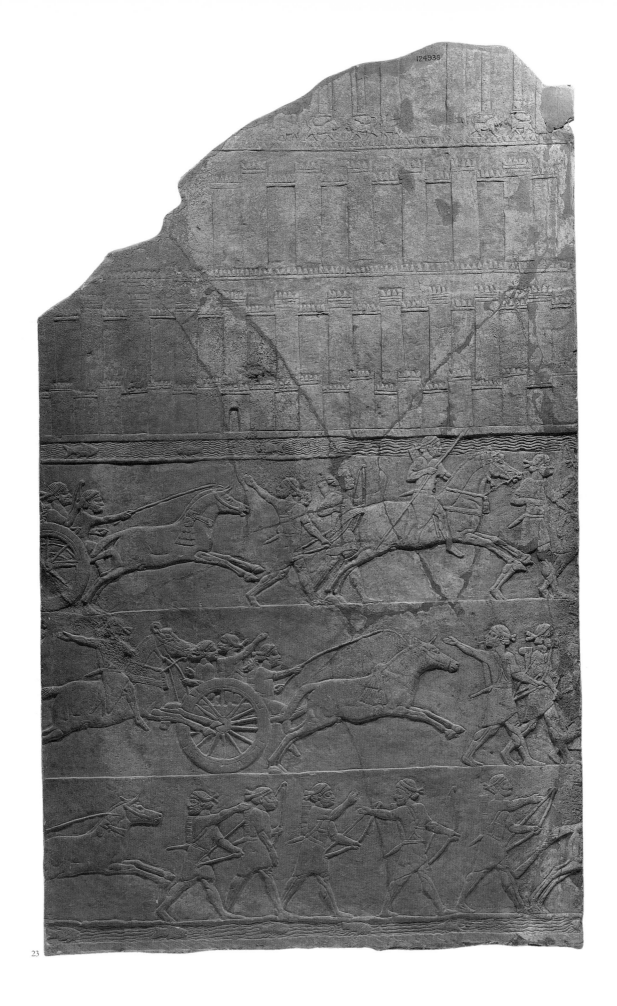

23

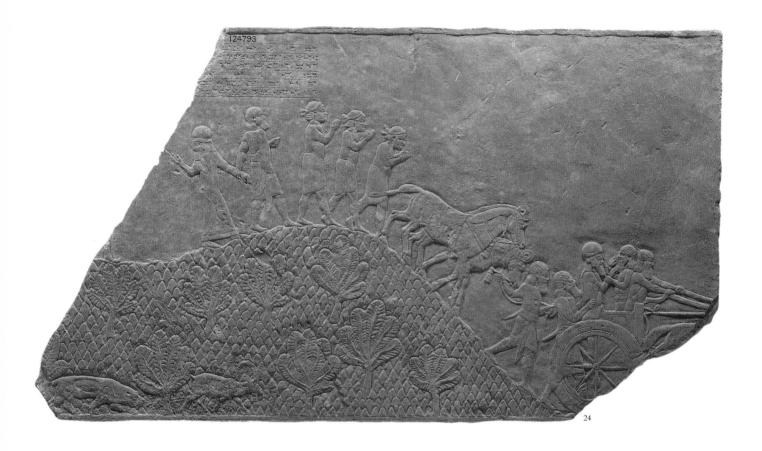

24

## 24 The capture of an Elamite king

Ummanaldash, king of Elam, lost his throne and took refuge in the mountains of Luristan, in a small state whose ruler then handed him over to the Assyrians. This fragment of a lost composition incorporates a sequence of events in which the protagonist appears more than once (see also nos 20–22 and 28–9). A caption explains what is happening.

On the left Ummanaldash, with his distinctive high royal hat and long robe, turns back with a reproachful wave towards a figure who is mostly lost but can be seen to be wearing shoes turned up at the toes. This must be one of the mountaineers who have refused him asylum. An Assyrian officer holds Ummanaldash by the wrist, and three other Elamites who have also been surrendered walk in front of the pair, their arms raised imploringly. Another Assyrian leads two horses, perhaps those ridden by the emissaries on their mission. On the right Ummanaldash is being forced into a chariot, and an Assyrian seems to be pulling his beard roughly. The charioteer waits to drive off to Assyria.

The mountainous terrain is represented conventionally by a scale pattern, with stylised trees. Below, to the left, a lioness creeps up on a wild goat. There may be symbolism here, a parallel with the Assyrians ineluctably stalking their prey. There is a contrast between the relative formality of the capture of Ummanaldash and the drama of the hunt in the wild: the Assyrian sculptors often seem to have been better at representing animals than people. The Assyrian pushing Ummanaldash into the chariot has been partly recut. He was originally carved standing in front of the chariot wheel. This would have been wrong in reality, because he must have stood behind the wheel in order to propel his prisoner through the door at the back of the cab. The anomaly would not have disturbed an Assyrian sculptor of the ninth or eighth century, but on this occasion someone decided to rectify it and to recut the wheel so as to obscure the lower half of the man's body.     JER

About 645–640 BC
From Nineveh, North Palace
WA 124793
H 73 cm, W 129 cm, extant TH 4.7 cm
Barnett 1976: 49, pl. XL. Reade 1976: 104, pl. 28, 1

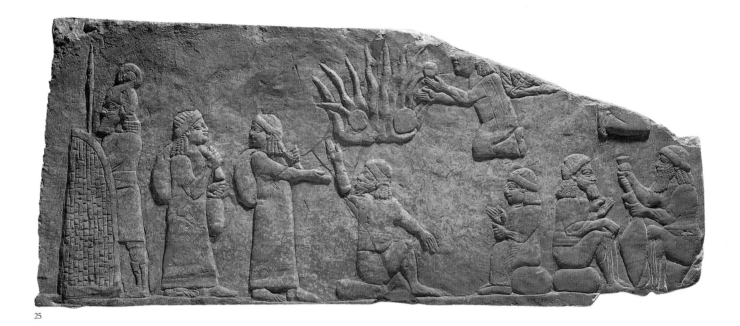

25

## 25 Prisoners in camp

This represents a group of Babylonians, perhaps members of a Chaldean tribe from the marshes of southern Iraq. They are encamped, and at the top a kneeling woman reaches towards a log fire. Behind her are traces of a seated animal, perhaps a sheep, and of another kneeling woman. Below, to the right, a seated man holds a skin of water or some other liquid, and he is drinking with a friend. Two central figures are seated on bundles, gesticulating, and one of them turns to address two women, who are standing with more bundles over their shoulders.

On the left an Assyrian soldier in crested helmet stands on guard, and the scene will have been part of a long composition showing conquest and deportation. Probably the king was represented nearby, reviewing the fruits of victory. It was common Assyrian practice to deport defeated populations for resettlement in areas where they could not cause trouble. The bundles carried by these people are all the possessions they have.　　JER

About 645–640 BC
From Nineveh, North Palace
WA 124788
H 29 cm, W 69 cm, extant TH 2.5 cm
Barnett 1976: 49, pl. XL

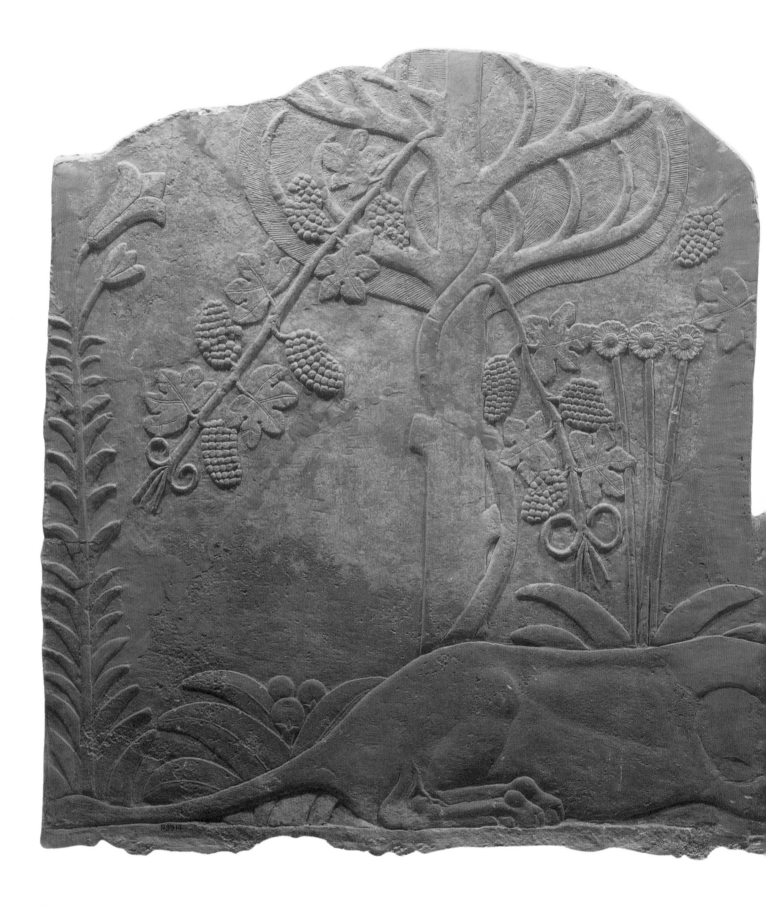

## 26 Lions in a garden

A lion and lioness relax peaceably in a garden, beside a tree, perhaps a cypress; the trunk of a palm-tree is visible too, and a vine with bunches of grapes is draped over both of them. There are flowers which may be lilies to left and right, and a plant with flowers like daisies grows behind the lioness; there is also a plant beside her tail.

This is perhaps the most attractive of all Assyrian sculptures, suggesting a love of nature belied by the lion-killing scenes which were displayed nearby. Apparently the Assyrian kings did sometimes keep lions as pets, and one painting shows a lion by the royal throne, but the progeny of this contented pair may well have been destined for the arena.                           JER

About 645–640 BC
From Nineveh, North Palace, Room E, panels
    7–8
WA 118914
H 98 cm, W 178 cm, extant TH 10 cm
Barnett 1976: 39, pl. XV

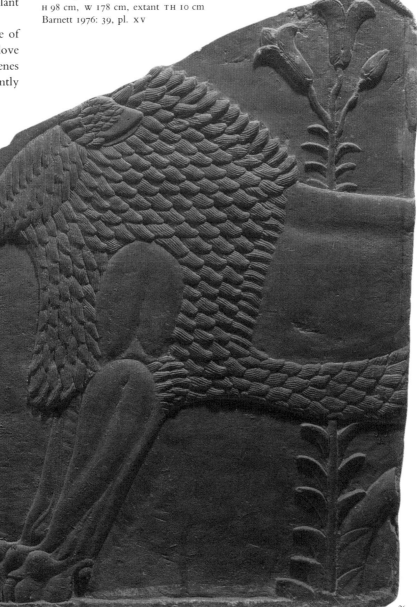

26

## 27  Going to the hunt

This wall-panel comes from a series along a corridor which led to a postern gate out of the palace; possibly the king passed this way as he went out to hunt, and the panels showed him and his attendants, with their animals and equipment.

The dogs are ferocious mastiffs, not so different from a kind of shepherd's dog one sometimes sees today in rural Turkey. The man or eunuch holding the lead is beardless, but his hair ends in a row of plaits, in a simpler style than that of his companion; men leading donkeys in this procession have similar plaits, which may have been worn by people of lower status at the Assyrian court. The Assyrian eunuch in front is carrying a net and stakes, and there is another bundle of stakes over the shoulder of the figure in front.

Another Assyrian sculpture (*below*) shows how this equipment was used in hunting deer. Apparently, once the herd had been located, it would be hunted with dogs, but a net would have been laid across the path which the herd was likely to take. Once the animals were entangled, huntsmen would emerge from their hiding places to take charge. This was the Assyrian version of a technique reaching far back into prehistory, when animals were trapped in so-called 'desert kites', stone walls of great length which gradually directed fleeing animals into small enclosures where they were killed.    JER

About 645–640 BC
From Nineveh, North Palace, Room R, panel 7
WA 124893
H 157 cm, W 118 cm, extant TH 10 cm
Barnett 1976: 49, pl. XL

Relief from the palace of Ashurbanipal at Nineveh showing huntsmen trapping deer in nets (WA 124871).

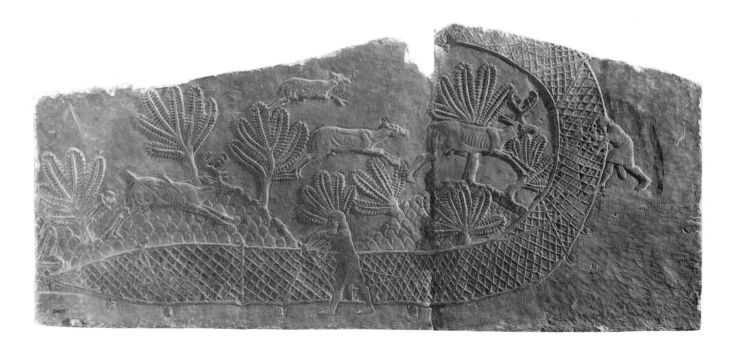

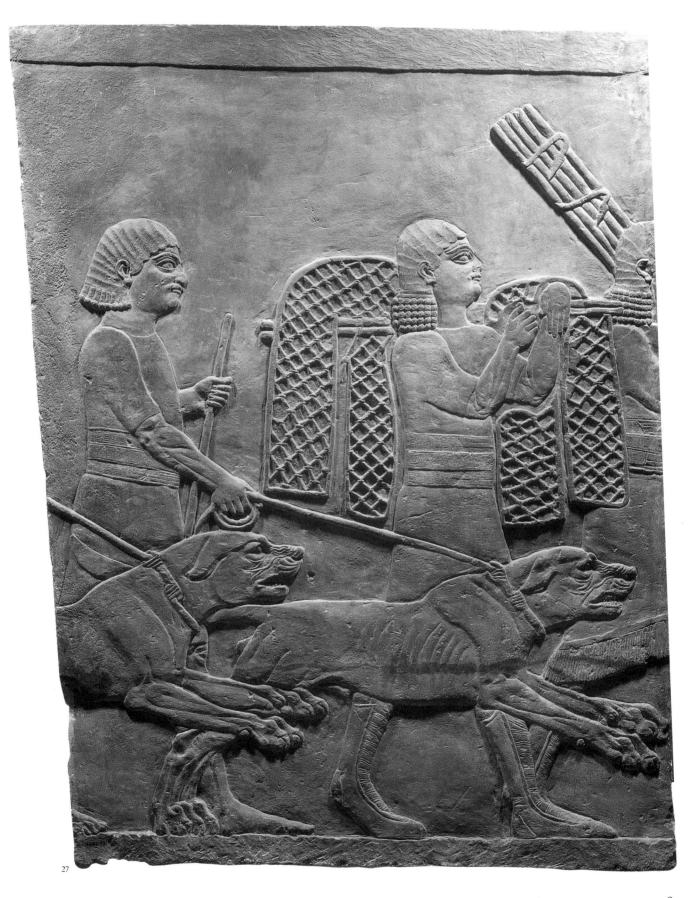

27

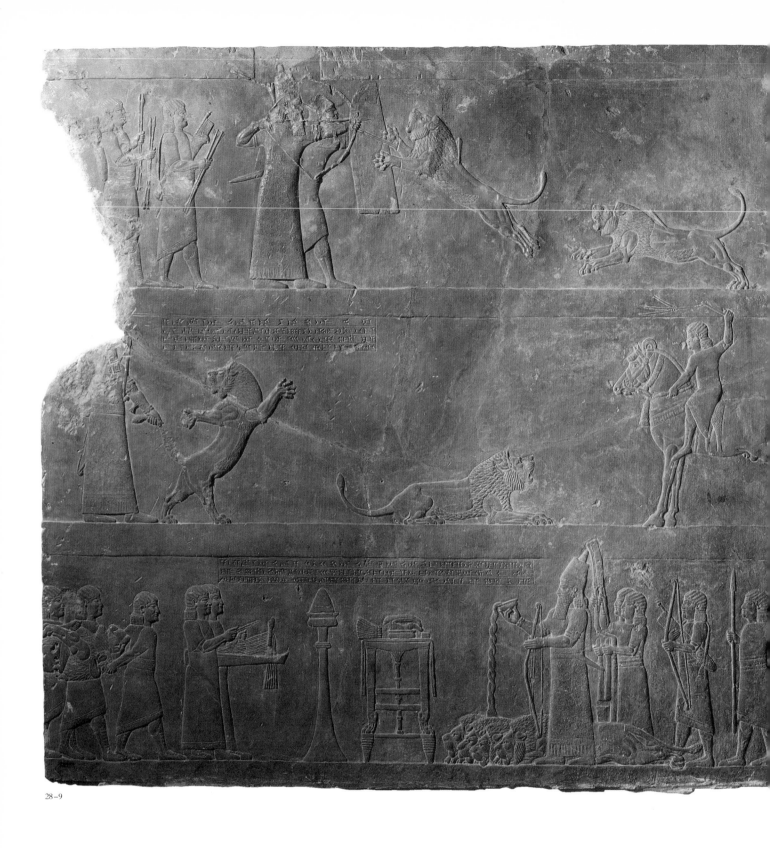

28–9

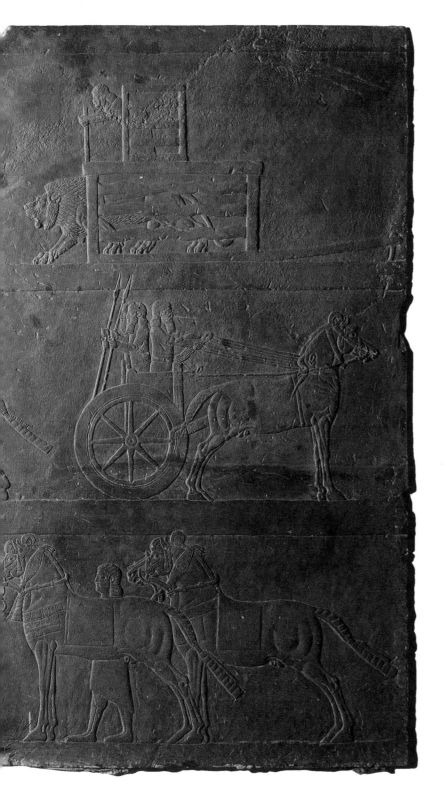

eunuch, who is himself protected from the lion by a smaller cage. The lion advances left, and is hit by arrows shot by the king. They fail to kill it, and it leaps at the king who continues shooting, guarded by a shield-bearer; eunuchs with spare arrows stand behind him. The final act, on another panel to the left which is now in the Louvre, Paris, showed the lion confronted face to face, in the attitude of the Assyrian royal seal (see no. 191), with the king, who stabs it with his sword.

The central register is again read from right to left. On the right an Assyrian horseman, guarded by spearmen in a chariot, distracts a somewhat uninterested lion. The king comes up from the left and grabs the lion by the tail; the king's right hand, not visible here, held a mace ready to strike the lion over the head, as described in the accompanying caption. It is notable that much of the lion's tail has been chipped away, so that the lion has been, as it were, set loose; this defacement was probably the action, at once humorous and symbolic, of some enemy soldier busy ransacking the palace in 612 BC.

In the lower register dead lions are brought from the left. A musician with a plectrum plays a triumphant tune on a seven-stringed horizontal harp; there is another man beside him, perhaps a singer, unless we are to envisage a second harp. The tall stand is for burning incense. An elaborate table or altar, laid with a cloth, holds a bowl containing a leg of meat and a jaw, what may be a bunch of onions, and a smaller container. The king himself is pouring a libation, which the caption tells us is wine, over the bodies of four lions. Behind him stand attendants with fans and towels, his bodyguards, and grooms with the royal horses.      JER

About 645–640 BC
From Nineveh, North Palace, fallen into Room S
28  WA 124886
H 160 cm, W 169 cm, extant TH 17 cm
29  WA 124887
H 159 cm, W 95 cm, extant TH 13 cm
Barnett 1976: 54, pl. LVII

## 28–9   The killing of lions

Ashurbanipal records that in his time there was ample rain in Assyria and lions abounded. He took much pleasure in the traditional royal sport of killing them, which was frequently done after they had been captured or possibly reared in captivity. This is the subject here, on panels which probably decorated one of the king's own private apartments. The king is shown wearing full regalia, though a comparable series elsewhere shows him in more practical dress.

The top register consists of a sequence of events. On the right a lion is being released from its cage by a small boy or

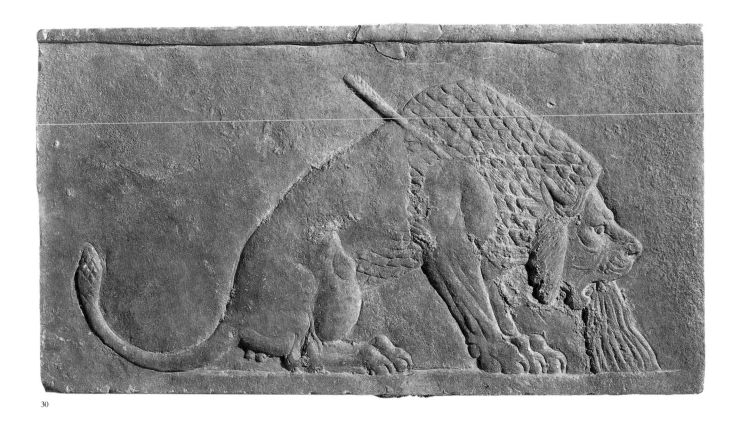

30

## 30   The dying lion

This lion, hit by an arrow and dying, derives from a scene in which Ashurbanipal was shown hunting from his chariot. It has long been acclaimed as a masterpiece. Curtis (1992: 113) has described it as follows:

The lion itself is squatting on its haunches, facing right. It has been mortally wounded by an arrow that has penetrated deep into its chest from above the shoulder. Blood is gushing out of the mouth of the beast, and it is straining every muscle and sinew in a last futile attempt to stay upright. The veins on its head are standing out, its eyes are beginning to glaze over, and it is desperately gripping the ground with its claws. Although the suffering of the animal is horrible to behold, the sculptor has perfectly captured the animal in its death-throes, and we see here a naturalism that is rarely encountered in Assyrian art.

It has been suggested that scenes such as this imply that the artists had some degree of sympathy with the victims of the Assyrian king, rather than with their patron as a mighty hunter. Lions were regarded, however, as symbolising everything hostile to urban civilisation, and it is more probable that people looking at scenes like this were meant to laugh, not cry.                                    JER

About 645–640 BC
From Nineveh, North Palace. Presented by Miss L.M. Boutcher
WA 1992-4-4,1
H 16.5 cm, W 30.6 cm, extant TH 2.5 cm
Curtis 1992

## 31   Protective spirits

At the top of this panel are three examples of the *ugallu*, 'Great Lion', with one broken figure who may be the House God. Underneath is an *urmahlilu*, 'Lion-Man'. They are all good spirits, whose presence was intended to protect the palace from evil and bad luck, just as Ashurnasirpal's palace had been protected over two centuries previously (see nos 8–9), though the identity of the spirits has changed. The Great Lions wear a simple Assyrian kilt, and make threatening gestures with daggers; their maces symbolise authority. They have eagles' claws for feet, and high, alert ears. The House God is better preserved on no. 32. The Lion-Man makes a more pacific gesture, but its import is the same. The horns on his helmet show that he is a god; horns were a divine symbol from the remotest past in Mesopotamia, when wild bulls were among the most powerful of natural forces encountered by men.            JER

About 645–640 BC
From Nineveh, North Palace, Room T, door b, panel 2
WA 118912
H 146 cm, W 111 cm, extant TH 11 cm
Barnett 1976: 53, pl. LV

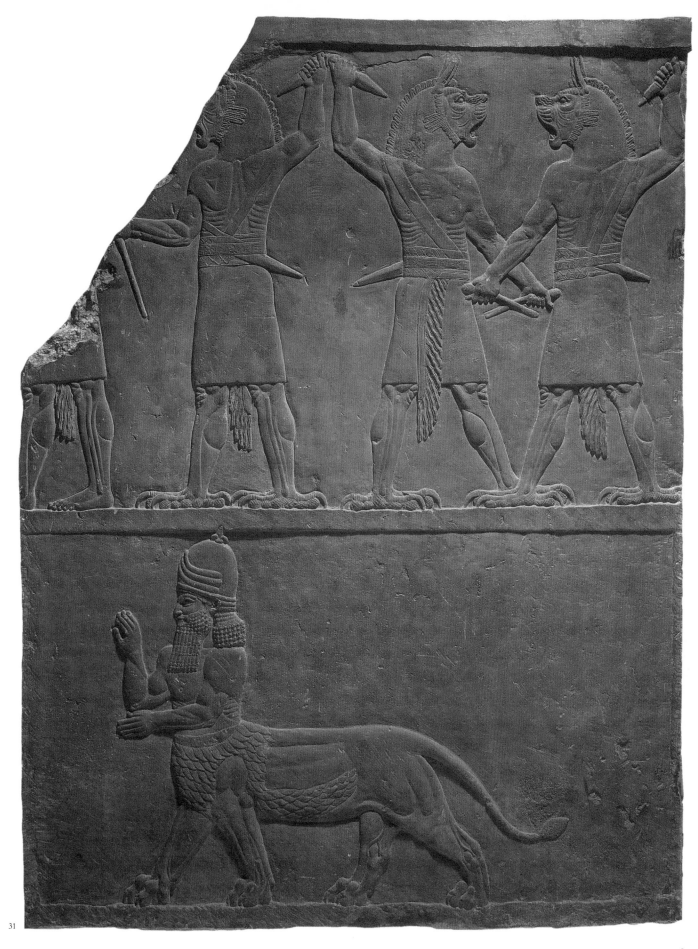

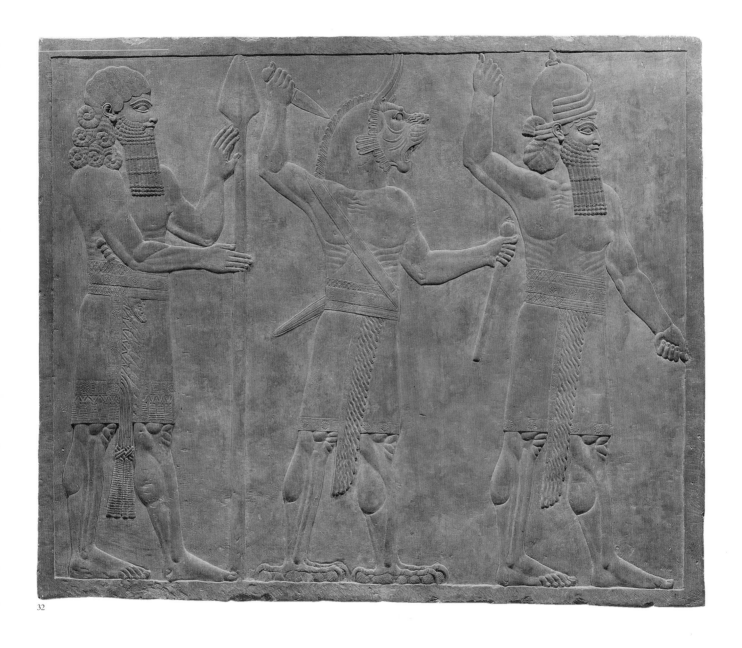

32

## 32  Set of protective spirits

These spirits are, from left to right, a *lahmu* (see also nos 65–6), an *ugallu* or 'Great Lion', and probably the House God. The hair of the *lahmu* is arranged in elaborate ringlets; this was an ancient style, seen on semi-divine figures struggling with animals on cylinder seals over 2,000 years previously. The tassels hanging from his kilt also indicate divine status. He balances a spear on the ground, and the sheath of his dagger is carved with an animal's head. The Great Lion is similar to the ones on no. 31, but the details of his kilt are finer, and red paint is visible on his head. The House God on the right, if correctly identified, has the horned helmet of divinity and another hair-style inherited from remote antiquity. All the features of figures like these conformed with precise rules, and these three were a set. The supernatural protection of the palace was probably designed with great care by the king's most experienced magicians.

The upper halves of the two right-hand figures are shown as viewed from the front, while their heads are in profile. This was a standard Assyrian convention for representations of the human body. JER

About 645–640 BC
From Nineveh, North Palace, Room B, door a
WA 118918
H 157 cm, W 189 cm, extant TH 9.5 cm
Barnett 1976: 36, pl. IV. Green 1983: 90–92, pl. XId

## 33  Three protective spirits

These three figures are all that survive of the decoration on the façade of Ashurbanipal's throne-room. Each carries a small axe in his raised right hand and a wide-bladed dagger in the left, but traces indicate that originally there was a bow in the left hand. The bows have been erased,

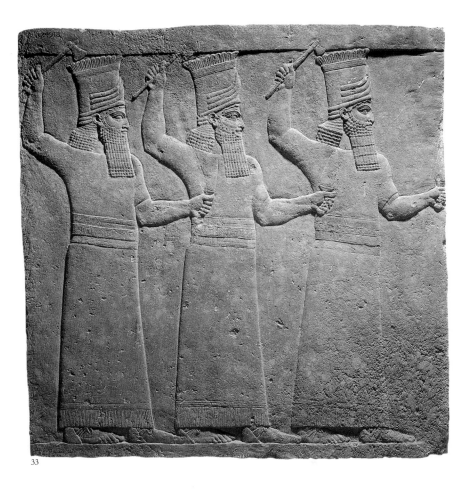

33

leaving slight depressions in the stone; this alteration is clearly original Assyrian work, and must reflect either a mistake or a change of mind about the appropriate magical requirements. The high, flat, horned crowns, possibly feathered at the top, are a grander version of the horned helmet worn by many other protective spirits. It has been suggested that these are three of the Sibitti, seven gods corresponding to the modern constellation of the Pleiades. JER

About 645–640 BC
From Nineveh, North Palace, Court O, panel 4
WA 124918
H 87 cm, W 90 cm, extant TH 7 cm
Barnett 1976: 48, pl. XXXVIII

# 2 PALACES AND TEMPLES

The basic building material in Assyria was mud-brick, which was used to construct everything from the humblest village hut to the grandest palace. Usually the mud-bricks were sun-dried, but occasionally they were stamped with a royal inscription (no. 59) or with a design (nos 60–62) and fired. These baked bricks are generally found in pavements. To the shell of sun-dried mud-bricks were added, particularly in important administrative and religious buildings, fixtures and fittings in various materials.

In palaces, important entrances were guarded by colossal stone figures, generally human-headed winged bulls or lions. Sometimes palace façades were very elaborate, and an illustration on a relief (no. 23) shows, in addition to the human-headed winged bulls, lions supporting columns on their backs. Assyrian texts (nos 37, 39) indicate that such column-bases were sometimes made of bronze. It was a considerable technological achievement to make bronze castings on this scale, and Assyrian kings boasted about it. The small stone figure of a winged sphinx supporting a column-base (no. 44) may be from a model of a palace of this kind. Models are sometimes shown on the Assyrian reliefs, where they had a symbolic significance, and a large pottery bin (no. 57) has sides in the form of a fortified city wall. Whereas the column-bases would have been of bronze or stone, the columns themselves were made of wood. Sometimes, however, they were overlaid with metal, usually bronze but sometimes gold as well. Evidence for this comes from several of the temples at Khorsabad. In one case, at the entrance to the Shamash Temple, the columns were not covered with sheets of metal but were decorated with bronze bands with embossed scenes.

The columns at Khorsabad were set on pedestals which were sometimes decorated with panels of polychrome glazed bricks: one of these, in the Nabu Temple, has motifs including a plough, a lion, a bull and a bird. Glazed bricks are a distinctive feature of major Assyrian buildings and have been found at a number of sites. At Nimrud, for example, glazed brick panels were set up above courtyard entrances. A particularly elaborate panel, reconstructed by Julian Reade, shows Shalmaneser III beneath a winged disc, framed by a border of kneeling goats and floral motifs (Reade 1963).

The main rooms of Assyrian palaces were, as we have seen, often lined with carved stone slabs, and sometimes stone slabs decorated with geometric and floral designs were also placed on the floor, in doorways (e.g. no. 45). Above the stone slabs lining the walls the plaster was often brightly painted with a variety of designs (see no. 243). Occasionally

David Oates, director of the 1962 excavation, inspecting mud-brick architecture in Fort Shalmaneser at Nimrud.

set into the walls at a high level were plaques, either circular in outline or square with slightly concave sides (the two types sometimes alternated). The plaques were fixed in position with pegs. Generally they are of glazed terracotta with painted designs (nos 50–52), but examples are also known in bronze. Often, instead of actual plaques, reproductions were included in the painted plaster decoration. In the palace of Ashurnasirpal II at Ashur imprints of plaques were found on the walls, showing they had been fixed high up at regular intervals around the room (Preusser 1955: pls 15–16).

The rooms were roofed with wooden beams covered with matting and a thick layer of mud. The beams were probably painted and sometimes may even have been covered in precious metal. Under the ends of the beams were sometimes placed model fists mounted on shanks, known as 'hands of Ishtar'. From the floor it would have appeared as if these hands were supporting the beams. At Ashur, where they were found in position in a collapsed wall in the palace of Ashurnasirpal II (Preusser 1955: pl. 14b), they were arranged in a row with the flat sides uppermost and the whole shaft buried in the wall, so that only the fist protruded. These 'hands of Ishtar' are generally in terracotta (nos 53–5), sometimes glazed and sometimes inscribed with the names and titles of a king. There survive a few examples of bronze coverings from 'hands of Ishtar' which may have been of wood.

In Assyrian palaces and temples wooden doors were sometimes decorated with horizontal strips of bronze with embossed and chased decoration reproducing in miniature form the type of scenes familiar from the large stone reliefs. The best known of these bronze doors come from Balawat, where three complete sets have been found, two dating from the reign of Ashurnasirpal II and one from that of Shalmaneser III (nos 42–3). Fragments of similar bronze bands are known from Nimrud, Khorsabad and Ashur. Examples have also been found at Tell Hadad in the Hamrin basin north-east of Baghdad, in a temple paved with bricks of Ashurbanipal (Curtis 1988: 87–8). There are sporadic references to metal gates in the Assyrian royal inscriptions from the reign of Adad-nirari I (1305–1274 BC) onwards (Grayson 1991: 321–2). Usually they are bronze or copper, but sometimes gold and silver, such as the gates of the Temple of Esagila at Babylon, restored by Esarhaddon.

So much for fixtures and fittings that were clearly visible. Hidden from view were foundation records in stone (nos 34–6) and clay (nos 37–8). Such inscriptions could also be on metal, as at Khorsabad where Place found buried in a wall a stone box containing five tablets in various metals including gold and silver (Place 1867–70: III, pl. 77).

Glazed brick panel of Shalmaneser III from Nimrud, now in the Iraq Museum, Baghdad.

## FOUNDATION RECORDS

The Assyrian kings wrote their names prominently over the palaces and temples they constructed, and the long inscriptions on the Assyrian sculptures are a prime source of historical information. The kings were well aware, however, that mud-brick buildings cannot stand forever, and they were determined to ensure that the memory of their achievements should not perish. Following an ancient Mesopotamian tradition, they therefore buried permanent records of what they had done in the foundations, and with time these became increasingly detailed. They give the kings' titles, recount their activities in war, and usually end with descriptions of the buildings for which they were designed. They were effectively a second line of defence against oblivion, and occasionally express the specific hope that future rulers coming across them should treat them with respect.  JER

## 34  Foundation record of Shalmaneser I

This stone stela describes how Shalmaneser I (1273–1244 BC) rebuilt one of the gateways at Ashur: 'I cleared away its debris, reconstructed the weakened portions, and rebuilt the ruined section from top to bottom. I deposited my stelas. May a later prince restore the dilapidated gate and return my inscribed name to its place.' The inscription gives the month in which it was written, and the name of the official after whom the year was named, but exactly which year this was is not known.

1273–1244 BC                    JER
From Ashur
WA 115691
H 26 cm, W 22 cm, D 8 cm
Grayson 1972: 94–5

## 35 Foundation record of Tukulti-Ninurta I

This stone stela describes how Tukulti-Ninurta I (1243–1207 BC) rebuilt the Temple of the goddess Dinitu from its foundations: 'I built within a lofty dais and an awesome sanctuary for the abode of the goddess Dinitu, my mistress, and deposited my stelas.' The inscription is unusual in including at the end the name of Ubrum, the scribe responsible for writing it.                                    JER

1243–1225 BC
From Ashur
WA 114263
H 41 cm, W 32 cm, D 8 cm
Grayson 1972: 114–15

## 36 Foundation record of Ashurnasirpal II

This stone stela records the king's work on the Temple of Ishtar Kidmuri, which is known to have existed at Nimrud before Ashurnasirpal (883–859 BC) refounded the town as his capital city. He erected a golden statue of the goddess in her shrine. The text ends with an invocation to some future restorer of the building. If he is respectful and simply adds his own name beside that of Ashurnasirpal, then the gods will give him success in war and general prosperity. If he erases Ashurnasirpal's name or mistreats the inscription in any other way, then there are curses: he is to lose the throne and be captured by the enemy; there is to be famine in the land; his name and posterity are to perish.

About 875–865 BC                                    JER
From Nimrud, Temple of Ishtar
  Kidmuri
WA 92986
H 37 cm, W 29 cm, D 5 cm
Grayson 1976: 178

36

37

## 37 Foundation record of Sennacherib

Terracotta foundation records were introduced by Tiglath-pileser III (744–727 BC); they could accommodate more information than stone records, and could be produced quickly in far greater numbers.

This hollow barrel cylinder, manufactured like a pot, was written for burial at Nineveh in the foundations of the palace of Sennacherib (704–681 BC); a note at the end specifies that it is ninety-four lines long. It includes the earliest known description of the building: construction continued for several years, and later inscriptions recount further developments. This one mentions bronze lion-bases supporting cedar columns (see no. 23), and describes how prisoners were forced to drag stone slabs to the palace for erection around the walls. These slabs must be the wall-panels on which Sennacherib's achievements were commemorated in sculpture.                                    JER

About 703 BC
From Nineveh
WA 113203
L 23.5 cm, DIAM 13.5 cm
S. Smith 1921

38

### 39 Letter about doors and column-bases

Contemporary records show that the construction of Assyrian royal buildings was by no means a simple matter. Men, materials and other resources had to be found and organised, and there were practical difficulties and shortages as well as achievements. The kings took a close interest in the progress of the work. Here the writer, in response to an enquiry from the king, gives a date for the casting of bronze column-bases in the shape of lions for part of the royal palace of Sargon at Khorsabad. He also reports on the progress of manufacture of the temple doors, which are to be covered with silver and bronze sheet. JER

About 715–705 BC
Probably from Nineveh
WA K943
H 7.7 cm, W 4.2 cm, TH 2.2 cm
Parpola 1987: 63–4

39

### 38 Foundation record of Esarhaddon

This solid terracotta decagonal prism is one of a group of texts in which Esarhaddon (680–669 BC) records how, in the first year of his reign, he began the reconstruction of Babylon. They refer obliquely to Sennacherib's destruction of the rebellious city a few years previously, and describe how Esarhaddon rebuilt the great shrines and brought back the dispersed population, providing clothes, land and guarantees of freedom. In return for this demonstration of his excellence as a king, Esarhaddon prays for long life and prosperity. JER

674–672 BC
From Babylon
WA 78221–2
H 19 cm, max. W 10.5 cm
Borger 1956: 10–29. Porter 1993: 41–66

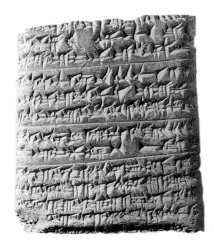

40

## 40 Captions for sculptures

This text gives a list of captions for the series of carved wall-panels of which nos 20–22 form part. It is one of several such lists, and a few of the captions on the texts correspond closely to those on surviving panels. The theme may have been represented several times over in different rooms. It is unclear whether the tablets were written in the course of designing the series or as a record of captions already on the walls.      JER

About 645 BC
From Nineveh
WA Sm1350
H 6 cm, W 5 cm, TH 2 cm
Weidner 1932–3: 188–9

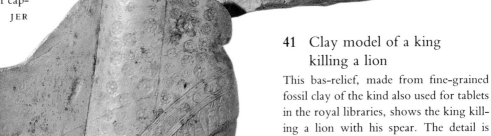

41

## 41 Clay model of a king killing a lion

This bas-relief, made from fine-grained fossil clay of the kind also used for tablets in the royal libraries, shows the king killing a lion with his spear. The detail is exceptionally fine. It has been suggested that this was one of the models used by the men responsible for cutting the larger stone sculptures of similar subjects on the walls of the palace of Ashurbanipal (668–c.631 BC). One letter refers to a scribe making a model of a royal statue.      JER

About 660–640 BC
From Nineveh
WA 93011
Mounted: H 34 cm, W 26 cm
Barnett 1976: 35, pl. 1

## THE BALAWAT GATES

These doors were erected by Shalmaneser III (858–824 BC) in his palace at Balawat. They are the finest surviving examples of a kind of door that was made for many Assyrian official buildings. The original gates were of wood, partly covered and reinforced by embossed and chased strips of bronze, and it is the bronze which has survived; the strips were nailed to the faces of the doors and around the door-posts. There were sixteen in all, eight on each side, and there is a great variety in the details of the subject-matter and in the workmanship. It is clear that several different workmen were involved in the process of manufacture, possibly even one for each individual strip.     JER

### 42   Bronze door decoration

In the upper register the Assyrian camp appears at the far right. Inside it is the royal kiosk and people who are probably preparing food. The army advances left, waving weapons but unopposed, across a mountain range represented by a scale pattern. After a plain there is another range to be crossed, and grooms haul on the chariot-horses to help them forward. The Assyrians have now arrived at Lake Urmia, and are leading cattle and sheep to a sacrifice. There are two harpists, and three priests in high hats. The king himself, Shalmaneser III, stands in front of a jar on a folding stand. A tall incense-burner and an altar table have been set up in front of the sacred standards, which themselves stand in front of a rock-cut stela of the Assyrian king, made to commemorate his expedition. On the left two Assyrian soldiers are throwing joints of meat to a strange dog-like creature in the lake; a fish can be seen too.

The lower register shows an incident from the same campaign, which took place in the king's year of accession, 859 BC. The Assyrians advance from a circular camp on the left, and attack the town of Sugunia. The king himself has dismounted from his chariot and is shooting arrows, protected by a shield-bearer. The enemy are shooting back, but their town

is already on fire and bodies are draped over the battlements. To the right the prisoners are led away, naked and bound. They are met by another group of Assyrians with chariots.     JER

About 848 BC
From Balawat
WA 124662
H 27 cm, W 180 cm
King 1915: 21–2, pls I–VI

### 43   Bronze door decoration

The upper register shows Shalmaneser III, in the first full year of his reign, receiving tribute from the cities of Tyre and Sidon, great Phoenician trading ports in what is now southern Lebanon, on the Mediterranean coast. The Phoenicians in their pointed caps enter from the left, ferrying goods across from their island fortress to the mainland, in boats with animal-headed prows. The man and woman staying on the island are probably the Phoenician king and queen. The goods consist of bales, cauldrons and trays of jewellery. They are received by an Assyrian eunuch, who waves back to introduce them into the presence of the Assyrian king. He has entered from the right, and raises arrows in his hand in token of conquest; his robe rides up over his scabbard. Shalmaneser is accompanied by courtiers and attendants, and his royal chariot and mount wait behind him. They are followed by other chariots, including two with the sacred standards which accompanied Assyrian kings on campaign. The fortified rectangular Assyrian camp appears at the far right, with a royal tent or kiosk in one corner. The lower right-hand corner has been cut away during the attachment of the bronze band to the door-post.

In the lower register the Assyrians are attacking from the right. They slaughter the enemy, and scale the walls of the town of Hazazu, in Syria, which is then set on fire. The prisoners – women, children, and naked bound men – are escorted left into the presence of the Assyrian king,

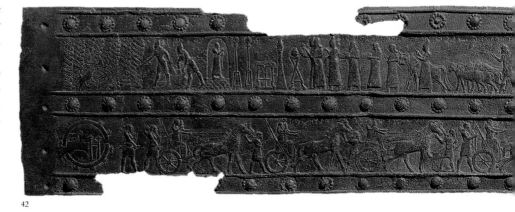

42

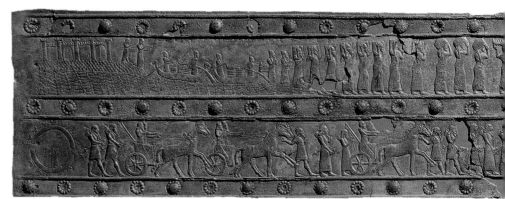

43

who has his usual entourage of courtiers, attendants and sacred chariots. At the far left is a circular Assyrian camp.   JER

About 848 BC
From Balawat
WA 124661
H 27 cm, W 180 cm
King 1915: 23, pls XIII–XVIII

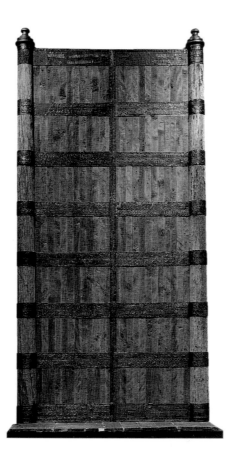

Modern restoration of the Balawat Gates, as exhibited in the British Museum.

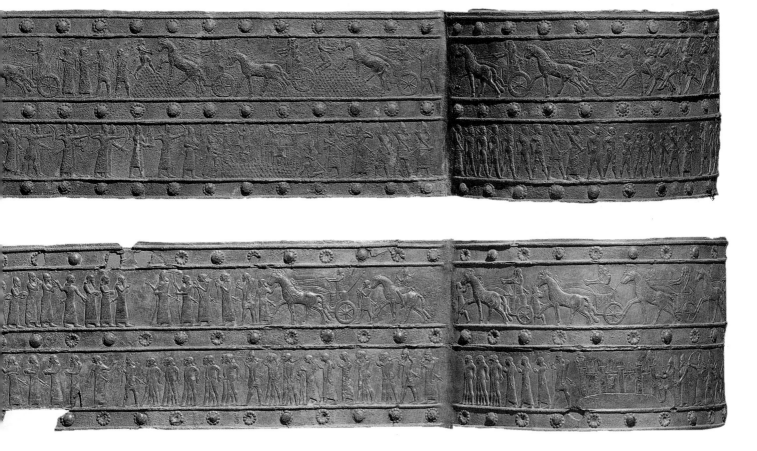

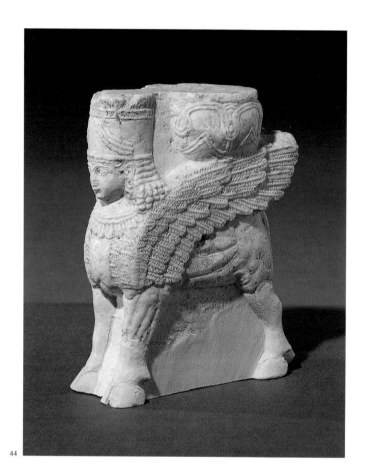

44

## 44  Model column-base

This stone model represents a kind of column-base used in Assyrian palaces of the seventh century. The type was borrowed from the west. It represents a beardless sphinx in a high, flat, horned hat, supporting a column-base with scale decoration. Its excavator, the renowned Assyriologist George Smith, supposed that it represented a human-headed cow, and the nineteenth-century restoration of legs and tail has been retained.　　　JER

7th century BC
From Nineveh
WA 90954
H 9.1 cm, L 8.3 cm, W 3.8 cm
G. Smith 1875: 431

## 45  Stone carpet

This is part of one of the door-sills of the throne-room of Ashurbanipal (668–c. 631 BC). We have to envisage the floors of the Assyrian palaces as covered in brightly coloured textiles. The doorways, instead, sometimes had hard-wearing imitation carpets such as this (Albenda 1978). The overall pattern of the principal rectangle is a field of interlocking circles, drawn with a compass, giving the effect of flowers with six petals. There is a row of rosettes around the edge, while an arcaded lotus and bud pattern forms an outer fringe. The lotus and bud motif originated in Egypt, spread to Phoenicia and became popular in Assyria towards the end of the eighth century. Phoenician textiles were imported to Assyria, and the design of this stone carpet may have been based on them.　　　JER

About 645–640 BC
From Kuyunjik, North Palace, Room I,
　door b or d
WA 118913
L 127 cm, W 124 cm, TH 7.5 cm
Barnett 1976: 43, pl. XXVII

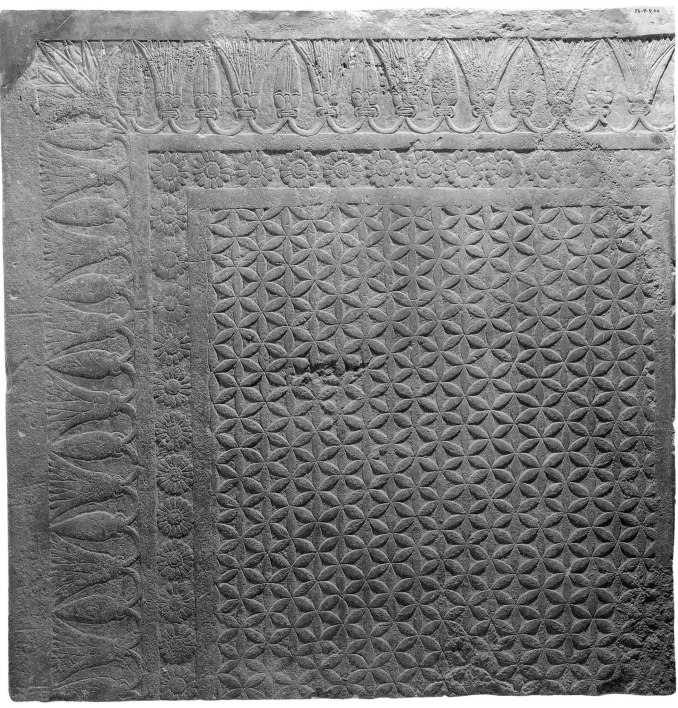

45

## 46–8 Stone arms

The function of these arms, of which several more examples exist, is unknown. They may have belonged to composite statues, but no other parts were recorded in association with them. They projected outwards, being fastened at the elbow with iron tenons. The rosettes on the wristlets suggest royal or semi-divine status. A hole between thumb and forefinger indicates that something was originally inserted there, perhaps the stem of a metal flower.　　　　　JER

7th century BC
From Nineveh, South-West Palace
**46** WA 92-5-22,582 + 592
H 5 cm, W 17 cm, D 4 cm
**47** WA 93025
H 5 cm, W 17 cm, D 4 cm
**48** WA 89-4-26,219 + 82-5-22,284
H 5 cm, W 17 cm, D 4 cm

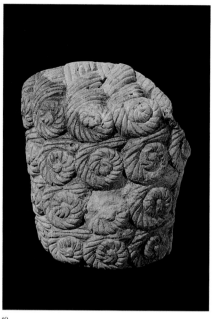

49

## 49 Beard from a statue

This elaborately curled beard originally belonged to a type of composite statue well known in antiquity, of which no complete example survives. A wooden matrix would have been inlaid with a range of other materials, such as this 'Egyptian blue' beard. Despite its name, the material does not come from Egypt: it was artificially made from copper silicate, and shaped in a mould. It provides an unusual example of a bright colour surviving in a fair state of preservation, giving some indication of the brilliant interiors of Assyrian buildings.　　　　JER

About 875–865 BC
Probably from Nimrud, Temple of Ninurta
WA 120465
H 8 cm, W 7 cm, D 7 cm
Layard 1853: 357–8

## GLAZED TERRACOTTA WALL DECORATIONS

Decorative plaques and knobs of glazed terracotta were inserted in the walls of some rooms a little above head height (Andrae 1925: fig. 35). They were often copied in wall-paintings, which show that they were liable to be fixed in a row, alternately square and circular. The patterns – palmettes, pomegranates, targets, guilloches, chevrons, squares of contrasted colours, notably black and white – are typical of the ninth century, and probably all embodied protective symbolism. The glaze colours would originally have been brighter.　　　　JER

## 50 Glazed wall-knob

This is inscribed with the names of Ashurnasirpal II (883–859 BC) and of the temple where it was placed. There are remains of the unglazed shank which fixed it to the wall.　　　　JER

About 875–865 BC
From Nimrud, Temple of Ishtar Kidmuri
WA 91687
DIAM 15 cm, L 24 cm
Grayson 1976: 199. Albenda 1991: 46

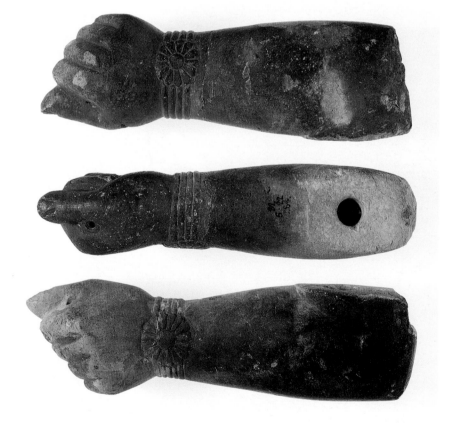

46–8

50

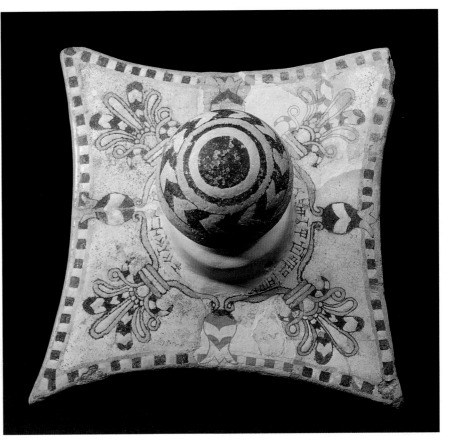

51

## 51 Glazed wall-plaque

The concave sides of this type, which was fixed to a separate shank by a pin, may be a reflection of the curved lines taken by textiles hanging in Assyrian buildings. It bears a text of Ashurnasirpal II (883–859 BC).                                    JER

About 875–865 BC
From Nimrud, Temple of Ishtar Kidmuri
WA 91680 + 131664
W 28 cm, TH 15 cm
Albenda 1991: 46

## 52 Glazed wall-plaque

This will have been fixed with a pin to a separate shank which held it on the wall. A hole for a pin is visible in the neck.

About 875–865 BC                    JER
From Tell Billah (ancient Shibaniba)
WA 91679
DIAM 44 cm, TH 15 cm
Albenda 1991: 45

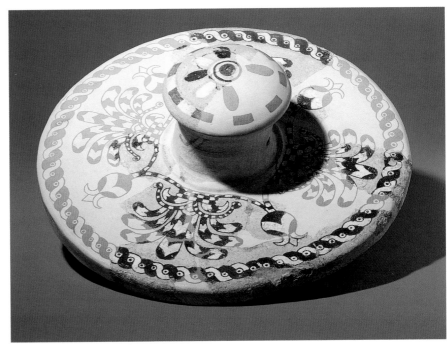

52

## MINIATURE CORBELS

Terracotta clenched fists with long shanks, usually inscribed and sometimes glazed, have been found in the ruins of several important buildings at Ashur, Nimrud and Khorsabad (Frame 1991).

The thumb is stylised as a fifth finger. They appear to have been inserted high into the walls of major rooms, so as to appear to support the beams of the ceiling (Andrae 1925: fig. 36). They are usually stained with bitumen, a material occurring naturally in Assyria and regularly used as a protective coating for vulnerable parts of mud-brick buildings. As far as we know, the fists had an entirely decorative function, but because the hand can today be a magical lucky symbol in the Near East, associated with Fatima, modern scholars have sometimes described them as 'hands of Ishtar', Ishtar being one of the most powerful goddesses of antiquity.

JER

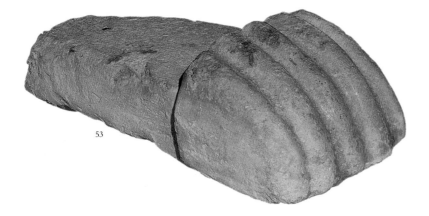

53

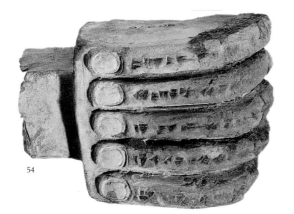

54

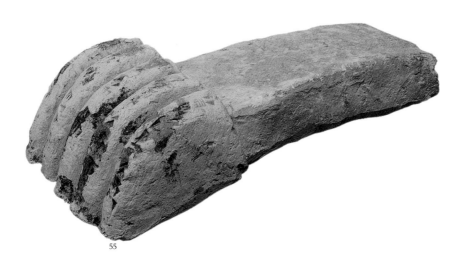

55

### 53 Miniature corbel

The fingers of the fist, which would have been visible from below, are covered with blue glaze; a paler undercoat is visible at the sides, and trickles down the back.

9th–8th century BC                         JER
Probably from Nimrud, North-West
    Palace
WA 92095
L 21 cm, W 9.5 cm, D 6 cm
Layard 1849a: 18, pl. 84, nos 14, 16. Frame 1991:
    350, no. 44

### 54 Miniature corbel

This example is exceptionally well made, with the fingernails individually delineated; the shank is broken. The inscription begins with the name and titles of Ashurnasirpal II (883–859 BC). The damaged last line may state that the fist is the property of the god Enlil, who occupied one of the shrines at Nimrud.          JER

About 875–865 BC
From Nimrud
WA 90976
L 12.7 cm, W 7.8 cm, D 5.3 cm
Frame 1991: 364, no. 36

### 55 Miniature corbel

The inscription, which has been partly filled by bitumen, gives the name and the ancestry of Ashurnasirpal II (883–859 BC), and states that the fist belongs to the Temple of Ninurta, principal god of Nimrud.          JER

About 875–865 BC
From Nimrud (ND 634)
WA 140430
L 21.5 cm, W 9.52 cm, D 5 cm
Frame 1991: 369, no. 74

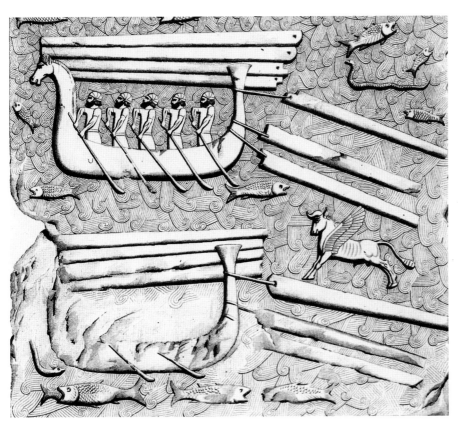

Drawing of a relief of Sargon showing
Phoenicians shipping logs for the king's
palace (Botta and Flandin 1849–50: I, pl. 33).

## 56  Segment of cedar wood

Wood seldom lasts long underground, but archaeologists in Assyria have occasionally found substantial pieces that had been encased in falling debris. In describing the excavation of the temple quarter at Nimrud, Layard recounts how one day, standing on a distant part of the mound, he smelt the sweet smell of burning cedar. His workmen had dug out a beam and made a fire to warm themselves. This fragment, recovered by him in an earlier expedition and subsequently cut and polished, has been definitely identified as cedar. One important purpose of Assyrian expeditions to the Mediterranean was to collect the longest possible cedar trunks for the ceilings of major buildings, since the width of rooms was dependent on the length of the beams available.                                    JER

9th–7th century BC
From Nimrud
WA 122117
H 10 cm, L 21 cm, W 7 cm
Layard 1849: II, 37, 259; 1853: 357

56

## 57 Model fortress

This is part of a large terracotta bin whose sides represent a fortified wall with towers and slightly projecting battlements. A stamp has been used to impress rows of rosettes below the crenellations, corresponding to the rosettes of glazed brick which were regularly placed as protective symbols along fortress walls, both in Assyria and elsewhere. The broken outline of the crenellations themselves has been indicated by a plain rectangular stamp. Most pottery containers of this size were plain and utilitarian; this was clearly designed for a special purpose.     JER

9th–7th century BC
From Nimrud, Fort Shalmaneser, West Gate
  (ND 11407)
WA 1987-1-31,117
H 52 cm, W 51 cm, D 16 cm
Mallowan 1966: 462–3

57

58

## 58 Terracotta wall-boss

This boss, inscribed with the name and titles of Ashurnasirpal II (883–859 BC), was probably placed with many others like it on the exterior walls of the Temple of Ishtar at Nineveh. It will have been fixed to the wall by a peg passing through the central hole, and secured with a bituminous glue which has left dark traces on the surface. The use of terracotta pegs and bosses inscribed with a king's name and inserted in temple walls was a tradition which went back over 2,000 years in Mesopotamia.     JER

About 880–860 BC
From Nineveh
WA 56-9-9,136 + 143 + 184
H 6 cm, DIAM 12 cm
Grayson 1976: 189

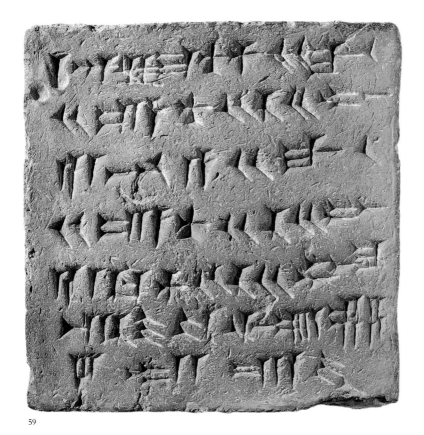

59

### 59 Inscribed brick of Shalmaneser III

'Shalmaneser, the great king, strong king, king of the world, king of Assyria, son of Ashurnasirpal, the great king, strong king, king of the world, king of Assyria, son of Tukulti-Ninurta, king of the world, king of Assyria. Construction of the ziggurat of Kalhu.' The ziggurat (temple pyramid) attached to the temple of the god Ninurta was the most prominent building in the capital city of Nimrud (Kalhu); its construction was completed by Shalmaneser III (858–824 BC). The outer face was built of baked bricks, each of which was similarly inscribed. The ziggurat was probably about 60 metres high.

About 859–840 BC        CBFW
From Nimrud
WA 90224
L 40 cm, W 40 cm, D 15 cm
Walker 1981: 113, no. 159

60

### 60 Stamped brick

Bricks used for the principal public buildings of Assyria were often inscribed before firing with the names of the king and of the building for which they were being made. Stamped bricks, common in Babylonia, are infrequent in Assyria. This uninscribed brick has a square stamp showing the *mush-hushshu* dragon bearing on its back the emblems of the gods Marduk and Nabu. An inscribed example bears the name of Ashur-etel-ilani (*c.* 630–627 BC). Bricks with similar pictorial stamps were found in the eighth-century palace of Sargon II at Khorsabad. CBFW

Probably 630–627 BC
From the Temple of Nabu, Nimrud (ND 6216)
WA 132263
L 40 cm, W 40 cm, D 15 cm
Mallowan 1966: I, 643

62, 61

## 61 Bronze brick-stamp

This stamp has a cut-out shape in the form of a running lion. At the back is a Y-shaped attachment that would have fitted into a handle, probably of wood. Baked bricks with similar stamped designs have been found at Nimrud (see no. 60) and Khorsabad (Loud and Altman 1938: pl. 65b), and they are also known from Susa in south-west Iran (Hesse 1973). This is one of a group of five similar brick-stamps found by Layard at Nimrud. These stamps may have been kiln or brickmakers' marks, or they may have had some other significance that is now obscure. At Khorsabad there is a variety of stamped designs on bricks including, as well as the lion, a bull and a dagger.

Probably 8th century BC          JEC
From Nimrud
WA 124598
H 2.9 cm, W 5 cm, D (including broken attachment) 4.8 cm
Hesse 1973: pl. 11, no. 19

## 62 Bronze brick-stamp

Cut-out stamp as no. 61 above.          JEC

Probably 8th century BC
From Nimrud
WA 135467
H 2 cm, W 3.1 cm, D (including broken attachment) 4.9 cm
Hesse 1973: pl. 11, no. 19

# 3 MAGIC AND RELIGION

In a world of uncertainties, fears and difficult conditions – disease, injury, death, depression, poverty, natural disaster, overwork, absence of work, failures, frustrated ambition, unrequited love – the strong hope of, and recourse to, intervention from some higher power than is currently available in the physical or human world will understandably manifest itself. Magic, like religion, implies belief in, and a degree of knowledge about, supernatural forces or beings; and magical practices, which have been employed in one form or another in all human societies throughout recorded history, presuppose a belief or hope in an ability to influence the supernatural to effect a desired change, often including the redetermination of future events. Naturally, such practices are capable of being used for good or ill, hence the distinction between 'white' and 'black' magic, yet the techniques employed are often much the same. In many modern societies, the term 'magic' has acquired a pejorative sense, suggesting something sinister or deceitful, but such overtones do not obtain where magical practices and beliefs concur with the prevailing world-view. Except in today's major world faiths, wherein natural and moral law are regarded as immutable, there is often no very clear-cut distinction between magic and religion, though the former may lay greater emphasis on action, the latter on the underlying beliefs. In ancient (and 'primitive' modern) societies, moreover, the distinction may also be blurred between magic and medicine, while practices labelled as the latter still inspire an at times naïve faith and unrealistic expectation in the western world.

In Assyria magical techniques and rituals were employed, for example, to keep at bay, expel or overpower harmful supernatural beings; to reverse the bad consequences of acts which had offended the gods; to predict future events and to avoid their portended ill effects; to restore or to increase sexual potency; to attain the item or person of one's desires; to calm down naughty children; to hurt one's enemies; to turn away harm inflicted by enemies on oneself. The practitioner responsible for magic and some aspects of medicine was called an *ashipu* or *mashmashu*. Another, the *asu*, specialised more in medicine. Divination was practised by the *baru*. Singing *naru* priests and bands of *kalu* priests gave musical accompaniment to some rituals. Divination, or fortune-telling, was based especially on astrology (reading the stars), extispicy (inspection of the entrails of a sacrificial sheep), oneiromancy (the interpretation of dreams), libanomancy (observing the directions taken by smoke from burning incense), and predictions from a wide variety of natural and human phenomena (omens). Necromancy (the raising of ghosts from

the dead for consultation) was seldom used and was regarded as highly dangerous. There were numerous other rare forms of divination.

Assyrian and Babylonian magical rites are known to us from many sources. Written tablets preserve incantations or spells, as well as rituals describing the actions to be performed and incantations to be uttered by the magician or the patient. Amulets, often inscribed with incantations, were worn on the person (usually strung around the neck) or placed within the house, sometimes hanging on the wall. Magical figurines were placed within buildings or, more usually, buried in the foundations to protect against evil beings. In the late second and early first millennia BC, while some supernatural spirits have human form, battalions of terrifying monsters are also present in Assyrian imagery, dominating some aspects of life and indeed of death – for one view of the underworld considered it a realm populated by such monsters.           ARG

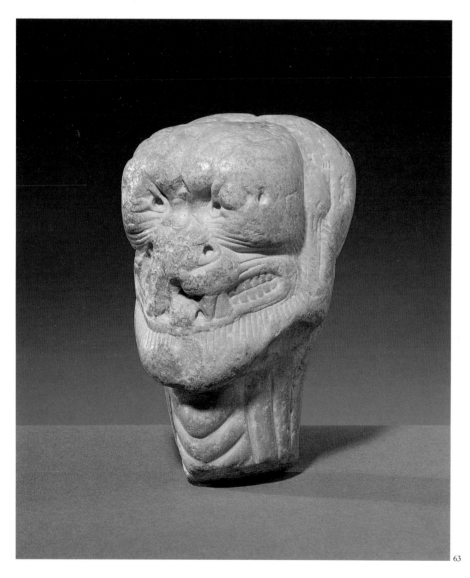

63

### 63  Stone head of Pazuzu

Pazuzu was a prominent demonic figure, named and depicted for the first time in the Assyrian period. The inscription on the back and sides of the head is an extract from an incantation to him, thus identifying the god with certainty.

Pazuzu, son of the west wind, has the face of a lion or dog (lions were regarded by the Assyrians as part of the canine family) with unnaturally bulging eyes, and horns. Complete figures show him with a scaly body, a snake-head penis, the fore-paws of a lion, the talons of a bird, and a scorpion's tail; he is usually winged. Often he raises his right hand in a gesture of menace. The rituals concerning this deity emphasise his evil nature, yet he could also be turned to good use (see no. 64).           ARG

8th–7th century BC
Probably from Babylon
WA 91876
H 9.9 cm, W 5.8 cm, D 7 cm
Campbell Thompson 1903–4: pl. II. Borger
  1987: 16–22

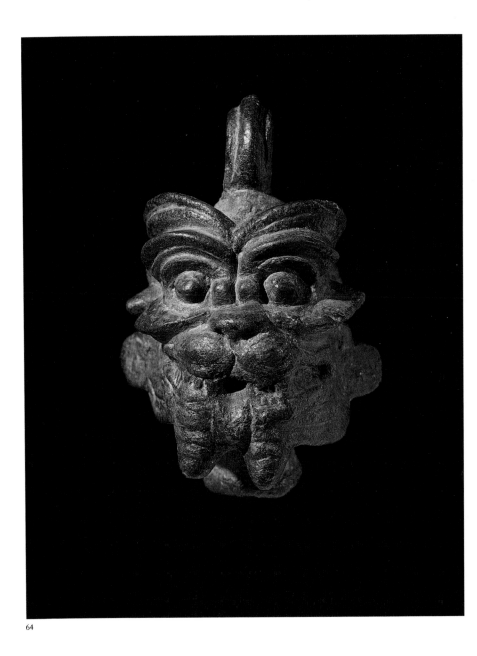

64

## 64 Bronze head of Pazuzu

This head was probably suspended close to a woman in labour, for protection against the female demon Lamashtu. A 'bronze Pazuzu', presumably an amulet much smaller than this, is prescribed to be worn for this purpose, and a stone Pazuzu is reported to have been part of a necklace found within a grave. When applied to clothes, bronze fibulae – brooch-like safety-pins (see nos 175–7) – bearing the head of Pazuzu probably protected mother and baby. Plaques of various materials (see no. 178) show Pazuzu repelling Lamashtu, while offerings such as a fibula provide a further incentive for her to leave.

Lamashtu herself is conventionally shown as a mainly leonine hybrid. She was known for her attacks on unborn and newly born babies – apparently miscarriage, still-birth and cot-death were attributed to her. She seems to be the archetypal jealous and vengeful sterile female and frustrated would-be mother (instead of babies, a piglet and a cub suckle at her breasts). It is said by Russian anthropologists that in the western Pamirs of Tajikistan a large-breasted she-devil named Almasti or Albasti is still feared today as a killer of babies and infants.                    ARG

8th–7th century BC
Provenance unknown
WA 132964
H 10.5 cm, W 7.2 cm, D 6 cm, WT 1113.6 g
Braun-Holzinger 1984: 78, no. 264, pl. 53.
   Thureau-Dangin 1921: 184–5. Wiggerman 1992: xiii

## FIGURINES OF
## UNBAKED CLAY

In order to counter evil and disease, the Assyrian exorcist could call on the power not only of Pazuzu but of a wider, though restricted and well-defined, circle of supernatural beings. These creatures appear commonly in the magical art of the time, most notably as defenders of the royal palaces, in monumental wall-sculpture (see nos 8–9, 31–3) and as small figurines of sun-dried clay. Some were very ancient iconographic types, others more recent but provided with a mythical antiquity; many were entirely new, so far as we know, but were again regarded as having been present at the beginning of time. Rather different from the images of supernatural beings, but part of the same ritual series, were model clay dogs.

Clay figurines were used to protect a building and its inhabitants from evil spirits and and diseases, or to evict those already present. The material, though easily modelled, is also easily damaged, but the figurines were protected by being buried under the floors, placed either in boxes of stone or clay or else in pottery vessels. They have been discovered at the Assyrian urban sites of Ashur, Nineveh, Nimrud, Khorsabad and Tarbisu, and (exclusively during the period of Assyrian control) at Ur in Babylonia. The elaborate rituals attendant on their use included the driving out of evil demons by the chiming

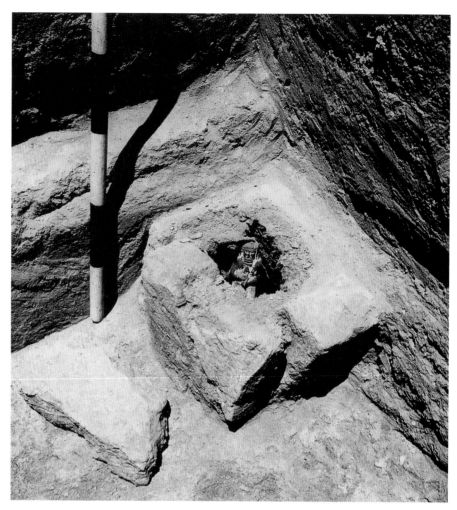

Clay figurine of an apotropaic figure as found in a brick foundation box in Room S57 of Fort Shalmaneser at Nimrud.

of bells; one bell probably employed for this purpose bears images of protective beings of types well known from the palace sculptures and from figurines (Green 1986: 209–10, pl. 31).          ARG

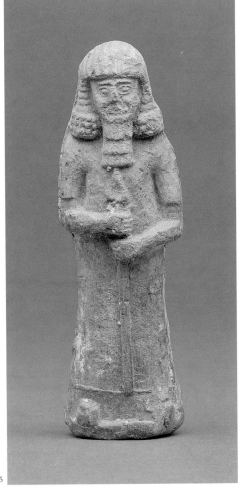

65

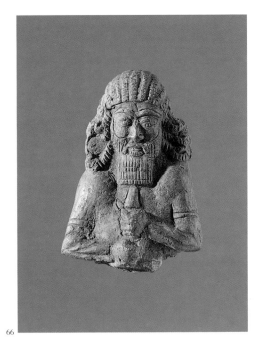

66

## LAHMU FIGURINES

Foundation figurines showing a long-haired man, often with six large curls, have been identified as representations of a *lahmu*. This was a minor god, associated with Ea, great god of the sweet-water abyss (or *apsu*). Ritual texts prescribe that such figurines, holding a *marru* spade or hoe (triangular headed and approximating to a spear in shape), should be inscribed in exactly the manner of no. 65 and buried in the corners of the room and in the courtyard (Wiggerman 1992: 49, 164–6; Rittig 1977: 51–8, 213–15). They are to be covered in gypsum plaster, over which water is to be painted in black wash. One such figurine that has preserved its plaster coating shows these vertical streams in black paint (Green 1983: 91–2, pl. XIIIb).                ARG

### 65  Lahmu

This clay figurine of a *lahmu* is inscribed, on the right and left arms respectively, 'Enter, spirit of peace!' and 'Depart, spirit of evil!'. It appears to have been used twice, first in the reign of Esarhaddon (680–669 BC) and subsequently in the reign of Sinsharrishkun (c. 626–612 BC).

7th century BC                ARG
From Nimrud, Fort Shalmaneser,
  Room S41 (ND 9344)
WA 140435
H 12.7 cm, W 4.1 cm, D 3.3 cm
Oates 1961: 9

### 66  Lahmu

This broken clay piece shows exceptionally fine modelling.                ARG

7th century BC
Probably from Nineveh, North Palace
WA 91841
H 5.2 cm, W 3.9 cm, D 2 cm

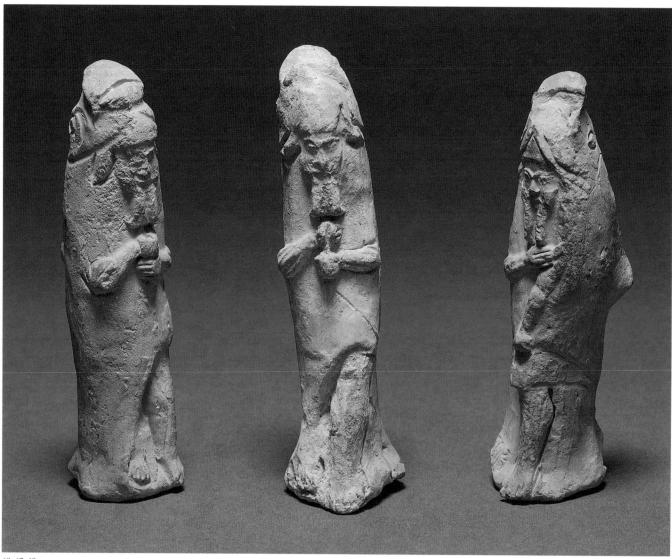

68, 67, 69

## APKALLU FIGURINES

Two of the deposits prescribed to be buried in a house in a ritual for its magical protection are 'seven figurines of *apkallu* dressed in the skin of a fish' and 'seven figurines of *apkallu* with the faces of birds and wings' (Rittig 1977: 153, 164). The *apkallu* were primeval sages, associated with the water god Ea, who were thought to have brought wisdom to mankind.                    ARG

### 67–9   Fish-cloaked apkallu

These figurines represent three out of six similar surviving examples, probably deriving from an original deposit of seven.

8th–7th century BC                           ARG
From Nimrud or Nineveh
**67**  WA 90999
H 13.2 cm, W 3.5 cm, D 4.4 cm
**68**  WA 91837
H 12.8 cm, W 3.1 cm, D 3.9 cm
Rittig 1977: 84
**69**  WA 91836
H 12.7 cm, W 3.1 cm, D 4.1 cm
Rittig 1977: 85

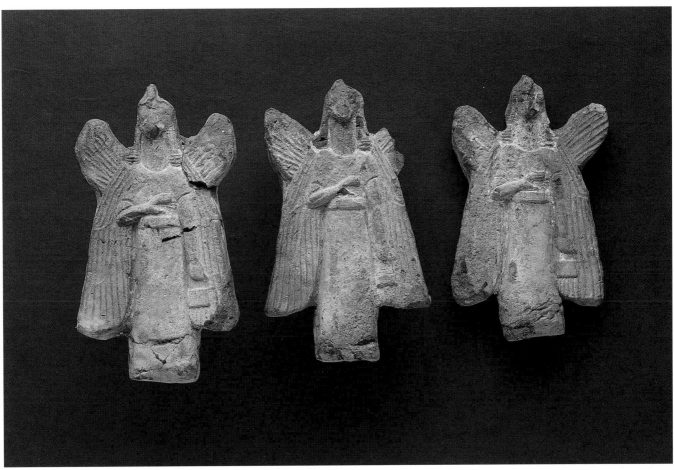

71, 72, 70

**70–72  Bird-headed apkallu**

These are recorded as having been found
'in a brick receptacle let into the floor' (G.
Smith 1875: 78). Like nos 67–9, they are
probably part of an original deposit of
seven.                                    ARG

**70**  WA 91839
H 11.9 cm,  W 7.3 cm,  D 2.4 cm
Rittig 1977: 72
**71**  WA 90992
H 12.6 cm,  W 7.2 cm,  D 2.3 cm
Rittig 1977: 72
**72**  WA 90989
H 12.3 cm,  W 7.6 cm,  D 2 cm
Rittig 1977: 72

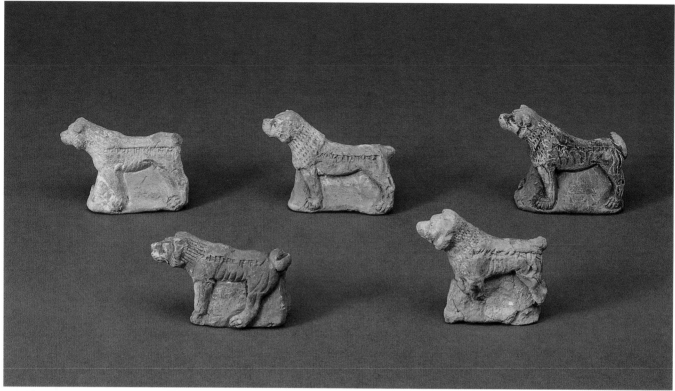

*(From left)* 75, 74, 76, 73, 77

## MODEL DOGS

A written ritual prescribes that model clay dogs should be deposited in groups of ten – two painted in each of five colours – with their names inscribed on them (Rittig 1977: 159, 168). A set of five dogs from Nineveh (nos 73–7) represents half such a group. They are mastiffs of the royal hunting breed (see no. 27). The names inscribed on them, and their colours (white with red spots, red, yellow-white, green-blue, black), correspond closely to those ritually prescribed. They were deposited in a niche on one side of a door leading out of the palace of Ashurbanipal; the second set of dogs will have been on the opposite side of the door. At Ur a set of five clay figurines of sitting dogs, seemingly uninscribed, one with traces of red paint, was recovered from a brick box placed under the floor of the palace of the daughter of the later Babylonian king Nabonidus (555–539 BC); another four, one still showing red paint, one blue and one green, were found in the same building (Woolley 1965: 94, pl. 32).

Two clay figurines of sitting dogs, one with traces of green paint and inscribed, were found in a building at Kish near Babylon, and are thought to have been part of a similar set of five (Langdon 1924: 91, pl. 28.1).

Apparently these were not supernatural creatures but substitutes for living dogs (Postgate 1994: 176–84), still renowned in the Middle East as effective guard-animals. The efficacy of the figurines as protection against demons and disease may have been increased by an association with Gula, goddess of healing, whose distinctive animal was the dog. A tablet from Ashur bears the impression of a cylinder seal with the image of an Assyrian king worshipping before a shrine housing a cult-statue of a dog, and there are known to have been temples to Gula at Ashur and Nimrud (Parker 1986). According to a text dating to the time of a later Persian king, Artaxerxes, five dogs coloured white, black, red, spotted and yellow stood on the right of a statue of the god Ninurta and on the left of a statue of Gula (Nougayrol 1947).

The Assyrian clay dogs should be clearly distinguished from the clay dog figurines of the first millennium BC from Babylonia, found not in boxes but loose in the fill beneath floors. These latter were pre-emptory goodwill and votive thanksgiving offerings to Gula; some of them are inscribed in dedication to her. There are also Assyrian and Babylonian figurines of dogs cast in copper or bronze (Rittig 1977: 117–27). It is unclear whether they were dedicatory or magically protective. Like model dogs inscribed to Gula, they have been found not in boxes but loose under (in one case, on) the floor. There is some evidence for bronze dogs in groups of seven, since a group of this kind was found at Nimrud (Green 1983: 94, pl. xive), thrown down a well in the North-West Palace of Ashurnasirpal II (883–859 BC). At Ur four bronze statuettes of dogs (the face of one covered in gold) were found under the pavement in the same Assyrian building as protective clay figurines (Woolley 1962: 16, pl. 25), which may suggest that the former also were guardian watchdogs. ARG

## 73 Clay dog

Painted white with red spots, and inscribed 'Expeller of evil!'. ARG

About 645 BC
From Nineveh, North Palace, Room S, door d
WA 30001
H 5.5 cm, L 6.5 cm, D 2.1 cm
Barnett 1976: 36, pl. I

## 74 Clay dog

Painted red, and inscribed 'Catcher of the enemy!'. ARG

About 645 BC
From Nineveh, North Palace, Room S, door d
WA 30002
H 4.5 cm, L 7 cm, D 1.9 cm
Barnett 1976: 36, pl. I

## 75 Clay dog

Painted yellow-white, and inscribed 'Don't think, bite!'. ARG

About 645 BC
From Nineveh, North Palace, Room S, door d
WA 30003
H 5 cm, L 6.8 cm, D 2.6 cm
Barnett 1976: 36, pl. I

## 76 Clay dog

Painted green-blue, and inscribed 'Biter of his foe!'. ARG

About 645 BC
From Nineveh, North Palace, Room S, door d
WA 30004
H 5.4 cm, L 7.5 cm, D 2.8 cm
Barnett 1976: 36, pl. I

## 77 Clay dog

Painted black, and inscribed 'Loud is his bark!'. ARG

About 645 BC
From Nineveh, North Palace, Room S, door d
WA 30005
H 5.6 cm, L 7.3 cm, D 2.8 cm
Barnett 1976: 36, pl. I

## 78 Bronze dog and master

When a human figure is cast in bronze together with a dog in this way, he is always male. He may himself be a god (Enlil, Marduk and Ea all had their fierce hounds, while Ninurta had five), or he may be the offerer of the dog (perhaps to Gula), or the person seeking the protection of the dog or its patron deity. Alternatively, the master may be a protective spirit. The figurine could then have had a magical function, and could either have stood on its own or derive from a set of seven dogs, one of which was led,

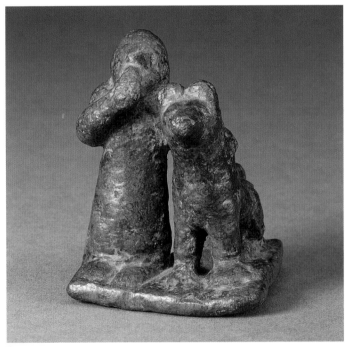

78

like the sets of seven *apkallu* spirits. Protective figurines made of bronze might have remained visible in houses, rather than being buried. A group of seven dogs, one with its master, was found at Nippur in Babylonia, on a floor dating from the Assyrian period or somewhat later.

7th–6th century BC ARG/JER
Probably from Babylonia
WA 94346
H 7.3 cm, W 5.6 cm, D 5.8 cm, WT 350 g
Braun-Holzinger 1984: 94–5, pl. 64. Crawford 1959: 81

## MAGIC AND RELIGION:
## THE TEXTUAL EVIDENCE

The library of Ashurbanipal has preserved for us many examples of inscriptions concerning magic and religion, from which it has been possible for modern scholars to understand much of this side of life in ancient Assyria.

The distinction between magic and religion is not, of course, always entirely clear, but among the surviving cuneiform sources many documents can be conveniently classified as magical or religious, in that magic relies on spells, incantations and special rituals to bring about the desired effect for an individual, whereas most known religious texts are from the world of the state, and involve propitiation of the gods, important and unimportant, in order to preserve the status quo in the known world.

Broadly speaking, magic in ancient Mesopotamia functions to repair or to prevent: there are few examples of manipulative magic designed to bring about a desired effect from scratch, as it were. The associated study of omens was important, since if experience showed that ominous signs threatened serious consequences, special magical procedures (called *namburbi*) were available to deal with them.

Perhaps a majority of incantations concerns demons, malevolent semi-divine figures who existed in great number and who were always ready to bring distress into human life. They lived in the steppe, in ruined buildings and in other such places. There were many ways in which they could cause problems, among which sickness and disease were probably the most commonly mentioned. Others attributed to magic were social ostracism and failed business enterprise, although occasionally these, like illness, were attributed to human rather than demonic

agents. There are, as a result, magical tablets detailing ceremonies designed to deal with witchcraft and sorcery, in which figurines of the responsible parties were burned, in order to render them ineffective. Other magical texts had a specialised function, such as to ensure good luck on the founding of a new building, or to bring in good custom for an ale-house. In comparison with later magical tradition such texts are few in number.

Religious texts are also abundantly represented at Nineveh, to the point that few compositions are known from other sites that are not represented by a copy from the royal libraries. Within this category are many examples of liturgical texts, hymns addressed to a particular god or goddess that were recited in temples by a special group of priests, almost certainly to traditional musical accompaniment. Many such hymns were composed in the ancient language Sumerian, and by the end of the second millennium BC, with the decline of spoken Sumerian, they had become obscure outside the most learned of circles. As a result they are often found with an interlinear translation into Assyrian (Akkadian). This type of bilingual text has been of great use in the modern decipherment of Sumerian.

The practical side of religious life is reflected in rituals, and again the survival of abundant literature has given us many details about cult practice in the city temples; lists of gods and their abodes, details of their offerings and daily life, the refurbishment of divine statues and the celebrations of seasonal festivals are all covered in tablets from the Assyrian capitals.

King Ashurbanipal seems to have had a personal interest in literature. An acrostic hymn based on the syllables of his name and addressed to the goddess Ishtar was composed for him, if not by him.      ILF

## 79 Magic against witchcraft

This is a nearly complete copy of the seventh tablet of the series Maqlu, 'Burning'. The series is the most important source for the study of witchcraft in Mesopotamia. Its eight tablets contain a manual for the ceremony to be used in burning a figurine to dispel the effects of witchcraft and the complete text of all the incantations to be recited during the ceremony. In this, its latest, version the ceremony was probably performed in the month of Abu, beginning at night and being concluded on the following morning. The seventh tablet contains fourteen incantations, marked off from each other by ruled lines.     CBFW

7th century BC
From Nineveh, library of Ashurbanipal
WA K2950
H 20 cm, W 13 cm, TH 3 cm
Meier 1937: 46–53

## 80 Necromancy ritual

This is the upper half of a cuneiform tablet inscribed with necromantic incantations and rituals to enable a man to see and question a ghost for the purpose of learning the future. A mumbo-jumbo spell is recited over a specially prepared mixture, and this is applied as an ointment to the eyes. The result is expressed as follows: 'You will see the ghost: he will speak with you; you can look at the ghost: he will talk with you.' The subsequent passage gives magical procedures to protect the necromancer from the dangers involved in trafficking with the dead. Necromancy is only rarely referred to in cuneiform sources. This tablet is in Babylonian script, and was clearly brought from southern Mesopotamia to fill a gap in the royal library at Nineveh.     ILF

7th century BC
From Nineveh
WA K2779
H 9.5 cm, W 9.5 cm, TH 2 cm
Finkel 1984. Tropper 1989: 90–92

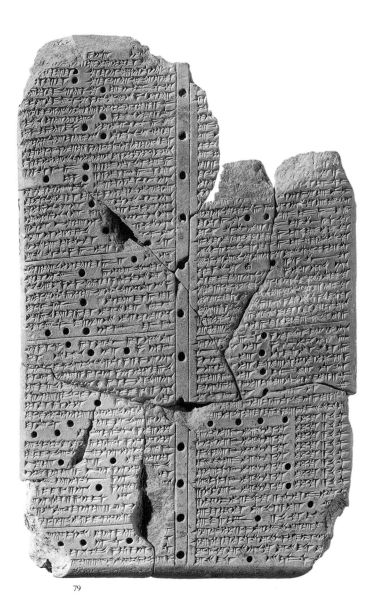

79

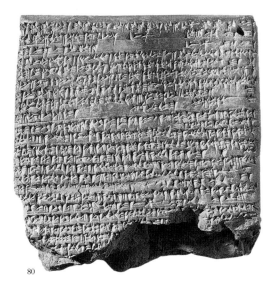

80

## 81 Ritual for building a temple

This tablet, pieced together from six different fragments and now nearly complete, describes the ritual required for the building or rebuilding of a temple for the great gods. Experts have to be consulted about the location of the temple and the approval of the gods has to be obtained for the work to begin. Altars have to be set up and offerings and sacrifices made to many gods. The ruler should recite three times an incantation to the god Enmesharra, lord of the underworld, since the foundations of the temple were deemed to reach down to his domain. A statuette of the ruler, adorned with gold and silver, should be prepared and buried under the foundations. Only then may the work of building begin. The ritual is written in Standard Babylonian, a literary language, and probably derives from Babylonia.  CBFW

7th century BC
From Nineveh, library of Ashurbanipal
WA K48+
H 14.6 cm, W 7.5 cm, TH 2.1 cm
Borger 1971

## 82 Royal court ritual

This well-preserved ritual is written in the native Assyrian dialect, suggesting that it was probably not imported from Babylonia like many other religious texts, but is an authentic example of Assyrian cult practice. The nature of the ritual is not quite certain, since this tablet appears to be the second of two, and the first is unknown. It appears to have something to do with the use of a statuette as a substitute to avert evil from the royal court. The first section of the ritual contained on this tablet concerns the preparation of a bed, the second section describes a ceremonial 'burning'.  ILF/CBFW

7th century BC
From Nineveh
WA K164
H 11 cm, W 5.5 cm, TH 2 cm
Von Soden 1939: 42–61. Ebeling 1931: 63–5

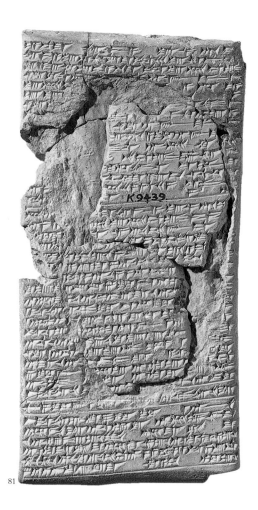

81

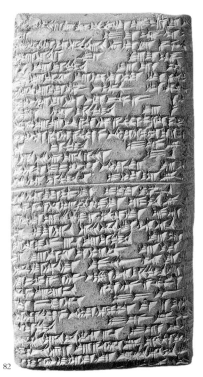

82

# 4 Furniture and Fittings

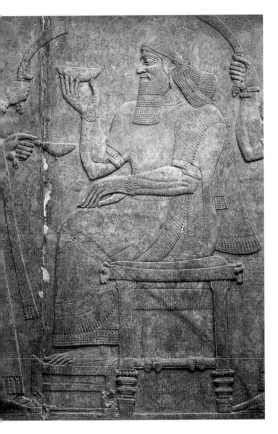

Relief of Ashurnasirpal showing the king seated on a backless throne (WA 124565).

There is much evidence for furniture in the Late Assyrian period (ninth to seventh centuries BC) but its immediate antecedents are obscure because of the scarcity of evidence from the preceding Middle Assyrian period. Nevertheless, it is clear that Late Assyrian furniture derives from a long-standing Mesopotamian tradition that was itself much influenced by forms from Syria and Phoenicia and, ultimately, Egypt. A good indication of the splendour of some furniture in the Ancient Near East in the years before the Late Assyrian empire is provided by the Biblical description of the throne of the tenth-century Israelite king Solomon: 'Then the king made a great throne inlaid with ivory and overlaid with fine gold. The throne had six steps, and its back had a rounded top. On both sides of the seat were armrests, with a lion standing beside each of them. Twelve lions stood on the six steps, one at either end of each step' (I Kings 10: 18–20). The Late Assyrian kings therefore had a rich legacy to draw upon, and there is ample evidence that they exploited it to the full. The Assyrian reliefs show a range of elaborate furniture, and this pictorial evidence is supplemented by archaeological discoveries.

On the reliefs the main pieces of furniture shown are thrones, both high-backed and backless, footstools, tables, couches and beds. Actual finds of furniture have included a backless throne similar to that seen on a relief of Ashurnasirpal discovered by Layard in Room AB of the North-West Palace at Nimrud (Layard 1853: 198–200), and a couch found in Room NE26 of Fort Shalmaneser (Mallowan 1966: II, figs 321–2). This last is a curious piece which may have been wrongly interpreted. Apart from these complete items, however, parts of numerous other pieces have been found at the major Assyrian cities. This evidence allows us to make certain generalisations. In most cases the basic structure seems to have been of wood, but to this were added lavish amounts of bronze and other material. Bitumen was extensively used as a filler and an adhesive. Furniture feet were often of bronze, and the wooden substructure above was often covered with bronze overlay, either cast or hammered. Animal heads in bronze were sometimes added. However, bronze was not the only material used: for example, parts of furniture were sometimes made of stone, and there is extensive evidence for the use of ivory.

The vast quantity of ivory discovered in Assyria, principally at Nimrud, is an interesting phenomenon. It is obvious that the carved ivories are in different styles, representing the work of different schools, but the location of these centres of production remains elusive. In a rather

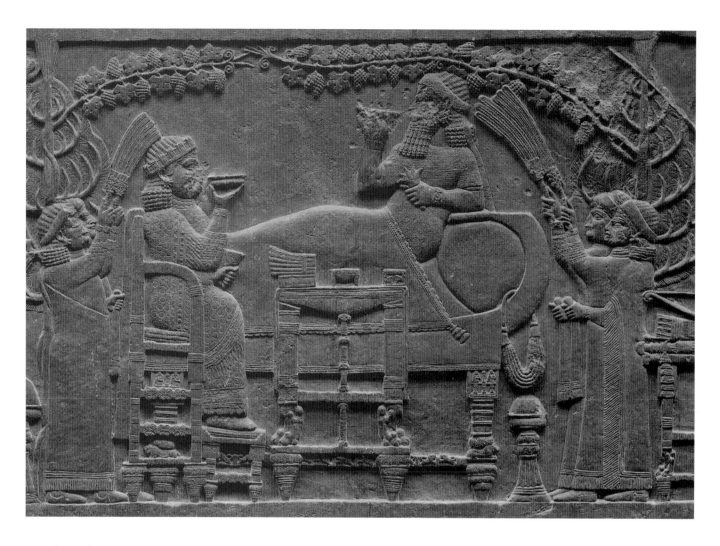

Relief of Ashurbanipal showing the king and his queen at a ceremonial banquet, *c.* 645 BC (WA 124920).

rough and ready way, and without regard to the political and social complexities of the Ancient Near East in the early first millennium BC, the ivories are often divided into Phoenician, Syrian and Assyrian styles. Phoenician art is characterised by considerable dependence on Egyptian styles and motifs, and such ivories might have been produced in centres such as the coastal cities of Tyre and Sidon. Syrian-style ivories, on the other hand, are supposed to derive from centres either in north Syria, such as Arslan Tash, or in south Syria, such as Damascus.

Identifying these centres of production is highly problematic, but in recent years significant progress has been made through the work of scholars such as Irene Winter (1976) and Georgina Herrmann (1989). For example, the latter has plausibly suggested that a group of ivories which she calls 'the flame and frond school' might have been produced at Tell Halaf. In the main, the Phoenician and Syrian ivories must have been imported to Nimrud, often as booty or tribute. This is clear from the fact that large quantities of ivory were stored in certain rooms, particularly in Fort Shalmaneser. In Room SW7, for example, there were

many ivory chair-backs (Mallowan and Herrmann 1974). When were these ivories made and seized? Winter has formulated the attractive theory that the Syrian centres of ivory production declined after their conquest by Sargon of Assyria in the late eighth century BC, so it must have been before then. We should not exclude the possibility, though, that foreigners might have been working in Assyria producing ivories to Assyrian specifications. For example, the famous couch on which Ashurbanipal reclines at a banquet in Nineveh – presumably an Assyrian product – is decorated with ivory 'woman-at-the-window' plaques (see no. 93), which are usually thought to be Syrian in origin. Lastly, there is the smaller group of Assyrian ivories, probably produced in Assyria by Assyrian craftsmen, which are characterised by their use of Assyrian motifs and iconography. On these plaques the decoration is usually incised.

To judge from the Assyrian reliefs and from the surviving remains there was a series of standard forms of furniture in Assyria, at least in court circles. Such types are also encountered beyond the Assyrian homeland in places under Assyrian influence, perhaps allowing us to speak of an 'Assyrian Empire style' of furniture. On the Assyrian reliefs, the most elaborate forms of furniture are the thrones with high backs which have Atlas-like figures with upraised arms on the sides. They are shown supporting the seat. The best-known throne of this type is that on which Sennacherib sits during the siege of Lachish. More ordinary types of throne have conical feet, consisting either of superimposed ribs or – particularly in the later periods – inverted pine-cones. Sometimes there is a palm capital above the foot. The cross-bar is usually decorated with opposed volutes. Backless thrones (or stools) often have bulls' heads at the corners of the seat, like the throne of Ashurnasirpal referred to above. Footstools accompany both high-backed and backless thrones. These sometimes have lions' paws resting on a bar which is supported by pine-cones. Otherwise lions' paws only occur on tables, which are generally thought to have had three legs. There are surviving examples in stone from Khorsabad. Tables sometimes have animals' heads at the corners, notably rams' and lions' heads. Occasionally tables are shown with crossed legs, demonstrating that Assyrian furniture was probably very often collapsible. Such tables generally stand on bulls' or goats' feet. Couches and beds are less commonly shown, but, like that of Ashurbanipal in the banqueting scene from Nineveh, these are sometimes very elaborate. Couches usually had a high rounded end under which a bolster could be fitted.                                    JEC

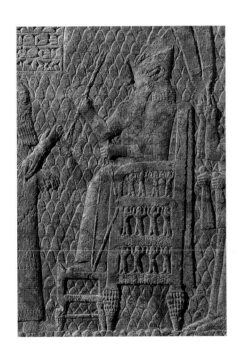

Relief showing Sennacherib seated on a throne after the capture of Lachish (WA 124911).

83

## 83 Bronze bull's head

This bronze head of a bull is probably cast (it is now filled with synthetic resin for conservation reasons, so details of manufacture or attachment are obscure). It belongs with a backless throne or stool found by Layard in a corner of Room AB in the North-West Palace at Nimrud. There were in this room several pieces of furniture which were confused in Layard's account (1853: 198–200), but it seems clear that the backless throne had bronze feet, bronze sleeves with volute decoration on the cross-bar, bronze openwork plaques (see no. 84) on the upper part of the legs, and bulls' heads at the corners of the seat. A similar throne can be seen on a famous relief which shows King Ashurnasirpal seated in state and attended by courtiers (see p. 121). Backless thrones with bulls' heads are shown on the reliefs of several Assyrian kings: the bulls' heads may not always have been in bronze, as is shown by the survival of examples in other materials such as stone and ivory.

JEC

9th century BC
From Nimrud, North-West Palace, Room AB
WA N147
L 7.25 cm, H 8.6 cm, max. W 6 cm
Layard 1853: fig. on p. 199. Curtis 1988: pl. 74

84

## 84 Bronze openwork panel

This bronze openwork decoration consists of two panels connected by bronze strips. The metal has been cut out from a sheet and embossed and chased. In the upper panel two winged genies with horned caps are wrestling with a winged female-headed sphinx, also wearing a horned cap. In the lower panel two winged monsters, part lion and part bird, rest their forepaws on a 'Sacred Tree'. Further fragments of this openwork overlay in the British Museum indicate that it decorated the four sides of a rectangular post measuring about 13.45 by 9.75 centimetres. The decoration on the other sides

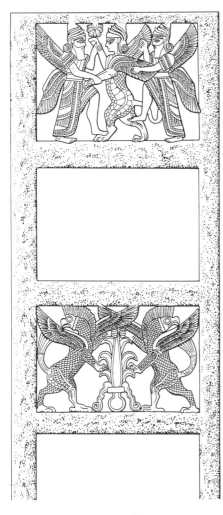

Reconstruction drawing of bronze openwork panel no. 84.

85

of the post is similar, but on the two short sides there are fewer figures. It is clear from Layard's account that this openwork ornament belonged to a backless throne found in Room AB of the North-West Palace at Nimrud. To the same throne belonged the bronze bull's head (no. 83). Layard described the throne as follows: 'It was of wood, cased or overlaid with bronze, as the throne of Solomon was of ivory, overlaid with gold. The metal was most elaborately engraved and em-

bossed with symbolical figures and ornaments. . . . As the woodwork over which the bronze was fastened by means of small nails of the same material, had rotted away, the throne fell to pieces, but the metal casing was partly preserved' (Layard 1853: 198–9). The openwork ornament was probably fixed to the upper parts of the legs. Bronze panels of exactly the same kind and with the same decoration were found by the British School expedition to Nimrud in Room NE26 of Fort Shalmaneser (Mallowan 1966: II, figs 324–5). The designs on these openwork panels are reminiscent of those which appear on costumes shown on reliefs of Ashurnasirpal II (e.g. Layard 1849a: pls 8–9, 43–50), but there are no exact parallels.

JEC

9th century BC
From Nimrud, North-West Palace,
  Room AB
WA N2073
Overall H 31.3 cm, max. W 13.6 cm
Layard 1853: 198, 200. Curtis 1988: pl. 75

## 85  Bronze palm capital

A heavy bronze casting in the form of a circular moulding with hanging leaves around the edge. The interior is hollow except for a cylindrical sleeve by which this moulding was fixed to the wooden framework of the furniture. There are twenty-seven leaves, each outlined by a raised rib with another in the middle. On the Assyrian reliefs, mouldings of this shape are generally shown in connection with thrones, both with and without backs. They are placed at the top of the feet, which are tapering, and below the cross-bar. Leaf-shaped mouldings are also known in other materials, notably ivory and stone. This example was found inside a cauldron with three others.      JEC

9th–8th century BC
From Nimrud, North-West Palace, Room AB
WA N271
H 4.55 cm, DIAM 15.5 cm
Layard 1853: fig. on p. 179. Handcock 1912:
  pl. XXVIII

88, 87, 86

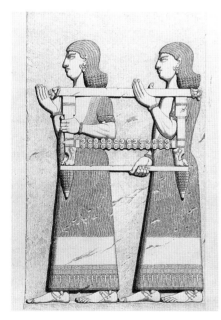

Drawing of a relief of Sargon showing courtiers carrying a table (Botta and Flandin 1849–50: I, pl. 22.

## 86–8  Bronze lions' paws

These three similar lions' paws are hammered from sheet bronze. They are open at top and bottom, and have a semicircular opening at the top front. On the Assyrian reliefs lions' paws are shown in connection with both footstools and tables, and the size of these examples indicates they must come from the latter. Such tables are often depicted on the reliefs, with conical feet which support the lions' paws. It is generally supposed that these tables had three legs, like surviving stone tables from Khorsabad, and the fact that these three lions' paws were found together provides further confirmation of this.          JEC

9th–7th century BC
From Nimrud, Trench P near centre of acropolis
    mound
86  WA 48-11-4,84
Extant H 10.9 cm, max. W 11.4 cm
87  WA 48-11-4,85
Extant H 14.0 cm, max. W 10.9 cm
88  WA 48-11-4,86
Extant H 11.2 cm, max. W 10.5 cm
Layard 1849a: pl. 96.2–3. Thompson 1963: 129,
    fig. 3

## 89  Stone head of a woman

This head of a woman, disc-shaped at the top and made of limestone, has been much burnt. A decorative fillet, or braid, marked by small holes for inlay, runs across her forehead and down the sides of her face, probably following the hairline. The stone was originally inlaid with glass, light blue or red in colour. At the back of the head, her hair falls down in four tresses. There is a circular hole through the centre of the head, about 3.5 centimetres in diameter, by which it was probably mounted on a wooden shaft. On each side of the head are small dowel holes, through which it must have been fixed to the shaft by nails. The carving is crude and the head has a lifeless, wooden appearance that is more familiar in Syrian than Assyrian art. Stylistically, too, it may be compared with ivory heads which have been identified as Syrian products.

This is one of at least three examples found together in a shrine. Layard conjectured that they 'may have been parts of a

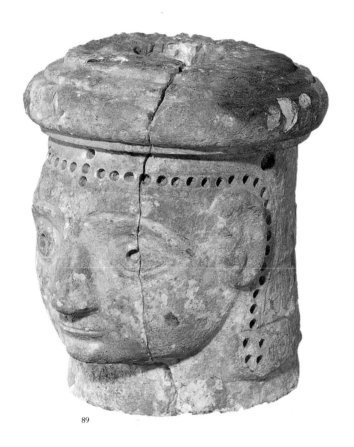

89

90

## 90 Rock crystal inlay

When it was found by Layard this oval piece of ground quartz or rock crystal was immediately identified as a lens, and it has come to be known as the 'Nimrud lens'. One surface is plane and the other convex, and it could certainly have been used as a crude magnifying glass, with a focal length of 12 centimetres from the plane surface. Over the years it has been examined by a number of opticians (e.g. Gasson 1972), many of whom believe that it was deliberately manufactured as a lens. However, although this piece of rock crystal has been carefully ground and polished, and undoubtedly has optical properties, these are probably accidental. There is no evidence that the Assyrians used lenses, either for magnification or for making fire, and it is much more likely that this is a piece of inlay, perhaps for furniture. This is supported by Layard's statement that this object 'was buried beneath a heap of fragments of beautiful blue opaque glass, apparently the enamel of some object in ivory or wood, which had perished' (Layard 1853: 198). JEC

9th–8th century BC
From Nimrud, North-West Palace, Room AB
WA 90959
L 4.2 cm, W 3.45 cm, max. TH 0.64 cm
Layard 1853: 197–8. Gorelick and Gwinnett 1981: figs 7a–b

throne or altar, or of some architectural ornament' (Layard 1853: 362). It is certainly possible that the heads are from a piece of furniture, but if so it is a type not shown on the Assyrian reliefs. In Egypt, however, human heads do appear at the front of seats, as on the chair of the Eighteenth Dynasty princess Sitamum (Baker 1966: fig. 68, col. pl. IVb), and this tradition might have reached Syria and Phoenicia.

One possibility is that the heads were indeed original fittings of the shrine, per-haps belonging to the throne of the goddess, but that they were made by western artists familiar with the unusual technique of decorating stone with inlaid glass. A fragment of a lifesize head in the same style, also in the British Museum (WA 139615), may have belonged to the statue of the goddess herself. JEC/JER

9th century BC
From Nimrud, Temple of Ishtar Sharrat-niphi
WA 92234
H 12.5 cm, max. W 11.35 cm
Layard 1853: fig. on p. 362. Barnett 1975: 46, figs 8a–b

## 91 The Lioness and the African

Ivory plaque showing a lioness mauling an African. The lioness is standing over her victim, who has his knees drawn up and is lying back supported by his hands on the ground behind him. The lioness is biting his throat. The African wears a short kilt covered in gold leaf. The tight curls of his hair are indicated by gilt-topped ivory pegs. In the background are lotus and papyrus flowers, covered in gold leaf and inlaid with lapis lazuli and cornelian. There is also a spot of lapis lazuli inlay on the forehead of the lioness. On the top of the plaque are two square mortise-holes and an incised letter *aleph* in West Semitic script, while on the base are two rectangular holes and another incised *aleph*.

This plaque was found with an almost identical example which is now in the Iraq Museum, Baghdad. They were recovered at great risk to the excavators from the sludge at the bottom of an ancient well. From the same place came a fine collection of luxury items, including two splendid ivory heads popularly known as the 'Mona Lisa' (see p. 15, Fig. 7) and the 'Ugly Sister'. The two Lioness and African plaques probably come from an ornate piece of furniture, but it is not known exactly what. They show strong

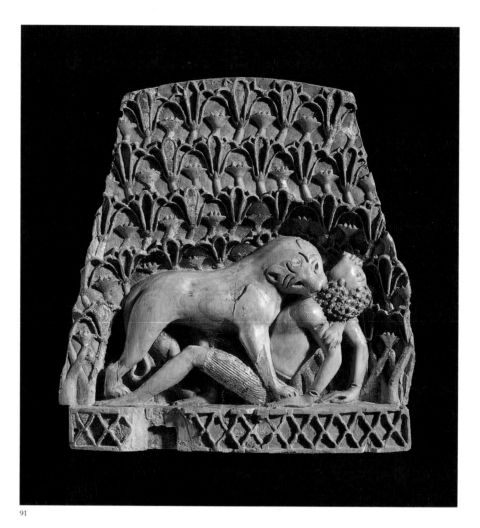

91

Phoenician influence, and were probably carved by a Phoenician craftsman. They are amongst the finest examples of ivory-carving to have survived, not just from Assyria but from the ancient world. JEC

9th–8th century BC
From Nimrud, North-West Palace, well in Room MM (ND 2548)
WA 127412
H 10.35 cm, W 10.2 cm, max. D 2.45 cm
Mallowan 1966: I, 139–44, figs 81–2, 84. Barnett 1975: 190, O.1, frontispiece

## 92 Striding sphinx

Ivory panel in openwork showing a male human-headed winged sphinx walking amongst flowering plants. He wears the double crown of Upper and Lower Egypt, and hanging from his chest is an apron with a projecting uraeus (cobra). This sphinx may be compared with the falcon-headed sphinxes on a bronze bowl from Nimrud (no. 100); like them it has the Egyptian double crown and the apron

with attached serpent. This ivory panel, like the bronze bowl, shows strong Egyptian influence and was probably made by a Phoenician craftsman.  JEC

9th–8th century BC
From Nimrud, Fort Shalmaneser, Room SW11/
 12 (ND 12132)
WA 134322
H 6.9 cm, W 7.75 cm
Barnett 1975: 235, Suppl. 33, pl. CXXXIV

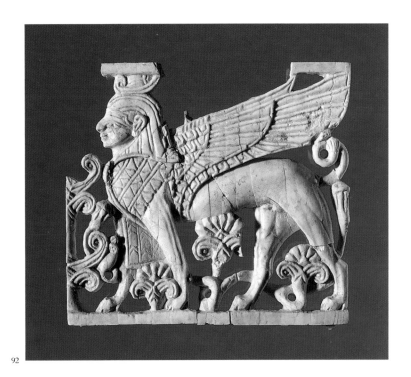

92

## 93  Woman at the window

Ivory panel showing a 'woman at the window'. She has a full Egyptian hairstyle and wears a necklace. The window-sill is supported by four palm columns. The scene is set within a recessed frame and at the top and bottom of the panel there are tenons for attachment. On the back is incised twice the letter *gimel* in West Semitic script. It is often thought the woman is a sacred prostitute, but the exact significance of the scene is unclear.

This panel is one of a group found by Layard and further examples come from Mallowan's excavations at Nimrud, both in the North-West Palace (Mallowan 1952: pl. XIII) and in Fort Shalmaneser (Mallowan 1966: II, figs 429, 554–5). There are examples from the Nabu Temple at Khorsabad (Loud and Altman 1938: pls 51–2). Further afield, there are collections from Arslan Tash in Syria (Thureau-Dangin *et al.* 1931: pls XXXIV–XXXVI) and to a lesser extent from Samaria in Israel (Crowfoot and Crowfoot 1938: 29–30, pl. XIII.2). Double versions of these plaques can be seen decorating the legs of the couch on which Ashurbanipal reclines in the famous banquet scene at Nineveh (see p. 122).  JEC

9th–8th century BC
From Nimrud, North-West Palace, Rooms V–W
WA 118159
H (including tenons) 11 cm, W 8.85 cm
Layard 1849: pl. 88.3. Barnett 1975: 172–3, C.12,
 pls IV, CXXXII

93

## 94 King holding a lotus

Ivory panel showing a man identified as a king by the uraeus at the front of his cap. He grasps the stalk of a gigantic lotus flower. His dress is short, coming to just above the knees, and over it is a cloak. At the top and bottom of the panel are tenons for attachment. On the front of the lower right-hand tenon is incised the letter *bet* in West Semitic script. This panel is one of half a dozen similar examples found together by Layard; on three of them the figure faces left and on the others it faces right. These panels were presumably fixed together in a series.　JEC

9th–8th century BC
From Nimrud, North-West Palace, Rooms V–W
WA 118147
Overall H (including tenons) 10.3 cm, W 6.0 cm
Layard 1849: pl. 88.1. Barnett 1975: 171, C.4,
　pl. III

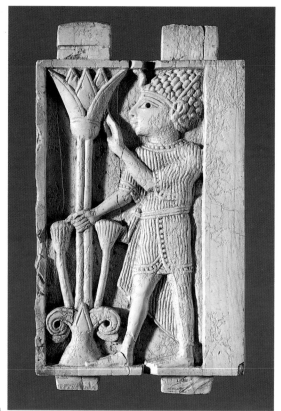

94

## 95 Human head

Part of an openwork ivory panel in high relief, blackened by fire. It shows a beardless human head with a plain Egyptian hair-style. Resting on the head is a disc, probably the sun, framed by an uraeus. A sun-disc resting directly on the head is unusual in Egyptian art, showing the artistic licence enjoyed by the Phoenician artists responsible for such panels.　JEC

9th–8th century BC
From Nimrud, Burnt Palace
WA 118199
H 8.4 cm, W 5.7 cm
Barnett 1975: 217, S.340, pl. XCVI

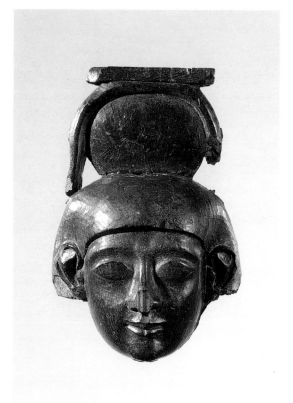

95

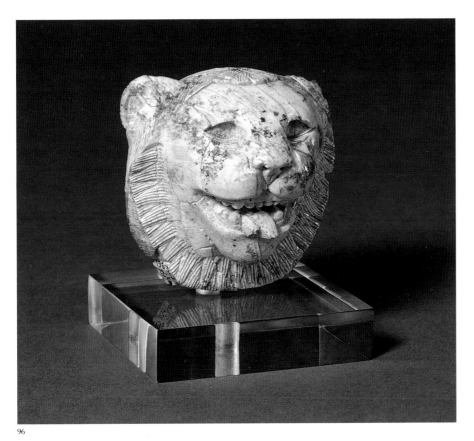

96

## 96 Lion's head

This head is in very high relief. The back is flat with a rectangular mortise for attachment. It probably comes from a piece of furniture: in Egypt lions' heads sometimes appear at the front of thrones, as on the throne from the tomb of Tutankhamun (Baker 1966: col. pl. VI) and this tradition might have passed into Phoenician art. On an Assyrian relief of Sargon a table is shown with lions' heads at the corners (Albenda 1986: pl. 50). JEC

9th–8th century BC
From Nimrud, Fort Shalmaneser, Room SW11/
   12 (ND 12070)
WA 134320
H 5.5 cm, W 5.4 cm, D 3.85 cm
Barnett 1975: 235, Suppl. 32, pl. CXLI

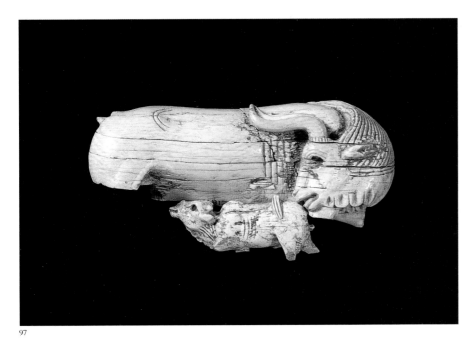

97

## 97 Cow and calf

Part of an openwork ivory panel showing a cow in high relief, looking back over its shoulder, and a suckling calf. The two pieces are not certainly related, but the form of such plaques is well known. Fragments of at least nine plaques of this kind were found together by Layard in the North-West Palace at Nimrud, and a number of examples come from the excavations at Arslan Tash in north Syria (Thureau-Dangin et al. 1931: pls XXXVII–XLII). Partly because of this, such plaques are thought to be the products of a Syrian ivory-carving centre. JEC

9th–8th century BC
From Nimrud, North-West Palace, Rooms V–W
Cow: WA 118129
H 3.3 cm, W 8.0 cm
Calf: WA 123827
H 1.5 cm, W 4.1 cm
Layard 1849a: pl. 91.32. Barnett 1975: 174, C.23,
   C.31, pl. V

## 98 Figure beside a tree

Two fragments of a panel that originally showed two figures under a winged disc, the tail of which is an inverted palmette. From it hang bunches of fruit, probably dates or grapes. The one surviving figure, probably male, is beardless and wears a long dress. From one hand is suspended a mace (see nos 179–81), and with the other he picks fruit.

This panel was apparently found with two or three similar examples. They show Assyrian influence, and are possibly the products of an Assyrian school of ivory-carving. This plaque is carved in low relief, in contrast to most Assyrian-style ivories, which are incised.                JEC

9th–8th century BC
From Nimrud, North-West Palace, Room AA(?)
WA 118115
H 10 and 12.5 cm, W of each 4.5 cm
Rawlinson 1871: I, fig. on p. 573. Barnett 1975: 183–4, F.2, pl. XII

## 99 Gaming board

A large fragment from an exotic stone gaming board of red mottled marble, the track for the pieces being indicated by holes, some marked with rosettes. The edge of the board is decorated with a relief frieze showing winged and human figures, and quadrupeds. The game, sometimes called the 'game of fifty-eight holes', was a race game for two players, played with stick pieces which moved round the track at the throw of dice. The game first appears in Egypt before 2000 BC, and was popular there and across the Ancient Near East throughout the second and first millennia BC. Many discoveries show it to have been played at all levels of society. The present example is one of several evidently expensive and prized boards excavated by Layard. It is inscribed in cuneiform, revealing that it was the property of Esarhaddon, king of Assyria.                ILF

680–669 BC
From Nimrud or Nineveh
WA 123333
L 12 cm, W 15 cm, TH 7.5 cm
Gadd 1934: 47

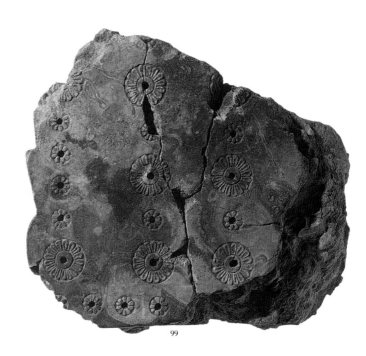

98

99

# 5 VASES AND VESSELS

For vases, vessels and other containers we have three rich veins of evidence: the finds themselves, depictions on the Assyrian reliefs, and descriptions in contemporary cuneiform texts. In the latter case, although we are often told what was in the vessels and other interesting contextual information, it is sometimes difficult to know the shape and form of the vessels that are being referred to. Happily this is not the case with the reliefs, but here we have different problems. We do not know what the vessels depicted contained, and no doubt the range of types shown is highly selective. The actual finds are a mine of information, but sometimes we cannot distinguish between Assyrian products and material imported from abroad. However, in spite of these problems, the combined evidence from the various sources gives us a good picture of the sorts of vases and vessels in use in Assyria.

A particularly good indication of the material in use at the Assyrian court is provided by the contents of the tombs of Assyrian queens recently discovered in the North-West Palace at Nimrud by the Iraq Department of Antiquities. They demonstrate the extraordinary richness of Assyrian material culture. Accompanying the bodies of these Assyrian queens were containers in silver and rock crystal and above all a splendid series of gold bowls, the most magnificent of which, in the Phoenician style, has in the centre a crocodile surrounded by boats in a papyrus thicket. There were also carved wooden boxes with lids, these being among the rare examples of wooden artefacts to survive from ancient Mesopotamia.

We also get an indication of the vessels in use at the Assyrian court from the Assyrian reliefs. Thus, the bowls being held by both kings and queens at feasts and at important ceremonial occasions are of the distinctive Assyrian type with carinated shoulders and flared rim. These bowls are generally shown resting on the fingers of one hand. It is also from such a bowl that Ashurbanipal pours a libation over dead lions after one of his hunts. At a banquet represented on reliefs of Sargon, there are also large cauldrons on conical stands. These appear together with lion-headed buckets and lion-headed drinking cups, and probably made up sets for drinking wine. Animal-headed drinking cups were also made in pottery, and there are good examples from Nimrud and Khirbet Khatuniyeh. Layard found twelve bronze cauldrons in Room AB of the North-West Palace, but none of them now survives. They may have been Assyrian, but were more probably imported from the west with the tripods and other material found in this room. A large hoard of bronze bowls was also found here, some of which may have belonged

Late Assyrian ram-headed drinking-cup from Khirbet Khatuniyeh in the Eski Mosul Dam Salvage Project.

to wine sets of the type described above. For religious and ceremonial occasions, other types of vessel were used. For example, the reliefs show elaborately decorated buckets being carried by winged genies in a ceremony thought to have involved fertilising date-palms. Pine-cones are dipped into the buckets, which probably contained pollen.

In more ordinary contexts, and particularly amongst the common people, pottery was undoubtedly the main material used for containers. We know from the archaeological record that vast quantities of pottery were in use, in a wide variety of forms ranging from tiny cosmetic containers to large storage jars. Pottery was even used for making coffins. When a more prestigious product was required, coffins of the same shape were made in bronze.

Because of the scarcity of most types of wood in Mesopotamia, it may never have been widely used for vessels and boxes. Ivory must have been highly prized, and carved boxes in this material were no doubt restricted to a limited circle.

JEC

## THE NIMRUD BOWLS

On 5 January 1849 Layard made a remarkable discovery in Room AB of the North-West Palace at Nimrud, the so-called 'Room of the Bronzes'. Behind the twelve cauldrons found in this room was a pile of bronze bowls which proved to be of extraordinary interest. Layard himself described the find as follows:

In one place were piled without order, one above the other, bronze cups, bowls, and dishes of various sizes and shapes. The upper vessels having been most exposed to damp, the metal had been eaten away by rust, and was crumbling into fragments, or into a green powder. As they were cleared away, more perfect specimens were taken out, until, near the pavement of the chamber, some were found almost entire. Many of the bowls and plates fitted so closely, one within the other, that they have only been detached in England. It required the greatest care and patience to separate them from the tenacious soil in which they were embedded. Although a green crystalline deposit, arising from the decomposition of the metal, encrusted all the vessels, I could distinguish upon many of them traces of embossed and engraved ornaments.

The bowl at the bottom of the heap was in a particularly good state of preservation:

Part of the bronze was still bright, and of a golden colour; hence the report spread at the time of the discovery, that an immense treasure in vessels of gold had been dug up at Nimrud. (Layard 1853a: 182–6)

Apart from those bronze bowls recovered from the pile, a few more were found in some of the cauldrons. Layard reports (1853: 190–91) that about 150 of these bronze vessels were brought back to the British Museum, but not all can now be accounted for and many are fragmentary. Many of the bowls have intricate chased or incised decoration on the inside, and sometimes the designs are embossed or raised from the back. There is a variety of decorative schemes, but friezes of animals

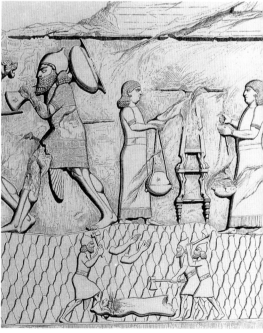

Drawing of a relief from the palace of Sargon showing Assyrians weighing booty from Musasir (Botta and Flandin 1849–50: II, pl. 140).

CXXIV

*Arabs at a well.*

and hunting scenes are most common, alongside bowls with complex floral and geometric patterns. There is a marked preponderance of Egyptian or Egyptianising motifs, such as sphinxes, scarab-beetles, uraei (cobras) and even degenerate Egyptian hieroglyphs. Just as there is a variety of designs, so there are different shapes, ranging from almost flat plates to deep basins. Some have handles in the form of rings or loops fixed to the side of the bowl. Many of the bowls are quite plain, or almost so, and amongst these are some which, because of their shape, can be regarded as native Assyrian products.

Where did these bowls come from? Groups of comparable bowls are known from Cyprus, from the Idaean Cave in Crete, from a number of Greek shrines such as Olympia and Delphi, and from some Etruscan tombs in Italy. But, just

as most of the Nimrud bowls were imported, so might these others have been. In fact, the decoration on these bowls, with the extensive use of Egyptian motifs, friezes of animals and combat scenes, points to centres of production in the western part of the Ancient Near East. Many are clearly the work of Phoenician artists, but there are north Syrian elements as well, and possibly also Palestinian. To judge from the wide range of designs, there must have been many different centres of production. Unfortunately it is very difficult to localise them, as we simply do not have enough evidence at present, but Phoenician cities such as Tyre and Sidon and Syrian centres such as Hama, Damascus and Tell Halaf are all likely candidates. Some bowls may even have been made on Cyprus. As far as we can tell, nearly all the bowls belong to the

Watercolour by F. C. Cooper, 1850, showing excavations in the Room of the Bronzes at Nimrud.

ninth or eighth century BC. Some nine of the Nimrud bowls are inscribed with names which are presumably those of their original owners, and it might be thought that these would be helpful in determining provenance. Eight have West Semitic alphabetic inscriptions (Barnett 1967: 4–7; 1974: 16–17), but there is much argument about whether the inscriptions are Phoenician, Aramaic or Hebrew. Barnett has suggested (1969: 22–4, fig. 9) that the ninth inscription might be Lydian.

The bowls are thus unlikely to have been made at Nimrud, even by foreign craftsmen working there, and were presumably brought as booty or tribute by one of the kings who campaigned in the

west, such as Tiglath-pileser III or Sargon. It is known from contemporary Assyrian accounts that vast quantities of booty were removed from captured cities. For example, when Sargon sacked the Urartian city of Musasir during his eighth campaign in 714 BC, he carried away hundreds of bronze and silver bowls and other vessels. Why the bowls came to be piled up in a palace room at Nimrud is unknown. Perhaps this room contained mainly booty or tribute brought from abroad, or perhaps it was simply a store-room for valuable material. The presence in the hoard of a small number of bowls of native Assyrian origin – distinguished by their carinated shoulders and flared rims – perhaps supports this, but they could also have reached a non-Assyrian centre and in due course been reimported to Assyria. JEC

## 100 Bronze bowl

Shallow bronze bowl with gently curving sides and a slightly raised central part. Four pairs of winged falcon-headed sphinxes confront each other. The sphinxes wear aprons with projecting uraei and the double crown of Upper and Lower Egypt. Each has a front paw resting on the head of a human figure with hands raised in adoration. Between the confronted sphinxes are papyrus columns, and above them winged sun-discs, while between each pair of sphinxes is a large papyrus column supporting a winged scarab beetle holding a sun-disc with double uraei. In the centre of the bowl is a floral motif surrounded by five friezes of lotus flowers. There are bands of cable pattern above and below the sphinxes.

This bowl is classified by Barnett among the 'marsh pattern' bowls of his group I (1974: 21–2), which are characterised by the extensive use of what is in fact 'a very degenerate lotus-pattern'. There is at least one other bowl from Nimrud with papyrus columns and sphinxes (Layard 1853a: pl. 68, top centre = N12), and two comparable examples from the Idaean Cave in Crete (Markoe 1985: 234–5, Cr 2–3). The 'marsh pattern' is quite common amongst the Nimrud bowls. The clearly Egyptian character of the motifs on this bowl indicates that it was made in a workshop much influenced by Egyptian taste, probably in Phoenicia.

JEC

9th–8th century BC
From Nimrud, North-West Palace, Room AB
WA 115505
DIAM 21.7 cm, H 2.85 cm
Layard 1853: 185–6, no. 1. Layard 1853a: pl. 63.
   Barnett 1967: pl. 11. Barnett 1974: pl. x

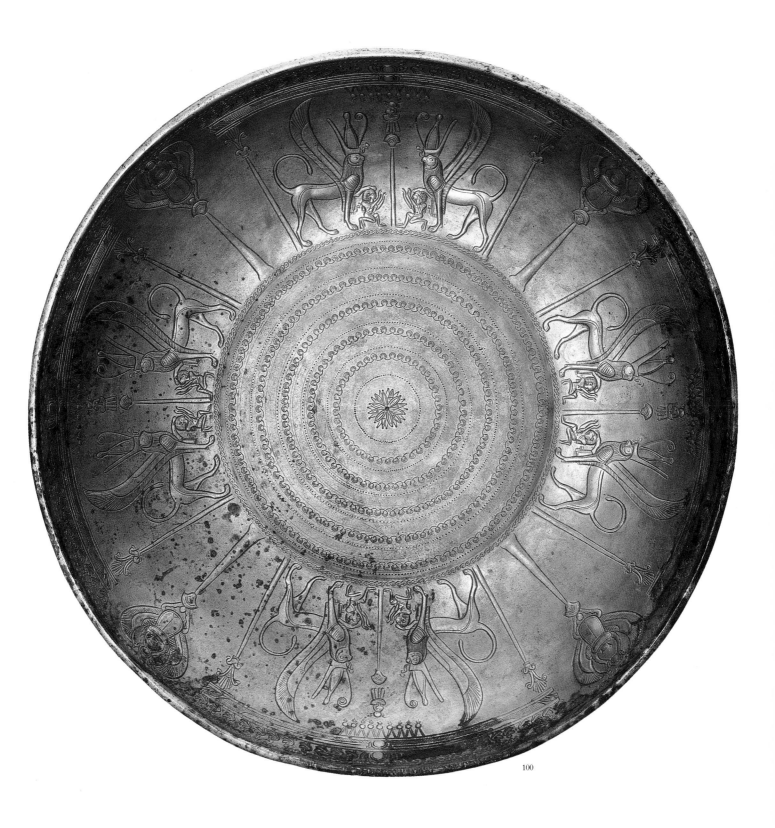

100

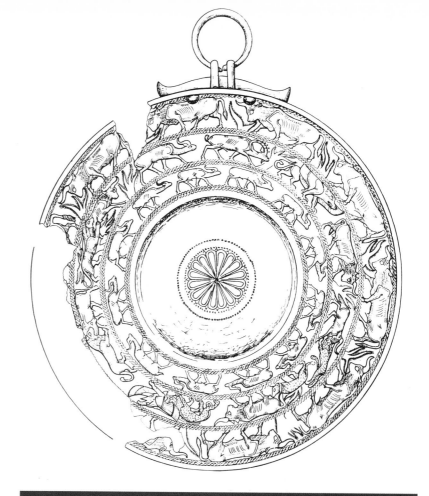

## 101 Bronze bowl

A large bronze bowl with circular base, slightly raised in the centre, angular shoulders and flared rim. A handle in the form of a bar-shaped attachment with two projecting lugs which support a bronze ring is fixed to the outside of the rim by two rivets. The bowl is mostly complete, but some sections of the rim and wall are missing.

The design consists of a flower pattern in the centre and, around the outside, three continuous friezes of animals separated by bands of cable pattern. The middle register is the most complicated and features bulls, gazelles, ibexes and winged lion-griffins. Some of these animals are being attacked by lions and leopards. In the outer register there are bulls, and in the inner register gazelles.

Markoe (1985: 17) regards this type of bowl, with a flower in the centre surrounded by two or three bands of animals in procession, as 'Syrianising'. This bowl is one of a number of examples from Nimrud and elsewhere that have ring or loop-shaped handles fixed to a bar riveted to the side of the bowl. Barnett includes them in his group 3, which he calls 'swinging-handle bowls' (Barnett 1974: 22–3). Processions of bulls, such as in the outer register here, figure largely on Syro-Phoenician bowls, sometimes being the only or the dominant motif. These latter are called bull-bowls, and are characterised by a distinctive central design which Barnett calls a 'rosebud' (Barnett 1974: 18–20; Falsone 1985).          JEC

9th–8th century BC
From Nimrud, North-West Palace, Room AB
WA N29
DIAM 27.1 cm, H 4.7 cm
Layard 1853: 183–4, no. 2. Layard 1853a: pl. 60.
  Markoe 1985: 356, comp. photo 2

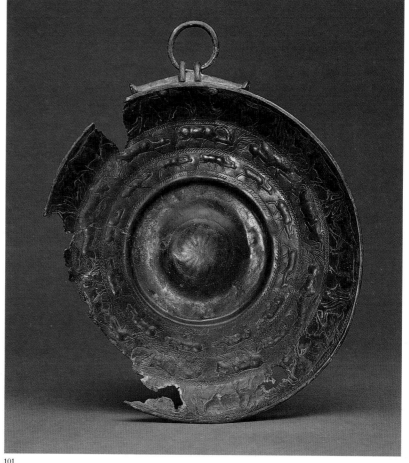

101

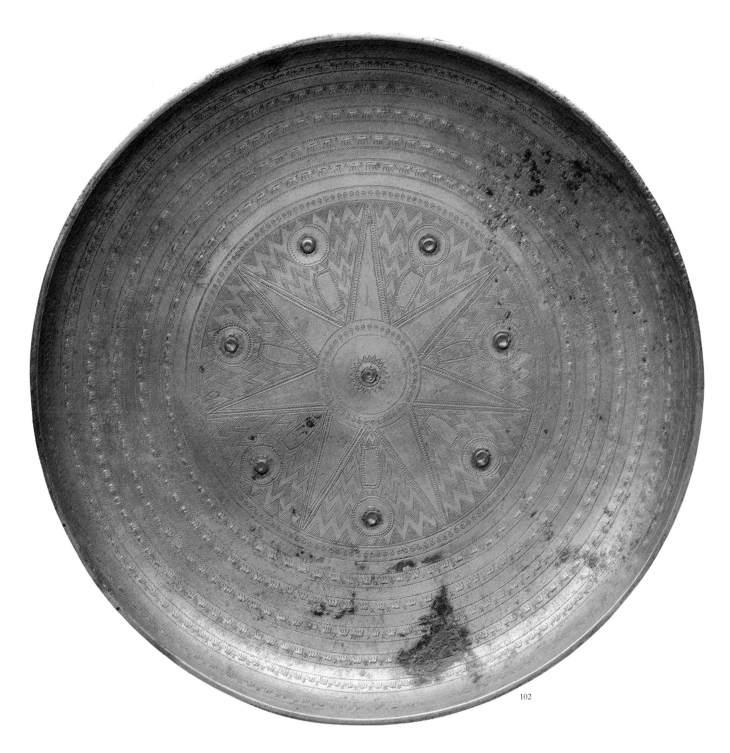

102

## 102 Bronze bowl

A shallow bronze bowl with curved sides and flat base. The decoration is dominated by a large seven-pointed star in the centre. Between the rays of this star are inlaid silver studs and zigzag patterns, a decorative effect which suggests to Barnett 'a shimmering, blinding light' (1974: 23). In the centre of the star and around its edges are bands of lotus flowers. Around the star are seven bands of tiny animals in procession. The representations are schematic, but the prominent horns show that the animals are meant to be stags or goats. There are about a dozen bowls of this type from Nimrud. Barnett calls them 'star bowls' and classifies them in his group 4. He believes they may be the products of an Aramaic-speaking centre, presumably in Syria.    JEC

9th–8th century BC
From Nimrud, North-West Palace, Room AB
WA NI
DIAM 21.85 cm, H 2.55 cm
Layard 1853: 188, no. 7/8. Layard 1853a: pl. 59C

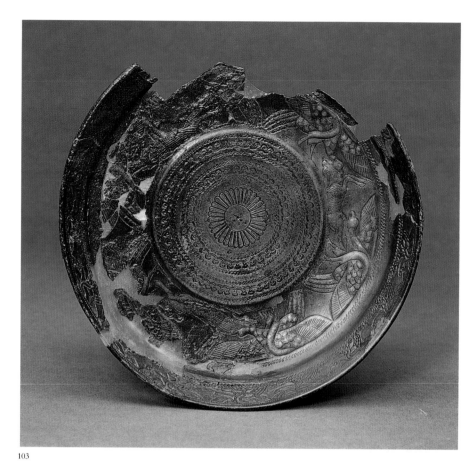

103

## 103 Bronze bowl

A shallow bronze bowl with slightly rounded base and flared rim. Sections of the rim and base are missing. In the centre of the bowl is a flower pattern surrounded by friezes of lotus flowers. Around this is a scene showing vultures tearing at animals with rough coats which are probably boars. Around the inside of the rim are more vultures, and on the outside is a five-letter West Semitic alphabetic inscription which has been translated 'belonging to Abipat' (Barnett 1967: 3). On the underside of the bowl is a large incised flower.

Barnett believes the decoration on this bowl to be in Syrian style and even identifies the place of manufacture as Hama, but this is speculative. Vultures were common in the Ancient Near East, and are shown both on Assyrian reliefs (e.g. Barnett and Falkner 1962: pls XLI, LXVI–LXVII) and on Nimrud ivories (Barnett 1967: pl. V.2). JEC

9th–8th century BC
From Nimrud, North-West Palace, Room AB
WA N19
DIAM 19.3 cm, H 2.55 cm
Layard 1853: 188, no. 6. Layard 1853a: pl. 62B.
 Barnett 1967: pl. V.I

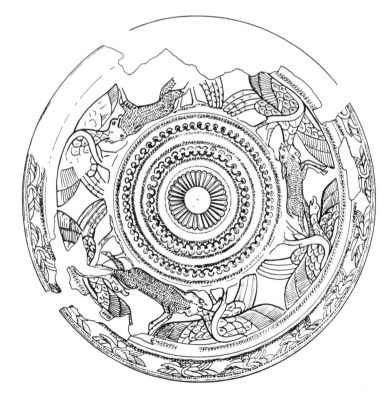

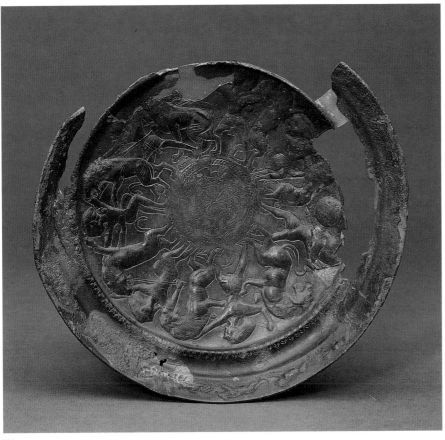

104

## 104 Bronze bowl

A bronze bowl with rounded base, angular shoulders and flared rim. Part of the rim and some of the base is missing. The main decoration on this bowl consists of alternating figures of a hero and a rampant lion engaged in combat. The human figure has an Egyptian hair-style and wears a kilt of Egyptian shape. He is armed with a spear or sword, with which he attacks the lion. In the centre of the bowl is a flower pattern surrounded by a frieze of gazelles and a lion, framed between bands of cable pattern. Around the inside of the rim is a frieze of running dogs, possibly in pursuit of a hare. On the shoulder, both inside and outside the bowl, are bands of segmented decoration.

Markoe believes that this and another Nimrud bowl showing a lion hunt (Layard 1853a: pl. 65; Markoe 1985: 358, comp. photo 4) are closely related to his 'Cypro-Phoenician group' (Markoe 1985: 18). JEC

9th–8th century BC
From Nimrud, North-West Palace, Room AB
WA N17
DIAM 22.9 cm, H 3.95 cm
Layard 1853: 186, no. 2. Layard 1853a: pl. 64.
  Markoe 1985: 357, comp. photo 3

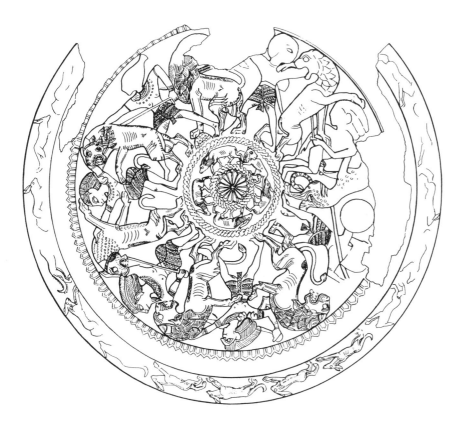

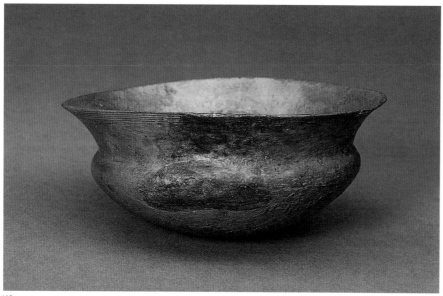

105

### 105 Bronze bowl

A carinated bronze bowl with flared rim. Plain except for a group of five incised lines running around the outside of the rim.

The distinctive carinated shape of this and related bowls identifies them as Assyrian, as bowls of this shape are shown on the Assyrian reliefs and were manufactured in large quantities in pottery. About six bronze bowls of comparable type were found in the Room of the Bronzes, and Mallowan found a fine example in a grave in Room DD in the North-West Palace (Mallowan 1966: I, fig. 59). The bowls are mostly plain, but several have an incised flower pattern or rosette in the centre surrounded by concentric circles. All have incised lines on the outside of the rim.

9th–8th century BC　　　　　　　　JEC
From Nimrud, North-West Palace,
　Room AB
WA 91297
DIAM 13.2 cm, H 5.4 cm

### 106 Spouted bronze bowl

A bronze spouted bowl with strap handle. The spout is open at the top, and the wide, flat handle is decorated with ribbed mouldings.

This spouted bowl would have been used as a dipper ladle. Such ladles belong with cauldrons, strainers and bowls, forming wine sets which might have been used at banquets. In fact, a bronze bowl-shaped strainer was found in the same

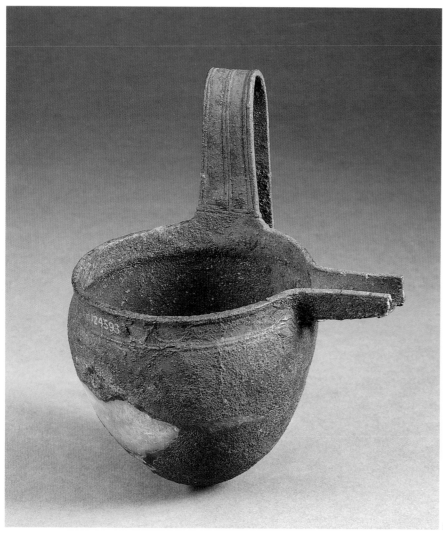

106

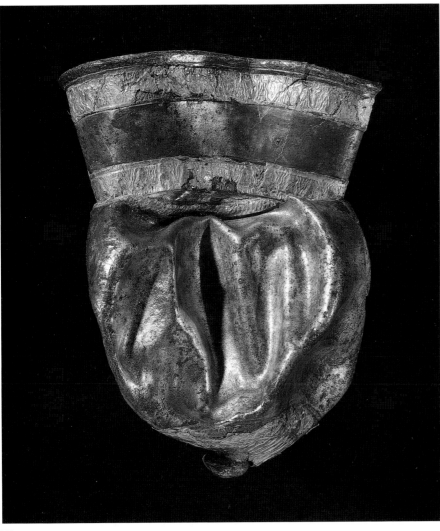

107

mal's head, a perforated base to act as a strainer and another strainer at the top of the spout. There is a spouted bowl with strap handle from Tell Halaf in Syria, and a similar vessel is shown on a sculpture at Karatepe in southern Turkey (Barnett 1974: figs 6–7). Both are quite close parallels to our Nimrud example. Such vessels are also found in Cyprus (Matthäus 1985: pl. 48). JEC

9th–8th century BC
From Nimrud, North-West Palace, Room AB
WA 124593
Overall H 15.6 cm, overall W 14.3 cm, DIAM of bowl 10.5 cm, H 9.15 cm
Layard 1853: 181, fig. top right

## 107 Silver beaker

A silver beaker with rounded body, flared rim and 'nipple' base, now crushed flat. There are two bands of gold leaf overlaying incised geometric and floral decoration on the neck and another at the base. The 'nipple' forms the centre of a rosette, the petals of which are also covered with gold leaf. Beakers of similar shape are known in pottery from Nimrud and Ashur. This example was found hidden beneath a floor, together with a silver bowl with gadroons ending in lions' heads which is now in the Iraq Museum, Baghdad. JEC

8th–7th century BC
From Nimrud, Fort Shalmaneser, Room C6 (ND 7485)
WA 132698
H (in crushed state) 12.3 cm, W 9.6 cm
J. Oates 1959: pl. XXXIVb. Mallowan 1966: II, 427–8, fig. 356

cauldron as this ladle (Layard 1853: 181, fig. bottom right). There were several other dipper ladles, or fragments, in the hoard of bronzes from Nimrud, and a clearly Assyrian example was obtained by Sir William Temple in Italy (Moorey 1980: 188–92, figs 2–4, pl. 111b). This vessel has elaborate incised decoration in the Assyrian style, a handle ending in an ani-

## TRIPODS

In association with the twelve bronze cauldrons in the Room of the Bronzes at Nimrud, Layard found parts of a number of tripods which must have supported them. He tells us that 'beneath the cauldrons were heaped lions' and bulls' feet of bronze; and the remains of iron rings and bars, probably parts of tripods, or stands, for supporting vessels and bowls; which, as the iron had rusted away, had fallen to pieces, leaving such parts entire as were in the more durable metal' (Layard 1853: 178–80). Altogether there are remains of at least sixteen tripods, suggesting that originally there may have been more than a dozen cauldrons in this room. All the tripods stood on bronze feet of bulls' hooves or lions' paws. These were attached to iron rods and there was an iron ring on the top for supporting the cauldron. The iron rods were fixed together by bronze jointing pieces. These bronze parts were apparently cast over the iron rods, testifying to a high degree of technical competence. A complete tripod has been reconstructed from surviving parts and is now in the British Museum (Barnett 1967: pl. 1.3). In this example the feet have just two rods springing out of them, but others have another rod coming from the back of the foot. Two of the jointing pieces have West Semitic inscriptions, which may well be original, giving the names of the owners.

The origin of these rod tripods is clearly closely linked to that of the cauldrons with which they are associated, and any discussion of where they were made must take account of where the cauldrons come from. On the Assyrian reliefs there is very limited evidence for cauldrons, and it seems they were not an important element in Assyrian material culture. On the contrary, the cauldrons with elaborate attachments, chiefly siren figures and bulls' heads, which have been found in various parts of the Ancient Near East as well as in areas to the west, were probably made in north Syria and the surrounding area (Muscarella 1992: 21–2). It is very likely that the rod tripods were also manu-factured here, although they are now widely distributed. For example, there is a very fine rod tripod (with bronze rods) on bulls' feet from Altin Tepe in Urartu (Azarpay 1968: pl. 30), and parts of a tripod from Kourion in Cyprus with bulls' feet, iron rods and bulls' heads on the ring at the top (Matthäus 1985: pls 110–11). They are also known from Greece and Italy (Riis 1939; H.-V. Herrmann 1979), although in these cases they are often copies of oriental forms. For the Nimrud tripods, the inscriptions perhaps support a Syrian origin.　　　　JEC

Bronze and iron tripod from Nimrud reconstructed from original parts. British Museum.

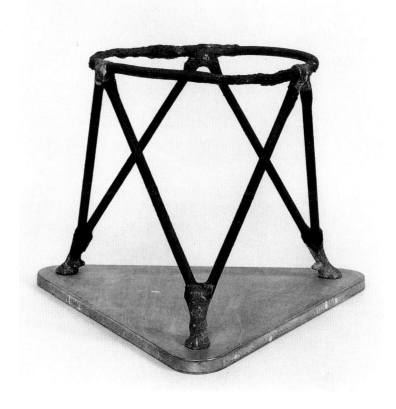

## 108–10 Bull's-hoof tripod feet

Three bronze bulls' hooves from a tripod, with pronounced dew claws or sesamoids on the back of the leg. Each has remains of two iron rods on top of the leg and another at the back. The bronze was apparently cast over the iron rods.    J E C

9th–8th century B C
From Nimrud, North-West Palace, Room AB
**108**  W A N235
H (standing flat) 10.6 cm, max. W (at top of leg) 3.8 cm
**109**  W A N235★
H 10.6 cm, max. W 4.4 cm
**110**  W A N254
H 10.6 cm, max. W 4 cm
Layard 1853: fig. on p. 178. Barnett 1967: pl. I.4

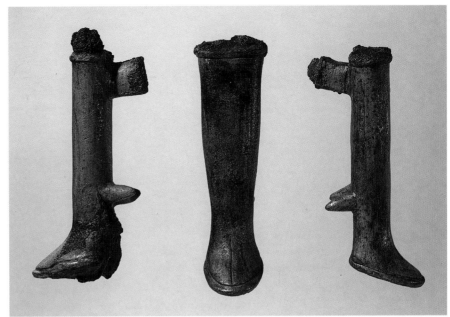

108–10

## 111–13 Lion's-paw tripod feet

Three lions' paws from a tripod with a stud or peg on the base. Each has remains of two iron rods on top of the leg. As with the bulls' hooves (nos 108–10), the bronze was apparently cast over the iron rods.    J E C

9th–8th century B C
From Nimrud, North-West Palace, Room AB
**111**  W A N265
H (including peg) 7.9 cm, max. W (at top of leg) 4.9 cm
**112**  W A N266
H 8 cm (part missing at top)
**113**  W A 118010
H 8 cm, max. W approx. 5.1 cm
Layard 1853: figs on p. 179

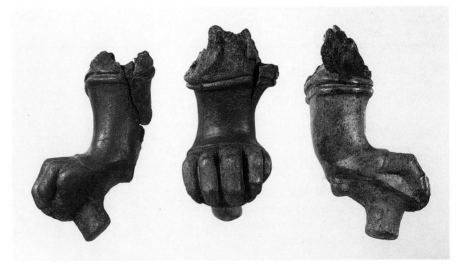

111–13

## 114 Tripod jointing piece

Rectangular bronze jointing piece from the ring at the top of a tripod which held together four iron rods. Remains of the iron rods project from the two ends of the jointing piece. The bronze has been cast over the iron rods. On the side there is a West Semitic alphabetic inscription which reads *lmwqr*, 'belonging to Mwqr'.    J E C

9th–8th century B C
From Nimrud, North-West Palace, Room AB
W A N353
Max. H 4.05 cm, L (excluding rods) 13 cm
Barnett 1967: 6–7, pl. I.1. Heltzer 1978: 3, 7–8

114

## GLASS

Glass vessels are known in the Ancient Near East from as early as the second half of the second millennium BC, but in this period they were core-formed, that is, the body of the vessel was built up around a core which was afterwards removed. Vessels made in this way include some attractive mosaic glass beakers. In the Late Assyrian period, by contrast, glass vessels were cast, probably by the lost-wax method, and then finished by grinding and polishing. The latter were techniques that would have been familiar from making stone vessels. Discoveries of glass in the Assyrian ruins prompted Layard to write, 'They [the Assyrians] had also acquired the art of making glass. Several small bottles or vases of elegant shape, in this material, were found at Nimroud and Kouyunjik. One bears the name of the Khorsabad king [i.e. Sargon]' (Layard 1849: 421). Fragments of many more bowls were found at Nimrud by the British School expedition.          JEC

## 115   The Sargon vase

The glass vessel known as the 'Sargon vase' is light green and has angular shoulders and two vertical lug handles. It is cast and then ground and polished. A cuneiform inscription reads É.GAL ᵐMAN.DU MAN KUR AŠ ('Palace of Sargon King of Assyria'). The inscription is accompanied by an engraving of a lion.

This important vessel is unique and has no close parallels, either in Assyria or in neighbouring areas. Barag (1985: 61) suggests that because the shape is comparable with an Egyptian vessel in rock crystal, the Sargon vase is possibly of Phoenician origin. The inscription is certainly Assyrian, but it could have been added later. The presence of the lion is

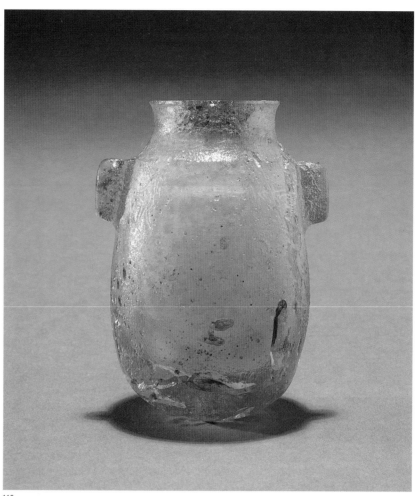

115

interesting. It often occurs in association with inscriptions of Sargon, for example on the stone vase no. 117 which was found with the Sargon vase, and is probably an official mark indicating that the article derives from or belongs to the palace or treasury of Sargon.          JEC

8th century BC
From Nimrud, North-West Palace, Room I
WA 90952
H 8.8 cm, DIAM 5.7 cm
Layard 1849: I, 343; II, p. 421. Layard 1853: fig. on p. 197. Barag 1985: no. 26, fig. 2, pl. 3, col. pl. B

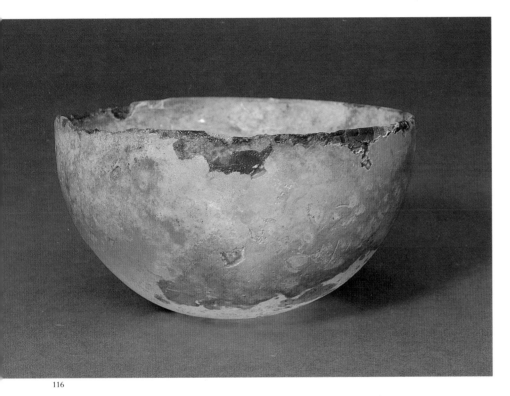

116

### 116 Glass bowl

Hemispherical bowl in light green glass, cast and then ground and polished. This bowl was found by Layard together with three others (Barag 1985: nos 28, 30–31). The similarities with the Sargon vase in terms of colour and technique are obvious and Barag (1985: caption to col. pl. c) firmly labels it as Phoenician. It was found in a room in the North-West Palace which contained much material certainly imported as booty or tribute, and this might support a foreign origin. However, we cannot completely exclude the possibility of Assyrian manufacture. JEC

8th century BC
From Nimrud, North-West Palace, Room AB
WA 91534
H 7.5 cm, DIAM 12.4 cm
Layard 1853: 196. Barag 1985: no. 29, fig. 3, pl. 3, col. pl. c

## 117 Stone vase

Alabaster vase with flat ledge-shaped rim and leaf pattern around the shoulder. On the shoulder is engraved a lion followed by an inscription in cuneiform, É.GAL <sup></sup>MAN.DU MAN KUR AŠ ('Palace of Sargon King of Assyria').

Layard tells us that beneath fallen slabs in Room I he found 'broken into a thousand fragments – a number of vases of the finest white alabaster. . . . These fragments were carefully collected, but it was impossible to put them together. I found, however, that upon some of them cuneiform characters were engraved, and I soon perceived the name and title of the Khorsabad king, accompanied by the figure of a lion' (Layard 1849: I, 342). He goes on to say that after one of the workmen discovered a complete vase which was then broken with a pick-axe, he himself took the pick-axe and, working carefully, found another complete alabaster vase (the present example) and the glass vase of Sargon (no. 115).                JEC

8th century BC
From Nimrud, North-West Palace, Room I
WA 91639
H 17.6 cm, DIAM 9.4 cm
Layard 1849: I, 343. Layard 1853: fig. on p. 197

## TRIDACNA SHELLS

Engraved shells of the giant clam *Tridacna* have been found in early first millennium BC levels at a number of sites in the Ancient Near East and beyond. This large bivalve is an Indo-Pacific shell, and occurs both in the Gulf and the Red Sea. Usually the bulbous umbo or hinge is sculpted in the form of a human head and there are outstretched wings on the back of the shell. This is supplemented by elaborate engraved decoration on the outside of the shell and sometimes on the inside as well. The decoration is sometimes related to the head, and shows a winged being, but on other shells the designs are independent and include elaborate compositions such as banquets and scenes of warfare and hunting. Lotus flowers and buds are a frequent background motif.

More than a hundred of these shells are known, found at sites ranging between Iran and Greece and including Egypt. However, perhaps the largest group comes from Mesopotamia, divided more or less equally between Assyria and Babylonia. The decoration can be related to that on some of the bronze bowls and ivories found at Nimrud and points to Syro-Phoenician workmanship. Very probably, then, examples found in Assyria were imported from the west. What these tridacna shells were used for is not quite certain, but they are most likely to have been cosmetic containers. This is supported by the fact that traces of a greenish deposit have been noticed on some shells.

                JEC

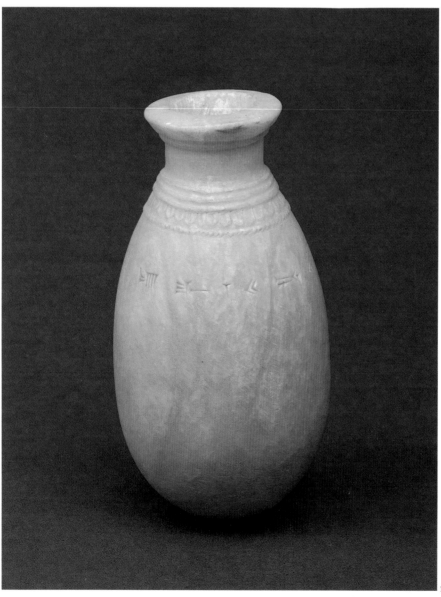

117

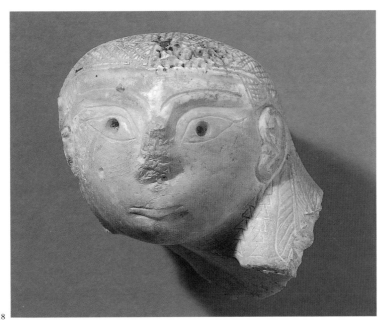

118

**118 Tridacna shell**

Umbo or hinge of a tridacna shell in the form of a woman's head. She wears an elaborate diadem and has a 'beauty-mark' on her cheek. JEC

9th–8th century BC
From Nimrud
WA 48-11-4,187
H 6.3 cm, W 6 cm, D 5.5 cm
Layard 1849a: pl. 95.7. Stucky 1974: no. 14,
  pl. VIII

119

**119 Tridacna shell**

Fragment of an engraved tridacna shell with two folds, showing on the outside and inside surfaces a winged sphinx wearing the double crown of Upper and Lower Egypt amongst lotus flowers. JEC

9th–8th century BC
From Nineveh
WA 99392
H 11 cm, W 9 cm
Stucky 1974: no. 17, pl. X

### 120 Tridacna shell

Fragment of an engraved tridacna shell showing on both inside and outside surfaces a winged sphinx amongst lotus flowers. JEC

9th–8th century BC
From Nineveh
WA 118000
H 8 cm, W 6 cm
Stucky 1974: no. 18, pl. X

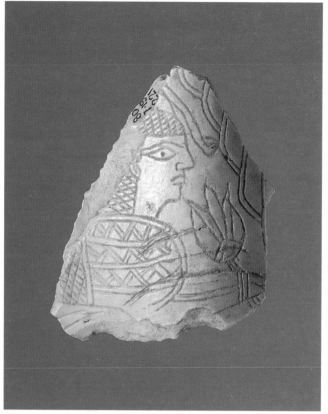

120

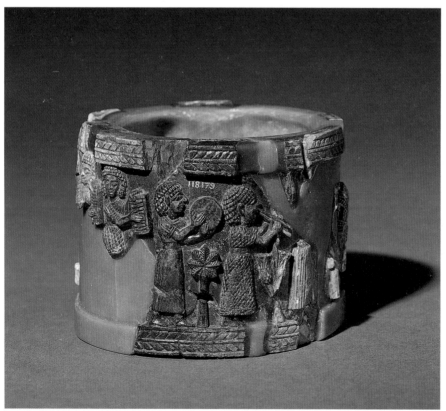

121

### 121 Ivory pyxis

A circular ivory box or pyxis with a continuous frieze of carved decoration. This pyxis is badly burnt, but shows musicians playing double pipes, zithers and the tambourine. They stand amidst palm and lotus trees and behind a goddess seated on a throne. In front of the goddess is a cross-legged table piled with delicacies and behind this are two ladies, the first of whom is clearly an attendant. On the underside there is a West Semitic alphabetic inscription. Although it is obscure, E. Puech (1978) believes it can be read *l . . . bytgs*, 'belonging to . . . of Bît-Gusi', i.e. Arpad in north Syria. The missing part would be the name of the owner, probably a king. Whether or not this reading is correct, it seems certain that the pyxis derives from Syria or Phoenicia.

9th–8th century BC JEC
From Nimrud, Burnt Palace
WA 118179
H 6.7 cm, DIAM 9.5 cm
Barnett 1975: 191, S.3, pls XVI–XVII

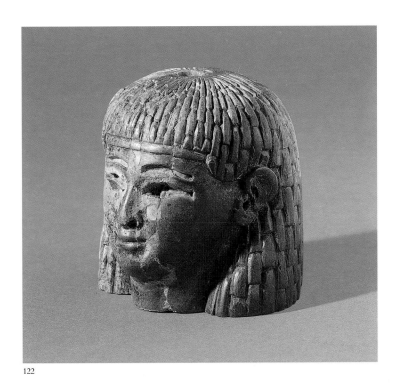

122

## 122 Ivory head

Ivory head of a woman (?) with full Egyptian hair-style, now burnt. The eyes and eyebrows were originally inlaid. There is a circular hole, approximately 0.7 centimetres in diameter, in the top of the head. Parts of the inner core of this piece are missing, so the means of attachment at the base are unknown.

The purpose of this head is unclear, but one possibility is that it fitted on to a hollowed-out tusk which might have served as a luxury receptacle or container. Such a tusk, with a woman's head, was found in the well in Room AJ of the North-West Palace by an Iraqi expedition (Safar and al-Iraqi 1987: 30–32).        JEC

9th–8th century BC
From Nimrud, Burnt Palace
WA 118186
H 6.1 cm, W 6 cm, D 6.1 cm
Barnett 1975: 210, S.186, pl. LIX

## POTTERY

As is generally the case in the Near East, large quantities of pottery have been found on most Late Assyrian sites. Sometimes the vessels are complete, but more often they have been smashed into many fragments as a result of the collapse of the buildings in which they were stored. Because of the large amount of material the range of forms in use in Assyria is quite well known, but the dating of the different types is more problematic. This is because much of the pottery has been found in levels dating to the destruction of the Assyrian towns and cities in 612 BC. For anything up to a couple of centuries prior to that, the large public buildings, at least, were kept in good repair and the floors swept clean. In many cases, then, the date of 612 BC is simply a *terminus ante quem*, and the pottery could date from the eighth or seventh century BC or even sometimes to the ninth.

Surprisingly, Layard does not seem to have found very large quantities of pottery at Nimrud, but this is probably because he was digging mainly in the apartments of state in the North-West Palace, where one might not expect to encounter large amounts of domestic paraphernalia. By contrast, the British School expedition to Nimrud did find a very great deal of pottery. It was widely distributed, but there were particularly large caches in certain rooms. These included Room ZT15 in the administrative wing of the North-West Palace (Mallowan 1966: I, 180, fig. 115), some of the houses adjoining the town wall on the acropolis, and some of the rooms in Fort Shalmaneser (e.g. Mallowan 1966: II, 438, fig. 364). Some of this pottery has been studied and published by Joan Oates (1954; 1959), and her contributions have laid the foundations for subsequent studies of Assyrian pottery. More recently, interesting collections of Late Assyrian pottery, possibly sometimes extending into the post-Assyrian period, have been found at sites in the Eski Mosul Dam Salvage Project to the north-west of Mosul. These sites include Khirbet Khatuniyeh (Curtis and Green 1987; Curtis 1992a) and Qasrij Cliff and Khirbet Qasrij (Curtis and Collon 1989).

It is difficult to make general observations about Late Assyrian pottery, but it is very often characterised by the large amount of vegetable-based temper used in its manufacture. When the pottery is fired these sorts of inclusion burn out, leaving tiny holes and crevices both on the surface of the pottery and in the core. As for colour, shades varying between off-white and buff are commonly found. Perhaps the most distinctive Assyrian shape is the bowl with carinated profile and flared rim (no. 127). There are a number of variations on this form, but they are all easily recognisable. Occasionally these bowls are turned into 'tripod bowls' by the addition of three rather crude feet. These tripod bowls are often grey or red. The fabric or body of Assyrian bowls is usually quite coarse, but occasionally it is very fine, in which case it is described as 'palace ware'. Vessels in palace ware are wafer-thin and extremely delicate, with no obvious inclusions in the fabric. Also sometimes made in palace ware were beakers with flared rims and dimples on the body.

Other particularly Assyrian forms are goblets with pedestal bases (e.g. no. 131), double-saucer lamps (no. 152) and small straight-sided drinking vessels which are the same shape as tea-glasses in use today and therefore called 'istikans' (nos 132–5). As one might expect, jars come in many different forms and sizes. The medium-sized jars are often rounded in shape and have simple, folded rims. Amongst the very large storage jars, straight-sided 'torpedo' jars (no. 148) seem to have been especially preferred.

Painted pottery is unusual in Assyria but there are small pointed ('carrot-shaped') bottles and jars decorated with bands of red or brown paint. Perhaps better known are glazed wares. Here, particularly distinctive are small polychrome glazed jars with a leaf pattern around the shoulder. There are also larger vessels with bands of chevron decoration on the shoulder. In these attractive jars the main colours seem to have been blue-green (nos 141–2), orange or yellow and white.

JEC

Late Assyrian potsherds from Khirbet Khatuniyeh laid out in the garden of the Nineveh dig-house.

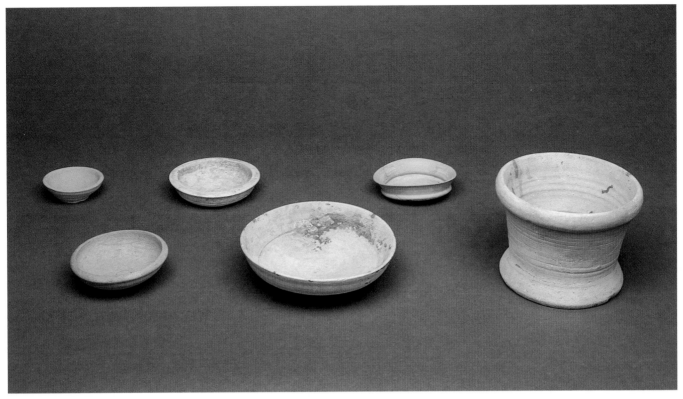

*(From left)* 123–8

### 123   Pottery saucer

A complete saucer with a flaring rim tapering to a flat string-cut base. There are signs of wet-smoothing on the exterior. The fabric is orange in colour, with some fine grit and occasional vegetable inclusions.                    H M

7th century B C
From Nimrud, Fort Shalmaneser, Room SE18
   (N D 7260)
W A 1992-3-2,79
H 3 cm, rim D I A M 8.8 cm, base D I A M 4.8 cm

### 124   Pottery bowl

A complete small bowl, with a rolled rim and a flat finished base. The orange fabric has vegetable and some white grit inclusions. There is encrustation on the interior, as a result of soil conditions.   H M

7th century B C
From Nimrud, Fort Shalmaneser, Room SE18
   (N D 7267)
W A 1992-3-2,74
H 4.2 cm, rim D I A M 12.4 cm, base D I A M 4.5 cm
J. Oates 1959: pl. X X X V.3

### 125   Pottery bowl

A complete shallow bowl with a ledge rim and a groove just above the flat finished base. The fabric is buff-coloured, with vegetable inclusions and a little fine grit.

7th century B C                              H M
From Nimrud, Trench DE.M (N D 5058)
W A 1992-3-2,73
H 3.2 cm, rim D I A M 13.6 cm, base D I A M 9 cm

### 126   Pottery bowl

A shallow carinated bowl with a ring base. The carination is marked on the interior of the bowl with a groove. The bowl is complete but cracked, and the rim is slightly irregular, more oval than circular. Buff in colour, with a well-finished surface on which sparse vegetable inclusions are visible.                    H M

8th–7th century B C
From Nimrud, North-West Palace
W A N I 558
H 6 cm, rim D I A M 20.5 cm, base D I A M 7.7 cm

### 127   Palace ware pottery bowl

This restored bowl made from the egg-shell-thin 'palace ware' has a simple carinated shape with a flaring rim and a shallow rounded base. It is pale green in colour, with no visible inclusions.   H M

8th–7th century B C
From Nimrud, Governor's Palace, Room C
   (N D 51)
W A 1951-2-10,33
H 3.6 cm, rim D I A M 12.6 cm

### 128   Pottery bowl

A deep bowl with a rolled rim, below which it tapers slightly until it joins the heavy splaying ring base. Orange-buff in colour, roughly finished with heavy chaff temper and some fine grit inclusions. There are drips of black bitumen on the interior and rim. The bowl has been restored.                    H M

7th century B C
From Nimrud, Trench IA50, Room 3 (N D 525)
W A 1992-3-2,49
H 13.7 cm, rim D I A M 18.8 cm, base D I A M
   7.2 cm

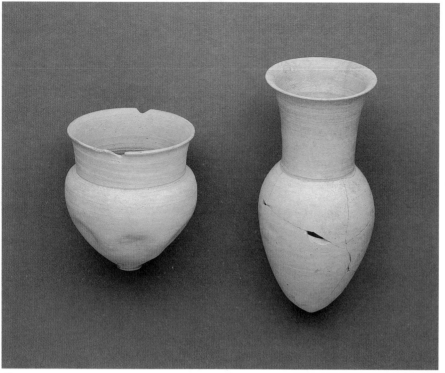

129, 130

### 129 Palace ware pottery beaker

This wide-mouthed palace ware beaker is complete, except for three chips on the slightly everted rim. It has a small shoulder and the body tapers to a small disc base. There are six deep dimples round the body, with visible finger marks in some of the depressions. The beaker is buff in colour, varying to a darker orange-brown near the base, and the fabric is very fine and well levigated, with no visible inclusions.                                    HM

7th century BC
Probably from Nimrud
WA 92885
H 9 cm, rim DIAM 7.8 cm, base DIAM 1.7 cm

### 130 Palace ware pottery beaker

A beaker with a slightly everted rim, long straight neck, pear-shaped body and pointed base. There is a shallow groove where the neck joins the shoulder, and the surface has a subtle burnish. The fabric is a pale brown fine palace ware with no visible inclusions. Palace ware is not generally burnished, so this piece is unusual. The beaker has been mended.    HM

8th–7th century BC
From Nineveh (Ni 486)
WA 137259
H 15.6 cm, rim DIAM 6.7 cm
Campbell Thompson and Mallowan 1933:
  pl. LXXIV.17

### 131 Pottery goblet

This complete cylindrical goblet or cup with a ring-based foot is rough and poorly finished. Brown in colour, the fabric has vegetable inclusions and large white grits are visible on the surface.          HM

7th century BC
From Nimrud, Fort Shalmaneser, Room SE18
  (ND 7257)
WA 1992-3-2,93
H 9.5 cm, rim DIAM 5.5 cm, base DIAM 5.2 cm
J. Oates 1959: pl. XXXVII.52

### 132 Miniature pottery beaker

A complete cylindrical beaker with a flat string-cut base, buff in colour with some fine grit and occasional vegetable inclusions.                                           HM

7th century BC
From Nimrud, Fort Shalmaneser, Room SE11
  (ND 7216)
WA 1992-3-2,147
H 8.1 cm, rim DIAM 4.7 cm, base DIAM 3.2 cm
J. Oates 1959: pl. XXXVI.47

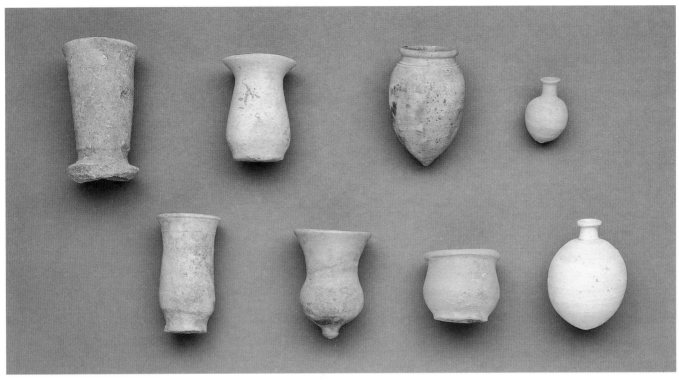

*(From left)* 131–8

**133  Miniature pottery beaker**

This complete miniature beaker, with a flared rim and a narrow neck, has a swelling in the lower body and a flat string-cut base. The colour varies from orange to buff, and the fabric has some grit and vegetable inclusions.          HM

7th century BC
From Nimrud, Fort Shalmaneser, Room NE49
  (ND 10905)
WA 1992-3-2,177
H 7.1 cm, rim DIAM 5.4 cm, base DIAM 3.5 cm

**134  Miniature pottery beaker**

A miniature beaker with a flaring rim and bulbous lower body, ending in a nipple base. The fabric varies in colour from orange to brown, with some fine grit inclusions. The beaker is incomplete, and part of the rim has been restored.          HM

8th–7th century BC
From Nimrud, North-West Palace, Room FF
  (ND 659)
WA 1992-3-2,131
H 7.6 cm, rim DIAM 5.7 cm, base DIAM 1.2 cm

**135  Miniature pottery beaker**

A complete beaker with a rolled rim, short neck and pear-shaped body, ending in a pointed base. The lower body and base have been shaved to shape, leaving slight ridges. The vessel is in the fine, well-levigated palace ware, with no visible inclusions. It is buff in colour, with some surface staining.          HM

7th century BC
From Nimrud, Fort Shalmaneser, Corridor E
  (ND 7293)
WA 1992-3-2,123
H 8.2 cm, rim DIAM 4.3 cm
J. Oates 1959: pl. XXXVII.70

**136  Miniature pottery jar**

A complete jar with a rolled rim, squat body and flat string-cut base. The exterior surface has been wet-smoothed, leaving visible finger marks. The fabric is bright orange in colour, with occasional fine grit and vegetable inclusions.          HM

7th century BC
From Nimrud, Fort Shalmaneser, Room SE18
  (ND 7243)
WA 1992-3-2,122
H 5 cm, rim DIAM 5.5 cm, base DIAM 4 cm
J. Oates 1959: pl. XXXVII.76

**137  Miniature pottery bottle**

A complete bottle with a bulbous body and a pointed base. The base is off-centre and has been formed by paring down the lower body. Greenish in colour, with sparse fine grit inclusions.          HM

8th–7th century BC
Probably from Nimrud
WA 122045
H 4.6 cm, rim DIAM 1.5 cm

**138  Small pottery bottle**

A complete bottle with a rolled rim, a short straight neck and a bulbous body ending in a pointed base. There is a shallow groove where the neck meets the shoulder, and another just below it on the shoulder itself. The lower body has been pared to make a pointed base. The fabric is buff in colour, with a few fine grit inclusions visible on the surface.          HM

8th–7th century BC
From Nimrud
WA 92868
H 7.7 cm, rim DIAM 1.8 cm

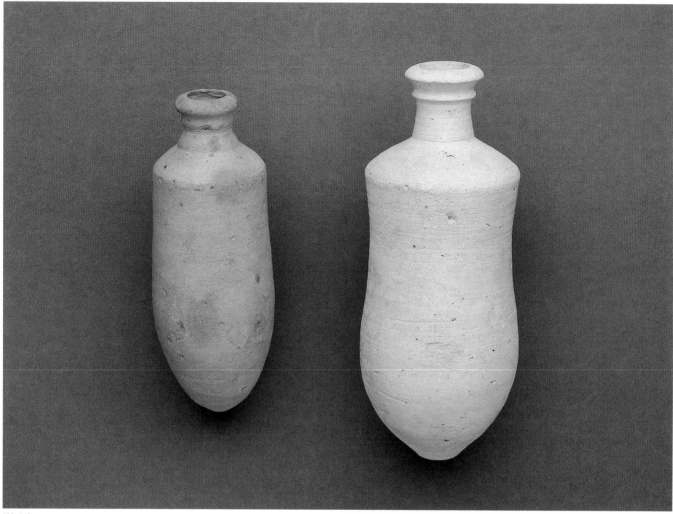

139, 140

### 139  Pottery bottle

This complete cylindrical bottle with a pointed base has a rolled rim, a ridge on the neck and a sloping shoulder. The surface is buff-coloured and the orange gritty fabric has some vegetable inclusions; occasional white grits appear on the surface.

8th–7th century BC        HM
From Nimrud, Governor's Palace,
  Room M (ND 16)
WA 1951-2-10,34
H 15.7 cm, rim DIAM 3 cm

### 140  Pottery bottle

A complete cylindrical bottle with a pointed knob base. There is a ridge on the neck, and the shoulder is pronounced. Pale buff, almost white in colour, and well finished with occasional fine grit inclusions.        HM

7th century BC
From Nimrud, Fort Shalmaneser, Room X2
  (ND 7314)
WA 1992-3-2,114
H 19 cm, rim DIAM 3.7 cm, base DIAM 2.1 cm
J. Oates 1959: pl. XXXVIII. 86

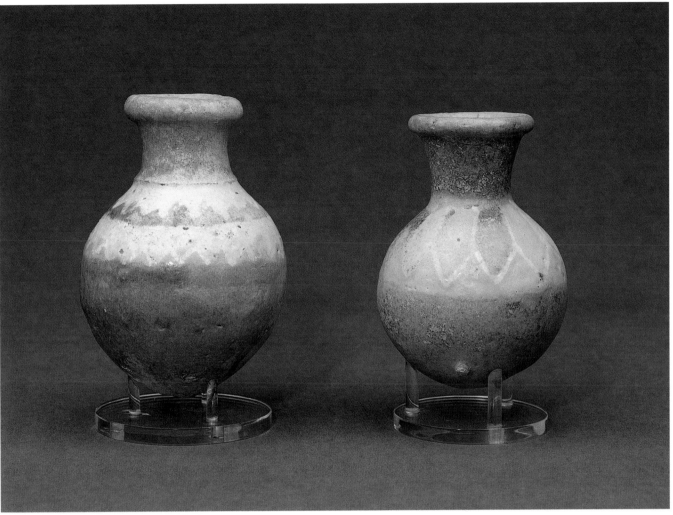

141, 142

### 141  Glazed pottery jar

A complete jar with rolled rim, straight neck, a ridge where the neck meets the shoulder and an oval body. The rim, neck and body are glazed blue-green, with a collar of white pendant triangles on the shoulder, and there is a white band with a zigzag lower edge on the body.  HM

8th–7th century BC
From Ashur
WA 116375
H 11 cm, rim DIAM 4.4 cm

### 142  Glazed pottery jar

A complete jar with rolled rim and globular body. The rim, neck and body are glazed blue, and there is a collar of white and greenish-blue pendant triangles on the shoulder.  HM

8th–7th century BC
From Ashur
WA 116378
H 10 cm, rim DIAM 4.7 cm

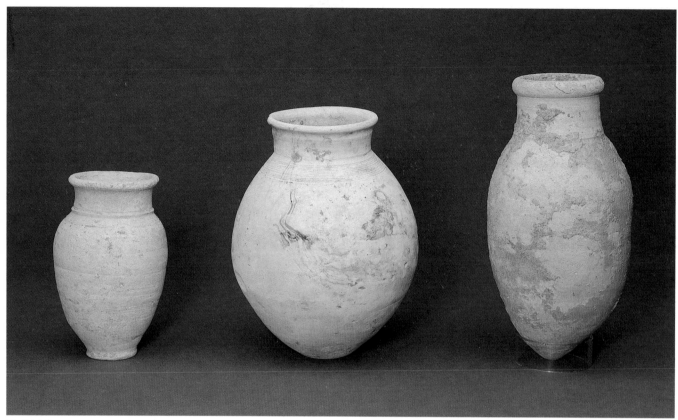

143, 144, 145

## 143 Small pottery jar

This complete wide-mouthed jar with a straight neck is decorated with a ridge where the neck meets the shoulder, and with a shallow groove on the shoulder itself. Below the shoulder the jar tapers to a ring base. The fabric is orange-buff in colour, with abundant fine black and white grit and some vegetable inclusions.

7th century BC                                    HM
From Nimrud, Fort Shalmaneser,
   Room SE18 (ND 7265)
WA 1992-3-2,40
H 17.1 cm, rim DIAM 8.9 cm, base DIAM 5 cm
J. Oates 1959: pl. XXXVIII.99

## 144 Pottery jar

A complete squat jar, with a band of incision on the shoulder made by a thirteen-pronged comb. The straight neck has signs of vertical burnishing, which has left a very subtle zigzag pattern. The fabric is buff-coloured, with some vegetable and grit inclusions.                          HM

8th century BC
From Nimrud, well in Burnt Palace (ND 4023)
WA 1992-3-2,30
H 23.2 cm, rim DIAM 10.8 cm, base DIAM 5 cm

## 145 Pottery jar

A complete jar with a rolled rim, straight neck, gently sloping shoulder, pear-shaped body and pointed base, made in a brown gritty fabric, with some vegetable inclusions.                             HM

7th century BC
From Nimrud, Fort Shalmaneser, Room S39
   (ND 9001)
WA 1992-3-2,32
H 27.4 cm, rim DIAM 8.8 cm

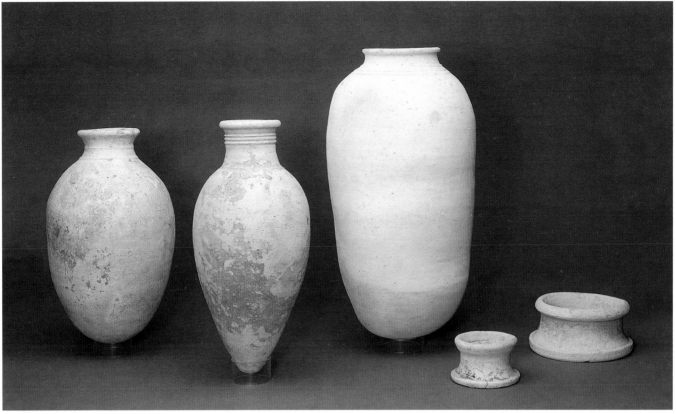

*(From left)* 146–50

## 146 Pottery jar

A complete jar, with an out-turned rim and an ovoid body with a rounded base which comes to a gentle point. There are two ridges on the neck. The jar has a buff surface, and the orange gritty fabric has vegetable inclusions.　　　HM

7th century BC
From Nimrud, Fort Shalmaneser, Room S40B
　(ND 9017)
WA 1992-3-2,20
H 40.6 cm, rim DIAM 11.8 cm

## 147 Pottery jar

A complete jar, with three pronounced ridges on the straight neck, and a band of incision made by a seven-pronged comb on the shoulder. The pear-shaped body tapers to a small rounded base. The fabric is buff in colour, with heavy chaff temper and some grit.　　　HM

7th century BC
From Nimrud, Fort Shalmaneser, Room S39
　(ND 9004)
WA 1992-3-2,18
H 43.5 cm, rim DIAM 10.5 cm

## 148 Large pottery jar

A complete storage jar with a wide mouth, short neck and cylindrical body. This type is sometimes known as a 'torpedo jar'. There is a ridge where the neck meets the shoulder, and two bands of comb incision on the shoulder. The fabric is buff-coloured, with grit inclusions.　HM

7th century BC
From Nimrud, Fort Shalmaneser, Room NW4
　(ND 10928)
WA 1992-3-2,22
H 55 cm, rim DIAM 14.8 cm, base DIAM 7.5 cm

## 149 Pot-stand

A complete small pot-stand, with a flaring rim, straight sides and a splaying base. It has a buff surface, and the orange fabric has occasional large white grits and some vegetable inclusions.　　　HM

8th–7th century BC
From Nimrud, Trench O.10 (ND 6608)
WA 1992-3-2,2
H 7.4 cm, rim DIAM 12.4 cm, base DIAM 11 cm

## 150 Pot-stand

A complete pot-stand with a rolled rim and slightly concave sides. It has a pale surface; the orange gritty fabric has white grits, which are visible on the surface, and some vegetable inclusions.　　　HM

7th century BC
From Nimrud, Fort Shalmaneser, Room NW19
　(ND 10924)
WA 1992-3-2,10
H 9.5 cm, rim DIAM 17.4 cm, base DIAM 19 cm

## 151 Pottery pipe-lamp

A pipe-lamp with a rolled rim, rounded body and spout. The surface is stained black and encrusted with bitumen. The end of the spout is incomplete. HM

7th century BC
From Nimrud, Fort Shalmaneser, Room XI
  (ND 7319)
WA 1992-3-2,181
H 7.5 cm, rim DIAM 8.3 cm, L 16 cm
J. Oates 1959: pl. XXXIX.104

## 152 Double-saucer pottery lamp

This lamp is incomplete, and the rim of the upper saucer is chipped. The vessel is formed from two saucers joined by a hollow pedestal. The upper saucer would have held the fuel, and the rim has been pinched to form a pouring lip, which would have supported the wick. The base of the lower saucer has been roughly scraped. The surface is buff-coloured, and the orange gritty fabric has plentiful vegetable inclusions. HM

7th century BC
From Nimrud, Fort Shalmaneser, Room NW22
  (ND 10929)
WA 1992-3-2,15
H 8 cm, rim DIAM of upper saucer 14.1 cm, rim
  DIAM of lower saucer 13.1 cm

## 153 List of offerings of wine and beer

A cuneiform tablet describing how two four-litre jars of wine and six eight-litre jars of different types of beer were offered by the queen of Assyria in the temple of Ashur in the city of Ashur for a festival commemorating the wedding of the goddess Mullissu to the god Enlil on the eighteenth day of the month. The wine came from Izalla in Turkey and Helbon in Lebanon. The jars were probably made of clay. The fact that this tablet and others from the same archive were found at

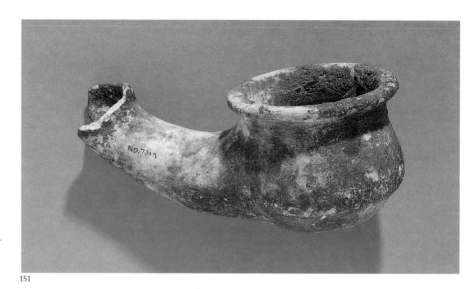

151

152

Nineveh suggests that the queen was resident and maintained her household administration there. CBFW

7th century BC
From Nineveh
WA K708
H 5.5 cm, W 3 cm, TH 1.5 cm
Fales and Postgate 1992: 182, no. 184. Van Driel
  1969: 206-20

153

# 6 HORSE TRAPPINGS AND HARNESS

Large quantities of horse trappings in bronze and ivory, and to a lesser extent in stone, have been found in Assyria, particularly at Nimrud. Those parts of the bridle which would have been of leather or wood have not survived. Important collections of horse trappings come from the Room of the Bronzes (AB) and from several of the wells in the North-West Palace. Others were found in a number of the storerooms in Fort Shalmaneser, particularly SW12, SW37, T10, T20, NW15, NW21 and NE50. The large amount of horse gear found in Fort Shalmaneser is probably a reflection of the fact that, as well as containing rooms of state for use by the king, this palace also housed troops and military equipment, and it is known that horses were extensively used by the Assyrian army.

In addition to these archaeological discoveries, the Assyrian reliefs are a mine of information about horse trappings; and some details can also be gleaned from contemporary cuneiform texts. It is clear that horses played an important part in Assyrian life: partly because of their extensive military programme, the Assyrians had a constant need for them, and as the Assyrian heartland was not suitable for raising large numbers of horses, they had to be brought from abroad. In their annals the Assyrian kings often list horses among the prizes of war. But they were not only obtained as military booty, as is clearly shown by a group of letters from Nineveh, probably dating from the time of Esarhaddon, which form an archive known as the 'horse reports' (Postgate 1974: 7–18). These describe the receipt, in a particular government department, of horses from all around the empire. In the Late Assyrian period, the areas that seem to have supplied most horses were to the north and north-east of Assyria, the lands of Urartu, Mannaea and Media. Here, the lush grasslands of the Zagros foothills and the Iranian plateau were ideal breeding-grounds.

Horses were used in Assyria both for riding and for pulling chariots, primarily for military purposes but also for hunting. Mounted troops are mentioned in texts as early as the reign of Tukulti-Ninurta II (890–884 BC), and they are shown on reliefs of his son Ashurnasirpal II (883–859 BC). At this period the troops rode in pairs with one soldier controlling both horses, leaving the other free to use his bow. Later in the Assyrian period, notably during the reigns of Sennacherib (704–681 BC) and Ashurbanipal (668–631 BC), improved riding techniques allowed soldiers to control their own mounts while at the same time using bows and spears. Stirrups had not yet been invented. The chariots pulled by horses were fast, two-wheeled vehicles with box-shaped cabs

in which the riders stood. As the Assyrian period progressed, chariots became bigger and the number of men they could carry increased from two to four.

In Assyrian times both ridden and draught horses were controlled in essentially the same way, that is by a bridle consisting of headstall, reins and bit. Little can be learned about the form of these horse-bits from the Assyrian reliefs, but we know from surviving pieces that they were made from both bronze and iron. They all have jointed canons and would originally have had cheekpieces fixed to them. On reliefs of Sennacherib an unusual type of cheekpiece appears in the form of a galloping horse, and an actual example was found by Mallowan in a well in the North-West Palace at Nimrud (Mallowan 1966: I, pl. 70). The cheekpieces are fixed by cheekstraps to the main part of the headstall. There is usually a browband, which sometimes has a brow cushion fixed to it, particularly after the time of Tiglath-pileser III (744–727 BC). A half-noseband becomes standard from the reign of Sargon (721–705 BC) onwards. The headstall straps are often decorated with small ornaments, as are the harness straps of draught horses and the breastbands of ridden horses. The reliefs show these ornaments to be plain circular discs, or rosettes, or little figure-of-eight appliqués. They can be exactly matched in the archaeological record. Most common are small bronze bosses, large numbers of which have been found at Nimrud (e.g. Curtis, Collon and Green 1993: fig. 15). Similar ornaments are often made of shell, in figure-of-eight, disc and floral shapes: many examples have been found at Nimrud, principally in the Room of the Bronzes and in the well NN, both in the North-West Palace (Layard 1853: fig. on p. 179; Mallowan 1966: I, fig. 65). Also known from Nimrud are large bronze bosses with loop fasteners on the back which decorated headstalls, mainly at strap intersections (e.g. Stronach 1958: pl. XXXIII.11–12; Mallowan 1966: II, fig. 336f). They are sometimes called 'phalerae'. In the reign of Ashurnasirpal II, the reliefs show that blinkers were sometimes attached to the headstall. Again, these survive in the archaeological record (see nos 154–6), as do frontlets or noseguards (nos 157–8), shown on reliefs mainly of Sennacherib and Ashurbanipal.

We see from the reliefs that most Assyrian horses, particularly in the later periods, wore ornaments known as poll decorations on the top of their heads (e.g. Littauer and Crouwel 1979: figs 55–6, 62, 77–8). These were fixed to the headpiece of the bridle and vary from simple sprays of feathers or tassels stacked on top of each other to crests similar to those shown on helmets. Sometimes the poll ornaments seem to have been sheets of metal with elaborate embossed and chased decoration, but actual examples do not survive from Assyria. Both draught and cavalry horses wore a band or strap around the neck, usually referred

to as a nape strap. From the time of Tiglath-pileser III onwards, bells or tassels are sometimes suspended from this strap (nos 159–65).

In the ninth century BC reliefs and glazed tiles show cavalry horses and, less often, chariot horses wearing a breastplate or gorget suspended around the horse's neck (e.g. Littauer and Crouwel 1979: fig. 76). This is crescentic or bib-shaped and has tassels hanging from it. Such breastplates were presumably made of bronze or leather, but there are no surviving examples from Assyria.

On the Assyrian reliefs both cavalry and draught horses are sometimes shown wearing trappers or horse-blankets. After the reign of Tiglath-

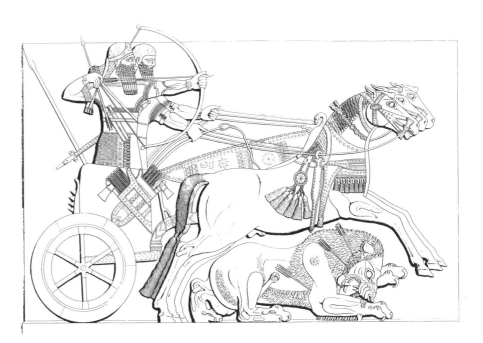

Engraving of a relief showing Assyrian chariot-horses in the time of Ashurnasirpal II (see no. 5). From Layard 1849a: pl. 31.

pileser III these are made of what looks like thick leather and are fixed together by toggles (nos 166–7). Sometimes decorative bronze plaques, examples of which are known from Nimrud, were fixed to these trappers.

We have mainly considered here trappings which are represented in the archaeological record. But where did the types originate, particularly as Assyria was not natural horse-breeding country? Many of the ivory trappings, such as frontlets and blinkers, have figural decoration which links them with north Syria and Phoenicia, but some of the other trappings, such as the bits and the cheekpieces, and the bronze bosses which decorated the headstall, are more familiar from the highland zones to the north and east of Assyria. This could either indicate that the trappings were imported with the horses or that the form of the trappings was sometimes copied in Assyria. The latter seems most likely.     JEC

## BLINKER ORNAMENTS

Blinker ornaments in ivory, bronze and stone have been found at Nimrud, but appear on reliefs only in the reign of Ashurnasirpal II (e.g. Layard 1849a: pls 26–8; Barnett and Lorenzini 1975: pls 32, 38). They are fixed to the horse's headstall but, curiously, do not cover the horse's eye. However, this may simply be an artistic convention and reflect a reluctance on the part of the artist to show the eye covered. The blinkers shown on the reliefs are all 'sole-shaped', and among actual blinkers found this shape is most common. From Nimrud there are many examples in ivory, usually decorated with lotus buds in high relief but sometimes with figural decoration such as a winged sphinx (e.g. Orchard 1967: pls XII–XXV). An example in bronze, again with embossed lotus buds, was recently found in Room T20 in Fort Shalmaneser (Curtis, Collon and Green 1993: 10–15, figs 9, 11.1).

Surprisingly, bronze blinker ornaments of this type are most commonly found in Cyprus and the Greek islands (Donder 1980: pls 15–17), which has prompted suggestions that they originated in the west. However, it is sometimes supposed that the basic form is north Syrian in origin (e.g. H.-V. Herrmann 1966: 138) and the decoration on the ivory examples would tend to support this. Also known from Nimrud are shield-shaped blinker ornaments, which exist in ivory and bronze. The ivory examples generally bear Egyptian designs or motifs (Orchard 1967: pls I–XI). JEC

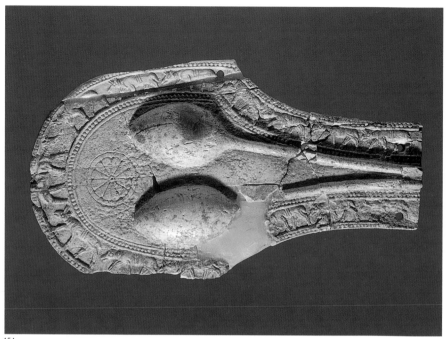

154

### 154 Ivory blinker ornament

Sole-shaped ivory blinker ornament with two lotus buds on long stems in high relief in the centre. Around the outside is a frieze of animals, probably goats, set between two bands of dotted decoration. There is an incised rosette between the lotus buds. Small parts of the blinker are missing, but originally there were two holes at one end and a hole on each side for attachment.

9th–8th century BC          JEC
From Nimrud, Fort Shalmaneser,
  Room SW37 (ND 11131 + ND 10752)
WA 132993 + 134960
L 16.1 cm, max. W 8.7 cm
Orchard 1967: pl. XVIII, no. 98. Barnett 1975:
  Suppl. 50, pl. CXXXV

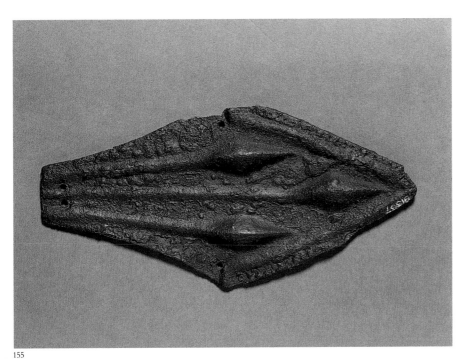

155

## 155 Bronze blinker ornament

Sole-shaped bronze blinker ornament with three embossed lotus buds on long stems in the centre. At one end there is an embossed rib and a cable pattern design around the edge. There are two holes at the other end and a hole on each side for attachment. JEC

9th–8th century BC
Possibly from Nimrud
WA 91337
L 16.8 cm, max. W 8 cm

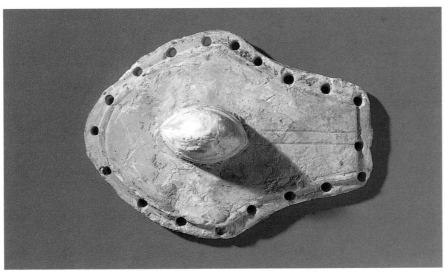

156

## 156 Stone blinker ornament

Sole-shaped white stone blinker ornament with a lotus bud in high relief in the centre. It is stepped down at the edge with holes at regular intervals for fixing it to a background. JEC

9th–8th century BC
From Nimrud, Fort Shalmaneser, Room T10
  (ND 11200)
WA 132997
L 11.3 cm, max. W 7.9 cm
Orchard 1967: pl. XLIV, no. 202

## FRONTLETS

Assyrian reliefs show that frontlets were sometimes worn on top of the horse's nose, suspended from the browband that formed part of the headstall. Such frontlets are also called noseguards or chamfrains. They are shown mainly during the reigns of Sennacherib and Ashurbanipal (e.g. Barnett and Lorenzini 1975: pls 127–9) and appear as thin strips above the horse's nose. They are worn by both ridden and draught horses. From Assyria actual examples of frontlets survive in stone, as the examples below, and in ivory (e.g. Orchard 1967: pls XXVI–XLI). These stone and ivory examples are generally triangular or quadrilateral in shape and taper towards the bottom. Sometimes the ivory frontlets have relief decoration in the form of a naked woman in Phoenician or north Syrian style. Bronze frontlets do not survive from Assyria, but elaborate examples are known from elsewhere in the Near East, particularly Salamis in Cyprus (Karageorghis 1969: figs 15, 23–4, 48). JEC

### 157 Frontlet

White stone frontlet of quadrilateral shape tapering towards the bottom. It is stepped down at the edge, with holes at regular intervals for fixing it to a background, probably of leather. The surface is blackened by fire. Sections of the edge are missing. JEC

8th–7th century BC
From Nimrud, Fort Shalmaneser, Room T10
(ND 11209)
WA 140416
H 12.8 cm, max. W 9.2 cm
Orchard 1967: pl. XLV, no. 206

### 158 Frontlet

A white stone frontlet similar to no. 157. Sections of the edge are missing. JEC

8th–7th century BC
From Nimrud, Fort Shalmaneser, Room T10
(ND 12503)
WA 140417
H 11.1 cm, max. W 7.9 cm
Orchard 1967: pl. XLVI, no. 210

## BELLS

In two of the cauldrons in the Room of the Bronzes (AB) in the North-West Palace at Nimrud, Layard found what he rightly identified as 'ornaments of horse and chariot furniture'. Amongst them was a large collection of bells which are now in the British Museum (Layard 1853: 177–8). Altogether they number nearly eighty, varying in shape from large examples with rounded shoulders and a ring at the top to smaller pieces with straight flaring sides and a figure-of-eight holder at the top. They range in height from 4.5 to 8.3 centimetres. A noticeable feature of all these bells is that they have clappers in the form of thick iron rods. These clappers sometimes survive intact, but are mostly missing.

The Assyrian reliefs clearly show that bells were suspended around horses' necks. From the time of Tiglath-pileser III onwards, bells or tassels sometimes hang from a band or strap, sometimes of plaited leather and usually referred to as a nape strap (e.g. Littauer and Crouwel 1979: fig. 62). Both draught and cavalry horses are shown wearing bells, the purpose of which seems to have been purely decorative. Large numbers have been found in Urartu, the Caucasus and western Iran, suggesting that the fashion for using them as horse trappings comes from those areas. It is interesting that these are the same regions, to the north and north-east of Assyria, which also bred horses. JEC

### 159 Bronze bell

A large bell with rounded sides, a flange around the base, and a ring holder at the top cast in one piece with the bell. The clapper does not survive, but there are traces of an iron fixture inside the bell, at the top centre. JEC

8th century BC
From Nimrud, North-West Palace, Room AB
WA N157
H 8.2 cm, max. DIAM 5.9 cm

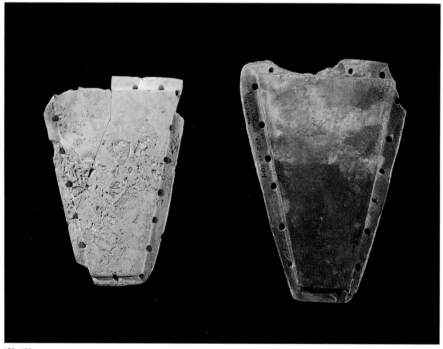

158, 157

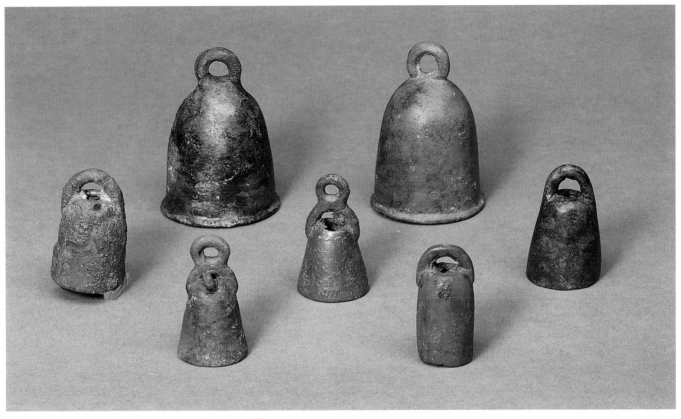

*(From left) back row:* 160, 159; *middle row:* 161, 165, 162; *front row:* 164, 163

## 160   Bronze bell

A large bell similar to no. 159 above.

8th century BC                                    JEC
From Nimrud, North-West Palace,
   Room AB
WA N155
H 8.15 cm, max. DIAM 6 cm

## 161   Bronze bell

A bell with straight sides, a hole at the
top, and a loop handle cast in one piece
with the bell. An iron clapper in the form
of a thick iron rod is still in position, held
in place by a horizontal iron pin fixed into
small holes in the sides of the bell.   JEC

8th century BC
From Nimrud, North-West Palace, Room AB
WA N162
H 5.2 cm, max. DIAM 3.45 cm
Rimmer 1969: pl. xxb, left. Spear 1978: fig. 108

## 162   Bronze bell

A bell of the same type as no. 161, but
with the clapper missing.             JEC

8th century BC
From Nimrud, North-West Palace, Room AB
WA N193
H 5.35 cm, max. DIAM 3.4 cm
Spear 1978: fig. 100

## 163   Bronze bell

A bell of the same type as no. 162, with
the clapper missing but with traces of an
iron pin still in position.            JEC

8th century BC
From Nimrud, North-West Palace, Room AB
WA N215
H 4.85 cm, max. DIAM 2.45 cm

## 164   Bronze bell

A bell with straight, flared sides, a hole
at the top, and a figure-of-eight holder
probably cast separately onto the top of
the bell. The clapper is missing, but seems
to have been held in position by iron wire
threaded through the lower loop of the
holder.                               JEC

8th century BC
From Nimrud, North-West Palace, Room AB
WA N182
H 5.2 cm, max. DIAM 3 cm

## 165   Bronze bell

A bell of the same type as no. 164, again
with the clapper missing and traces of iron
wire at the top.                      JEC

8th century BC
From Nimrud, North-West Palace, Room AB
WA N177
H 5.45 cm, max. DIAM 3.3 cm, WT 6.2 g

## TOGGLES

Objects which are unmistakably toggles occur from time to time on the Assyrian reliefs, sometimes in connection with horses. They are used to hold in position the trappers or horse-blankets sometimes shown being worn by cavalry and draught horses. On reliefs of Ashurbanipal, toggles are shown being used either to fix two sections of these trappers together (Barnett 1959: pl. 120) or to secure the straps of the trappers (Layard 1853a: pl. 47; Barnett 1976: pl. LXVIII). These trappers were presumably made of leather. However, toggles also had other uses. For example, they appear in the scene of the siege of Lachish holding together the covers of Assyrian battering-rams (Layard 1853a: pl. 21), and on reliefs of Ashurbanipal they secure straps on the royal chariot (Barnett and Lorenzini 1975: pl. 105). Sometimes they are simply shown suspended from belts (Botta and Flandin 1849–50: II, pls 106, 107). As well as stone toggles of the type described below, bronze toggles have been found at Nimrud.                       JEC

166, 167

## 166  Stone toggle

An oval stone toggle with a groove around the centre.                       JEC

8th–7th century BC
From Nimrud, Fort Shalmaneser, Room SE11
   (ND 7814)
WA 140336
H 12 cm, max. DIAM 4.5 cm

## 167  Stone toggle

A cylindrical stone toggle with bulbous ends and a groove around the centre.  JEC

8th–7th century BC
From Nimrud, Trench O6 (ND 6043)
WA 140401
H 7 cm, max. DIAM 3.2 cm

## SHELL ORNAMENTS

Ornaments with ring-and-dot decoration carved from the Indo-Pacific shell *Lambis* are known from a number of places in the Ancient Near East. They have a drilled hole in the centre which sometimes contains a bronze pin. Examples have been found at several sites in Mesopotamia, including Nineveh (Barnett 1963: pl. xvia–c, e–f), Nimrud (Mallowan 1966: i, 125, fig. 66; ii, 452; Barnett 1963: pl. xv), and Sippar (Barnett 1963: pl. xvid).

The precise purpose of these shells is unclear. Herzfeld (1941: 140) suggested that they were shield buckles. By contrast, Barnett (1963: 84) interpreted them as clappers or castanets, 'perhaps some of the musical instruments of the dancing girls of Hamath'. Joan Rimmer (1969: 40, pl. xxiii) also subscribed to the view that they were clappers used by dancers. Mallowan (1966: i, 125) thought it more likely that they decorated some part of a king's chariot or perhaps a battering ram. None of these suggestions is altogether plausible. It seems most likely that these shells were suspended, probably by threads or wires through the holes in the bronze pins. In this case, they might well have been decorative horse trappings. Against this, it has to be admitted that no evidence can be found on the Assyrian reliefs for horse trappings of this kind. However, fragments of a number of such shells found in Room T10 in Fort Shalmaneser at Nimrud were inscribed with Hittite hieroglyphs thought to give the name of Irkhuleni, a king of Hama who was a contemporary of Shalmaneser III (Barnett 1963). If this is correct, it would indicate that the shells were probably imported

*(Top)* 168, 169; *(bottom)* 170

from the west, which might explain why they are not depicted on the Assyrian reliefs.                              JEC

### 168   Shell ornament

A carved lambis shell with incised ring-and-dot decoration on the outer surface. There is a drilled hole in the centre, through which has been fixed a bronze pin with a large domed head at one end and a shank with a hole through it at the other. This pin evidently served to attach or suspend the shell by a thread or wire.

9th–8th century BC                              JEC
From Nineveh
WA 124604
8.3 × 6.9 cm
Barnett 1963: pl. 16f

### 169   Shell ornament

Another carved lambis shell as no. 168.

9th–8th century BC                              JEC
From Nineveh
WA 124606
8.1 × 7.1 cm
Barnett 1963: pl. 16b. Herzfeld 1941: fig. 254

### 170   Shell ornament

A carved lambis shell with closely packed, incised ring-and-dot decoration. There is a large central hole, but no pin survives.

9th–8th century BC                              JEC
From Nimrud, North-West Palace,
     well in Room NN (ND 2240)
WA 140424
8 × 7 cm

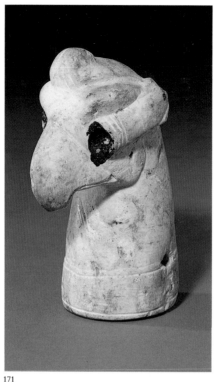

171

172

## 171 Stone griffin's head

This head of a griffin, with a large, promi-
nent beak and a crest on top of its head
and ears, is made from a smooth white
stone and there are traces of bitumen in
the eye sockets. In the base is a circular
dowel hole 1.8 centimetres in diameter
and 3.5 centimetres deep, and in the neck
of the creature are two holes for securing
it with nails to a shaft, probably of wood.
There are several similar griffins' heads in
existence, for example from Sippar (Hall
1928: pl. LIX, top left). Layard saw them
as 'most probably belonging to a wooden
figure, or to the top of a staff' (Layard
1853: 362). However, it is more likely that
they were associated with chariots, or at
least the traction gear of chariots. Assyrian
reliefs show that the yokes fixed to chariot
poles sometimes ended in animals' heads
(Littauer and Crouwel 1979). Also, the
chariot pole itself occasionally terminates,
appropriately enough, in a horse's head
(Hrouda 1965: pl. 17.2–3). It is possible,
then, that the stone griffins' heads might
have served either purpose, but Barnett
(1964: 84, pl. VIB) points out that a grif-
fin's head is shown fixed onto a chariot
pole on a Tell Halaf relief, and therefore
suggests that the stone heads were in fact
chariot-pole ornaments.                JEC

9th century BC
From Nimrud, Temple of Ishtar Sharrat-niphi
WA 91665
H 10.55 cm; head 7.4 × 4.4 cm
Layard 1853: fig. on p. 362. Barnett 1964:
   pl. VIIC

## 172 Letter mentioning a horse

Numerous documents refer to the interest
of the Assyrian kings in ensuring an
adequate supply of horses, and some of
them were clearly accomplished riders.
This is a letter from Shamash-shum-ukin,
eldest son of Esarhaddon (680–669 BC)
and crown prince in Babylon, addressed
to his father the king. It refers to a horse
from the city of Rasappa.            JER

About 670 BC
From Nineveh
WA K637
H 4.5 cm, W 2.9 cm, TH 1.5 cm
Parpola 1972: 21

# 7 DRESS AND EQUIPMENT

U
ntil recently the amount of gold jewellery known from Assyrian sites was meagre. Exceptional was the wonderful collection of earrings, necklaces and pendants from Tomb 45 at Ashur (Haller 1954: pls 27–36), which contained a male and a female skeleton, but this tomb dates from the Middle Assyrian period, probably from the time of Tukulti-Ninurta I (1243–1207 BC). From Late Assyrian times we had only a very small amount of gold jewellery, but rather more material in bronze, such as earrings, bracelets and fibulae, mainly recovered from graves. Now the situation has completely changed with the discovery of a series of rich graves, all apparently of high-ranking women, in a part of the North-West Palace at Nimrud – the south wing – which may have been the harem.

The graves were found between 1988 and 1990 by Muzahim Mahmud of the Iraq Department of Antiquities. Beneath the floors of different rooms in the palace were four subterranean chambers with barrel-vaulted roofs, in three of which were astonishing collections of jewellery. The first tomb, in Room MM, contained a pottery sarcophagus and jewellery that included a gold fibula and chain attached to a stamp seal in a gold mount. The second tomb, in Room 49, had various inscriptions mentioning Yabâ, Banîti and Atalia, 'queens' or 'palace women' of Tiglath-pileser III (744–727 BC), Shalmaneser V (726–722 BC) and Sargon (721–705 BC) respectively. There was a stone coffin with at least two bodies and a vast array of grave-goods, including a Phoenician-style gold bowl showing boats in a papyrus thicket. It is estimated that the gold objects in this tomb weighed 14 kilograms. Altogether there were more than eighty gold earrings, many of them with elaborate clusters of pendants, and nearly ninety necklaces, mostly incorporating gold beads. There were also gold anklets, bracelets, fibulae, clothing plaques, a diadem with a tasselled fringe at the front and bracelets inlaid with glass and precious stones. The third tomb, in Room 57, was originally the grave of Mulissu-mukannishat-Ninua, a queen of Ashurnasirpal II (883–859 BC), but it had been reused. The original stone sarcophagus was empty, but badly preserved bones and an astonishing variety of grave-goods were found in three bronze coffins in the antechamber outside the tomb. The large number of gold objects, here estimated at an almost incredible 23 kilograms, included an intricate crown or headdress. The fourth tomb contained large numbers of glazed pottery and alabaster vessels. All the jewellery is now in the Iraq Museum in Baghdad.

These Nimrud tombs have provided a dramatic indication of the wealth of Assyrian material culture. It had not previously been imagined,

at least with regard to jewellery, that there was such a rich range of types or that the workmanship was so exquisite. It was sometimes believed that the Assyrian reliefs showed an idealised view of Assyrian culture, that in reality it was much poorer than the reliefs suggest. It is now clear that this is certainly not the case. If anything, the reverse is true, and Assyrian culture was even richer. Apart from jewellery, we may suppose that Assyrian dress, at least in royal and official circles, was very lavish. The same may well be true of military uniforms. It is interesting that the single iron helmet that survives more or less intact from Nimrud has very elaborate bronze inlay decoration. With regard to other accoutrements and paraphernalia, we know that things such as maceheads were skilfully manufactured from a combination of bronze and iron and were decorative as well as symbolic. Such expensive items may have been more widespread than hitherto supposed. JEC

## 173 Iron helmet

A conical helmet with pointed top, hammered out from one piece of iron. It is decorated with bronze inlay in the form of parallel lines around the base of the helmet. Between the two upper lines is a procession of officials or attendants which runs around the entire helmet. A further panel of bronze inlay at the front of the helmet shows the king with the crown prince and an attendant, framed by a bud-and-garland border. Around the base of the helmet is a series of holes, probably for the attachment of a lining. This helmet is restored from fragments.

Pointed helmets of this shape are commonly shown worn by soldiers on the Assyrian reliefs. However, they were not always made of iron, as we know from the discovery of bronze helmets of this shape at Khorsabad (Place 1867–70: I, 64–6). Further evidence for iron helmets with bronze inlay comes from Assyrian provincial centres in Syria: an actual example was found at Zincirli (Andrae 1943: fig. 88, pl. 41), while on the wall-paintings at Til-Barsip helmets are shown in blue, presumably representing iron, with yellow decoration which must be inlaid bronze (Thureau-Dangin and Dunand 1936: pls 49–51). Together with the present helmet, Layard found in Room I of the North-West Palace at Nimrud sixteen iron fragments with bronze inlay belonging to at least four different crested helmets (Dezsö and Curtis 1991: 107–22). JEC

8th century BC
From Nimrud, North-West Palace, Room I
WA 22496
H 30.8 cm, DIAM 21.7 cm, WT 3049 g
Layard 1849: I, 341. Barnett 1953. Dezsö and Curtis 1991: 121–5, fig. 21, pl. XIX

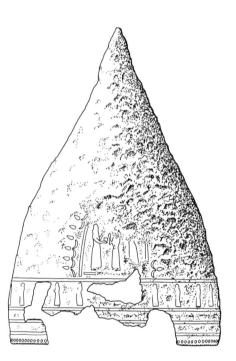

Iron helmet from Nimrud (no. 173) showing details of bronze inlay.

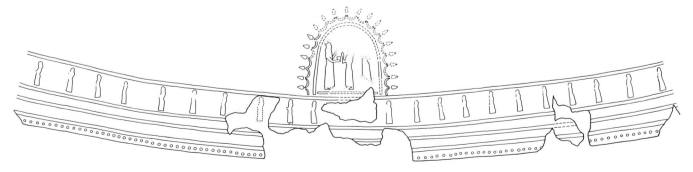

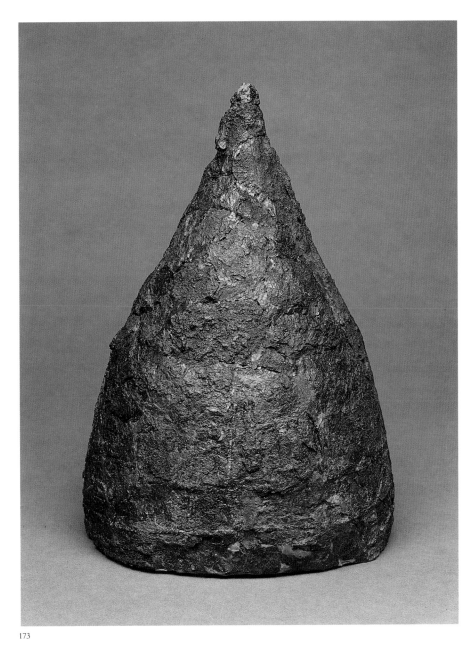

173

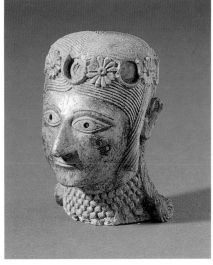

174

may have been made of a different material, such as wood.

This is one of a series of ivory heads found in the Burnt Palace at Nimrud by both Loftus (Barnett 1975: pls LXX–LXXII) and Mallowan (1966: I, 212–14) showing women wearing elaborate headbands. The flowers or rosettes in such headbands were probably of gold, and the discs may have been inlaid with glass. Although the style of these heads is usually regarded as Syrian, similar headbands are shown on the Assyrian reliefs, generally in the time of Ashurnasirpal II (Hrouda 1965: pl. 8.8–12). The impression that expensive headbands were worn at the Assyrian court is reinforced by the newly discovered tombs of the Assyrian queens at Nimrud, which contained gold diadems with hanging tassels. These diadems were set with glass and semi-precious stones.          JEC

9th–8th century BC
From Nimrud, Burnt Palace
WA 118234
Overall H 4.4 cm, max. W 3.1 cm
Hogarth 1908: pl. XXIX.2. Barnett 1975: 205,
   S.172, pl. LXXX

## 174  Ivory head

Head of a woman with long hair and wearing a necklace with four rows of beads. She wears a headband or diadem, knotted at the back, consisting of alternating flowers and discs linked together. The discs have hollow centres and would originally have been inlaid. On the base of the neck there is a rectangular mortise for attachment and the remains of what was probably a fitter's mark in the form of three parallel incised lines. This head probably belonged to a statuette which

## DECORATED BRONZE
## FIBULAE

M ost of the bronze fibulae or safety-pins that have been found in Assyria are relatively plain. Generally triangular in shape, they usually have ribbed and beaded decoration on the bow. They were used as garment pins, to hold folds of cloth together. In addition to these plain fibulae there is a small group of examples, mostly unprovenanced, with figural decoration on the arms of the bow. This consists of a head of the demon Pazuzu (see no. 63), a bird of prey and the bust of a woman, in various combinations. The exact symbolism of this decoration escapes us, but it is possible the fibulae were worn by women during childbirth to protect them from demons. The iconography, and particularly the figure of the demon Pazuzu, links these fibulae with Mesopotamia and suggests they may be Assyrian products. This is supported by the discovery of a stray bronze example at Tell Deir Situn, northwest of Mosul, and by the presence of a magnificent gold example in one of the newly discovered tombs at Nimrud (Curtis 1994: fig. 5, pls 4, 6). JEC

### 175 Bronze fibula

Triangular bronze fibula with one arm ending in a head of the demon Pazuzu and the other in the upper part of a woman with hands clasped under her breasts. The woman wears a dress with a round neck ornamented at the back with two registers of incised zigzag pattern. At the bottom of the arms and above the apex of the bow are two rams' heads with long curled horns. The spring and the pin are missing, and the clasp for the pin is in the form of a human hand. JEC

8th–7th century BC
Provenance unknown
WA 1992-5-16,1
H 3.27 cm, W 5.4 cm
Curtis 1994: 49, no. 1, fig. 1, pls 1–2

### 176 Bronze fibula

Triangular bronze fibula with one arm ending in a head of the demon Pazuzu and the other in a perched bird of prey. The bird has a large curved beak and folded wings. At the bottom of the arms and above the apex of the bow are two rams' heads. On the bottom of the bow is a block with an incised seal design of radiating lines. The spring and the pin are missing. The hooked beak of the bird served as a clasp for the pin. JEC

8th–7th century BC
Provenance unknown
WA 140827
H 3.5 cm, W 5.88 cm
Curtis 1994: 50, no. 2, fig. 2, pls 1–2

### 177 Bronze fibula

Triangular bronze fibula with one arm ending in a head of Pazuzu and the other in a perched bird of prey. In these respects it is similar to no. 176, but is less elaborate and lacks the rams' heads at the bottom of the arms. On the other hand, there is a more sophisticated stamp seal design on a block at the bottom of the bow, showing a kneeling goat or ibex with a branch and foliage above its back. The spring and the pin are missing. The beak of the bird would have served as a clasp for the pin. JEC

8th–7th century BC
Provenance unknown
WA 1993-1-25,1
H 2.76 cm, W 3.77 cm
Curtis 1994: 50, no. 3, fig. 3, pls 1–2

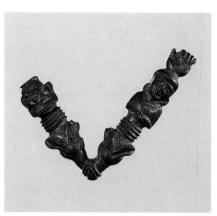

175

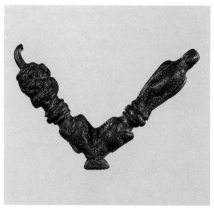

176

177

## 178 Stone jewellery mould

One half of a jewellery mould in a light-coloured limestone. It consists of a square block with matrices or negatives on both sides for casting trinkets, probably in lead but possibly in gold. The missing part of the mould probably consisted of a plain stone so that all the trinkets would have had flat backs. Each intaglio is connected to the side of the block by a pour-channel for the molten metal. The matrices on one side include a naked human figure, a goat, a bird, a crescent, an earring with a bunch of three globules on the base, and two discs, one with radiating lines and the other with a gazelle and above it seven dots representing the Seven Gods (Akkadian Sebittu) who are associated with the group of stars known as the Pleiades in the constellation Taurus. The outstanding matrix on this side, however, is a plaque showing the evil goddess Lamashtu. She has a lion's head and rides in a boat which floats along the river of the underworld. On the other side of the mould are forms for casting a double spiral pendant, an altar with a horned crescent and an enigmatic shape that may be a two-headed animal.

This mould and others like it were used for making trinkets or small items of jewellery, mostly with a magical or apotropaic purpose, probably to protect the wearer. It is possible that the moulds belonged to travelling smiths who journeyed from village to village producing trinkets on demand, but this remains speculative. Trinket moulds were particularly common in Anatolia around 2000 BC, but they continued in use and several other examples are known from Late Assyrian sites.                                           JEC

8th–7th century BC
From Nineveh
WA 91904
H 8 cm, W 8.7 cm, TH 1.8 cm
Layard 1853: fig. on p. 597

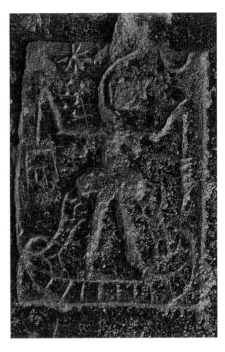

Detail of jewellery mould no. 178 showing the figure of Lamashtu.

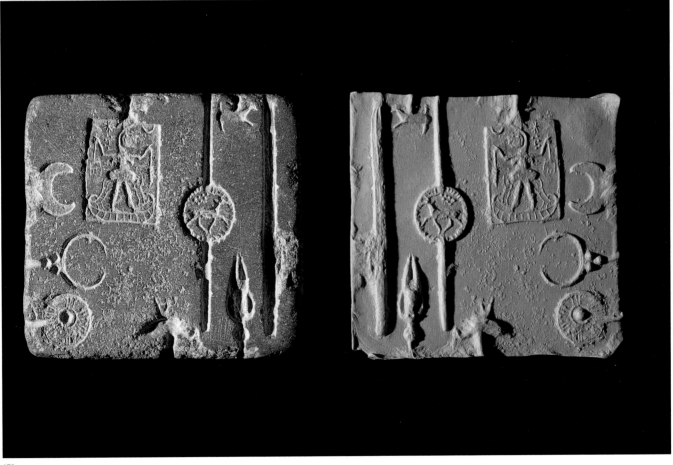

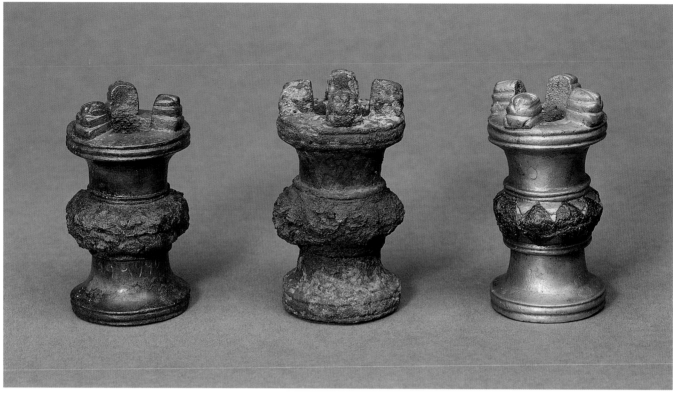

181, 179, 180

## BRONZE AND
## IRON MACEHEADS

Eight bronze and iron maceheads with lions' heads at the top were found by Layard in the 'Room of the Bronzes' (Room AB) in the North-West Palace at Nimrud (Layard 1853: 178). As much of the material in this room is known to have been imported from areas to the west, principally from Syria and Phoenicia, it is highly probable that the maceheads also derived from those areas. This provenance is supported by the fact that five of the maceheads have West Semitic alphabetic inscriptions giving the names of the owners (Barnett 1967; Heltzer 1978). Also, they are known either from actual examples or in representations from sites such as Byblos, Zincirli and Carchemish. However, maceheads of this kind are best represented in Assyria itself. In Sargon's palace at Khorsabad, Place found no less than fifty-four of them, at least one with a cuneiform inscription (Place 1867–70: I, 65–6; III, pl. 74.11–13), and on reliefs of Sargon they are shown being carried by courtiers or attendants (e.g. Barnett 1967: pl. VIII.2). In this case their purpose is purely ceremonial, but on stone reliefs at the Assyrian provincial capital of Arslan Tash they are being carried by soldiers, showing that they sometimes had a military use (Thureau-Dangin and Dunand 1931: pls 8–10). The evidence suggests, then, that maceheads of this kind were widely distributed across the Ancient Near East.   JEC

### 179   Bronze and iron macehead

Macehead with a bulbous centre and a ribbed flange at top and bottom. It is made of bronze, skilfully cast over an iron centre. Four stylised lions' heads project from the upper flange. There is a centrally placed vertical shaft-hole, about 2.5 centimetres in diameter, right through the macehead.   JEC

9th–8th century BC
From Nimrud, North-West Palace, Room AB
WA N261
H 9.1 cm, DIAM at top 5 cm
Layard 1853: fig. on p. 178

### 180   Bronze and iron macehead

Another as no. 179, also with four lions' heads on the top.   JEC

9th–8th century BC
From Nimrud, North-West Palace, Room AB
WA N262
H 9.2 cm, DIAM at top 5.2 cm
Layard 1853: fig. on p. 178

### 181   Bronze and iron macehead

Another as no. 179, but with three lions' heads on the top and with an incised West Semitic alphabetic inscription near the base. The inscription reads lnnwry, 'belonging to Ninuari'.   JEC

9th–8th century BC
From Nimrud, North-West Palace, Room AB
WA N257
H 8.7 cm, DIAM at top 5.1 cm
Layard 1853: fig. on p. 178. Barnett 1967: 5, 7. Heltzer 1978: 4, 8–9

183, 182

## 182 Faience macehead

Faience macehead, oval in shape, with a vertical central hole about 1 centimetre in diameter. At the top and bottom the macehead is brown in colour, and around the centre is a wide band of off-white. The two colours are sharply differentiated, and have probably changed since antiquity.

On the Assyrian reliefs maces are shown both as ceremonial objects and as weapons, but ornate maceheads such as this example made of a brittle material must surely have been ceremonial. Such maces are emblems of authority, and on the reliefs are shown being held by kings and courtiers as well as by genies. The reliefs show a range of different shapes, including plain oval and spherical maceheads like this and the following example (e.g. Hrouda 1965: pl. 32.1–17).

In the Late Assyrian periods maceheads of similar shape are also known in glass (Barag 1985: 75, no. 61, fig. 6, pl. 8). The use of faience (sintered quartz composition) as a material in the Late Assyrian period is unusual. JEC

9th–8th century BC
From Nimrud
WA 118776
H 6.15 cm, max. DIAM 5.7 cm
Layard 1853: pl. 55.7

## 183 Faience macehead

A faience macehead, spherical in shape, with a vertical central hole about 1 centimetre in diameter. Coloured brown and white as no. 182. JEC

9th–8th century BC
From Nimrud
WA 118775
H 5 cm, max. DIAM 5.55 cm

## 184 Ivory handle

Ivory group in the form of two women standing back to back. They have long hair and necklaces, and are naked except for straight-sided hats with vertical lines. These are sometimes called *polos*-hats and are shaped like a fez. Above the heads of the women is a leaf-shaped capital. There is a circular dowel hole at the top, and the remains of a peg on the base.

This object was probably a handle, perhaps from a fan or a mirror. On the Assyrian reliefs fans or fly-whisks with elaborate handles are shown being carried by attendants, and a mirror is held by Esarhaddon's mother Naqi'a on a bronze slab in the Louvre (Parrot and Nougayrol 1956). The style of this and comparable pieces is generally regarded as Syrian.

9th–8th century BC                    JEC
From Nimrud, Burnt Palace
WA 118102
H 13.4 cm, max. W 4.9 cm
Barnett 1975: 207, S.210, pl. LXXIV

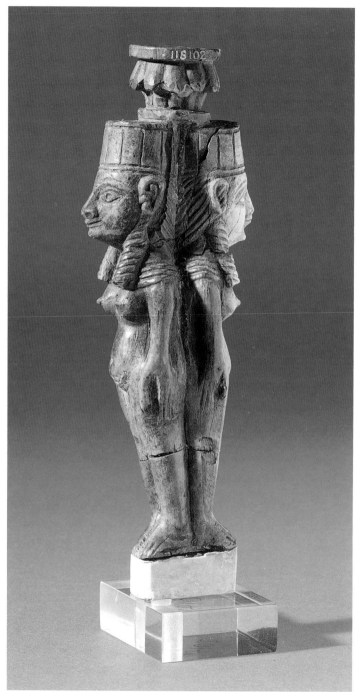

184

# 8 SEALS AND SEALINGS

The practice of sealing goods, probably a Near Eastern invention, goes back to around 5000 BC. The earliest evidence for the administrative use of seals comes from the prehistoric site of Arpachiyah near Nineveh, where incised hand-shaped stone amulets were impressed on elongated lumps of clay shaped round the knot in string securing a package. Since then, at all periods, seals have been used for marking ownership and securing jars, baskets, boxes and storerooms, for sealing ration lists, contracts, treaties, letters, scrolls and consignments of goods traded over great distances, often revealing unexpected international contacts.

Around 3500 BC a distinctive type of seal shaped like a cylinder was invented in southern Mesopotamia or south-western Iran. With the invention of writing, the use of cylinder seals for sealing clay tablets written in the cuneiform script spread rapidly throughout the Near East and continued for over 3,000 years. However, in the early centuries of the first millennium BC, alphabetic scripts such as Phoenician and Aramaic became popular; these were written on leather scrolls and papyrus which were rolled up, tied with string and secured with small lumps of clay which it was easier to seal with a stamp seal. In Assyria, therefore, cylinder seals and stamp seals were both used, the latter gradually becoming more popular until, in the seventh century BC, stamp seals were even being impressed on cuneiform tablets (see nos 210–12), although cylinders continued to be made and used until around 350 BC.

The role of seals as protectors of property was extended to protection of the individual. As the ownership of a seal was a mark of prestige, seals were often made of precious materials and are jewels in their own right. Some designs are beautifully cut and provide fascinating evidence of the techniques used. The subjects depicted have also proved a mine of information for art historians and archaeologists. The choice of stones depended on fashion and on availability. Rare stones were imported over huge distances (see no. 191) and provide clues as to the trade-routes in operation. Some stones were thought to have magical properties and were used as amulets and in rituals.

Among the seals in the styles attributed to the Assyrians, there are more provenanced examples than for any previous period. Conversely, however, the criteria for dating are surprisingly few. Differences in style and subject-matter coincide with variations in materials used, so that it is impossible to tell to what extent such differences are technical or chronological. Nor is it clear to what extent certain styles are survivals or revivals of those which existed before the little-known period 1200–

900 BC. Large numbers of cylinder seals have been recovered from numerous Assyrian sites, including the major cities of Ashur, Nimrud, Khorsabad and Nineveh, and various parts of the Assyrian empire or areas under Assyrian influence such as Hasanlu in Iran, Tell Halaf, the Carchemish and Khabur areas in Syria, and many sites in the Levant. Unfortunately, the circumstances of recovery of these seals are often unclear, but in any case seals are notoriously unreliable for dating an archaeological context: they can be kept as votive objects or heirlooms and found in much later contexts, or they can roll down drains and animal burrows and appear in contexts earlier than those in which we would expect to find them. In dating seals, therefore, style, design, inscription, material, and impressions on dated texts have also to be taken into consideration. Few impressions on dated texts have survived prior to the eighth century BC and most date from the seventh. The impressions on the seventh-century texts are poor and details are rarely clear. Many seem to have been made by earlier seals kept as heirlooms. Comparison with other arts, such as ivories, stone reliefs and metalwork, is disappointing because the conventions of representation and the subjects depicted varied considerably from medium to medium and were not interchangeable. The development of such motifs as winged sun-discs and trees should provide indications of chronology, but in most cases their variations seem to be dictated by provenance, material and technique rather than by relative date.

Traditionally the seals have been classified on the basis of technique, as follows.

ASSYRIAN LINEAR STYLE

During the period 1200–900 BC the use of cylinder seals was severely curtailed, and probably ceased altogether in some areas. From the beginning of the ninth century BC, the Assyrians, under a series of dynamic rulers, began expanding their frontiers and conquered large areas of Syria. There is some evidence to suggest that linear-style cylinder seals were being made in the Neo-Hittite and Aramaean kingdoms of north Syria and that this led to their revival in Assyria. Assyrian seals in the linear style are made of serpentinite, a material which had barely been used since Akkadian times, some one and a half millennia earlier. They are carved with scenes showing the king partaking in a ritual meal (no. 185), an archer shooting animals, chariot scenes, and animals and mythical creatures in procession. This style was particularly popular in the ninth century BC but probably also continued into the eighth, as suggested by the discovery of linear-style seals at Khorsabad, the short-lived capital of Sargon II of Assyria at the end of the eighth century BC.

ASSYRIAN CUT AND DRILLED STYLE

Designs executed with cutting-wheel and drill on hard stones, such as

cornelian and various chalcedonies, can be fairly closely dated because this is the one category of seal which was inscribed with any frequency. The seals often bear the names of *limmu*-officials, who were eponyms for specific years. Most can be dated to the latter part of the ninth century and the first half of the eighth century BC. During this period the *limmu*-officials became increasingly powerful and this is reflected in the iconography of the seals. Whereas many of the linear-style seals had focused on the king, the cut and drilled seals depict the official receiving his authority from the gods (no. 187). The execution of the designs is often fairly crude. The power of the *limmu*-officials was curbed under Tiglath-pileser III (744–727 BC), but it is not clear for how long the style associated with the *limmu* seals continued beyond this reign.

ASSYRIAN MODELLED STYLE

The Babylonians seem to have developed, to a higher degree than the Assyrians, the techniques required for cutting hard stones, and they used their expertise in the production of modelled seals where the marks left by the cutting-wheel and drill were hidden beneath carefully carved details of clothing or musculature. The style seems to have been introduced from Babylonia after the capture of Babylon by Tiglath-pileser III in 729 BC. The fashion for things Babylonian, and the clear superiority of the Babylonian modelled style over the Assyrian cut and drilled style, led to the establishment of an Assyrian modelled style (no. 188). From then on a common iconography seems to have developed, with a hero or winged genie between two animals or winged monsters, and Assyrian and Babylonian modelled styles become hard to differentiate. The situation is not helped by the fact that there are almost no provenanced examples of this particular category of seal. However, one such contest scene bears an inscription naming Urzana, the king of Musasir who was defeated by Sargon II in 714 BC. The finest pieces in this Assyro-Babylonian modelled style are exceptionally beautiful.

LATE CUT STYLE

Sometimes the modelled style degenerates and there is no attempt to mask the use of cutting-wheel and drill (no. 189). Although some pieces may have been unfinished, most of them were conceived from the start as cut-style seals. Generally the seals depict the winged genie between winged monsters familiar from the modelled style.

FAIENCE SEALS

A number of faience seals have survived and many are provenanced. They seem to have been popular throughout the Ancient Near East, and they display a fairly restricted but widely distributed range of subjects. Several show an archer shooting at an animal (no. 186). More often the archer shoots at a coiled, dragon-headed snake; in varying but often cursory styles this subject has been found geographically from Hasanlu

in Iran to Tharros in Sardinia, and from Karmir Blur in the Republic of Armenia to Nippur in Babylonia, and chronologically, it seems, from the ninth century to the seventh. Another popular subject shows processions of ostriches; sometimes this design is reduced to a pattern of lines.

## The Change to Stamp Seals

The royal administration adopted stamp seals in the ninth century BC, and a 'royal seal type', with the king stabbing a rampant lion, was used extensively in many versions (no. 194). On stylistic grounds, some stamp seals can be dated to the eighth century (no. 191), but although the stamp seal replaced the cylinder seal in the western parts of the empire, there is little evidence for its widespread adoption in Assyria before the seventh century BC; we are, however, hampered by the lack of dated impressions. It is difficult to ascertain to what extent the cylinder seals used in the seventh century were heirlooms. In some cases related motifs appear on stamp seal impressions dated to the seventh century BC (no. 212), on actual stamp seals (no. 193) and on cylinder seals (no. 190), and a seventh-century date is therefore likely. Bull-men supporting winged sun-discs (no. 193), and Gula, goddess of healing (no. 192), were particularly popular subjects, carved on small conoids, often made of blue chalcedony (no. 193).

The stamp seal was the main seal type from the seventh century BC onwards, although the cylinder seal survived in the Babylonian and Achaemenid Persian administrations for more than two centuries.

## Techniques of Manufacture

Hand-held tools were used at all periods, at times even for quite hard stones; the linear-style seals would have been cut in this way. By Late Assyrian times horizontally mounted cutting-wheels and drills, powered by a bow, were used for cutting hard stones. Given patience, the most intricate designs could be cut using flint and copper tools, provided a good, fine abrasive was available, such as emery from the Aegean island of Naxos or from India.

Most people, when they see seals for the first time, wonder how such fine work could have been produced. There is no evidence to suggest that any form of magnification was available and it is probable that short-sighted (myopic) craftsmen were employed: because they would have had to hold the seal closer in order to focus on the design, they would have seen it enlarged.

The seals are described from their impressions and generally from left to right. The impressions are modern. DC

## 185 Linear-style cylinder seal

The bearded king wears a fringed robe; he holds a cup in one hand, and a mace just below the head in the other. He stands facing an attendant who is similarly attired and holds a flag-shaped fan and a towel. Between the figures is a pot on a stand, and behind them are three trees beneath a star. There are three notches in the field above the fan, and chevron borders around the ends. The fan, made of split and flattened reeds, is a type still used in Iraq today.

This slightly barrel-shaped seal is made of black serpentinite and is shiny, with some chipping of the upper edge.     DC

9th century BC
Provenance unknown (acquired by Layard)
WA 89618
H 3.75 cm, max. DIAM 1.35 cm

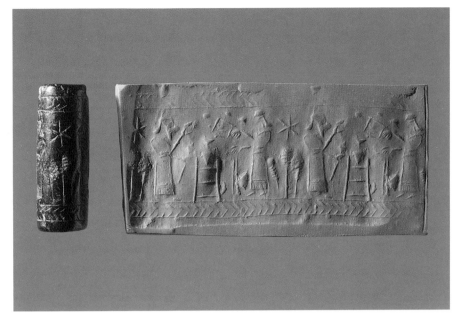

185

## 186 Faience cylinder seal

A winged bull stands facing a standing archer wearing a long fringed robe; the archer is aiming an arrow at the bull. Above the bull are a crescent and two wedges, and in front of it is a palmette-like plant. There are line borders around each end.

The seal is of faience (now brown and green) with a low lead antimonate content; its edges are chipped.     DC

About 850–700 BC
Probably from Nimrud (acquired by Layard)
WA 89419
H 3.5 cm, DIAM 1.4 cm
Collon 1987: no. 337

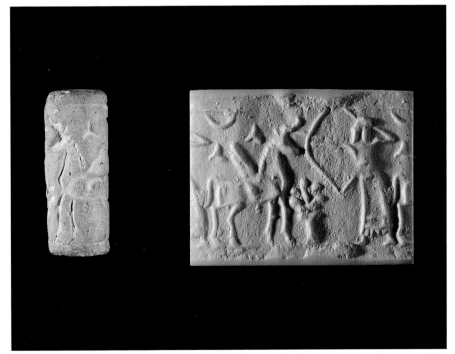

186

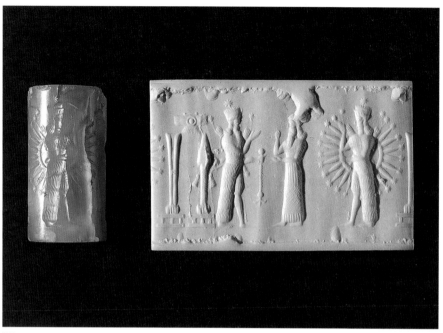

187

and tiered open robes with very fine undulating vertical striations; on their backs they have crossed star-tipped bow-cases and quivers. The god wears a sword and holds a mace with a beaded handle ending in a pomegranate. The goddess holds a beaded circle with star-tipped rays which encircles her.

The subject-matter is typical of the cut and drilled style. However, the careful workmanship and detail, the prominence given to the symbols of Babylonian gods, and the grid-patterned dresses of the figures make it likely that the seal dates to the last third of the eighth century, after the Assyrian conquest of Babylon. The identity of the warrior deities and worshipper is uncertain. The stars surrounding the goddess are her *melammu* or divine radiance.

The seal is of banded grey and brown agate; its edges are chipped and there is a large chip by the worshipper's head. There are vertical faults in the stone by the spade.                                    D C

About 729–700 BC
Provenance unknown
W A 89810
H 3.65 cm, DIAM 1.9 cm

## 187 Cut, drilled and modelled-style cylinder seal

On the left are the symbols of the Babylonian gods Nabu (the stylus) and Marduk (the tasselled spade with chevron-decorated handle) standing on altars beneath a winged sun-disc, symbol of the sun god Shamash. In the centre of the scene is a bearded worshipper who wears a robe with a vertical grid pattern on the bodice and a diagonal grid on the fringed skirt, each square being filled with a small dot executed with a tiny drill; over this garment he wears a fringed shawl. He stands facing left, pointing with his raised right hand and extending the other palm upwards. Facing him on either side are two deities, a bearded god on the left and a goddess on the right, both raising their right hands. They are crowned with star-topped, flaring, feathered and horned headdresses with tassels hanging down their backs, and they wear grid-and-drill-hole patterned upper garments and fringed kilts, criss-cross patterned belts

## 188 Modelled-style cylinder seal

A bearded genie or hero stands facing left and grasps the foreleg of a rearing winged bull on each side. He wears a short-sleeved bodice and a belted, fringed, open skirt, both patterned with hexagons, over a short, diagonally cross-hatched, fringed kilt. The two striding, rampant winged bulls have their heads tucked in and horns pointing forwards; the backs of their necks and their forelegs are decorated with curls and their necks and bodies are covered with fine, undulating lines. The foreleg nearest the viewer is bent and the tail is curved round in a semicircle. At the end of the scene there was a panel for an inscription beneath which was carved a hunting dog facing left, with tightly

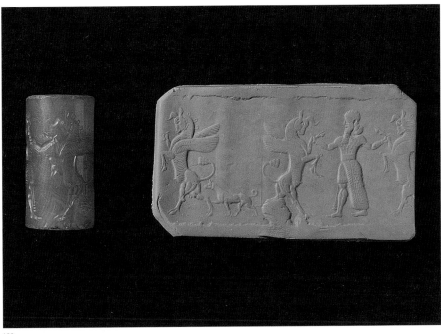

188

curled tail and the right forepaw raised to touch the right-hand bull's leg. The inscription was erased (faint traces remain of some of the signs) but it was never recut.

This seal is one of the products of a workshop which made such spectacular seals that it was probably a royal workshop, established in the reign of Sargon II (721–705 BC). It is of banded grey and white agate, and is chipped at the bottom.

About 720–700 BC                    DC
Provenance unknown
WA 129098
H 3.65 cm, DIAM 1.95 cm
Collon 1987: no. 656

## 189 Late cut-and-drilled-style cylinder seal

A bearded genie or hero stands facing left and grasps in his raised right hand the paw (or hand?) of a human-headed, bearded, winged and scorpion-tailed monster on the left. Between them are a crescent and a rhomb. The design is reduced to a pattern of wheel-cut lines and drill-holes with no attempt at finer detail. As a result, the hero's open skirt is indicated only by a series of drill-holes which are larger and more closely spaced along his left leg than along his right (compare with no. 188). He has a sword in his belt. Lack of detail also makes it impossible to tell whether the monster has a human or a leonine body, but the latter is more likely as feet are not indicated. The hero raises his left arm as if to grasp another monster, but instead in the space behind him there is a winged sun-disc above a star, a folding table with a cloth on it, and a fish.

The stone is a clear light grey chalcedony, and the seal is slightly barrel-shaped.                    DC

7th century BC
Provenance unknown
WA 101960
H 3.45 cm, max. DIAM 1.25 cm

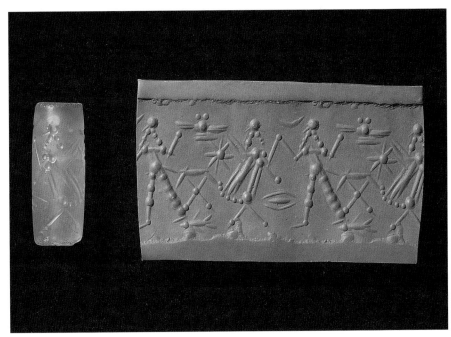

189

## 190 Late cut-and-drilled-style cylinder seal

The scene consists of a tree with a winged disc above it, supported on either side by a small scorpion man, flanked by a worshipper on the left and by a god on the right. Behind the god is a hero grasping stags and gazelles, with an Aramaic inscription to his right divided by a globe-topped dagger shape. There are three bearded heads on the wings, two with globe-topped headdresses at either end facing a god in a tall, globe-topped, horned headdress who raises one hand and faces left. The tree consists of a palmette-topped upright with double lines at the bottom, above a globe in the middle, and above a globe at the top, enclosed in an arch decorated with spiked globes. The scorpion men face each other on either side of the tree; they raise both hands towards the wings but do not actually touch them. They are bearded, and human above the waist, with pectoral muscles indicated by drill-holes; they have a scorpion's tail and the legs and talons of a bird of prey. The back leg of each rests on the front foot of the flanking figures. The worshipper on the left is beardless, wears a fringed shawl over a fringed robe and raises the palm of one hand towards him; there is an unexplained cluster of four drill-holes on the upper part of the body. The god stands facing left; he is bearded and wears a striated headdress resembling hair, possibly horned and with a palmette-crest at the top, and with a streamer hanging down behind. He wears

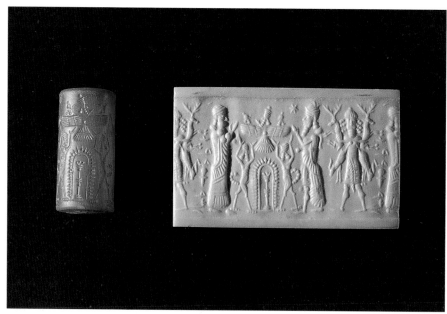

190

a fringed shawl and a fringed and tiered open skirt over a kilt, raises the palm of his left hand towards him and extends the other in a fist. The hero is bearded and shown frontally, apart from his feet which are turned towards the left. His hair is fastened in a topknot and falls in three long curls on either side of his face; he wears a broad-belted kilt decorated with dot-filled squares, with a fringe down the front, the end of which hangs between his legs. Against his chest he holds two small stags whose legs stick out on either side and whose antlers frame his head; in his fists, which are clenched against his chest, he holds the hindlegs of two gazelles which hang down on either side.

The Aramaic inscription, *lmr brk*, runs from the bottom of the seal upwards and is to be read from right to left on the impression: 'Of [i.e. belonging to] Mar-Barak'. The globe-topped dagger shape, set at right angles to it, is used to separate the two parts of the name. The inscription has been dated between about 700 and 630 BC, a date which corresponds well with the style and iconography. The stone is cornelian.                          DC

7th century BC
Provenance unknown (acquired before 1857)
WA 102966
H 2.4 cm, DIAM 1.2 cm
Collon 1987: no. 355. Galling 1941: no. 154

## 191 Oval stamp seal

A goddess with one hand raised holds a beaded circle with star-tipped rays – her *melammu* or divine radiance – which encircles her. She was probably crowned with a feather-topped, horned headdress, and two drill-holes represent her hair; she wears a three-tiered, pleated, open skirt over a fringed kilt and had a star-tipped sword at her waist. In antiquity this seal was cut down from a larger one, and the feet of the goddess and much of her headdress are therefore missing; many of the stars of the *melammu* had to be redrilled.

This seal is of lapis lazuli; it has a flat back, is perforated lengthwise, and is worn. Lapis lazuli was imported from Afghanistan and was a rare and highly prized stone at all periods. Judging from its relative scarcity in Late Assyrian times, it must have been difficult to obtain and this would explain why the seal was reused by a later owner. It may have been cut down from a scaraboid which had become damaged.    D C

8th century BC
Provenance unknown (acquired in 1841)
WA 41-7-26,150
H 0.6 cm, base 2.1 × 1.6 cm
Lajard 1847: pl. XLVI.25

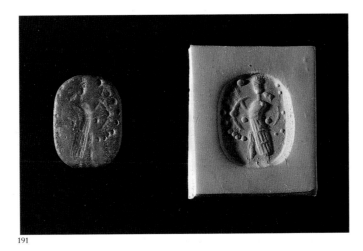

191

## 192 Conoid stamp seal with an oval base

On the base of this seal a standing bull faces left but looks over its shoulder towards the right; its tail is curved up over its back. Above is an eight-rayed star, below is a palmette, and behind is a crescent. On the side Gula, the goddess of healing, sits on a throne, the back of which is decorated with five drill-holes representing stars; it rests on her recumbent dog. She wears a tall, star-topped, horned headdress, and a dress with fringes down the front, across the knees and round the hem. She raises one hand and holds her dog's lead in the other. A bearded worshipper stands facing her and raises one hand. He wears a shawl with a deep fringe wrapped over a fringed robe.

The seal is of light grey chalcedony with a modern gold setting. The base is slightly convex.    D C

7th century BC
Provenance unknown. Presented by G. D. Hornblower Esq.
WA 130814
H 2.4 cm, base 1.5 × 1.7 cm

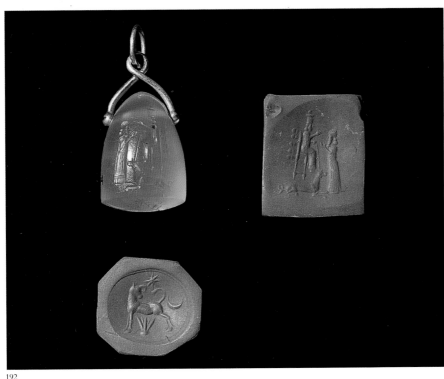

192

## 193 Conoid stamp seal with a circular base

On the base two bearded bull-men face each other and raise their hands to support a winged sun-disc from which rises the head of a bearded god facing right with one hand raised; below is a palmette-topped tree. On the left side a bearded hero or genie, facing right and wearing an open, many-tiered skirt, raises his arms on either side; two mermen (bearded, human-headed fish), one on either side, seem to press their faces against the hero's forearms. On the right side a bearded, fish-cloaked figure stands facing right, raises his right hand and holds a bucket in his left.

This seal is blue chalcedony. The base is slightly convex and the top flattened. There are remains of a metal pin in the perforation, and one end of the perforation has been chipped – probably in an attempt to remove the pin.　　DC

7th century BC
Provenance unknown
WA 115561
H 2.4 cm, base DIAM 1.5–1.6 cm

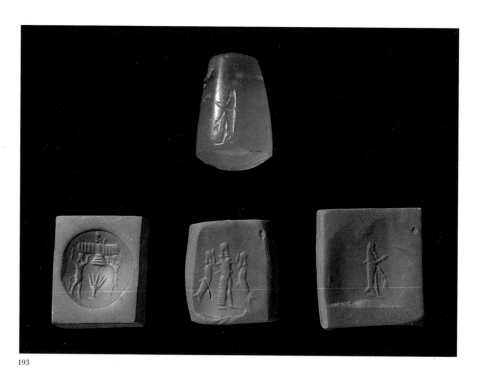

193

## 194 Impression of a 'royal seal'

This stamp seal impression depicts the bearded Assyrian king, wearing the royal tiara with tassels hanging behind, and a kilt. He stands facing right and fights with a rampant lion, grasping its mane in his left hand and stabbing it in the chest. The posture of the lion is distinctive: it stands with one paw up behind its head and one paw down in front. A simple guilloche border with central dots runs round the seal.

The seal was impressed on a circular disc of clay applied to the knot in the string around a wooden box (the grain of the wood can be seen on the reverse of the impression). A cuneiform inscription, dated 25th Tebêtu 715 BC, was written

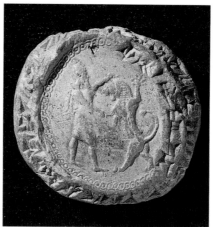

194

around the impression: 'ilku payment which Sargon took from the bel pihati official.'

With variations in details of dress, size of lion in relation to the king, size of seal and type of border, this was the type of seal used by the Assyrian royal palace administration for three centuries and it is known as the 'royal seal type'. No actual example has survived, but numerous impressions are known. However, unlike the present example, most of them are uninscribed and therefore cannot be dated.

715 BC　　　　　　　　　　　　DC
From Nineveh
WA Sm2276
DIAM 3.8 cm, TH 2.0 cm
Sachs 1953: 169 no. 7, pl. XVIII.4

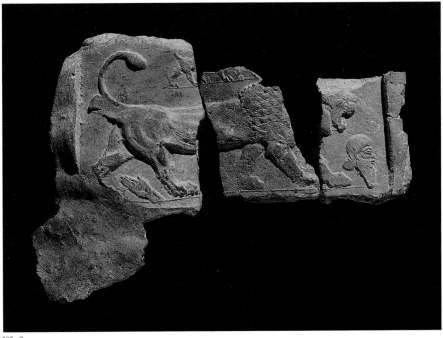

195–7

## 195–7 Seal impressions showing a lion

These three fragments, from different impressions, were probably made by the same large stamp seal with a deeply carved design. It shows a lion with its tail curved over its back, pacing on a ground-line towards the right with its jaws open. Between its hindlegs is a human hand, set at an angle and overlapping the ground-line. In front of the lion is a bearded human head with shoulder-length hair, facing right. Above the lion is a much smaller lion in a similar posture on its own ground-line; the human hand is missing but it may have had a human head in front of it. Indeed, a further fragment in the British Museum (WA 122107) shows such a head, though it was made by a different seal and the hair on the head is shorter.

The seal, which originally measured about 5.8 by 7.4 cm, was impressed on reddish clay. On the reverse are the impressions and holes left by string (diameter 3 mm) securing leather (the larger fragment) or coarsely woven cloth (the two smaller fragments) which covered the wide, slightly flaring neck of a jar or similar container. It is tempting to suggest that the seal could have been used to seal booty from Assyrian campaigns, with the different enemy heads indicating the origin of the booty. DC

Probably 7th century BC
From Nineveh
195 WA 122108 (left)
H 9.4 cm, W 6.5 cm, TH 1.9 cm
196 WA Rm656 (centre)
H 5 cm, W 4 cm, TH 2.5 cm
197 WA Rm657 (right)
H 4.4 cm, W 3.3 cm, TH 2 cm
Herbordt 1992: 136, pl. 19

# 9 ADMINISTRATION AND SOCIETY

The Assyrian empire depended on an efficient local and provincial administration for the collection of its revenues and the conscription of military and civil service. Only a minute fraction of the records of this administration remain today. The senior administrators, who mostly got their jobs as a result of family connections and patronage, were not necessarily literate themselves but would have relied on literate clerks. Almost all records are in the Assyrian cuneiform script on clay tablets; but from the ninth century BC onwards people of Aramaean descent played an increasing part in the administration, and this is reflected in occasional notes written in Aramaic on the edges of tablets. Later, under the Achaemenid empire, Aramaic became the standard language of the imperial administration.

Clay tablets were the standard medium for the long-term preservation of records, but being heavy would not have been convenient for the transfer of large collections of administrative data. The illustrations on reliefs of scribes writing or drawing on writing-boards and leather scrolls suggest that these media too may have had a part to play in administration, but only a few writing-boards and no leather scrolls have survived. There is evidence that many of the literary texts were copied from tablets on to writing-boards and later recopied from the writing-boards back on to tablets.

The economic basis of the heartland of Assyria was agriculture, animal husbandry and trade. The crown owned its own estates and in addition derived revenues and services from taxation, tribute and conscription. In the Late Assyrian period all agricultural land was subject to a grain and straw tax, all animals were taxed, and much land was held in return for the obligation to perform military or civil service when required. Eventually this obligation was probably extended to all citizens. As the empire expanded new provinces were taxed, and tribute was collected from those lands which were allowed to remain nominally independent. Tribute was a particularly important source of luxury goods. The commodities, goods and services thus procured served for the maintenance of the bureaucracy, palaces and temples throughout the empire. There is evidence that the burden of supporting the growing bureaucracy and non-productive city-dwellers and financing long series of military campaigns became increasingly difficult to bear and may have contributed to the final collapse of Assyria. CBFW

198

### 198 Waxed ivory writing-boards

These are two of a set of sixteen writing-boards hinged together as a folding set. They were scored on the back and front to receive the wax surface, which would have been inscribed in cuneiform with a stylus. One of the set is incised on the outside with an inscription indicating that the set had contained a part of the astronomical omen series Enuma Anu Enlil and had originally been intended for the palace of Sargon II at Khorsabad. CBFW

About 720–710 BC
From Nimrud, North-West Palace, well in Room AB (ND 3566–7)
WA 131952-3
H 34 cm, W of each 16 cm, TH 1.5 cm
Howard 1955. Wiseman 1955

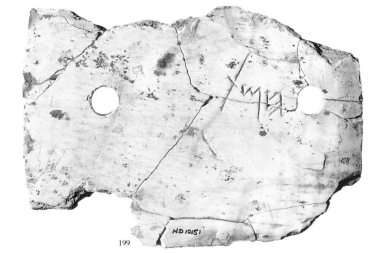

199

### 199 Ivory label naming Hamath

Tribute and tax came in many forms. From the mid-ninth century BC on, the kings of Hama (ancient Hamath) in Syria sometimes resisted and sometimes, by paying tribute, accepted Assyrian hegemony; in 720 BC the city was finally conquered and the region became an Assyrian province. This ivory plaque, simply inscribed *hmt* in the Aramaic alphabet, may have come with goods which reached Assyria either as tribute from Hamath or as booty after its conquest. It was found in a storeroom among the remains of ivory furniture from the west, much of which had once been overlaid with valuable gold-leaf; at some stage the gold had been removed. JER

9th–8th century BC
From Nimrud, Fort Shalmaneser, Room SW37 (ND 10151)
WA 132994
H 6.5 cm, W 9.2 cm, TH 0.4 cm
G. Herrmann 1986: 53, 237, no. 1272

## 200 An account of linen and wool

The text records the expenditure (described as 'consumption') of 274 talents of linen fibre, 109 talents of madder (for dyeing), 22 talents of red wool, and 53 talents of red dye. An Assyrian talent corresponded to about 30 kilograms. The individual entries refer to some of the cities and towns of Assyria, including Nineveh and Kalhu (Nimrud), to various palaces and officials, and to the production of different types of garments and textiles. A separate group of entries at the end accounts for 30 talents of linen which had been purchased.                    CBFW

7th century BC
From Nineveh
WA K1449
H 11 cm, W 6 cm, TH 2.5 cm
Fales and Postgate 1992: 121, no. 115

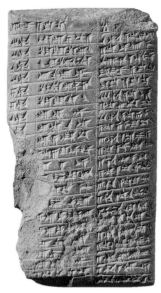
200

## 201 An administrative text concerning estates

Details are given of more than thirty different estates in various parts of the Assyrian homeland and to the west, at Halzu, Arbail (Erbil), Kalhu (Nimrud), Barhalza, Izalli and Halahha. In each case the size of the estate and its location, the number of orchards, and the names of the farmers are recorded.          CBFW

7th century BC
From Nineveh
WA 79-7-8,309
H 22 cm, W 13 cm, TH 5 cm
Fales 1973: 74–81, no. 24

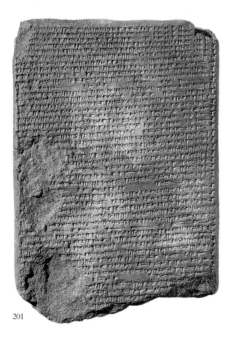
201

## WEIGHTS

There were many variant systems of weights in the ancient world. One Late Assyrian system follows the earlier Babylonian standard which had a basic unit, the mina, corresponding to about 500 grams, subdivided into 60 shekels. However, alongside this system is another which uses a 'heavy' mina, corresponding to about 1 kilogram. The lion-weights shown here belong to this second system. The reasons for its development are quite unclear, but it certainly goes back to at least the ninth century BC, and to judge by references in economic texts it became the more commonly used system in Assyria. This Assyrian system is also unusual in providing weights which represent unit fractions of the mina, one-quarter, one-fifth, one-sixth and one-eighth.

Many Assyrian weights are marked 'mina of the king' or 'mina of the land'. These apparently synonymous terms, which can be used with either the 'heavy' or the 'light' mina, seem to mean 'official weight standard'.          CBFW

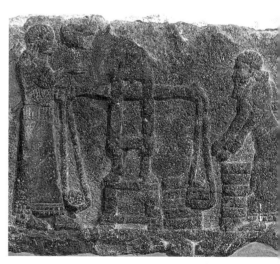

Detail from the Rassam Obelisk of Ashurnasirpal II showing the weighing of tribute (WA 118800).

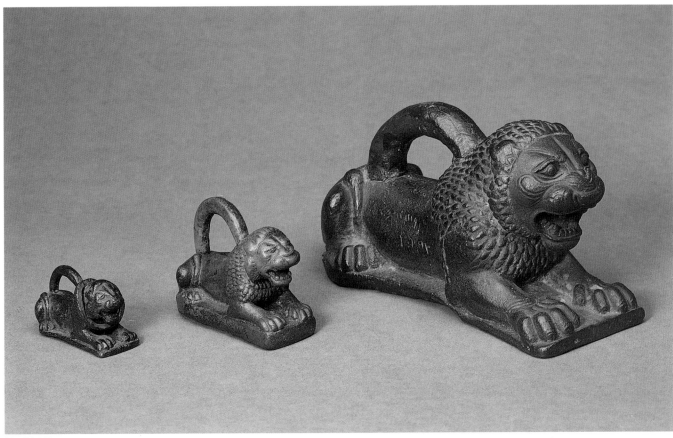

204, 203, 202

## 202 Bronze lion-weight

Layard found a group of sixteen Assyrian bronze lion-weights at Nimrud, eight of which were plainly part of a single set made for Shalmaneser V (726–722 BC) and belong to the system of the 'heavy' mina. This weight is inscribed in Assyrian, 'Palace of Shalmaneser, king of Assyria, five mina of the king', and twice in Aramaic, 'Five mina of the land' and 'Five mina of the king'. Five lines are incised on the flank of the lion to represent the number 'five'.                    CBFW

726–722 BC
From Nimrud, North-West Palace, Room B
WA 91221
H 10.5 cm, L 20 cm, W 8 cm, WT 5042.8 g
Layard 1853: 601. Thureau-Dangin 1921a: 139.
    Mitchell 1990: 130–31

## 203 Bronze lion-weight

The weight is inscribed in Assyrian, 'Palace of Shalmaneser, king of Assyria, two-thirds of a mina of the king', and in Aramaic, 'Two-thirds (of a mina) of the land'. A cross, perhaps intended to represent 'two-thirds', is incised on the flank of the lion.                    CBFW

726–722 BC
From Nimrud, North-West Palace, Room B
WA 91230
H 6.4 cm, L 8.8 cm, W 2.5 cm, WT 665.7 g
Layard 1853: 601. Thureau-Dangin 1921a: 139.
    Mitchell 1990: 132

## 204 Small bronze lion-weight with ring

The weight is inscribed in Assyrian, 'Palace of Shalmaneser, king of Assyria, one-fifth of a mina of the king', and in Aramaic, 'One-fifth'. Five lines are incised on the flank of the lion, presumably to represent 'one-fifth'. The lion, when originally cast, was too light, and the ring around its neck brought its weight up to the desired amount. CBFW

726–722 BC
From Nimrud, North-West Palace, Room B
WA 91233
H 4 cm, L 6.5 cm, W 2.5 cm, WT 198.4 g
Layard 1853: 601. Thureau-Dangin 1921a: 139.
    Mitchell 1990: 134–5

205

### 205 Stone duck-weight

The damaged inscription indicates that the weight was royal property and ends with the word 'one-sixth', showing that the weight belongs in the 'heavy' mina series.

8th century BC           CBFW
From the North-West Palace, Nimrud
WA 91439
H 4 cm, L 7 cm, W 4 cm, WT 178.3 g
Kwasman and Parpola 1991: fig. 6b (right)

206

### 206 Stone duck-weight

The lion incised on the duck's flank marks the weight as royal property. Beneath the lion the Assyrian inscription 'one-eighth' shows that the weight belongs in the 'heavy' mina series.    CBFW

8th–7th century BC
From Nimrud
WA 91442
H 4 cm, L 6 cm, W 4 cm, WT 127.8g
Kwasman and Parpola 1991: fig. 6c

## 207 Stone duck-weight

The weight of this duck corresponds approximately to one 'heavy' mina or two 'light' minas.    CBFW

8th–7th century BC
Probably from Nineveh
WA 91435
H 7 cm, L 14 cm, W 7 cm, WT 969.7 g
Kwasman and Parpola 1991: fig. 5b

207

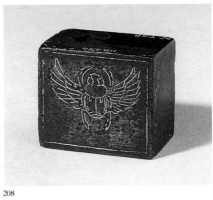

208

## 208 Cubic bronze weight

This weight is made of cast copper inlaid with gold wire. A similar example also in the British Museum (WA 119433) weighs 265.3 grams, and the pair may represent 20 and 30 shekels respectively, though not by the Assyrian standard. The scarab is a motif of Egyptian origin. It has been suggested that the winged scarab was the official royal symbol of the kings of Judah (Yadin 1967), though it may also have been used by other states in Palestine or Phoenicia. It seems probable, then, that this weight came to Assyria as part of a consignment of tribute or booty, and was simply left in store about 710 BC when the North-West Palace ceased to be a royal residence. It was found in a storeroom which included many items (e.g. nos 100–104) which could well have belonged to some such consignment or consignments from the west, since the Assyrians did not necessarily have any use for all the things they collected; the storerooms full of ivory furniture at Fort Shalmaneser (see nos 92, 96) are a notable example.    JER

8th century BC
From Nimrud, North-West Palace, Room AB
WA 119434
L 3.5 cm, W 3 cm, D 3 cm, WT 174.9 g
Layard 1853: 196

## PROPERTY

In theory all land belonged to the king as representative of the gods. In practice much was held either by temples or by private citizens. Privately owned land could be rented out or transferred by sale, by inheritance or on marriage. Legal contracts deal with all these possibilities. Such contracts were normally made in the presence of witnesses, written down and sealed. Disputes were resolved not by courts but by senior administrative officials. No Late Assyrian law code survives, and of the fragmentary law code of the Middle Assyrian period only a few sections deal with landed property, mostly being concerned with disputes between brothers or neighbours. One of these provides that on a transfer of land within the city of Ashur or within any other city a herald must make proclamation of the proposed transfer three times within a month, after which the mayor and city elders confirm that the transfer may take place.

Slaves, agricultural workers and subordinate family members could also be treated as transferable property. Women and children were often given as pledges for debt and could be subjected to severe ill-treatment. The Middle Assyrian laws leave the impression that women had a very inferior and disadvantaged status.

CBFW

## 209 Dedication of property to a Nabu Temple

This bronze plaque is in the form of an amulet, with a lug for suspension at the top and traces of corroded wire surviving in the hole through the lug. The figures of four deities, including Marduk and Nabu, are incised above the inscription. Their position is reminiscent of the seal impressions on Neo-Assyrian conveyance texts and dedication texts. The inscription records a gift made by a man named Ashur-resua to the temple of the god Nabu. The gift included a house in the city of Kalhu, and two agricultural estates together with the farmers who worked

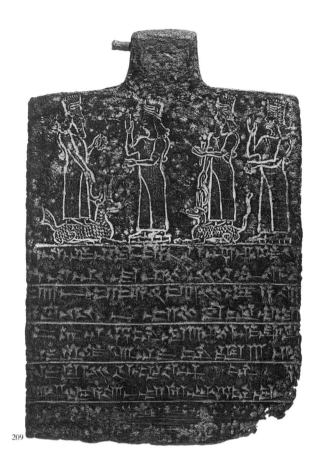

209

them. Ashur-resua may be identified with an official of the imperial administration of Sargon II (721–705 BC).　　CBFW

8th century BC
Probably from Nimrud, Temple of Nabu
WA 118796
H 11 cm, W 8 cm, TH 1 cm
Postgate 1987: 57–63

## 210 House sale contract

Sharru-lu-dari, a charioteer in the royal household, sells a house in Nineveh with its roof timbers, six doors and a well, to Kakkullanu for two minas of silver. The money has been paid. If Sharru-lu-dari or his family later claim that they have not been paid, they shall pay a penalty of ten minas of gold to the temple of Ishtar. Date: 17th Simanu, eponymy of Sin-sharru-usur. There were twenty-three witnesses.

The tablet has been impressed three

210

times, between ruled lines, with a conoid or perhaps scaraboid seal. The impression shows a robed worshipper with both hands raised, standing facing left towards a star and crescent. The seal was chipped, both below the crescent and behind the worshipper, where there are traces of some other symbol. DC/CBFW

About 624–615 BC
From Nineveh
WA K311
H 10 cm, W 5 cm, TH 3 cm. Seal impression:
 H 1.55 cm
Kwasman 1988: 150–51, no. 123. Herbordt 1992:
 218, Ninive 49

## 211 Marriage contract

This clay tablet is inscribed with the record of the sale of the daughter of Nabû-rehtu-usur to a woman as a bride for her son, in the year named by the eponym Ashur-mata-tuqqin. A space has been ruled on the front of the tablet and the same oval seal has been impressed twice sideways on. According to the text, three people sealed the tablet: Nabû-rehtu-usur and his two sons. Since only one seal was impressed, it was presumably a family seal used by all three members of the family. The seal depicts a griffin-headed demon who raises a cone in one hand and carries a bucket in the other. He faces a winged sun-disc which has streamers grasped by a four-winged genie who kneels on one knee, facing left; the heads of three deities rise from the disc and wings and there is a crescent to the left.

A corner of the tablet is missing.

About 625–617 BC        DC/CBFW
From Nineveh
WA K295
H 7.4 cm, W 3.9 cm, TH 1.9 cm. Seal
 impression: H 2.55 cm
Kwasman 1988: 253–4, no. 214. Herbordt 1992:
 225, Ninive 79

## 212 Contract for an exchange of slaves

Three people, two of whom are brothers, give their male slave, Ishtar-dur-qali, to Kakkullanu, an army commander, in

211

exchange for his slave-girl, Abi-lihya. Date: 20th Ayaru, eponymy of Sin-sharru-usur. There were eleven witnesses. The Aramaic note on the edge reads, 'Sale document of Ishtar-dur-qali'. It is likely that this note was intended to assist record-keepers who could not read the cuneiform script.

The tablet has been impressed three times sideways with a scaraboid seal, between ruled lines. The seal has an Egyptianising motif within a line border. A seated god holds the symbol for 'years', meaning 'millions of years'; beneath it is a basket; above is a highly stylised version of the winged sun-disc, or perhaps a disc with uraei. DC/CBFW

About 624–615 BC
From Nineveh, North Palace, Room C
WA K329
H 8 cm, W 4 cm, TH 2 cm
Fales 1986: 206–7, no. 31. Lieberman 1968.
 Kwasman 1988: 153–4, no. 125. Herbordt 1992:
 219, Ninive 53

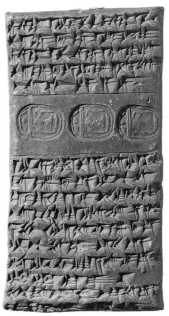

212

decades of the Assyrian empire. The upper edge of the tablet has three fingernail impressions and two impressions made perhaps by beads, instead of seal impressions. CBFW

About 670 BC
From Nineveh
WA 81-2-4,148
H 5 cm, W 4 cm, TH 2 cm
Fales 1986: 157–61, no. 13. Lieberman 1968.
 Herbordt 1992: 249, Ninive 186

213

## 213 An Aramaic docket

Two people pledge a child or a slave as security for a loan of silver which is to be repaid within thirty days. There are seven witnesses to the transaction. The docket is evidence for the increasing use of the Aramaic language and script as an alternative to Assyrian cuneiform during the last

# 10 LITERATURE AND SCIENCE

L iterature was already very ancient by the period of the late Assyrian kings, since early scribes committed their myths and other *belles-lettres* to writing on clay soon after the first development of the cuneiform script in about 3000 BC. Many literary texts of widely varying lengths have survived from subsequent periods.

Science went something of its own way in Mesopotamia, in that much effort and attention was always lavished on various techniques for predicting the future. Mathematical writings appear about 1700 BC, and rather later texts demonstrate an interest in astrology, astronomy and medicine, fields of investigation which only reached their full flowering in the period after the fall of Assyria, when Mesopotamian achievements could make their contribution to Greek scientific thinking.

Texts from both these broad categories have survived in abundance in the libraries from Kuyunjik (Nineveh), the discovery of which in the nineteenth century was the single most significant event in the modern process of recovering information about ancient Assyria. The last great Assyrian king, Ashurbanipal (668–*c.* 631 BC), was motivated to develop a major library in his capital city, whether by a love of learning or a desire to control his astrologers and counsellors, who relied on written authority. The effect of this was to accumulate a major proportion of

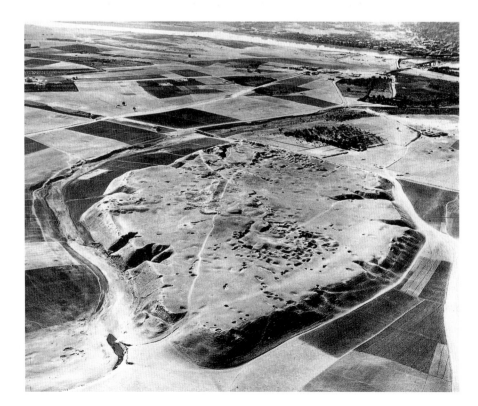

Aerial view of Kuyunjik, one of the mounds of ancient Nineveh (RAF photograph, 1948).

the extant literature in the cuneiform script. The chancery was staffed by some of the country's most able calligraphers, and as texts came it was their job to prepare immaculate, carefully edited manuscripts on clay which were marked as belonging to the king's library. In many cases duplicate copies were produced, for reasons unknown. It transpired that there were many compositions for which sources were not to hand. As a result the king despatched messengers south to Babylonia, to seek

(*Left*) George Smith (1840–76), who became famous through his recognition of tablets containing 'the Chaldaean account of the Deluge'.
(*Right*) Hormuzd Rassam (1826–1910), who discovered the North Palace of Ashurbanipal at Nineveh and some tablets belonging to the royal library.

out what was needed from libraries there. These were taken to the capital and usually recopied in Assyrian script. Letter-orders with instructions on this point have been discovered among the Kuyunjik tablets, together with lists of impounded documents, including waxed writing-boards which have perished irretrievably. Other records describe copying work in progress, detailing what remains to be done.

The destruction of the palace left many tablets broken, but ironically the burning of the building contributed to their preservation. The task of rejoining the 30,000 fragments to produce complete tablets has occupied Assyriologists continuously since their discovery.                    ILF

## LITERATURE

Perhaps the best known tablets from Ashurbanipal's library fall into the general category of literature, although we do not in most cases know how such texts were classified by their ancient authors. The reconstruction of literary texts is an ongoing procedure, and many compositions are still fragmentary or incomplete.

A high proportion of known literary texts was represented in the royal library. The Epic of Gilgamesh, Atra-hasis (the Flood story), myths such as Etana, Adapa, or the various traditions of Enuma Elish (the Creation epic) are all known chiefly from tablets excavated at Nineveh. Much literature known from Assyrian manuscripts dates from an earlier age. Gilgamesh, for example, a long narrative spread over twelve tablets, represents a reworking of a cycle of stories largely composed in Sumerian and originally in separate compositions. In the main, cuneiform literature was anonymous, but the principal editor of Gilgamesh is known to have been a man named Sin-leqe-unninni.

An important group is often referred to as 'wisdom literature', since it touches on the plight of human beings, the injustice of the natural world, and the unpredictability of the gods. A related genre is proverbs, some of which were collected together for the royal library. Side by side with the more famous items of literature are many less well-known compositions, some rather unexpected. For instance there is a group of humorous or satirical texts, which seem to belong to a category of poetic literature which was popular in court circles in the seventh century BC.

ILF

214

## 214 The Epic of Gilgamesh, Tablet VI

The Epic of Gilgamesh, king of Uruk, is the single most significant work of Mesopotamian literature. If Gilgamesh was a real historical figure, he is probably to be dated to the early third millennium BC. At some time early in the second millennium BC a group of originally disconnected Sumerian stories, some of which (like the Flood story) had nothing to do with Gilgamesh, were translated into Akkadian and woven together into a single epic which was again rewritten during the first millennium BC. The popularity of the story is proven by the fact that fragments have been found as far afield as Hattusas in Turkey, Emar in Syria and Megiddo in Israel. The theme of the epic is Gilgamesh's friendship with the wild man Enkidu and their exploits together, the death of Enkidu, and Gilgamesh's unsuccessful quest for immortality. In the sixth tablet the goddess Ishtar admires Gilgamesh and woos him for her husband; but Gilgamesh rejects her, and Enkidu adds to the insult by killing the Bull of Heaven which the supreme god Anu had given to Ishtar. It was in revenge for this that Ishtar demanded the death of Enkidu.

7th century BC                      CBFW
From Nineveh, library of Ashurbanipal
WA K231
H 13 cm, W 14 cm, TH 2.5 cm
Campbell Thompson 1930: pls 20–26. Kovacs 1985: 50–56. Dalley 1989: 77–83

215

216

### 215 The Legend of Etana

The Etana story was one of the first pieces of mythology recovered from Assyrian library tablets to be published by George Smith in 1876, although it is still far from complete. In it King Etana, described as the first king of Sumer, seeks the 'plant of birth' for his childless wife. This journey takes him up to Heaven on the back of an eagle, an event that is sometimes represented on cylinder seals. This tablet preserves part of the first-millennium version of the story, and describes how the gods laid the foundations of the city of Kish and established Etana as king there.

7th century BC                    ILF/CBFW
From Nineveh
WA K2606
H 9 cm, W 6 cm, TH 2.5 cm
Kinnier Wilson 1985. Dalley 1989: 189–91

### 216 Bilingual hymn from the series Ershahunga

This tablet contains a literary hymn of lamentation originally written in Sumerian, the classical language of ancient Mesopotamia, and later translated into Akkadian, the language spoken by the Assyrians. Both versions are given on this tablet. It is one of a series of library copies of cultic texts, and the number of lines (65), and the first line of the next tablet are carefully noted. A colophon on the bottom edge, scratched into the clay at a later date, records that the tablet belonged to King Ashurbanipal.          ILF

7th century BC
From Nineveh, library of Ashurbanipal
WA K2811
H 21 cm, W 7.5 cm, TH 2.5 cm
Maul 1988: 237–46

## SCRIBAL TRAINING

The training of scribes in the practices and traditions of cuneiform writing was fundamental to the preservation and transmission of all Mesopotamian literature and science. Writing was probably limited to the upper classes of society and their professional adherents, who used it as a means of maintaining their special status. Ashurbanipal proudly boasts of his own ability to read and write and of his knowledge of Sumerian. All scribes began by learning the basic repertoire of cuneiform signs, and proceeded to copy lists of vocabulary, grammatical texts in Sumerian, and extracts from the basic literary repertoire. This practice of making and adding to lists is in many respects the fundamental characteristic of what the Mesopotamians themselves might have designated their 'sciences'. Copies of literary or technical texts frequently have a note appended to indicate the source from which the scribe made his copy, in order to emphasise the continuity of tradition. These notes sometimes suggest the pleasure which scribes took in accidentally recovering an old text from a rubbish heap or from an excavation for the foundations of a new building.          C B F W

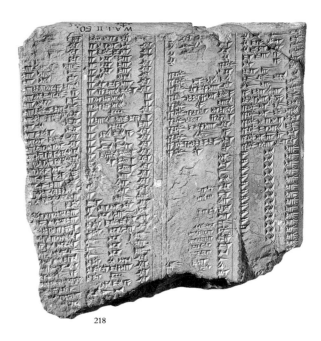

218

## 217   God list

From the very beginnings of cuneiform writing scribes learned to copy lists of the names of the various gods of Mesopotamia. Many additions were made to these lists during the following 3,000 years. Gods with similar characteristics were compared with one another and grouped together. As the fortunes of different cities rose and fell, their gods increased or declined in importance and they assimilated one another or were assimilated. Foreign gods, too, were gradually included in the lists. By the time of Ashurbanipal the standard list of gods, known after its first line as 'An = Anum' (the Sumerian god-name An is the equivalent

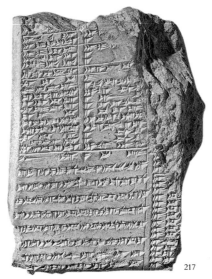

217

of the Akkadian god-name Anum), contained several thousand entries. This fragment gives some of the many names of the storm god Adad.          C B F W

7th century BC
From Nineveh, library of Ashurbanipal
W A K2100
H 11 cm, w 8 cm, TH 2.5 cm
King 1909: pls 16–18

## 218   Bilingual geographical list

The lists learned by trainee scribes included the names of all the cities, towns, rivers and temples in the region of southern Mesopotamia and the names of many foreign countries and peoples. Like the lists of gods, the geographical lists might include both Sumerian and Akkadian names. The present list has the names of many of the ancient cities of Sumer, such as Ur, Larsa, Uruk and Kullab, the countries of Subartu (Assyria) to the north, Amurru to the west, Elam and Gutium to the east, the rivers Tigris and Euphrates and the canals Arahtum and Iturungal. It also includes more general terms, such as four different terms for mountain and words for hostile and rebellious lands. These would have been

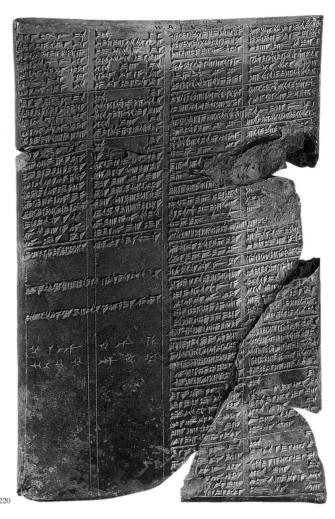

220

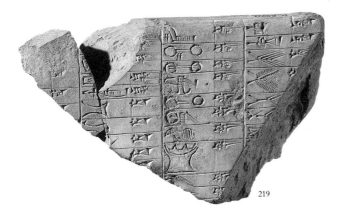

219

used in training experts to read the traditional texts concerning the various types of omens and their interpretation. CBFW

7th century BC
From Nineveh
WA K2035a + 4337
H 12.5 cm, W 12.5 cm, TH 2.5 cm
Landsberger 1974: 54–6

## 219 Archaic cuneiform signs

The Assyrians were aware that a long history of development lay behind their cuneiform system of writing. In some cases Assyrian and Babylonian monuments were deliberately inscribed with earlier sign-forms. This is a fragment of the standard list of Late Assyrian cuneiform signs, Syllabary A, with fanciful

drawings of the pictures which the scribe imagined to be the original forms of the signs. The pictures which he draws do not correspond to the signs found on the earliest tablets from Uruk. CBFW

7th century BC
From Nineveh
WA K8520
H 8 cm, W 13 cm, TH 3 cm
Landsberger 1955: 10. Houghton 1878

## 220 Legal language in Sumerian and Akkadian

This is tablet 7 of the scholastic series of tablets anciently known as Ana Ittishu. It comprises a collection of short legal clauses in Sumerian preserved from the

previous millennium, supplied with an Akkadian translation. This is presented in parallel columns rather than in the more common interlinear arrangement. Two examples read as follows: 'If a woman hates her husband and has said to him, "You are not my husband", they will throw her in the river.' If a husband says to his wife, "You are not my wife", he will have to pay one half mina of silver.' It is evident that the function of such literature was to promote the understanding of Sumerian rather than to record current legal practice in Assyria. ILF

7th century BC
From Nineveh, library of Ashurbanipal
WA K251
H 21 cm, W 14 cm, TH 3 cm
Landsberger 1937: 90

## MEDICINE

Mesopotamia's contribution to the history of medicine was probably considerable, but the question of what scientific knowledge is embodied in the texts still requires serious investigation. Medical texts in cuneiform script are rare before the first millennium BC, but large numbers have been discovered in the Assyrian capital cities, especially Ashur and Nineveh, as well as further south in Babylonia.

Most such documents are compendia, short recipes for related medical problems collected together for easy reference. Subsequently these individual compendia were grouped into long series running over several large tablets. The recipes take the form, 'If a man is suffering from the following symptoms, the problem is . . . ; take the following drugs, prepare and administer them as follows.' Within this format much information is to be found, although descriptions of symptoms are mixed up with other data, and it is not easy to identify modern diseases from ancient descriptions. Diseases were often attributed to the 'hand' of a certain god, and large collections of medical omens were gathered in which symptoms were described and their cause diagnosed in this fashion. These omens, like other categories of medical writing, were arranged following the parts of the body, from head to foot.

Medicine was in the hands of two practitioners. The first, the *asu*, was closer to what we would call a doctor. He operated with poultices, salves, potions, enemas, and so on, depending on a vast pharmacopoeia of which only a handful of plants can be identified for certain. His colleague, with whom he appears to have collaborated, was the *ashipu*, rather more of a conjuror, whose healing repertoire entailed spells, incantations, amulets and related practices. The consistent way in which recipes were preserved suggests that at least some herbal treatments were effective in healing, although it is obvious that no modern understanding of disease was achieved. Knowledge of anatomy was slight, and mostly derived from animal

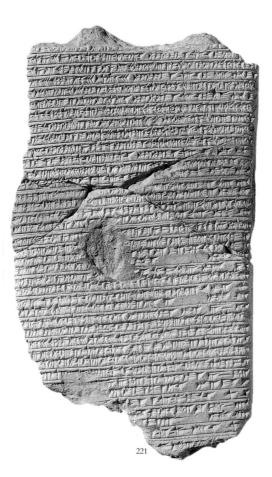

221

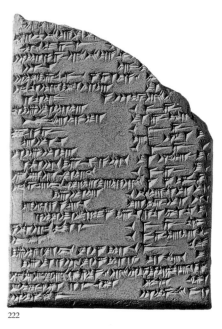

222

sacrifice. Some texts hint at an idea akin to contagion, but if this did exist, it was a matter more of instinct than of science.     ILF

## 221   Teatment for ear-ache

This tablet contains incantations and prescriptions for the treatment of ear problems, chiefly the sensation of roaring in the ears. Each ruled section gives a recommended procedure, and the tablet thus consists of a collection of varied remedies brought together for convenience in a large compendium. An interesting point is that the spells quoted belong to the category of untranslatable mumbo-jumbo, since they seem to be corrupted versions of older texts in Elamite from Iran. These have been borrowed as 'foreign magic' and have become unintelligible through repeated copying.     ILF

7th century BC
From Nineveh
WA K2472
H 16 cm, W 9 cm, TH 1.5 cm
Köcher 1979: no. 506

## 222   Treatment for headache

This tablet is inscribed with bilingual (Sumerian and Akkadian) incantations against the evil *asakku* demon, which together with many other malevolent forces has attacked the sufferer in the head. The first spell describes its evil effects, and the second is recited over a kid, as a substitute to which the evil is transferred so that it can be effectively banished. The tablet is part of a much larger compilation of magical exorcistic texts whose general title is 'Grievous Asakku'. This is the eleventh tablet of the series.     ILF

7th century BC
From Nineveh, library of Ashurbanipal
WA K3118
H 10 cm, W 7 cm, TH 2.5 cm
Campbell Thompson 1903: pls 9–11; 1903–4:
   28–37

## MATHEMATICS
## AND ASTRONOMY

The development of Babylonian sexa-gesimal mathematics and its event-ual application in the late first millennium BC to the description and prediction of astronomical events are among the most significant and long-lasting of Mesopota-mia's contributions to western civilisation. Perhaps as a result of the accidents of archaeological discovery there is little evidence for an Assyrian contribution to these developments. Only a handful of tablets of mathematical interest are known from the Late Assyrian period and the astronomical records that survive are all in the form of letters and reports sent to the king to offer and substantiate advice on political and religious matters. If the Assyrian astronomers, who were in any case formally employed in quite different roles, had kept permanent records of astronomical observations, as did their Babylonian counterparts, there is no reason to suppose that these would have been stored in the royal archives. It is not at present clear that the few compendia of astronomical information found in Assyrian libraries – lists of stars, rules for the calendar, and so on – represent much more than an Assyrian re-editing of Babylonian material. CBFW

## 223 Mathematical table

Mathematical tablets from Assyria are very rare. Historical records of booty and captured prisoners show the use of a decimal system, counting in tens, hundreds and thousands. This tablet is one of the few pieces of evidence that the Assyrians were also aware of the sexagesimal system first invented by the Sumerians and developed by the Babylonians, counting in tens and sixties. As aids to calculation the Babylonians had multiplication tables, tables of reciprocals for use in division, tables of squares and square roots, and tables of cubes and cube roots. This tablet is part of a table of reciprocals on a base of $1;10$. For instance, in the fourth line $3 \times 0;23,20 = 1;10$. CBFW

7th century BC
From Nineveh
WA K2069
H 5.5 cm, W 5 cm, TH 2 cm
Neugebauer 1931; 1935–7: I, 30–32; II, pl. 10

223

## 224 Babylonian lunar table

This is a table for the daily change in the duration of the visibility of the moon on the thirty days of the month of the winter solstice according to the tradition of the city of Babylon. The duration of visibility is measured in 'time-degrees' of four minutes each. The numerical errors in the text and the addition of two omens at the end concerning the rising sun and a woman giving birth to a ewe or a cat suggest that the tablet was written as a school exercise.

CBFW

7th century BC
From Nineveh
WA K90
H 8 cm, W 5 cm, TH 2 cm
Al-Rawi and George 1992: 66–8, 73

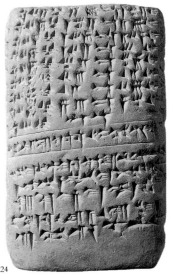

224

## DIVINATION AND THE SCIENCE OF PREDICTION

Divination in all its forms, whether involving the inspection of a sheep's liver or making astronomical observations or watching the flight of birds or the pattern of oil poured on water, was for the Babylonians and Assyrians the pre-eminent science.

The Mesopotamian attitude (and in cultural matters Assyria largely reflects Babylonia) is summarised in a Babylonian diviner's manual of the seventh century BC preserved in Ashurbanipal's library: 'The signs on earth just as those in heaven give us signals. Sky and earth both produce portents; though appearing separately, they are not separate (because) sky and earth are related' (translation by A. L. Oppenheim). The portents are not causative. Neither the planets nor a sheep's liver have any influence of themselves, but they forecast future possibilities and give an indication of the intention of the gods. If in the past an eclipse of the moon occurred on the fourteenth of the month Du'uzu and began and cleared up on its southern quarter, and if this eclipse was followed by the death of a great king, then the next time such an eclipse occurs there is a risk that another great king will die. The risk may be removed or mitigated by the appropriate ritual.

As with other branches of learning in Mesopotamia, the study of divination was characterised by three features, the making of lists, respect for tradition, and extrapolation from observed experience *ad absurdum*. The interest in historical tradition led the scribes to compile collections of omens which had preceded significant historical events in the past, and these may be used with caution to supplement other surviving historical records. CBFW

## 225 Omens from the 'path'

Divination was practised in many different ways in ancient Mesopotamia. One of the most popular and enduring was extispicy, the examination of the viscera of sacrificed sheep for significant marks. It was held that Shamash, the sun god, used this as a medium of communication with mankind. Consequently diviners had to be specially trained to identify and interpret the various possible features. This complex discipline gave rise to much technical literature, in which long lists of possible signs were listed for reference (protases), together with their implications for king and state (apodoses). The present tablet concerns the 'path', Akkadian *padanum*, which is the term for the groove which runs horizontally below the vertical groove on the left lobe of the liver. One apodosis reads: 'The army will go on campaign, and will be beset by thirst. They will drink bad water and die.' ILF

7th century BC
From Nineveh
WA K3999
H 10 cm, W 9 cm, TH 3 cm
Campbell Thompson 1904: pls 7–8

## 226 Extispicy month by month

Although most of the texts concerning extispicy have to do with the fortunes of the king and his country, this kind of divination was also used by the common people. This text, which is an extract from a larger tablet, forecasts month by month throughout the year the unpleasant consequences of a sheep being found to have no gall-bladder. The forecasts mostly involve the death of the man who has commissioned the sacrifice, or the death of his family and flocks. CBFW

7th century BC
From Nineveh
WA K717
H 5.5 cm, W 10 cm, TH 2 cm
Handcock 1910: pl. 44

225

226

227

228

229

## 227 Physiognomic omens

One series of omen texts, the ancient name of which is not preserved, deals with physiognomic omens – omens from the appearance of various parts of the body. This tablet is highly unusual in including illustrations of some of the unusual features on which the experts based their opinions. For instance the first complete illustration, which looks like the letter 'Y', is apparently meant to represent a palm-tree and to be a mark of good luck. Where on the human body the expert might find something looking like a palm-tree is not explained.                    CBFW

7th century BC
From Nineveh
WA K2087
H 13.5 cm, W 8 cm, TH 2 cm
Kraus 1935; 1939: pls 35–6, no. 27a

## 228 Celestial omens

This tablet comments on excerpts from tablet 50 of the celestial omen series 'Enuma Anu Enlil' ('When the gods Anu and Enlil . . .'). Tablet 50 seems to have contained omens concerning the appearance of various stars or constellations and their relation to events on earth. For instance, 'The Plough is for starting the furrow. The Raven relates to a steady market. The Fox is for breaking into houses.'                    CBFW

7th century BC
From Nineveh
WA K4292
H 13 cm, W 8 cm, TH 2 cm
Reiner and Pingree 1981: 29–34, 40–45

## 229 The omen series 'Shumma alu'

In the series 'Shumma alu ina mele shakin' ('If a city is set on a hill'), the longest of the Mesopotamian omen series, predictions drawn from a whole variety of occurrences and observations are carefully collected and ordered. Any ominous phenomenon which did not conveniently fit into another series was included in 'Shumma alu'.

This tablet concerns the relations between a man and his wife. At the end of the tablet the scribe has recorded the number of lines written on the tablet (73), the first line of the next tablet, and a note that this is tablet 104 of the complete series 'Shumma alu'. A colophon indicates that it was written for the library of Ashurbanipal. The signs of burning on this and many other of Ashurbanipal's tablets are evidence of the destruction of the library by the Babylonians and Medes.                    CBFW

7th century BC
From Nineveh, library of Ashurbanipal
WA K1994
H 12 cm, W 7.5 cm, TH 2 cm
Gadd 1925: pls 44–6

## 230 Historical omens

The art or science of interpreting ominous phenomena goes back at least to the time of the kings of the Dynasty of Akkad (c. 2334–2154 BC). Because of the perceived historical significance of these kings, scribal tradition preserved the memory of a number of omens from extispicy observed during their reigns and the events which followed. The compiler of this text has collected those omens which related to military and civil events. These include references to Sargon I's conquests in Amurru and Elam, his suppression of rebellions at home in Akkad and in the city of Kazallu, and the building of his royal palace; also to Naram-Sin's conquest of Magan (on the Gulf coast) and his suppression of a rebellion in the city of Apisal. CBFW

7th century BC
From Nineveh, library of Ashurbanipal
WA K2130
H 16 cm, W 10 cm, TH 2.5 cm
King 1907: 25–39, pls 129–37

230

## PRACTICAL APPLICATIONS OF DIVINATION

The Assyrian kings relied heavily on their astrologers. The surviving archive from Nineveh, which covers the period from 674 to 648 BC, contains letters and reports to the kings Esarhaddon and Ashurbanipal from their local experts and from a variety of other centres in Assyria and Babylonia. It gives us our best contemporary picture of the astronomer-astrologers in action. These men had direct access to the king and were influential on the highest political level and also in apparently mundane aspects of the king's daily life. No military campaign or major civil event took place without first watching the stars and performing an extispicy. The royal court as the centre of power was also a stage for jealousy and intrigue. It is clear that the kings were suspicious of the quality of the advice given to them and would set one expert against another. Extispicy offered a means of checking on the forecasts of the astrologers. It may well be that Ashurbanipal's assiduous collection of religious and technical texts from Babylonia was intended in part to give him independent expertise. CBFW

231

## 231 A letter about the Manneans

Bel-ushezib reports to King Esarhaddon on an observation of the crescent of the moon at sunrise and its consequences for the Mannean kingdom to the north, against which Assyrian armies were campaigning. Similar astrological portents have been followed by the defeat of any country which was being attacked at the time. The Assyrian army should press home its attack on the Manneans. Bel-ushezib also reports on rumours of a conspiracy against Esarhaddon by the governors of two cities in Babylonia.

About 675 BC          CBFW
From Nineveh
WA K1353
H 10 cm, W 6.5 cm, TH 2 cm
Parpola 1993a: 91–3, no. 112

## 232 Request for an oracle

The official appointment of an heir to the throne, usually chosen from among the king's sons, was a major political decision, and it was desirable to ensure favourable omens. On this, and many other critical matters, the sun god Shamash was consulted.

In this tablet Esarhaddon (680–669 BC) enquires whether he should appoint his son Sin-nadin-apli as crown prince. 'Is it pleasing to your great divinity? Is it acceptable to your great divinity?' The god's answer will be embodied in the inner parts of a sacrificial ram. JER

7th century BC
From Nineveh
WA K195
H 8 cm, W 15 cm, TH 5 cm
Starr 1990: 160–61, no. 149

232

are quoted, mostly forecasting evil for the king and the country. The text may be dated exactly. CBFW

11 June 669 BC
From Nineveh
WA K750
H 4 cm, W 8 cm, TH 2 cm
Campbell Thompson 1900: I, pls 80–81, no. 271;
II, 100–101, no. 271. Hunger 1992: 5–7, no. 4.
Parpola 1983: 403–5, 422, 424, 429

233

## 233　Advice to the king to stop fasting

Balasi and Nabu-ahhe-eriba, senior court officials and astronomers, advise King Esarhaddon, who has been ill and has lost his appetite, that after three days of fasting he should eat again. He should at least begin to eat again when the new moon appears. He should be encouraged by the fact that Jupiter has just risen heliacally and will be visible for a whole year. The letter may be dated exactly. CBFW

4 May 670 BC
From Nineveh
WA K569
H 7 cm, W 3.5 cm, TH 2 cm
Parpola 1983: 57–60, no. 51. Parpola 1993a: 33, no. 44

## 235　Letter to the king reporting an eclipse of the moon

Nabu-ahhe-eriba, a senior court official and astronomer, reports to King Ashurbanipal that a total eclipse of the moon has been observed, beginning on the eastern quadrant of the moon and spreading over the whole of the western quadrant. The planets Jupiter and Venus were visible during the eclipse. The eclipse forecast evil for countries to the west of Assyria. The eclipse is datable to 21 April 667 BC.

667 BC　　　　　　　　　　　　　CBFW
From Nineveh
WA 83-1-18,40
H 6 cm, W 3 cm, TH 1.5 cm
Parpola 1983: 66, no. 61. Parpola 1993a: 57, no. 75

235

## 234　Advice concerning an eclipse of the moon

An Assyrian astronomer, perhaps Issarshumu-eresh, advises the king on the interpretation of a partial eclipse of the moon which has apparently taken place on the 14th day of the month Sivan, during the morning watch. The moon had been in the constellation Sagittarius, and Jupiter had been visible. Various traditional opinions

234

# 11 ASSYRIA REVEALED

Any picture of Assyria would be incomplete without reference to the great interest generated by the early Assyrian excavations, an interest which continues unabated to this day. Layard's achievement was truly remarkable, not least because he achieved what he did in the face of quite inadequate funding by the British Museum and the British Government. His archaeological achievements are legendary. As well as the North-West Palace at Nimrud and the South-West Palace at Nineveh he excavated many other buildings and made discoveries of immense importance. All this was achieved with a bare modicum of assistance. He was aided by a succession of young British artists, Fred-

Engraving showing a winged lion arriving at the British Museum, from the *Illustrated London News*, 28 February 1852.

erick Cooper, Thomas Bell and Charles Hodder, but none of them was entirely satisfactory, and by Hormuzd Rassam, a local man from a Christian family in Mosul. It was Rassam who continued the excavations after Layard's departure. Layard may be justly described as one of the great pioneers of archaeology; his powers of observation and interpretation were extraordinary and, contrary to beliefs that are sometimes expressed, he had a clear understanding of stratigraphy. He got through an astonishing amount of work, and himself drew many of the sculptures and copied the cuneiform inscriptions.

In view of the scale and importance of his discoveries, it might be expected that Layard received enthusiastic support to publish them as soon as possible. But this was not the case: the Treasury turned down a grant of £4000 to cover the costs of publication. This parsimony was in marked contrast to the attitude of the French Government, which earmarked a generous sum – in fact more than the cost of the excavations – to publish the results of Botta's work at Khorsabad. This appeared in

five sumptuous volumes entitled *Monument de Ninive* (Paris 1849–50). The publication of Layard's drawings had to be supported by private subscription. Many were eventually published by John Murray of Albemarle Street, in two large folio volumes entitled *The Monuments of Nineveh* (no. 241). Murray also published Layard's two-volume work *Nineveh and its Remains* (no. 239), containing a popular account of his first campaign of excavations. The appearance of these books, together with *Discoveries in the Ruins of Nineveh and Babylon*, ensured that Layard became a celebrity, acclaimed by all sections of Victorian society.

The discoveries were greeted with intense curiosity and interest, and Assyrian civilisation had a considerable impact on the art and literature of the nineteenth century. When the Layards were invited to Osborne House on the Isle of Wight, Queen Victoria was fascinated by Lady Layard's cylinder seal necklace (see no. 250), and in the latter part of the century Assyrian-style figures were produced in Parian porcelain by W.T. Copeland & Sons Ltd (see page 13, Fig. 5) and are now sought after as collectors' items.

In addition to Layard there were of course other figures who played important roles in the discovery of Assyria. Some have been mentioned in this catalogue, including Paul Emile Botta, Victor Place and Hormuzd Rassam. Another was Captain Felix Jones, an Indian Navy surveyor, who made great contributions through his topographical work. One of his important maps of Assyria is included in this catalogue (no. 238).

It is now nearly 150 years since the publication of Layard's discoveries, but our fascination with them is as fresh now as it was in the mid-nineteenth century.

JEC

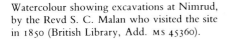

Watercolour showing excavations at Nimrud, by the Revd S. C. Malan who visited the site in 1850 (British Library, Add. MS 45360).

236

him in the local dress, such as he must have worn then, in front of a fanciful and romantic mountainous background. It was actually painted while he was attached to the British embassy in Constantinople (Istanbul). The artist, Amedeo Preziosi (1816–82), was a Maltese nobleman who had studied art in Paris and emigrated to Turkey. His fine depictions of life in this capital city of the Ottoman empire were much in demand among European visitors during the 1840s–1870s. This painting is signed, and dated 6 April 1843.

P&D 1976-9-25,9. Presented by      JER
  Miss Phyllis Layard
29.8 × 22.5 cm

## 236 Henry Layard in Bakhtiari dress

Before his Assyrian excavations, Layard travelled extensively. In Iran he remained a considerable time with one of the Bakhtiari tribes, and this watercolour shows

## 237 Nineveh and Mosul, seen from the east

This watercolour is by Frederick Charles Cooper, an artist (active 1844–68) who accompanied Layard's second Assyrian expedition in 1849–51. It was probably painted about July 1850, and shows in the foreground the village of Nebi Yunus and the tomb of the prophet Jonah, standing on a mound formed by the ruins of an Assyrian palace at Nineveh. The ruined city walls of Nineveh stretch across the picture, ending on the right in a high mound which may be part of Kuyunjik, where the principal palaces and temples of ancient Nineveh were situated. In the background is the River Tigris, with the modern city of Mosul on the far side, and the low hills beyond.

Some light lines in pencil appear to be notes for a different drawing. The archaeologists working in Assyria often reused paper, which seems to have been in short supply.                              JER

WA archive 213.13.1
15.6 × 39 cm

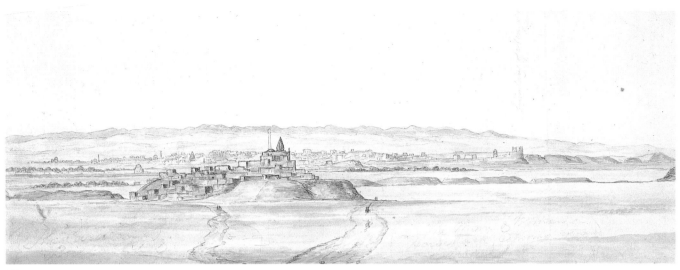

237

## 238  Early map of Assyria

One of the major problems for early archaeologists was the lack of adequate maps. Layard himself had left the field before this one was drawn and printed. The surveyor, Felix Jones, was employed by the authorities in British India and commanded a steam-ship which operated on the Tigris. He took a keen interest in the spectacular Assyrian discoveries, and gave Layard considerable help. This map, drawn in 1852, shows the principal sites and villages of the region, and was one of a set which included more detailed plans of Nimrud, Nineveh and Ashur. It includes information which is still valuable, such as the courses of Assyrian canals. The map was published by John Walker, Geographer to the East India Company, in February 1855.    JER

WA archive 213.13.2
124 × 70 cm

238 (detail)

239

240

### 239 Layard's *Nineveh and its Remains*

This two-volume work describes Layard's first campaign of excavations in Assyria between 1845 and 1847. Much of it was written at Canford Manor in Dorset where he stayed at the invitation of his cousin Lady Charlotte Guest. It is dedicated to his uncle Benjamin Austen, Esq., a London solicitor from whom he received his early legal training. The book concentrates on Layard's work at Nimrud, but also describes excavations at other sites. The name Nineveh appears in the title because initially Layard mistakenly believed that Nimrud was part of Nineveh. This extremely readable and informative book also contains a graphic account of Layard's travels in northern Mesopotamia during this period, including his visits to the Chaldaean Christians and the Yezidis in Kurdistan. It thus provides a unique glimpse into the conditions in this remote part of the Ottoman empire in the mid-nineteenth century. The books, with their distinctive black-on-red covers showing Assyrian winged bulls, were first published by John Murray in 1849 and went through six different editions. The popularity of the book can be judged by the fact that, as Layard himself observed, sales rivalled those of *Mrs Rundell's Cookery*.     JEC

Two volumes, each 25 × 15 cm
Vol. 1, pp. xxx, 399, 18 illustrations; vol. 2,
     pp. xii, 491, 82 illustrations

### 240 Layard's *Nineveh*

This is an abridged edition, dated 1858, of Layard's highly successful *Nineveh and its Remains* (no. 239). It appeared in the series 'Murray's Reading for the Rail'.

The book's appeal was partly as a travel story, but it was also one of the first examples of the successful popularisation of archaeological writing for the general public, and this handy edition with its handsome cover is the equivalent of a modern paperback sold on a station bookstall.     JER

One volume, 19.7 × 13.5 cm
Pp. xxiii, 360, 89 illustrations

### 241 Cover of Layard's *Monuments of Nineveh*

Layard's drawings of his discoveries, together with those of the artists accompanying him, were published as engravings in two large folio volumes known as *The Monuments of Nineveh*. The first

241

series, with 100 plates, appeared in 1849, and the second series, with 71 plates, in 1853. The illustrations are mostly of sculptures, but also included drawings of some small objects. There are also some reconstructions and general views. The two volumes contain a few colour prints of exceptionally good quality for this early date. Layard had great difficulty in getting these drawings published. The British Museum applied to the Treasury for a grant of £4000 to cover the cost, but this was rejected. Fortunately, Lady Charlotte Guest, Layard's cousin, was able to prevail upon the publisher John Murray to undertake the work, and she was instrumental in drawing up a long list of subscribers, thus ensuring that Murray's costs would be recovered. The two series of *Monuments* have card covers of the same design and colour as *Nineveh and its Remains* (no. 239), showing a winged human-headed bull in black on red. JEC

57 × 39 cm

## 242 Frontispiece of Layard's *Monuments of Nineveh*

The colour print forming the frontispiece of Layard's *Monuments of Nineveh* shows two winged human-headed lions supporting a gateway on their backs. The designs on the gateway are partly based on the painted plaster decoration found in the North-West Palace at Nimrud and published elsewhere in this folio volume (pls 86–7). The space in the middle of the gateway is left blank for the title of the book and the name of the author, written in pseudo-cuneiform script. JEC

57 × 38.5 cm

242

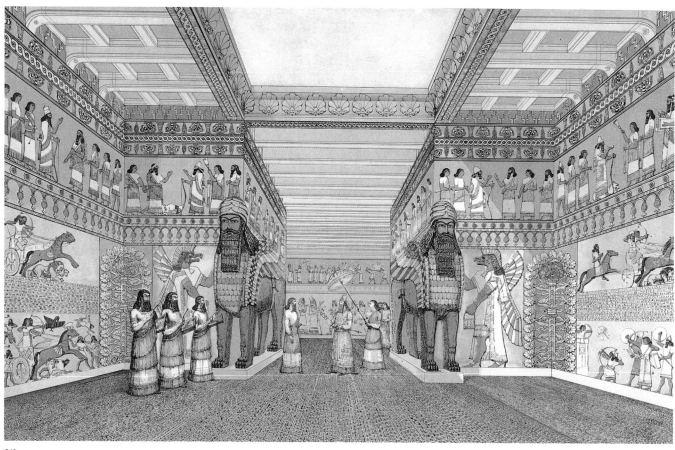

243

## 243 Reconstruction of an Assyrian throne-room

This colour print, which was plate 2 in *The Monuments of Nineveh*, shows, in Layard's own words, 'a hall in an Assyrian temple or palace, restored from actual remains, and from fragments discovered in the ruins'. Winged human-headed lions flank an entrance. On the lower parts of the walls are stone bas-reliefs, copies of actual examples found at Nimrud, but arranged here with no regard to their original positions. They are brightly painted as they would have been in antiquity. Above the reliefs there is painted plaster decoration. The dress of the figures is based on the evidence of the reliefs. The form of the ceiling is entirely speculative.

27.8 × 44.1 cm                                    JEC

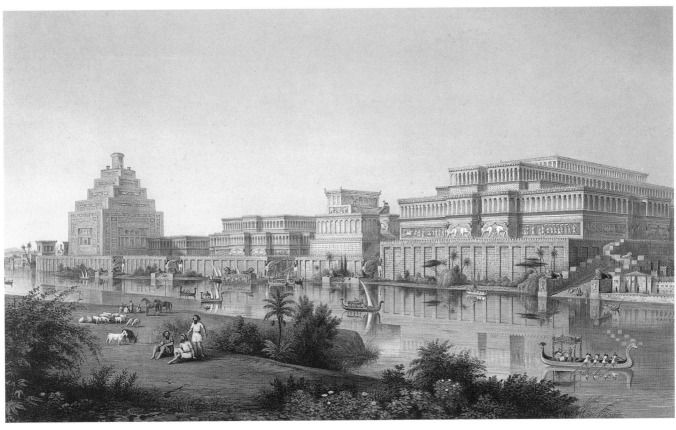

244

## 244 'The palaces of Nimrud restored'

This colourful print, which appeared as plate 1 of *A Second Series of The Monuments of Nineveh* (London 1853), shows the city of Nimrud from across the River Tigris. It is based on a sketch by James Fergusson, who himself wrote a book on the *Palaces of Nineveh and Persepolis Restored* (London 1851). On the left is the ziggurat, and to the right various palaces. Boats are plying up and down the river, while shepherds tend their flocks in the foreground. The reconstructions are highly fanciful, and bear little resemblance to the known appearance of Assyrian buildings.    JEC

28 × 46.5 cm

245

## 245 Painted head of a genie

Colour print of a fragment of a stone relief showing the head of a genie, from *The Monuments of Nineveh*, plate 92. Such genies are usually winged and hold a bucket in one hand (see no. 9). Traces of paint were found on many of the sculptures at Nimrud, but were exceptionally well preserved on this example.    JEC

44.9 × 36.6 cm

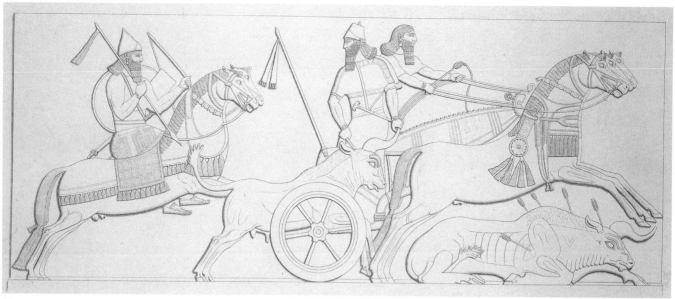

246

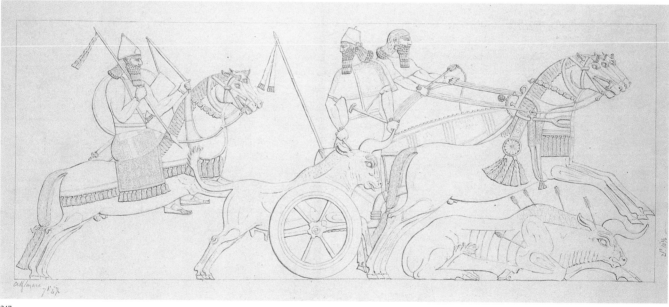

247

**246 Royal bull hunt: engraving**

This engraving of Ashurnasirpal's bull hunt was plate 12 in *The Monuments of Nineveh*. The engravings were based on Layard's field drawings (compare no. 247), which remained for a long time the only published illustrations of many of the discoveries at Nimrud.    JER

16.2 × 42.8 cm

**247 Royal bull hunt: original drawing**

This is an example of the drawings which Layard made in difficult conditions while excavating at Nimrud. Various minor inaccuracies can be seen on comparison with the original sculpture (no. 6). These drawings were used as the basis for the engravings published in *The Monuments of Nineveh* (see no. 246).    JER

WA archive, Original Drawing III, NW 25
16.2 × 41.6 cm

## 248 Painted sculpture: original drawing

Many of the Assyrian sculptures retained traces of paint on excavation. In the North-West Palace it was especially well preserved on the hair and sandals, as shown on this drawing made by Layard in the field. It is possible that the clothes had been painted in more fugitive colours.

JER

WA archive, Original Drawing III, NW 55, nos 9, 10, chamber G
19.1 × 25.5 cm

## 249 Cuneiform inscription: original copy

This copy, first done in pencil and then inked, was made by Layard about 1850, when the cuneiform script was still poorly known. Layard himself recognised the importance of the texts he had found, copied them assiduously and made some attempts at decipherment, but for the latter he came to rely on others, notably the brilliant Irish clergyman Edward Hincks. Later pencil annotations, added in Layard's hand, were probably made in 1852 when he was visiting Hincks in Ireland.

The two inscriptions on the right were carved on a series of sculptures showing the capture of a city. They are the earliest evidence for the reading of the place-name

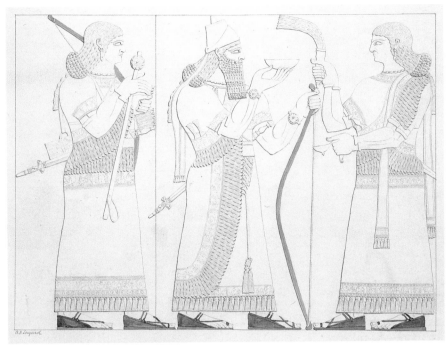

248

Lakisu in Assyrian, and its recognition as none other than the Biblical city Lachish, which was captured by Sennacherib in 701 BC. The inscription on the left was copied from a paving-slab of the Temple of Nabu at Nineveh; it recounts how Ashurbanipal (668–c.631 BC) harnessed no less than four captured Elamite kings to his coach.

JER

WA archive 213.11.1
Page 20 × 33.4 cm

249

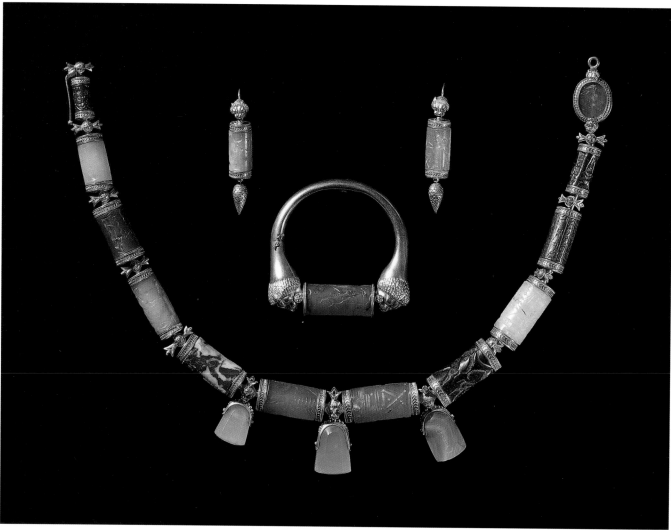

250

## 250 Lady Layard's jewellery

Layard married in March 1869 at the age of 52. His 25-year-old bride was Enid, daughter of Charlotte Guest, Layard's cousin, old friend and long-time supporter. As a wedding present, Layard had a number of seals which he had acquired during his travels made up into a necklace, bracelet and two earrings in Victorian gold settings. A portrait (no. 251) shows Enid wearing the jewellery, and she wrote in her diary that, when they dined with Queen Victoria in 1873, it was 'much admired'.

The gold settings were made by Messrs Phillips of Cockspur Street, with chevron borders which imitated Late Assyrian cylinder seals, such as one of those illustrated here (no. 185), and included Assyrian lions' heads and 'pine-cone' motifs. One cylinder seal was Akkadian (c. 2300 BC) and four belonged to the second millennium BC, but eight were Late Assyrian cylinder seals (nos 1–3, 5, 7, 9, 10, 12 in the jewellery case), including a very fine cornelian one used for the bracelet and two of grey chalcedony for the earrings. Late Babylonian and Achaemenid stamp seals (c. 600–350 BC) were used for the pendants and clasp. They are displayed with their original shaped leather box lined with violet velvet.          DC

WA 115656, 105111–105128 (1913-2-8,1-18).
  Bequeathed by Lady Layard
Box H 25 cm, W 36 cm, D 6 cm
Barnett 1978. Rudoe 1987

251

252

## 251 Portrait of Lady Layard

This oil painting in a heavy gilt frame shows Lady Layard wearing her jewellery in the Assyrian style (no. 250). Originally slightly larger, it was painted over no less than twenty-three two-hour sittings, by Vincente Palmaroli y Gonzales (1834–96), a fashionable portraitist who worked for periods in Paris and Rome and became director of the Spanish Academy in 1881. He painted this picture in 1870 in Madrid, where Layard had been appointed British ambassador. JER

WA 1980-12-14,1
101.5 × 78.5 cm
Rudoe 1987: 214–15

## 252 Portrait of Sir Austen Henry Layard

After the archaeological discoveries which established his reputation, Layard became a politician, ambassador and patron of the arts. There is a striking contrast between the dashing young Assyrian adventurer seen in no. 236 and the solemn Victorian worthy of later years. This oil painting in a heavy gilt frame is the work of Charles Vigor, an artist who worked in London between 1882 and 1917. Painted in 1885, it shows Layard holding a manuscript, probably one from his private collection.

WA 1968-5-18,1. Presented by     JER
   Miss Phyllis Layard
120.5 × 80.5 cm

# BIBLIOGRAPHY

ALBENDA, P., 1978. Assyrian carpets in stone. *Journal of the Ancient Near East Society of Columbia University* 10: 1–19

ALBENDA, P., 1986. *The Palace of Sargon, King of Assyria.* Paris

ALBENDA, P., 1991. Decorated Assyrian knob-plates in the British Museum. *Iraq* 53: 43–53

AL-RAWI, F. N. H., and A. R. GEORGE, 1992. Enuma Anu Enlil XIV and other early astronomical tables. *Archiv für Orientforschung* 38/39: 52–73

ANDRAE, W., 1925. *Coloured Ceramics from Ashur.* London

ANDRAE, W. (ed.), 1943. *Ausgrabungen in Sendschirli, V: die Kleinfunde.* Berlin

AZARPAY, G., 1968. *Urartian Art and Artifacts.* Berkeley/Los Angeles

BAKER, H. S., 1966. *Furniture in the Ancient World.* London

BARAG, D., 1985. *Catalogue of Western Asiatic Glass in the British Museum*, vol. 1. London

BARNETT, R. D., 1953. An Assyrian helmet. *British Museum Quarterly* 18: 101–2

BARNETT, R. D., 1958. The siege of Lachish. *Israel Exploration Journal* 8: 161–4

BARNETT, R. D., 1959. *Assyrian Palace Reliefs and their Influence on the Sculptures of Babylonia and Persia.* London

BARNETT, R. D., 1963. Hamath and Nimrud: shell fragments from Hamath and the provenance of the Nimrud ivories. *Iraq* 25: 81–5

BARNETT, R. D., 1964. The gods of Zinjirli. *Compte rendu de l'onzième Rencontre Assyriologique Internationale*: 59–87. Leiden

BARNETT, R. D., 1967. Layard's Nimrud bronzes and their inscriptions. *Eretz-Israel* 8: 1–7

BARNETT, R. D., 1969. A new inscribed Lydian seal. *Athenaeum* 47: 21–4

BARNETT, R. D., 1974. The Nimrud bowls in the British Museum. *Rivista di Studi Fenici* 2: 11–33

BARNETT, R. D., 1975. *A Catalogue of the Nimrud Ivories in the British Museum.* London

BARNETT, R. D., 1976. *Sculptures from the North Palace of Ashurbanipal at Nineveh.* London

BARNETT, R. D., 1978. Lady Layard's jewelry. In R. Moorey and P. Parr (eds), *Archaeology in the Levant – Essays for Kathleen Kenyon*: 172–9. Warminster

BARNETT, R. D., 1982. *Ancient Ivories in the Middle East* (Qedem 14). Jerusalem

BARNETT, R. D., and M. FALKNER, 1962. *The Sculptures of Tiglath-pileser III.* London

BARNETT, R. D., and A. LORENZINI, 1975. *Assyrian Sculpture in the British Museum.* Toronto

BORGER, R., 1956. *Die Inschriften Asarhaddons Königs von Assyrien* (Archiv für Orientforschung, Beiheft 9). Graz

BORGER, R., 1971. Das Tempelbau-Ritual K48+. *Zeitschrift für Assyriologie* 61: 72–80

BORGER, R., 1987. Pazuzu. In F. Rochberg-Halton (ed.), *Language, Literature and History: Philological and Historical Studies Presented to Erica Reiner*: 15–32. New Haven

BOTTA, P. E., and E. FLANDIN, 1849–50. Monument de Ninive (5 vols). Paris

BRAUN-HOLZINGER, E. A., 1984. *Figürliche Bronzen aus Mesopotamien* (Prähistorische Bronzefunde 1/4). Munich

BUDGE, E. A. W., 1914. *Assyrian Sculptures in the British Museum: Reign of Ashur-nasir-pal.* London

CAMPBELL THOMPSON, R., 1900. *The Reports of the Magicians and Astrologers of Nineveh and Babylon in the British Museum* (2 vols). London

CAMPBELL THOMPSON, R., 1903. *Cuneiform Texts from Babylonian Tablets in the British Museum*, part 17. London

CAMPBELL THOMPSON, R., 1903–4. *The Devils and Evil Spirits of Babylonia* (2 vols). London

CAMPBELL THOMPSON, R., 1904. *Cuneiform Texts from Babylonian Tablets in the British Museum*, part 20. London

CAMPBELL THOMPSON, R., 1930. *The Epic of Gilgamesh.* Oxford

CAMPBELL THOMPSON, R., and MALLOWAN, M. E. L., 1933. The British Museum excavations at Nineveh, 1931–32. *Annals of Archaeology and Anthropology* 20: 71–186

COLLON, D., 1987. *First Impressions: Cylinder Seals in the Ancient Near East.* London

CRAWFORD, V. E., 1959. Nippur the holy city. *Archaeology* 12: 74–83

CROWFOOT, J. W., and G. M. CROWFOOT, 1938. *Early Ivories from Samaria.* London

CURTIS, J. E., 1988. Assyria as a bronzeworking centre in the Late Assyrian period. In J. E. Curtis (ed.), *Bronzeworking Centres of Western Asia c.1000–539 BC*: 83–96. London

CURTIS, J. E., 1992. The Dying Lion. *Iraq* 54: 113–18

CURTIS, J. E., 1992a. Recent British Museum excavations in Assyria. *Journal of the Royal Asiatic Society* (3rd series, 2/2): 147–65

CURTIS, J. E., 1994. Assyrian fibulae with figural decoration. In N. Cholidis *et al.* (eds), *Beschreiben und Deuten in der Archäologie des Alten Orients: Festschrift für Ruth Mayer-Opificius*: 49–62. Münster

CURTIS, J. E., and D. COLLON, 1989. *Excavations at Qasrij Cliff and Khirbet Qasrij.* London

CURTIS, J. E., D. COLLON and A. R.

GREEN, 1993. British Museum excavations at Nimrud and Balawat in 1989. *Iraq* 55: 1–37

CURTIS, J. E., and A. R. GREEN, 1987. Preliminary report on excavations at Khirbet Khatuniyeh 1985. In *Researches on the Antiquities of (the) Saddam Dam Basin Salvage*: 73–7. Baghdad

CURTIS, J. E., T. S. WHEELER, J. D. MUHLY and R. MADDIN, 1979. Neo-Assyrian ironworking technology. *Proceedings of the American Philosophical Society* 123: 369–90

DALLEY, S. M., 1988. Neo-Assyrian textual evidence for bronzeworking centres. In J. E. Curtis (ed.), *Bronzeworking Centres of Western Asia c.1000–539 BC*: 97–110. London

DALLEY, S. M., 1989. *Myths from Mesopotamia.* Oxford

DEZSÖ, T., and J. E. CURTIS, 1991. Assyrian iron helmets from Nimrud now in the British Museum. *Iraq* 53: 105–26

DONDER, H., 1980. *Zaumzeug in Griechenland und Cypern* (Prähistorische Bronzefunde 16/3). Munich

EBELING, E., 1931. *Tod und Leben nach den Vorstellungen der Babylonier.* Berlin/Leipzig

FALES, F. M., 1973. *Censimenti e catasti di epoca neo-assira.* Rome

FALES, F. M., 1986. *Aramaic Epigraphs on Clay Tablets of the Neo-Assyrian Period* (Studi Semitici, nuova serie, 2). Rome

FALES, F. M., and J. N. POSTGATE, 1992. *Imperial Administrative Records*, part 1 (State Archives of Assyria 7). Helsinki

FALSONE, G., 1985. A Syro-Phoenician bull-bowl in Geneva and its analogue in the British Museum. *Anatolian Studies* 35: 131–42

FAUTH, W., 1981. Ištar als Löwengöttin und die löwenköpfige Lamaštu. *Die Welt des Orients* 12: 21–36

FINKEL, I. L., 1984. Necromancy in ancient Mesopotamia. *Archiv für Orientforschung* 29–30: 1–17

FRAME, G., 1991. Assyrian clay hands. *Baghdader Mitteilungen* 22: 335–81

GADD, C. J., 1925. *Cuneiform Texts from Babylonian Tablets in the British Museum*, part 39. London

GADD, C. J., 1934. An Egyptian game in Assyria. *Iraq* 1: 45–50

GALLING, K., 1941. Beschriftete Bildsiegel des ersten Jahrtausends v. Chr. vornehmlich aus Syrien und Palästina. *Zeitschrift des Deutschen Palästina-Vereins* 64: 121–202

GASSON, G., 1972. The oldest lens in the world: a critical study of the Layard lens. *The Ophthalmic Optician*, 9 December: 1267–72